The Patrick Moore Practical Astronomy Series

For further volumes:
http://www.springer.com/series/3192

Lessons from the Masters

Current Concepts in Astronomical Image Processing

Robert Gendler

Editor

Springer

Editor
Robert Gendler
Astropics
Avon, CT, USA

ISSN 1431-9756
ISBN 978-1-4614-7833-1 ISBN 978-1-4614-7834-8 (eBook)
DOI 10.1007/978-1-4614-7834-8
Springer New York Heidelberg Dordrecht London

Library of Congress Control Number: 2013941997

© Springer Science+Business Media New York 2013
This work is subject to copyright. All rights are reserved by the Publisher, whether the whole or part of the material is concerned, specifically the rights of translation, reprinting, reuse of illustrations, recitation, broadcasting, reproduction on microfilms or in any other physical way, and transmission or information storage and retrieval, electronic adaptation, computer software, or by similar or dissimilar methodology now known or hereafter developed. Exempted from this legal reservation are brief excerpts in connection with reviews or scholarly analysis or material supplied specifically for the purpose of being entered and executed on a computer system, for exclusive use by the purchaser of the work. Duplication of this publication or parts thereof is permitted only under the provisions of the Copyright Law of the Publisher's location, in its current version, and permission for use must always be obtained from Springer. Permissions for use may be obtained through RightsLink at the Copyright Clearance Center. Violations are liable to prosecution under the respective Copyright Law.
The use of general descriptive names, registered names, trademarks, service marks, etc. in this publication does not imply, even in the absence of a specific statement, that such names are exempt from the relevant protective laws and regulations and therefore free for general use.
While the advice and information in this book are believed to be true and accurate at the date of publication, neither the authors nor the editors nor the publisher can accept any legal responsibility for any errors or omissions that may be made. The publisher makes no warranty, express or implied, with respect to the material contained herein.

Springer is part of Springer Science+Business Media (www.springer.com)

This book is dedicated to the memory of Daniel Marquardt, who during his short time with us exemplified the goodwill and camaraderie of the worldwide astroimaging community.

Preface

For more than a century and a half, astrophotography has consistently brought us vital information about our universe as well as the visual splendor of the cosmos. By way of an amazingly rich journey and through the contributions of many individuals, we have now arrived at an era where astrophotography serves as both art and science. Along the way, we have learned that art and science are not mutually exclusive objectives but together can serve the human need to learn about our place in the universe and to experience and enjoy nature on the grandest of scales.

The process of astrophotography has transitioned over time from a purely technical exercise with a defined scientific and informational purpose to an increasingly human experience where the skillful management of light and color can reconstruct powerful cosmic scenes that reach out to us and enrich our understanding and appreciation of nature on many levels. The process has become increasingly personal in a sense. A given astronomical data set can produce many different results, each one valid, and each a reflection of the eye and imagination of the individual.

Mechanically speaking, astrophotography is fundamentally a two-step process. The two processes could not be more dissimilar. The first step of data acquisition requires the precise functioning of the equipment chain. The mechanics of light collection leave little room for error. Image acquisition is dogmatic and rigid by necessity, and imposes strict rules and limits. However, the second step of image assembly and enhancement is, on the contrary, an entirely fluid process. It requires a creative and flexible mindset, and demands experimentation in order to succeed. It is truly a dynamic and creative process.

This book is more about the second step of the process. Since I began astrophotography, it is this phase of the process which I have found to be the most personally rewarding and enjoyable. People often ask me how to produce images with high visual impact. I tell them the most essential element is to view and experience as

many astronomical images as possible and emulate the ones you admire most. Only in this way can one's own photographic eye and sense of style develop and mature. Programs such as Photoshop, as wonderful as they are, can only provide the raw tools. The road to good results can only be achieved by studying the works of others and ultimately tapping into that experience to carve out your own style and direction.

The organization and objectives of this book are based on my experience as a student of astrophotography, of which I remain and will forever be. Since the advent of the CCD camera and the subsequent birth of digital astrophotography, modern astronomical imaging has become increasingly diverse and rich. In the last decade, the craft has grown exponentially, resulting in a myriad of different applications and subdisciplines. Astrophotographers today possess the technical resources to record the faintest objects from the depths of space, the finest details of the Sun, the Moon, and planets, and the sublime beauty of the local night sky here on Earth.

Certainly, technical advancements in telescope and camera technology were critical in propelling astrophotography into the modern era. Nevertheless, the final outcome of the astrophotographic process rests on the imager's ability to assemble the astronomical data into a coherent image with maximal visual and informational impact. The creative aspect of the craft is increasingly driven and defined by the successful management and enhancement of data after it is collected at the telescope. Today, the measure of success of an astronomical image is increasingly dependent on the image-processing skills and creative vision of the astrophotographer. The modern practitioner of astrophotography cannot only be proficient at taking images but must stay current with the growing array of sophisticated digital techniques used to extract the finest details, the richest colors, and the faintest signal from his or her data.

Consequently, the mastering of astronomical image processing has become the essential task for the modern astrophotographer. As techniques and methods expand and evolve at an ever-increasing pace, staying current with the latest information has become the primary mission of the dedicated imager. Yet, the delivery of that information has become challenging. There are no formal university courses, apprenticeships, or degrees in astrophotography. As a result, astronomical imagers have become a self-taught breed relying predominantly on a combination of field experience, web-based resources, and informal instruction to learn the vast nuances of this extraordinarily complex and challenging craft. There exists today a paucity of books on astronomical image processing primarily because it is impossible for one author to cover the full range of subject areas with the expert precision each area deserves.

This book – by its very nature, a collection of works by individual contributors, each distinguished in their particular areas – will attempt to accomplish this task by covering in systematic detail each of the major subdisciplines of astrophotography. This approach offers the reader the greatest opportunity to learn the most current information and the latest techniques directly from the world's foremost innovators in the field today. Each chapter covers the specific processing techniques, methods, and strategies unique to each of the major subdisciplines of astrophotography. A large portion of the book is devoted to "deep sky imaging" since it represents the

foundation of astrophotography. Individual chapters cover specific challenges within the realm of "deep sky imaging," such as bringing out faint structure, enhancing small- and large-scale detail, noise reduction, and narrowband imaging. To add some practical elements to the instruction and ensure that all pertinent subject matter is covered, I asked three world-renowned imagers to write chapters in which they describe their preferred "deep sky" workflows in step-by-step detail.

The information in the pages ahead may not answer every processing question that arises, but it will provide the reader with the necessary skills and strategies for successful high-level imaging. The collective input from multiple contributors, all with different perspectives and experience, is extraordinarily valuable but also increases the chance that there may be some overlap in the information delivered. In this sense, overlap is a good thing. Some redundancy reassures and confirms that certain methods are more time proven than others. The field of astronomical image processing is not a static one, but a markedly fluid and ever-evolving craft. The challenge of trying to cover the most current material in a rapidly changing field is similar to chasing a moving target. Nevertheless, the pages ahead should offer the reader a strong foundation of skills and knowledge to build on for years to come.

For many, astrophotography is an adventure of the mind, heart, and spirit. It is a difficult and demanding journey, but one that pays back immensely and offers an unparalleled sense of discovery. The objective of this book is to provide guidance to those individuals who want to take this amazing journey themselves. They want to learn the powerful tools and techniques of image processing so they, too, can experience the joy and wonder of astrophotography. It is my hope that the pages ahead will provide motivated imagers with the necessary tools, techniques, and strategies to help them find their own path and direction in astronomical imaging.

Avon, CT, USA Robert Gendler

Contents

The Theory of Astronomical Imaging .. 1
Stan Moore

High Dynamic Range Processing ... 29
Ken Crawford

Intensifying Color ... 51
R. Jay GaBany

Revealing Small-Scale Details ... 73
Ken Crawford

Bringing Out Faint Large-Scale Structure .. 97
Rogelio Bernal Andreo

Narrowband Imaging .. 115
Don S. Goldman

Widefield Imaging: Selected Strategies for Processing Light-Contaminated Data ... 131
Stephen A. Cannistra

Noise Reduction Techniques .. 149
Tony Hallas

Deep Sky Imaging: Workflow 1 ... 159
Adam Block

Deep Sky Imaging: Workflow 2	193
Johannes Schedler	
Deep Sky Imaging: Workflow 3	217
Steve Mazlin	
High Resolution Lunar and Planetary Imaging	233
Damian Peach	
Secrets to Successful Earth and Sky Photography	261
Babak A. Tafreshi	
Imaging and Processing Images of the Solar Corona	293
Fred Espenak	
Catching Sunlight	319
Alan Friedman	
Aesthetics and Composition in Deep Sky Imaging	343
Robert Gendler	
Hybrid Images: A Strategy for Optimizing Impact in Astronomical Images	363
Robert Gendler	
Author Biographies	377
Index	383

The Theory of Astronomical Imaging

Stan Moore

This chapter presents a conceptual framework for understanding the basic physics and dynamics of astronomical imaging. The core concept is that an image captures information about astronomical objects (stars, galaxies, and such) and the quantity and quality of that information places strict limits on the image.

An understanding of these concepts can inform many decisions and expectations regarding astronomical equipment and imaging techniques. Although this information theory approach can be understood without solving mathematical equations, such an understanding is incomplete. The basic equations presented below are invaluable for understanding the sometimes unexpected behavior of signal-to-noise ratios and such equations are necessary for the analytics and predictions that can be put to practical uses.

The Photonic Nature of Light and Noise

Astronomical images present information from distant objects. That information is conveyed by light photons that are electromagnetic waves with a particle (quantum) nature. Photons are emitted and detected on an individual quantum basis, and this has profound effects on information carried by the light. The quantum photonic nature of light limits the quality of information about an imaged object due to inherent uncertainty associated with quantum information. This uncertainty is called Poisson noise.

Poisson noise can be demonstrated by measuring rainfall over an area by collecting rainwater in many buckets within a limited area. Water in each bucket is measured at the end of the storm to reveal that each bucket collected slightly different amounts of water due to the randomness of the falling drops. Averaging all buckets will produce a more accurate estimate of the rainfall than any single bucket.

Poisson noise is caused by random variations of quantum accumulations and exhibits a mathematical predictability. The uncertainty of an accumulation of random discreet events is described by:

$$Poisson\ noise = \sqrt{number_of_events}$$

Noise denotes the range of values for which there is 68 % likelihood that the true value is contained within that range, akin to the "margin of error" stated in opinion polls.

The inherent Poisson noise of light signals means that it is not possible to increase information by indefinitely amplifying or distilling a signal because the noise/uncertainty is intrinsic to the signal itself. So there are strict physical limits to what any camera can do, and it is useful to understand those limits and how they impact imaging decisions. It is interesting to note that this dynamic does not exist for pure wave energy, and imaging would have a very different dynamic if it were not for the quantum nature of light. Non-quantum energy does not embody the inherent uncertainty of Poisson noise. Noise in a non-quantum system is caused by extraneous sources that interfere with the pure signal so the noise level is unaffected by signal strength. A stronger non-quantum signal quickly overpowers noise, and S/N becomes nearly linear. In such a system, doubling a strong signal would also double S/N, whereas in a quantum system, it is necessary to quadruple the signal to double the S/N. CCD images offer proof that light has a profound quantum nature.

This image demonstrates limitations imposed by the quantum nature of light. This is a photon counting image of M57, the Ring Nebula. Each dot is a photon. For the short exposure time (30 ms) either a photon arrived at a location or not. The image was taken with a photon counting ICCD having zero read noise (ZeroCam) (Fig. 1).

The Virtual Image

The virtual image consists of information conveyed to the focal plane by photons from astronomical objects, regardless of camera ("before" the camera). Characteristics of the virtual image set limits on information that can be obtained by a camera. So it is important to understand the physics and dynamics of the virtual image, then examine how that interacts with the camera.

Light from astronomical objects is collected by a telescope aperture for a certain length of time. The collected photons are conveyed by the optics to the focal plane, where the virtual image is formed. Information about each object is contained in the virtual image. At root, that information consists of the location of every photon collected.

Signal to Noise (S/N) Ratio

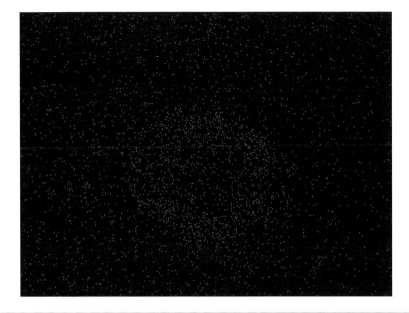

Fig. 1 M57 (Ring Nebula) 100 ms exposure from a photon counting camera

An object's information is based on the number of photons collected from the object, which is proportional to the area of the telescope's aperture and collection time. Focal length has no effect on the number of photons collected from an object. Thus focal length and f-ratio have no impact on the virtual image other than determining linear scale, which is irrelevant for angular properties.

Signal to Noise (S/N) Ratio

Information about the object is contained in the object's photon count, or "signal." Noise is the uncertainty of that information. The proportion of signal-to-noise is the "Signal to Noise Ratio," S/N or SNR. S/N is a widely used measure of information quality. S/N determines ability to discern contrasts in an imaged object.

An "object" can be anything, even an arbitrary patch of sky. But most meaningfully, an object is a star, galaxy, or nebula that occupies an angular area in the sky. A star object is the simplest. All stars have the same angular extent for a given system/exposure. Stellar S/N is a straightforward measure with many applications; for example S/N = 3 is the lowest S/N for star astrometric detection. Star S/N determines astrometric and photometric accuracy. The simple object S/N of large objects is affected by object size, so for large objects it may be preferable to use an angular measure such as square arcseconds. An angular measure is similarly used for galaxies – magnitude per arcsecond squared. For a large object, higher S/N reveals

finer contrasts, so a fuller description of S/N would include MTF terms, but that is beyond the scope of this chapter.

It is worth noting that this object information theory approach to imaging is not commonly employed (at least not explicitly), and that the usual definition of S/N is restricted to single pixel dynamics, oblivious to object/informational S/N. Pixel-based S/N is very easy to measure (at least for undifferentiated, non-dimensional illumination such as sky glow) and that ease and seeming simplicity can be seductive. This chapter primarily concerns the fidelity of representing an actual astronomical object and is less concerned with internal camera electronics or non-specific visual densities at particular image scales, as is a primary concern of "pixel S/N." Simple pixel S/N is a superficial concept that can too easily be misapplied, failing to account for the larger context of object fidelity, as illustrated by "the f-ratio myth" below. Pixel S/N can "fail to see the forest for the trees." However, most of this chapter and equations can easily be simplified to "pixel S/N" as a sub-domain of object S/N.

Object S/N of Pure Signal

Considering only the photons collected from the object and the associated Poisson noise:

$$\frac{S}{N} = \frac{nPhotons}{\sqrt{nPhotons}} = \sqrt{nPhotons}$$

The non-linear nature of simple S/N occurs repeatedly in astronomical imaging situations and issues (Fig. 2).

This simple equation contains advice for imaging. To double the S/N it is necessary to quadruple the signal, which can be accomplished by exposing 4× longer or using an aperture with twice the diameter. That relationship embodies a "hitting the wall" dynamic whereby reasonably long exposures cannot be significantly improved without expending inordinate amounts of time. For example, it is necessary to shoot an additional 12 h to double the S/N of a 4 h exp.

Object S/N with Sky

In addition to signals from astronomical objects the virtual image also accumulates photons from the atmospheric sky (high-altitude emissions and light pollution). Sky photons create a diffuse signal over the entire field. Because it is evenly diffuse the overall intensity of sky light can be subtracted but the sky's Poisson noise cannot be removed. This affects object S/N.

$$\frac{S}{N} = S \Big/ \sqrt{S + Sky}$$

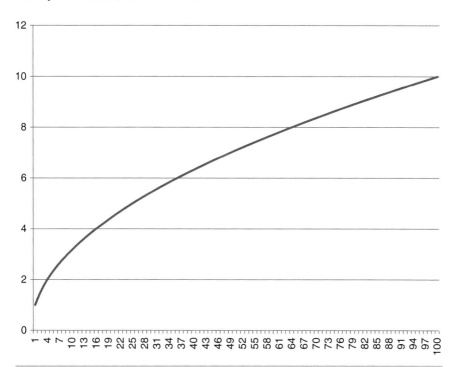

Fig. 2 Signal to Noise as a function of signal in the absence of other noises

where

S = Number of photons from object.
Sky = Number of photons from sky glow that occupies the same area as the object.

This equation contains further advice for imaging. Objects that are significantly brighter than the sky produce S/N only slightly less than would be the case for darker skies. But S/N for objects significantly dimmer than the sky is strongly constrained by sky brightness. For example, if the sky is 3× brighter than the object then S/N is about half as much as the same object in a much darker sky and so it would take 4× more exp time to compensate for the sky noise. Here is a graph of the effect on object S/N due to moderate sky glow (10 photons) at various signal intensities (1 = same S/N as if no sky glow) (Fig. 3).

Point-Spread Function (PSF) and FWHM

The virtual image information basically consists of photon arrivals. Every photon arrives at a different location (even if the distances are subatomic) and this location information constitutes the image resolution. At less than a particular distance,

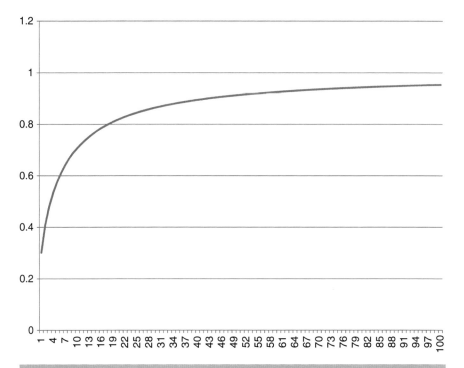

Fig. 3 Differential effect of sky glow (10 photons) on S/N by signal intensities (1 = same S/N as if no sky glow)

location precision has little or no effect on information quality because the resolution of the image is constrained by physical limits of diffraction, optical quality, atmospheric stability (seeing), tracking, and so on. This limit can be characterized as a point-spread function (PSF).

A point-spread function (PSF) is the result of blurring a point-source. Stars have incredibly small angular diameters that are essentially point-sources. The atmosphere, 'scope, and mount diffuse the starlight into a fuzz-ball that when graphed shows a bell-shaped curve (PSF). Although telescopes produce a complicated diffraction ring PSF the convolution from seeing over time intervals blur the PSF to closely approximate the Gaussian function.

The Gaussian function contains a parameter that defines the width of the PSF. This function width is a reliable and constant measure of resolving power regardless of intensity. Function width is a critical factor in the Nyquist sampling theorem discussed below. The commonly used FWHM (Full Width at Half Max) characterizes the PSF resolution by measuring the width (diameter) of the star at half of peak intensity. FWHM is directly related to the Gaussian function width by: FWHM = 2.355 * width.

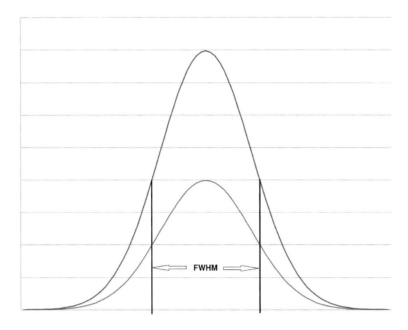

Fig. 4 Full Width at Half Maximum (FWHM) is constant regardless of star brightness

Star images will exhibit different "sizes" – brighter stars seem to be larger than dimmer stars. That is due to the bell curve of PSF, where the apparent diameter of a star is determined by particular intensity level. FWHM is a constant measure of PSF and resolution regardless of intensity. Both dim and bright stars have the same width at their half maximum intensity (of course that maximum intensity is different for different stars) (Fig. 4).

Sampling

To capture the virtual image as a digital representation it is necessary to sample the image information. Imagine overlaying the virtual image with a grid (graph paper) that combines/collapses photon locations into a limited number of grid squares. Each square embodies two types of information: the location/area of the square and the number of photons encompassed within. Each grid square is a pixel.

Nyquist Sampling Theorem

The virtual image itself is unaffected by different grid overlays or pixels sizes, but the sampled image is degraded if the sampling scale (pixel size) is insufficient to

preserve resolution. The Nyquist theorem postulates that to preserve information the sample size (or rate) must be no larger than the function width of the signal. The STD of Gaussian PSF is the function's width, so the Nyquist sample size for a Gaussian function measured as FWHM = 2.355 pixels (see PSF above). But because pixels are square with a long diagonal and because astro-images are routinely resampled (e.g., alignment registration), critical sample size should be adjusted upwards to FWHM = 3.0–3.4 pixels.

Images with FWHM < 2.3 pix are "under-sampled". Under-sampled images convolve information from the virtual image. For example, close double stars may merge and small details may wane in an under-sampled image. The degradation may be acceptable for modest under-sampling (FWHM = 2 pix) but can be significant for severe under-sampling (FWHM < 1.5 pix). Regardless, some images are deliberately under-sampled out of necessity to display a wide field on a small screen. Also there is an aesthetic that values the "pinpoint" stars of under-sampled images.

Images with FWHM > 3.5 pix are "over-sampled." Over-sampled images contain all of the useful resolution information of the virtual image, more than is strictly necessary. A modest amount of over-sampling can be useful for stacking and other processes such as deconvolution. But significant over-sampling (FWHM > 5 pix) can have undesirable consequences for real-world cameras (discussed below).

The Nyquist criterion can be used to quantify the spatial coverage of an image by dividing image size by the PSF width (3×FWHM). The result is the number of pixels necessary to capture and display the information. For example, if the corrected field of a scope is 30 arcmin and actual resolution (including seeing) is FWHM = 3 arcsec then the critically-sampled image size would be 1,800 × 1,800 pixels.

Image Scale and Pixel Size

Distances in the virtual image can be measured three ways: angular, linear, and pixel. For example the angular diameter of Jupiter might be:

- Angular: 40 arc-seconds
- Linear: 200 microns for focal length = 1 m
- Pixel: 40 pixels for focal length = 1 m and pixel = 5 microns

Angular distances are constant for all focal lengths and pixel sizes. Linear distance depends on focal length. Pixel measurements depend on both focal length and pixel size. For purposes of analysis and comparison it is often most useful to use angular measurements.

Object S/N Versus Pixel S/N

The virtual image of an astronomical object can be characterized by "object S/N," which is unaffected by sampling (unless severely under-sampled). In the sampled

image, the object's signal still consists of all photons from the object, regardless of which grid squares (pixels) they occupy. It is a simple matter to sum the relevant pixels' signals to derive the object's signal.

A single pixel in the sampled image may contain some object signal (photons from the object) but not the entire signal, which is distributed over several pixels. It is easy to measure the signal of a pixel and calculate pixel noise and S/N statistics. This "Pixel S/N" is a simplification that can be useful for understanding S/N dynamics, but it must be understood in the context of object information or it can result in misunderstandings and incorrect applications.

Pixels Are the Trees that Can Distract from Seeing the Forest!

Pixel S/N is most misleading when applied to different angular samplings. Consider a virtual image of a square object 2×2 arcsec and total intensity of 100 photons with no sky glow. Sample that image with 0.5″ and 1″ pixels:

- Object S/N = sqrt(100) = 10
- 1″ pixel: object occupies 4 pixels with mean signal = 25; pixel S/N = 5
- 0.5″ pixel: object occupies 16 pixels with mean signal = 6.25; pixel S/N = 2.5

The object's image is not somehow superior with the larger pixel because the pixel S/N is twice the S/N of the smaller pixel. It is the very same virtual image and only the number of pixels used to represent it has changed (i.e. the overlay grid has a different mesh size). This misunderstanding is the basis of the "f-ratio myth," and one way to unwind that myth is to use a "level playing field" by normalizing pixel sizes.

The F-Ratio Myth

Experienced photographers know that faster f-ratios mean shorter exposure times. Advertisements for telescope focal reducers often claim the faster f-ratio will take the same image in much less time. Similarly, it is often claimed that CCD binning will double S/N or shorten the exposure by 4×.

From an object information perspective, f-ratio per say is irrelevant (other than possible secondary effects of camera noise, discussed below). An object's photons are collected by aperture and time and that virtual image information is unaffected by focal length or sample size. It is not possible to magically create more information by simply changing sample size. Varying angular pixel size changes the pixel S/N but does not intrinsically affect an object's S/N (Fig. 5).

However, like most myths, there is some truth in the f-ratio myth. Certainly it is true when varying f-ratio by changing aperture while keeping focal length constant, as is the case for normal photographic exposure control. And the myth's f-ratio

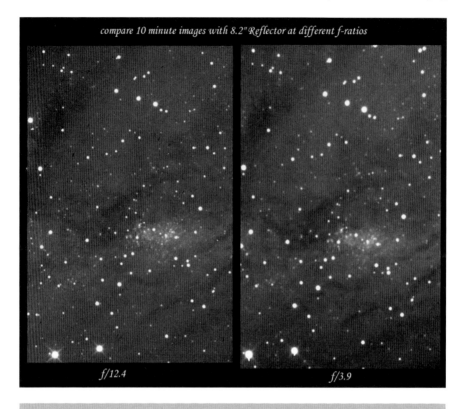

Fig. 5 Testing the "f-ratio myth": same aperture, same exposure times but very different FL and f-ratios

dynamic applies to non-normalized pixel S/N analyses, which can provide assessments of superficial visual quality at particular image scales. But perhaps most interestingly, the f-ratio myth's predictions can be approximately correct for short exposures, though for reasons entirely different than the myth's supposition, and this is due to imperfections of real cameras (read noise in particular).

Normalizing Pixel Size

To compare pixel based characteristics of different-sized pixels it is necessary to mathematically normalize the pixel sizes so that the angular sizes are equal (equivalent to defining an "object" with constant flux over a fixed extent). This is especially important when evaluating different cameras for use on a particular telescope. Camera specifications are per pixel. At first glance it might seem that a detector with 10 μm pixels having full-well depth of 40,000e- is deeper than a 5 μm detector

with full-well depth of 10,000e- until you consider that the depth per actual area is identical. A star that occupies 4 pixels in the first camera will occupy 16 pixels in the second and so each smaller pixel need not be as deep as the larger pixel.

The same dynamic applies to dark current; e.g., a 10 μm detector with dark current of 0.1e-/pix/s has the same effect as a 5 μm detector with dark current = 0.025e-/pix/s. Noise must be normalized quadratically (sqrt of the sum of squares), so it is a bit more complicated to normalize read noise; e.g., a 10 μm detector with read noise = 10e- produces half as much noise as does a 5 μm detector with read noise = 10e-.

Pixel sizes can be normalized from one detector to another or to a standard reference. Pixel sizes can be angularly normalized, such as 1 arcsec (to compare different 'scopes); or linearly normalized, such as 1 mm (for detectors used on the same 'scope). For example, to normalize detector characteristics to 1 mm:

$$Well\ capacity\ per\ square\ micron = \frac{full_well}{ps^2}$$

$$dark\ current\ per\ square\ micron = \frac{pixel_dark}{ps^2}$$

$$Read\ noise\ per\ square\ micron = \sqrt{\frac{rn^2}{ps^2}}$$

Where ps = pixel size in microns.

Real Cameras

A real camera is unable to perfectly capture a virtual image. Some information from the virtual image is lost (QE) and the uncertainty associated with the information is increased (camera noise). Both of those effects decrease object S/N.

Photon/Electron Accumulation, ADU, DN, and Gain

Imaging photon detectors such as CCDs and CMOS's accumulate photon information by converting incoming photons to stored electrons. For normal detectors each stored electron represents one photon (intensified detectors such EMCCD and ICCD employ many electrons per photon). At the end of an exposure the stored charges are read out to produce numeric digital values for each pixel. The pixel values are called ADU (Analog to Digital Units or Arbitrary Digital Units) or DN (Digital Number). The ADU values are related to electron/photon counts by Gain:

$$Photons\ detected = Electrons\ measured = Gain * ADU$$

Gain is usually documented for each camera and can be measured via various methods, most of which employ evenly illuminated frames to link measured noise (STD) with photonic Poisson noise. S/N and noise equations are quadratic (squares and square-roots) and require measurement in real quanta, so it is necessary to convert ADU to electrons:

$$elections = gain * ADU$$

Quantum Efficiency (QE)

Quantum efficiency (QE) is a measure of the percentage of incoming photons that are detected by the imaging sensor. For example, if QE=0.66 (or 66 %) then the sensor fails to detect 1 out of every 3 photons. QE is determined by material characteristics of the sensor and is also affected by the obstruction of overlaying circuit elements. Micro-lenses on each pixel are commonly used to route light around the overlaying circuit elements. "Back illuminated" sensors are fabricated to allow light to enter the sensor's back side, avoiding all circuit elements.

Camera Noises

As shown above, sampling (pixel size) has no intrinsic effect on object information (S/N) in the virtual image. But real cameras contribute noise at the pixel level and so the effects of that noise on objects' S/N must vary with pixel size. It requires more small pixels than large to encompass the same object, which imparts more camera noise into the object's S/N. There are two primary sources of pixel-based camera noise: read-out and dark current.

Read Noise

Read noise (or read-out noise) is uncertainty resulting from physically measuring each pixel's signal. CCD binning combines signals from multiple pixels prior to read-out; thus CCD read noise is associated with logical (binned) pixels, not physical pixels. CMOS detectors cannot be binned because read-out is direct access, so CMOS noise is always associated with physical pixels.

Read noise is commonly specified for astronomical CCDs and can be measured empirically. A simple measure of read noise can be done using two "bias" exposures (short-exp dark frames): subtract one bias frame from the other then measure the Standard Deviation (STD) of the resulting frame; convert STD to electrons (ADU * gain=electrons) and divide by sqrt(2).

Dark Current

Dark current consists of electrons generated by the molecular and atomic effects of heat. Dark current continually accumulates during the exposure and is normalized by dark subtraction calibration. Dark accumulation is subject to the uncertainty of Poisson noise that cannot be removed via calibration. So it can be important to minimize dark current by cooling the detector.

Object S/N with Sky and Real Camera

This equation captures the primary significant terms and dynamics for most imaging situations and contains many useful insights:

$$\frac{S}{N} = S*QE \Big/ \sqrt{(S+Sky)*QE + f*p*rn^2}$$

where:

S = Number of photons from object
Sky = Number of photons from sky-glow that occupies the same area as the object
QE = Quantum Efficiency (electrons/photon)
f = number of frames used in stack (f = 1 for single frame)
p = number of pixels covered by object (p = 1 for pixel S/N)
rn = read noise (electrons)

These noise and S/N equations are "quadratic." Terms are squared before being added, then the square-root of that sum produces the result. The squaring and square-root operations produce a dynamic that may be non-intuitive or even counter-intuitive, and many aspects of imaging may not follow common sense. Quadratic summation is non-linear, so increasing or decreasing the signal or noise usually does not produce proportional changes in S/N; for example, it takes four times more photons to double S/N.

Due to the squaring, high valued terms can potentially render low-value terms insignificant, meaning the resulting S/N is nearly the same with or without the low-value terms. This dynamic can be exploited by the imager; for example, the above equation reveals how exposure times and sampling can be set to produce "sky limited" exposures.

Example Application of S/N Equation: Sky Limited Exposures

An important dynamic of the S/N quadratic equation is the concept of "sky limited," whereby it is possible to relegate read-noise to near insignificance by manipulating exposure times and/or sampling (pixel size). Total noise is often dominated by the highest noise, whereby other noises are not great enough to significantly

affect the quadratic sum. For bright objects, the Poisson noise of the signal itself is the limiting factor. But for dim signals the S/N may be dominated by sky and/or camera noises, which limits the S/N. An exposure is "sky limited" when the background noise is dominated by sky rather than camera noises.
Using "pixel S/N" (p=1) to simplify the basic concept:

$$Background\ noise\ per\ pixel = \sqrt{skyRate * t * f + f * rn^2}$$

where:

skyRate = sky electrons per second per pixel
t = number of seconds per frame
*Total exp time = f * t*

Thus fewer frames require longer exposures per frame to maintain the same total exp time. Conversely, shorter exposures per frame require more frames.

$$Background\ noise\ per\ pixel = \sqrt{skyRate * totalTime + f * rn^2}$$

Stacking more frames per total exposure time increases the effect of read-noise while the sky term remains constant. Thus it would seem necessary to limit the number of frames by taking the longest possible exposure per frame. However, the quadratic equation contains a non-linear loophole: the exposure per frame only need be long enough for the sky noise to limit the total noise, regardless of number of frames. To see how that dynamic might work in a single frame (f=1), it is necessary to plug in a few typical values:
For:

$$skyRate = 10\ e-/s$$

$$rn = 12\ e-$$

If totalTime = 1 s then background noise = sqrt(10 + 144) = 12.4. The background noise is limited by readout; if sky was zero then N = 12, which is hardly any different. But if t = 100 s then background noise = sqrt(1,000 + 144) = 33.3, which is limited by sky; i.e. if read-out was zero then N = 31.6.

Effect of Sampling on Sky Limit

Object S/N provides further insight. The background contains no object but is subject to angular sky flux:

$$Background\ noise\ per\ area = \sqrt{skyAreaRate * t * f + f * p * rn^2}$$

where:

skyRate = sky electrons per second over the area
t = number of seconds per frame

Examine the dynamic of a single frame (f=1):

$$Background\ noise\ per\ area = \sqrt{skyArea + p * rn^2}$$

The number of pixels per area:

$$p = \frac{area}{pixelSize^2}$$

Smaller pixels result in more pixels per area and thus increase the impact of read-noise, while leaving angular/object signal and sky noise unaffected. This dynamic increases sky limited exposure times for smaller pixels.

Practical Considerations for Sky Limited Imaging

There are several sky limited exposure calculators on the web, but it is easy enough to estimate sky limited exposure times from the above equations.

$$Background\ noise\ per\ pixel\ (including\ read\ noise) = \sqrt{skyRate * t + rn^2}$$

$$Background\ noise\ per\ pixel\ (excluding\ read\ noise) = \sqrt{skyRate * t}$$

Use a threshold factor **h** to equalize the two (e.g., h=1.10 for 10 % tolerance):

$$h * \sqrt{skyRate * t} = \sqrt{skyRate * t + rn^2}$$

Solve for sky limited exposure time **t**:

$$t = \frac{rn^2}{skyRate * (h^2 - 1)}$$

Approximately 10 % tolerance:

$$t = \frac{rn^2}{skyRate * 0.2}$$

Measure and Calculate Sky Limited Exposure Time

Use a dark subtracted image to measure the mean or median background ADU to calculate skyRate:

$$skyRate = (background - pedestal) * gain\ /\ exposure_time$$

$$pedestal = ADU \text{ added in dark subtraction}$$
$$(determined\ by\ software, usually\ 100\ or\ 0)$$

Example

Calculate a sky limited exposure with 10 % tolerance using a camera with [gain=2, pedestal=0, read noise=10e-]
Reference a 100 s image with [100 ADU average background]:

$$skyrate = 100 * 2 / 100 = 2\ e-/sec/pix$$
$$t = 100 / (2*0.2) = 250\ sec$$

Impossible Limits

There are situations where it may be impossible to take sky limited exposures. The sky flux per pixel (skyRate) may be so low that the above equations produce untenable exposure times or long exposure times that result in excessive saturation of brighter objects. Dark skies, slow f-ratio, filters and smaller pixel size all decrease skyRate. Increasing pixel size increases skyRate, which can become a trade-off between S/N and resolution.

The sky limited exp times necessary for filters may be prohibitive, especially for narrowband filters. Even broad-band color filters can result in long exposure times. The LRGB technique of color imaging employs binned color data, which makes it easier to take sky-limited filtered exposures due to the increased skyRate of the larger pixels. Another way to understand that dynamic is that by reducing the number of pixels in the object(s) so the total read-noise is also reduced.

Image Construction and Processing

The principles of object information can also be applied to image construction and processing. Basic astronomical image construction consists of frame calibration to remove most of the pseudo noise due to predictable variations from the camera. Most deep space images are constructed from multiple frames and the principles of S/N can optimize "stack" operations. Additionally, S/N statistical processing can identify and modify bad data within or outside of the stacking operation. An image processing such as blurring or sharpening modifies object information in predictable ways.

Image Construction: Frame Calibration

The individual pixels of digital cameras vary from each other in two important ways: dark current and quantum efficiency (QE). These variations can produce undesirable artifacts such as a "salt and pepper" look, bright/hot or dark/cold pixels, anomalous columns, subtle grids, rectangles, and so on. Additionally the 'scope and optical elements produce varying obstructions such as vignette and dust spots. These effects may obscure or impair images. But these effects can be known, predicted and removed via calibration.

Calibration: Dark Subtraction

During an exposure, thermal molecular motions knock electrons into pixel wells and these electrons are indistinguishable from photon-generated electrons. Thermally generated electrons are called "dark current." Due to electronic structures and material/fabrication imperfections, different pixels accumulate dark electrons at different rates. Fortunately, each pixel's dark current is constant for stable temperature. This makes it possible to create a calibration "dark frame" to characterize the dark current. Each image pixel is calibrated by subtracting the corresponding dark frame pixel, thus removing the dark current.

According to information theory it is not possible to exactly remove the dark current from each pixel because that information is quantum (electrons) and thus subject to the uncertainty of Poisson noise. So each pixel contains dark noise from the image and dark subtraction. The total noise from dark current after dark subtraction is:

$$dark\ noise\ per\ pixel = \sqrt{darkCount + darkSubtractorNoise^2}$$

where:

$darkCount$ = total dark current electrons/pixel
$darkSubtractorNoise$ = dark frame noise

$darkSubtractorNoise$ can be decreased by combining many dark exposures into a "Master Dark Frame." For the most part, dark exposures contain noise from dark current and read-out.

$$darkSubtractorNoise\ per\ pixel = \frac{\sqrt{f*(darkCount+rn^2)}}{f}$$

$$= \frac{1}{\sqrt{f}} * \sqrt{darkCount+rn^2}$$

where:

f = number of dark frames used to construct Dark Master
rn = read noise (electrons)

The dark noise of a Master Dark decreases by the square-root of the number of frames. For example: a Master Dark made from nine frames has a third the noise of a single dark frame. It can take several frames to result in insignificant noise, and so it can be advantageous to maintain a "Dark Library" containing low noise Masters for re-use. The read-noise component may be relatively large, and thus it may be advantageous to take longer but fewer dark exposures to perform "adaptive dark subtraction," which mathematically re-scales the dark subtractor based on exposure times or noise profiles.

Dark noise may or may not be significant depending on the signal and other noises in the image. A dark noise term can be included in S/N equations such as:

$$pixel \frac{S}{N} = s \Big/ \sqrt{s + sky + dc + rn^2 + dfn^2}$$

where for single frame:

s = Number of electrons/pixel
sky = Number of sky electrons/pixel
dc = accumulated dark current electrons/pixel
rn = read noise (electrons)/pixel
dfn = dark frame noise/pixel

Dark current accumulates at a constant rate with time as does signal and sky.

Un-cooled cameras can generate enough dark current to rival or surpass sky levels, in which case an exposure may become "dark limited," not unlike sky limited.

Calibration: Flat Fielding

As the name implies, dark subtraction calibrates pixels by removing a fixed offset from each pixel. Flat fielding differently calibrates by applying a multiplicative factor to each pixel. Factoring is necessary to correct transmission variation due to vignette, dust spots, lens/filter angles and such. Factoring also corrects variations in pixel sensitivity; detectors can have subtle patterns due to electronic and material variations. Pixel calibration factors are embodied in a "Flat Frame" or "Master Flat."

A flat frame is an image of a uniformly illuminated object that extends beyond the imaging area. Uniformity of illumination is important because any non-uniformity will affect the calibration. A common target for flat frames is near zenith in a twilight sky.

The flat calibration process is performed after dark subtraction of the image, otherwise the flat pixel factor will also factor the dark current (which is unaffected

Calibration: Flat Fielding

by illumination). Also flat frames should be dark subtracted, primarily to remove any bias level that could distort factoring. The flat frame average ADU is normalized to 1.0 prior to the flat fielding process in order to preserve average image intensity then the normalized array is divided into the image frame:

$$imageCalibratedPixel = \frac{imageDarkSubtractedPixel}{flatDarkSubtractedPixel\ /\ AvgFlatADU}$$

Of course, most or all of this is done invisibly by software. But there are potential complications, especially when mixing software, so it can be useful to understand what is taking place. It is especially important to keep track of bias and pedestals because the unintended presence of any offsets in the image or flat will distort the function.

Recall that *Gain = electrons/ADU*. Thus flat calibration differently changes the effective Gain for nearly every pixel. ADU measurements taken after flat fielding may not accurately indicate the true electron signal. Vignette flatting imparts a higher effective Gain on central pixels and a lower effective Gain on peripheral pixels.

As with dark calibration, flat calibration is subject to noise, and a Master Flat made of many exposures will impart less noise into the calibrated image. As with a Master Dark, the quality of a Master Flat increases by the square root of the number of exposures. The quality of a Master Flat also increases with the illumination intensity:

$$single\ frame\ Flat\ \frac{S}{N} = s / \sqrt{s + rn^2}$$

where:

s = number illumination electrons per frame per pixel
f = number of dark frames used to construct Dark Master
rn = read noise (electrons)/frame/pixel

For well illuminated flat exposure, rn is usually trivial, and so Flat quality is approximately:

$$Master\ Flat\ \frac{S}{N} \sim \sqrt{f} * \sqrt{s}$$

where:

s = number illumination electrons per frame per pixel
f = number of dark frames used to construct Dark Master

Note that illumination intensity per frame is limited by detector capacity and linearity. Above a certain threshold, most detectors fail to accumulate electrons at the same rate thus becoming non-linear (i.e. the electron to photon ratio decreases). That threshold varies by detector, but most are linear at 50 % of capacity, which is usually more than enough signal to relegate read-noise into insignificance. So a simple rule for setting flat exposure time is to expose long enough for average ADU

to=highest ADU/2; e.g., for most 16-bit cameras the highest ADU is near 60,000, so expose the flats for 30,000 ADU.

Because the flat fielding calibration is multiplicative the effects on image noise is somewhat complicated. Here is an equation for flat field noise (neglecting usually minor effects such as chromatic error due to spectral differences between the object and flat):

$$pixel\ noise\ from\ flat\ field\ (ffn) = \frac{s+sky}{flatSN}$$

This equation exhibits some interesting dynamics:

- Higher flat S/N produces less noise. As Flat S/N trends to infinity (perfect) flat field noise trends to zero.
- Brighter signals create increased flat field noise and dimmer signals generate less flat field noise. Images of dim objects in dark skies may not require high S/N flats. Bright objects may suffer from low S/N flats, which can be detrimental for photometry but is usually of little concern for pretty pictures.
- Brighter sky glow requires better flats and dark skies (e.g. narrow band filter) may not require high S/N flat.

Pixel S/N Including Dark and Calibration Noise

$$pixel\ S/N = \frac{s}{\sqrt{s+sky+dc+rn^2+dfn^2+ffn^2}}$$

where for single frame:

s = Number of electrons/pixel
sky = Number of sky electrons/pixel
dc = accumulated dark current electrons/pixel
rn = read noise (electrons)/pixel
dfn = dark frame noise/pixel
ffn = flat field noise/pixel = $\frac{s+sky}{flatSN}$

Image Construction: Multi-exposure Frame Stacking

An exposure is information from a collection of photons from an aperture over a span of time. That time span can be divided into sub-exposures that together capture the same information. This practice of taking many sub-exposures is common, in large part because it is impractical or impossible to take very long exposures in a single shot.

Multiple Exposures

There are two ways to acquire and combine multiple exposures: the image object locations are static over all frames, or the objects are offset from frame to frame. A setup that continually guides while the camera takes multiple exposures produces a static set of frames (unless polar alignment or alt/az produces field rotation). "Dithered" guiding moves the guide star for each exposure to produce dithered frames. An unguided session usually produces offset frames, but the offset is regular and can produce undesirable artifacts due to correlated noise.

Multiple Static Exposures

Constructing an image from static frames is simpler than with offset frames because it eliminates the registration process. The simplest combine methods are sum and mean:

For each pixel location [x, y] in the image space over n frames:

$$imagePixel\ Sum = \sum_{frame=1}^{n} pixel(frame)$$

$$imagePixel\ Mean = Sum \div n$$

If the same calibration frames are used for every image then the S/N of the combined image contains redundant calibration noise. Images combined without realignment operate on the same pixel location across all images resulting in correlated dark and flat noise. The S/N of combined static calibrated images is the same as combining raw frames then calibrating that image. Dark frame noise accumulates arithmetically instead of quadratic. Also, static combines reinforce bad pixels (unrepresentative, hot, outlier noise, etc.) from the calibration frame that are immune to median or other combine data rejection methods because that pixel is bad in every calibrated image (or the in the calibration of the combined raw image). For these reasons, it is usually desirable to avoid static exposures.

$$combined\ static\ stack\ pixel\ \frac{S}{N} = \frac{s*f}{\sqrt{f*(s+sky+dc+rn^2)+(f*dfn)^2+(f*ffn)^2}}$$

$$= \frac{\sqrt{f}*s}{\sqrt{s+sky+dc+rn^2+f*(dfn^2+ffn^2)}}$$

where:

s = Average number of electrons/pixel/frame
sky = Average number of sky electrons/pixel/frame
f = number of frames

dc = *camera dark current/pixel/frame*
rn = *read noise (electrons)/pixel/frame*
dfn = *dark frame noise/pixel,* this is multiplied (above) by number of frames to fit the summed image
ffn = *flat field noise/pixel* = $\dfrac{s + sky}{flatSN}$, this is multiplied (above) by number of frames for summed signal

Multiple Offset Exposures

Constructing an image from offset (dithered) frames requires registration, comprised of two steps: alignment and resampling. Alignment determines the location of identical objects in different frames to create a function that maps locations of objects from one frame to another. That alignment function is used to resample the image. Recall that the virtual image was originally sampled by the camera, now that sampled image is mathematically resampled to register it with other frames. Alignment and resampling methods are not covered here but the S/N dynamics of resampled images are examined.

The concept of Object S/N is well equipped to deal with resampling and stacking. It is not always necessary to elaborate or employ a full object equation when a simpler pixel oriented equation can illustrate a particular issue. However, pixel equations can be misleading when unintentionally misapplied so care should always be taken to consider the larger context.

The S/N of an offset/resampled combined image is straightforward. Each image must be separately calibrated prior to resampling, so the calibration noise is present in each image. Furthermore calibration noise is different for every pixel location in the stack due to resampling so that noise accumulates quadratically, not arithmetically as for static stacks. This results in lower noise and better S/N. Also, the offset pixel locations facilitate robust data rejection methods. For these reasons, it is usually desirable to take offset exposures.

$$\text{combined offset stack pixel } S/N = \dfrac{\sqrt{f} * s}{\sqrt{s + sky + dc + rn^2 + dfn^2 + ffn^2}}$$

Resampling: Divergence of Informational S/N and Measured S/N

Up to the point of registration/resampling, the above equations should be consistent with proper measurements of real images. However, only one resampling method preserves empirical noise characteristics: "nearest neighbor" simply moves pixels from one location to another. All other resampling methods (e.g., bi-linear or bi-cubic) calculate the resampled pixel as a composite value from many original pixels. This compositing reduces variation and thus artificially suppresses noise. Measurements and calculations based on resampled images can indicate a higher S/N than is the true informational S/N.

Stack Data Rejection: Sigma Reject

There are several methods for removing and substituting bad data as part of the stacking process. For example, at each pixel location a median combine selects the frame-pixel with the middle value. Median is at its best with many frames but is always inferior to mean, except that median can remove outliers that persist in a mean. Sigma-reject combine methods modify the mean (or sum) method to efficiently remove outliers while producing maximum S/N.

Sigma-reject examines frame-pixels at each image location to assess the uncertainty (noise) to determine if any pixels in the stack exceed a noise threshold. The threshold is expressed in terms of Sigma (recall that there is a 68 % probability that the value is within the range of Sigma). There are two methods for deriving Sigma: empirical Standard Deviation and Poisson. The Standard Deviation method calculates the STD of the pixel stack whereas the Poisson method calculates the theoretically expected noise based on the average intensity of the pixel stack. The Standard Deviation method requires many sub-exposures (about a dozen or more) to produce a reliable rejection. The Poisson method works with any number of frames, even 2 (if 2 pixels diverge more than the noise factor then the highest one is suppressed).

For each pixel location [x, y]:

$$mean = \frac{1}{n} * \sum_{frame=1}^{n} pixel(frame)$$

$$SigmaFactror = userFactor^* \sqrt{meanADU * gain + c}$$

$$for \sum_{frame=1}^{n} if \left(Abs\left(pixel(frame) - SigmaFactor\right) > 0\right)$$

$$then\ [suppress\ pixel(frame)\ and\ reiterate$$

where:

n = number of frames (not including suppressed)
c = constant noise inflator (e.g., read-noise squared)
userFactor = aggressiveness adjustment

Image Processing: Transforming Information

Information in an individual or stacked image can be transformed to reveal features, suppress artifacts or to enhance aspects. Not unlike thermal energy, information is subject to the law of conservation: information within a closed system cannot be increased or decreased but can be transformed. Also like thermal energy, image transformations may increase entropic convolution. Thus not all that much can be done to improve an image once it has been taken and assembled. So it is important to acquire good data and treat it properly rather than depend on processing to magically improve deficient information: Garbage In → Garbage Out (GIGO).

Images contain intensity, contrast differentiation, and resolution information. Intensity corresponds to object brightness; contrast differentiation is an aspect of S/N; and resolution is characterized by PSF. These aspects are interrelated, and it is possible to transform one to the other. Intensity transformation that compresses pixel values can suppress apparent noise and increase apparent S/N. Convolutions such as Gaussian blur increase apparent S/N at the expense of degraded PSF. Deconvolution improves the apparent PSF at the expense of S/N. These transformations are useful for featuring some information over other information, but they are strictly limited by the information contained in the original sampling of the virtual image.

Intensity Transformations (Scaling)

Information intensity is basically photon-electron counts and is linear (e.g., 2× more photons = 2× higher intensity) unless the camera is defective or the image is over-exposed. Astronomical objects within a stacked image can span very large intensity ranges; an image containing a 5th magnitude star and a 20th magnitude galaxy captures an intensity ratio near one million. Most display devices are limited to 8 bits (grayscale), which can only accommodate an intensity span of 256. So it is usually not possible to directly display the true linear image without degrading large amounts of information. Thus a primary and essential information transformation is "scaling" the image data to produce a viewable display. Intensity scaling consists of mapping data pixel values to display pixel values using a transformation function.

The purpose of scaling is to reveal interesting objects by mapping the object's interesting intensities into a large range of display values (stretch) while assigning non-object or uninteresting intensities to a small range of display values (compress). There are several functions used to scale astronomical images, the most common being linear, gamma, DDP, and gamma/DDP. Linear is the simplest function and requires two parameters: minimum and maximum ADU (background and bright-limit).

$$linear\ displayADU = \frac{(maximumADU - minimumADU + 1)}{256} * (imageADU - minimumADU)$$

Nonlinear functions are used to capture large intensity ranges with overemphasis of low, mid or high values. The gamma function is well suited for this, but a more popular function is DDP, which was originally devised to mimic the non-linear response of photographic film. Non-linear functions require additional parameters that control the range and severity of the non-linear mapping. Scaling functions provide valuable ways to explore depths and features contained in image information.

Deconvolution: Enhancing Apparent Resolution

Intensity transformations result in a wide divergence between inherent informational S/N and pixel S/N or noise measured in the transformed image. The pixel S/N of transformed images can be an indicator of cosmetic attributes such as apparent smoothness, but that S/N is not a useful indicator of basic image qualities, such as limiting mag, photometric accuracy and true contrast differentiation (CTF or MTF).

Convolution: Enhancing Apparent S/N

The visual appearance of S/N can be modified by convolving information via resampling or blurring.

Pixel S/N can be doubled by simply combining signals of four adjacent pixels into one (binning 2×2). Object and angular informational S/N remains unchanged, and so the increased pixel S/N will not improve limiting mag or other informational qualitie, but it can produce a smoother, more pleasing appearance. The higher S/N comes at the cost of PSF sampling and can easily result in loss of resolution information due to undersampling.

Kernel filters are mathematical matrices that are applied to an image to redistribute pixel intensities. Most kernel filters result in a blending of pixel values that suppresses variation and thus suppresses apparent noise. The result is a smoother appearing image, though at the cost of resolution. Such smoothing blurs the PSF, increasing the FWHM. A commonly used convolution kernel filter is Gaussian blur, which simulates natural processes.

Deconvolution: Enhancing Apparent Resolution

The apparent resolution and PSF can be improved by deconvolving information via unsharp masking or iterative deconvolution such as Lucy-Richardson. Both methods exchange apparent S/N for apparent resolution. Low S/N objects deteriorate with noise while high S/N objects receive improved contrasts and finer apparent details. Some implementation algorithms compensate for this exchange by limiting the application to high S/N features, thus essentially producing a hybrid image. If the implementation of the sharpening algorithm does not limit such damage then the user can blend original and sharpened images to create a hybrid image.

Unsharp Masking

Unsharp masking sharpens an image and increases contrast for small details. Unsharp masking is a type of deconvolution that employs a clever use of convolution. The image is first convolved to produce an "unsharp" image that is then applied as a "mask" to the original image. The masking operation consists of a modified

subtraction that amplifies small scale differences between the unsharp image and the original image. There are several potential control variables in an unsharp masking operation, including the type of blur (e.g., Gaussian) and parameters for blurring (e.g., function width), the strength of the amplification and limits for mask application. The reason for limiting mask application is that all type of deconvolution, including unsharp masking, can produce unnatural artifacts such as dark rings around stars ("panda eye"). Sophisticated implementations of unsharp masking include parameters in the algorithm to suppress such artifacts by limiting contrasts.

DDP unsharp masking integrates the blurred mask into the DDP scaling algorithm. This integration produces a good sharpening with fewer artifacts than standard unsharp masking.

Iterative Deconvolution

Astronomical image information has been convolved by the atmospheric seeing, optics, guiding, and such to produce a Gaussian like PSF in the virtual image. If the Point Spread Function is sufficiently known then it can be employed in an inverse function to deconvolve the image to an original state. Stars are a near perfect source for determining PSF with high accuracy so astronomical images are well suited for PSF-based deconvolution.

Convolution scrambles information, which is much easier than unscrambling it. One problem with deconvolution (unscrambling) is that there are many potential original states that could possibly result in that scrambled state. Deconvolution employs an inverse PSF to redistribute intensities over pixel arrays. This function is iterated (applied repeatedly) on the evolving pixel arrays to converge on a likely solution. The certainty of the solution is constrained by uncertainty (noise) in the PSF and image.

Actual PSF may vary over the image field because optics often produce different off-axis effects such as coma. Such differences are most pronounced in the PSF "wings" – the dimmer outer regions. Differences between the real PSF in a part of the image and the model PSF used by the deconvolution can result in stars surrounded by black rings or other undesirable artifacts. These undesirable effects can be limited by editing the model PSF, for example clipping the wings or generalizing the PSF to a mathematical model to better fit most areas.

The PSF model and image are affected by sampling. Undersampling impairs the ability of deconvolution to improve resolution. Deconvolution of an undersampled image can increase high frequency contrasts, but deconvolution of an undersampled image results in a more severely undersampled image. Deconvolution benefits from oversampling. Oversampling can better characterize the PSF and produce a result-

Fig. 6 Image (**A**) on *left* is stacked with FWHM = 5.7 pixels (2.3 arcsec). Image (**B**) on *right* is deconvolved to apparent FWHM = 3.8 pixels (1.6 arcsec) using CCDStack positive constraint (The bright central star is an accidental foreground Milky Way star. The galaxy core is the condensation below that star)

ing image that is not undersampled. Additionally, sampling imposes constraints on the deconvolution process itself because the PSF cannot be modeled as a true point source. Some deconvolution implementations modify the algorithm to account for sample limits.

Different image objects are also affected differently by deconvolution due to object S/N. High S/N objects converge to a reasonable approximation, but low S/N objects may converge to nonsensical results consisting of amplified noise clumps. Thus there are practical limits on how much iteration can be performed until deconvolution produces inaccurate results, and those limits can vary within a single image. Some deconvolution implementations contain algorithmic limiters to suppress noise. Also, as mentioned above the user can deconvolve an image to several states and blend them into a hybrid image that features enhanced resolution for bright objects and good S/N for dim objects (Fig. 6).

NGC6207

Conclusion

The conceptual framework presented here is based on information theory applied to imaging astronomical objects. The concept of object photonic S/N offers an elegant insight into natural processes that have direct applications to real imaging issues. S/N and PSF analyses can be employed to optimize equipment, configurations and practices. It is the author's hope that this framework helps practitioners in continuing to achieve more difficult and amazing feats.

High Dynamic Range Processing

Ken Crawford

Deep sky astronomical Images are produced by capturing and building up very faint signals over an extended period of time. Although faint, some objects produce a wide range of signal intensity between the very brightest and the dimmest parts of an image. For instance; capturing bright detail of the surface of the Sun and displaying it alongside the exceedingly fainter prominences on the edge of the solar disk demands expert management of the very high dynamic range of brightness values. Currently, modern digital cameras can manage broad dynamic range in terrestrial scenes by taking several images at different exposure settings and then combining these exposures to make a coherent image. High Dynamic Range (HDR) imaging and processing are now the catch terms that refer to imaging and processing techniques that effectively manage high dynamic range data to produce images with high visual and informational impact.

HDR processing has been around for a long time. Ansel Adams used darkroom techniques to employ "dodging and burning" of specific zones to present his famous HDR images in very dramatic and memorable photographic prints. Today, even the iPhone can "auto"-produce HDR images, and high-level video cameras are beginning to deploy HDR principles to videography.

We live in a golden age of astrophotography. Today we enjoy a wonderful array of tools to help us manipulate the range of intensity, contrast, and detail of information we display in our images as digital renderings. The photographic tools of today are contained in an array of sophisticated graphic software programs such as Adobe *Photoshop* and *PixInsight*. Mastering HDR digital processing with Adobe *Photoshop CS5* will be the main focus of this chapter.

Combining Different Exposures

Typical HDR images are made by merging two different images of the same subject using different exposure settings to display a higher dynamic range than the camera can produce using only one exposure setting. Normally, this type of merger is accomplished in post processing software for astronomical images. A simple example would be combining an image containing very bright solar disk detail with another image of much fainter prominence detail to produce a final image that reasonably displays both at the same time. To capture the prominence I had to overexpose the solar disk. Next, I adjusted the camera settings to record the surface details as a second image. Then, using Masks, I combined the two for the final result (Fig. 1).

Practically speaking there are really very few deep sky targets that require separate exposures to capture the faintest regions of the object. The great nebula in Orion (M42) and Eta Carina are two that come to mind, but often the dynamic range of deep sky objects can be managed effectively to display the faint and bright areas in a single image or stack of images. If it cannot, then using selective processes to blend the details of two differently exposed images is the most effective way to go. "True" HDR images are produced by merging two or more images taken at different exposures or F stops. There are software programs out there that can accomplish this type of process, but what astrophotographers traditionally do is simulate HDR by controlling the dynamic range with selection, stretching, and toning tools.

HDR Tools

Currently some of the most popular HDR tools for astrophotography are DDP, HDRWaveletTransforms, mask stretching, and tone mapping. I have always believed that you cannot have too many tools in your processing toolbox, and it is very worthwhile to explore all the possibilities and find the methods you are most

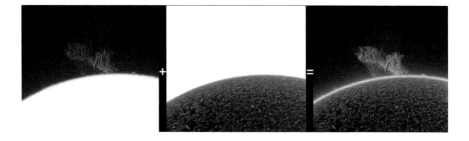

Fig. 1 Overexposed disk with prominence combined with the surface details

HDR Tools

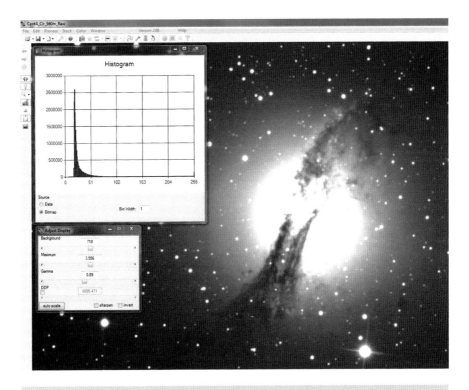

Fig. 2 Linear stretch until the dust lane is revealed

comfortable with. Remember that these are powerful processes, and you can use them with the precision of a surgeon's knife or a blacksmith's hammer.

DDP, or the "Digital Development Process," is a brightness scaling method that compresses or squeezes the large dynamic range of a CCD image to display the faint regions while maintaining control over the bright areas. There are several DDP software tools out there. I prefer *CCDStack*, as I can nicely control the final result with a real time full screen preview of the image. One thing you need to watch out for when using DDP or tone mapping tools is not to over-compress the dynamic range and end up with less contrast and a flat-looking image.

Using *CCDStack*'s DDP, you use the Adjust Display parameters while watching the histogram. The adjustments happen in real time to the display image and do not affect the underlying image data. Therefore you can manipulate the image to let you scale the brightness values to show the faint areas while at the same time control the top brightness values. In Fig. 2, you see the galaxy displayed in a linear stretch scaled up in brightness until you can see the fainter parts of the dust lane. As you can see, the core area is blown out and details are lost in the brighter regions.

Checking the DDP box turns on the DDP adjustment slider and control over the scaling of faint areas. Pushing the DDP slider to the left increases the brightness of

Fig. 3 The DDP button is checked to turn on the DDP adjustment slider

the faint areas and the compression of the dynamic range. Using the gamma and background sliders controls the histogram pedestal and clipping. Just make sure there is good shoulder room on the left side of the histogram. The Maximum slider is a progressive adjustment that controls the scale of the brightest pixels. Monitor the brighter structures and stars and the height of the histogram when making adjustments to the maximum values. Then adjust the DDP slider until you see the fainter details just start to show, as in Fig. 3.

You can almost simulate this type of a stretch using Levels and Curves in *Photoshop,* but it is not a one-step process, and DDP is much easier to use to produce the final result.

Using only DDP will help you display a larger dynamic range, but you also need to provide some type of sharpening and contrast adjustments or the image will appear a bit flat. You can accomplish those enhancements later in *Photoshop.* Once you have the DDP adjustments to their proper settings, you must save the image as a scaled file so it retains the values. Just be sure not to overwrite your existing pre-DDP file.

PixInsight has a very powerful process called HDRWaveletTransform that employs a wavelet method that selects parts of an image based on the features scale

while breaking them up into layers. Then contrast adjustments can be made to those isolated structures. Very nice results can be produced if the program is managed properly.

HDR Toning Tool

True HDR requires the merging of multiple images taken at different exposures or bracketed images using software such as *Photoshop CS5*. This software compresses the tonal range of multiple exposures into one image. But that is just the first step, as squeezing the tonal ranges into a smaller area can soften the look and flatten the contrast. You can simulate the HDR look without the work of producing multi images taken at different exposures. The HDR Toning Tool introduced in *Photoshop* CS5 can really give you some very interesting results.

There is a bit of a learning curve with this tool, as there are several adjustments that can be made to affect the outcome of your images. The first thing that I always do is to duplicate the image that I am working on. This is because the HDR Toning tool works in 32 bits, which gives you a larger range to work with. But the monitor cannot display the complete range perfectly, so this will not work with layers and will need to flatten the image if it has layers. Once you duplicate the image, you can then find the HDR Toning tool in the Image – Adjustments – HDR Toning (Fig. 4).

Make sure all of the adjustment sliders are in their neutral positions and the Method is set to Local Adaptation. You can save this as a pre-set so you can load it up later. First let's break down each of the adjustment boxes.

The Edge Glow box controls the adaptation size and the reach of the adjustment halo in pixels. The Radius and Strength sliders work together to expand or contract the size and power of the adjustments you leverage in the Tone and Detail control box (Fig. 5).

The Tone and Detail control box makes adjustments on the luminance levels. The Gamma slider adjusts the midtones while the Exposure slider adjusts the white point. Use these very carefully, as a little goes are very long way. The Details slider is a very effective sharpening tool and is used in concert with the Edge Glow controls. Use lower strength and radius values to tighten smaller scale structures while stronger strength and radius values will go after the bigger ones. I will normally make my contrast and toning curve adjustments first before going after any details.

The Shadows and Highlights add very fine adjustments to the dark and light areas of the image. You will normally have to pull down the highlights a bit on deep sky images to bring the brightest areas into a normal range in order to avoid bright detail being "blown out."

You can make saturation color adjustments using the Vibrance and Saturation sliders under the Color control box. Vibrance uses relative scaling, which was meant to protect skin tones while you brighten the colors around them. Saturation provides equal scaling to all the pixels so a combination of both seems to work the best.

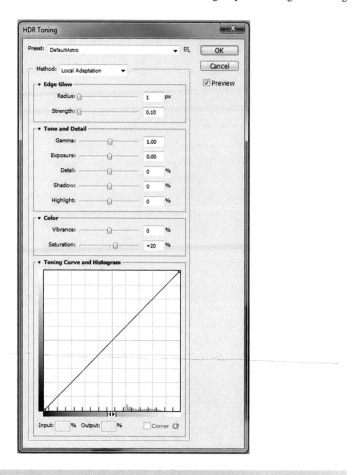

Fig. 4 HDR Toning tool

The Toning Curve and Histogram is where I normally start when using the HDR Toning tool. When you first open up this tool your image will look terrible as it is applying a default pre-set. I recommend that you set all the sliders to their neutral or lowest settings and save that as a pre-set. You can then load this pre-set to begin working on your image.

Once you have your sliders at neutral then begin by pulling the top of the Toning curve straight down along the right side of the control box. As you do this, keep your eyes on the brighter stars and make the sure they do not appear blown out. Then use the Shadows and Highlights sliders to make fine adjustments using the eye dropper tool to sample the areas that appear to need attention. You can place anchor points for the Toning curve with the eye dropper tool with CntL+Alt+Click (Fig. 6).

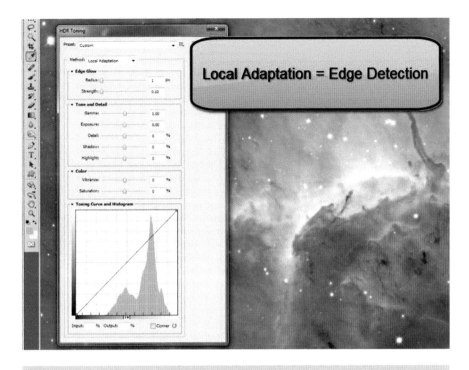

Fig. 5 HDR Toning

Fig. 6 Start with the Toning curve adjustments

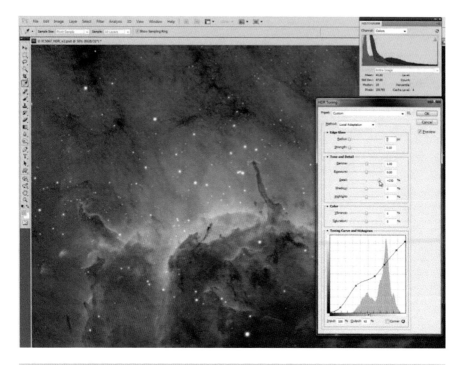

Fig. 7 Toning curves with adjustments

I normally place anchor points at the highlights, midtone, and shadow areas. Selecting an anchor point then allows me to use the up and down arrow keys for small changes to the curve. Keep making adjustments to the "Toning curve" until you have the highlights protected from being over cooked and good contrast in the midtones and shadows areas as demonstrated in Fig. 7.

Now is a good time to explore the "Details slider," which controls edge sharpening and contrast. This slider works in concert with the Edge Glow control box. I like to first increase the Detail slider up to 100 % so I can easily see the changes as I expand the adjustment halo.

For small-structure details use a small radius and go light on the strength. Then expand your reach by increasing the "radius" a little at a time to include the areas of interest. Increasing the strength applies the sharpening and acts a little like a fine adjustment knob for controlling the strength of the Details slider. You will notice contrast enhancements as the edges become more and more defined. This will take a bit of practice, and you will need to make small adjustments until you feel the right structures are included and defined. Once you are ready, move the Details sliders back and forth until just the right amount is applied to taste. It is a good idea to keep an eye on the histogram and the channels panel to ensure you do not create too harsh of an effect and blow out a color channel (Fig. 8).

HDR Toning Tool

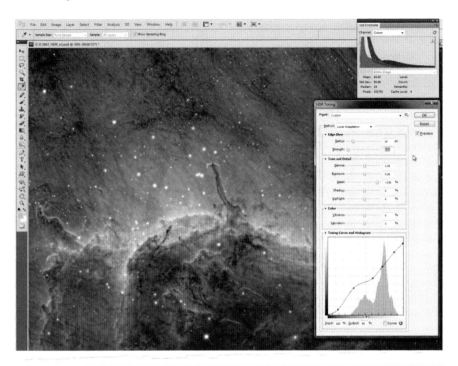

Fig. 8 Detail and edge glow adjustments

You can tweak the saturation and vibrance at this point as well as fine tuning adjustments to the Shadows and Highlights. Once you are done, it would be a good idea to save the pre-sct in case you want to return to this subject later. I have found that each image demands its own special setting, and I normally have to start from scratch every time (Fig. 9).

Now I will copy the HDR Toning adjusted image and paste it as a layer on top of the original image, where I can adjust the opacity to taste.

Because the HDR Toning tool works in 32 bits you can use the tool to bring in 32-bit FITS files for processing. You will need a FITS plugin like Eddie Trimarchi's FITS Plugin 2.0 so you can open up the 32-bit FITS file directly in *Photoshop CS5* or later. You can use the same methods I have described using the Toning Curve and Details enhancements to provide a nicely stretched and sharpened image ready for color mapping. This works best on narrowband data where you want to bring out contrast and details on each separate channel. The difference here is you want to open the HDR Toning by going to the *Photoshop* menu to Image – Mode and select 16 bits/Channel. This will allow you to make your toning adjustments in 32-bit, but then it will convert the image to 16-bit so you can utilize all of *Photoshop*'s tools, as most do not work in 32-bit space (Fig. 10).

The more you use the HDR Toning tool, the better you will like it, and you will find that it gives you amazing control over a very wide dynamic range.

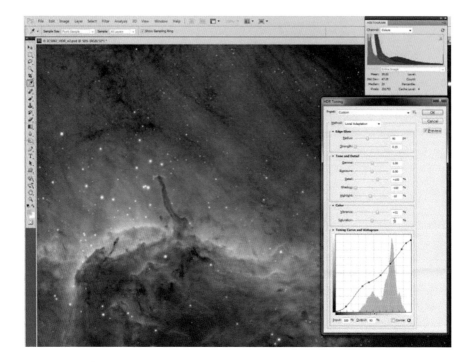

Fig. 9 Ready to save as a pre-set

Fig. 10 A 32-bit Ha FITS file opened with the HDR Toning tool

Using Star Masks to Boost Dynamic Range

When there is a very faint signal in an image that you would like to display, one of the common challenges is to display the faint structures without destroying the nice star profiles. If you over stretch the stars a host of negative effects can emerge, including fuzzy edges, color fringes, and bloated star sizes. One way around this is to produce a star mask to protect the stars while you increase the brightness of the faint areas you wish to highlight. You can also use this mask to isolate the stars from over saturation and sharpening. In this example I am using NGC225, which is a beautiful star cluster that also comprises some amazing gas and dust structures that are very faint. Since the stars are a very critical element of this composition, I want to make sure they are the focal point, but also emphasize the supporting structures and background containing the intriguing faint features of reflected dust and gas.

You can build a star mask in several ways, and the goal is to select the stars and protect everything else. One effective way is to first go into the "Channels" panel and select the channel that has the most contrast between the background and the stars. Then under the menu Select tab choose Color Range. This will bring up the color range tool box that controls the selection process based on the type of sampling you want to use. I could use the "eye dropper" to select the range of pixels I want to use, but many times I will use the drop-down box to automatically select a range of brightness values. So here I want to select the Shadows, which is all of the dark signal, then invert the selection and save it as a mask by clicking on the mask button (Save selection as a channel). This will give you a black and white alpha channel that contains the mask that we can refine and use as a layer mask (Fig. 11).

Once you have the alpha channel with the mask, rename it using a term that will remind you that this is the raw star mask before any refinements. Now we can begin to use this mask to protect the stars as we brighten and enhance the fainter things around it (Fig. 12).

Let's go over the steps to make this mask useful:

1. Select the Layers panel and then duplicate the layer.
2. Select the Channels panel and select Raw Star Mask alpha channel that we created earlier.
3. Load the mask as a selection by Ctrl+Clicking on the alpha channel that contains our mask. You will see the "marching ants" circling our stars.
4. Select the Layer panel and then select the top layer. You will see the marching ants have transported it to the top layer.
5. Click the "Add Layer Mask" button at the bottom of the layer panel. The marching ants will disappear from the main image and produce the layer mask linked to the top layer.

Another way you can do this is to:

1. Select the alpha channel that contains the mask and select all (Ctrl+A) then copy (Ctrl+C).

Fig. 11 Selecting the stars from the red channel

2. Select the Layers panel and Alt+Click the "Add Layer Mask" button at the bottom of the layers panel. This will produce a blank Hide All layer mask.
3. Alt+Click the layer mask then paste (Ctrl+V).

Either way will get you to the same place, and that is a layer mask that we can now refine and start to make adjustments to (Fig. 13).

To reveal the fainter structures hidden in the background and have some control over the stars we need to add a few adjustment layers to leverage the power of the mask.

First duplicate the layer with the mask and say "yes" to the "apply" mask option. We want a copy of the layer with its associated layer mask. Name the middle layer 'Brighten Background,' as this is the mask we will use to protect the stars and pump up the background (Fig. 14).

Using Star Masks to Boost Dynamic Range 41

Fig. 12 Alpha channel that contains the mask

Fig. 13 Star mask as a Hide All layer mask

Fig. 14 Two layers with star masks

Remember that the way mask works is "White selects – Black protects." So if we want to select the background, we need to turn it white on the mask with black around the stars. We will use the middle layer to control the background brightness, so we need to invert the middle layer's mask. For this and other adjustments we will need the Masks Panel. If you don't see this you may need to turn it on under the Window menu and make sure the Masks option is checked.

Select the Mask on the middle layer, and then on the Masks panel click the Invert button (Fig. 15).

After you have inverted the mask, you want to add a Curves adjustment layer so that it is on top of the Brighten Background layer with the newly inverted mask. You can use the Adjustments window to do this or the Layer Menu – New Adjustment Layer – Curves to accomplish the same thing. Now select the new Curves adjustment layer and go back to the Layer Menu and select Create Clipping Mask (Fig. 16).

Clipping Masks are a very powerful concept that allows adjustment layers to affect only the base layer, which is the layer that now has the layer name underlined. You can tell the adjustment layer is clipped by the indentation of the layer, and the down pointing arrow showing the path the adjustments will take to the base layer.

With the Curves adjustment layer selected, make a small adjustment to bring up the faint background data and stop right at the point where you start to get dark rings around the stars. This is the edge of the mask cutoff that we are seeing. If we refine the mask, we can blend in the hard cutoff with a nice, smooth transition (Fig. 17).

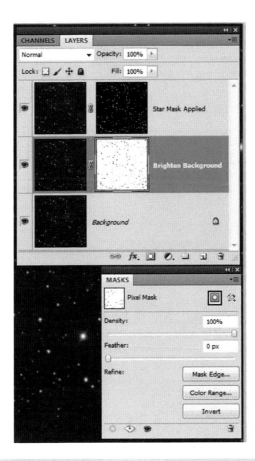

Fig. 15 Inverted star mask

Fig. 16 Curves adjustment layer as a clipping mask

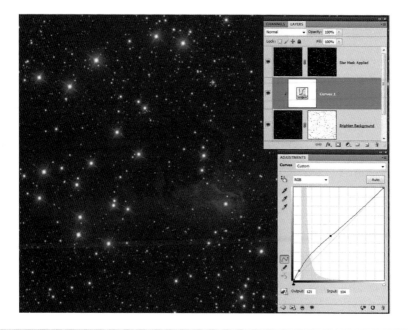

Fig. 17 Curves adjustment applied through the mask

To do this, select the mask and right click. This will bring up a drop-down menu where you can select Refine Mask for the mask refinement tools. This is the same as using the Mask Edge button on the mask's panel (Fig. 18).

Once the Refine Mask panel is up, we can look at which type of View mode will work best for our needs. First, select the Black and White option to reveal the mask in its true gray scale form. A useful keyboard shortcut is the letter K. You can see that the stars are shown as black with a white background. I repeat an important masking statement, "Black Conceals – White Reveals." Here we are selecting the background and protecting the stars. What we want to do is soften or feather the selection edges to smooth the transition between the black and white cut-off (Fig. 19).

With the mask showing, we will use the power of the Edge Detection controls. These controls were originally developed to help select and composite hair, which is normally very difficult. We will use it to select the star edges and their associated halos. Click the Smart Radius check box then push the radius size up in pixel size to a fairly large radius. In this example I am using a 55 pixel radius (Fig. 20).

Even though the edge detection is working well to select the halos, the transitions still have a very hard cut-off. The Adjust Edge control sliders allow fine adjustments of the edges of the mask. It is useful to add a small amount of smoothing and feathering. If you increase the contrast you will wipe out the selections of the star halo, so we will leave it alone for this mask.

Using Star Masks to Boost Dynamic Range 45

Fig. 18 Select the Refine Mask option

Fig. 19 Black & White (K) reveals the mask

Fig. 20 Edge detection adjustments

Because this is a "Reveal All" layer mask if we want to expand our reach of the protection, we need to increase the size of the black areas around the stars. To do this we need to shift the edges negatively, which will expand the black. In this case I shifted the edges by −30 %, and I follow what happens to the mask on the black and white view mode. But it is very useful to see the real time results by pressing the L key, which will switch the view mode to On Layers. I swap the views back and forth using the K and L keys to view the mask and the results at will (Fig. 21).

Once you are happy with your adjustment results, you need to determine how you want to save the changes to the mask. The Output controls allow you to save the changes with several options.

- Selection – this will turn your adjustments into a marching ant selection.
- Layer Mask – this will output your changes to the currently selected layer mask.
- New Layer with Layer Mask – this will create a new layer and layer mask with the adjustments applied. This is my favorite, as it will preserve the original mask.
- New Document and New Document with Layer Mask are not very useful for our purposes here but produce interesting combinations of the mask and picture in a duplicate image (Fig. 22).

Select the New Layer with Layer Mask option and click OK. This will create another layer and layer mask on top of the old layer with all the refinements. This action will also turn off the visibility of the original layer, but it is there for safe keeping (Fig. 23).

Fig. 21 Adjusting the edges of the mask

Fig. 22 Output options

Fig. 23 New layer with the refined layer mask

You can now adjust the layers' opacity to taste and even use the top layer with the 'Hide All' mask to apply adjustments to the stars while protecting the background. Adjustment layers such as Brightness and Contrast can control the star profile and brightness factors while Vibrance can add color and pop to the stars without over saturating the background structures. Using these methods you can selectively control color, contrast, and sharpness with precision targeting (Fig. 24).

Mastering the methods for controlling your High Dynamic Range will give your images more depth and dramatic appeal. The time and effort spent will reward you with the ability to have more control over the final result, allowing you to push your images to new heights.

Using Star Masks to Boost Dynamic Range 49

Fig. 24 Star adjustments

Completed image of NGC 225 using the methods described in this chapter

Completed image of IC 5067 using the methods described in this chapter

Intensifying Color

R. Jay GaBany

Astrophotographers are often asked questions from people with an interest in astronomy. For example, "Are the colors in astronomical pictures real? Would you see them looking through a telescope?"

Our retinas contain two types of light receptors called rods and cones. There are approximately 120 million rods compared to about 7 million cones. Rods are more sensitive to light, but only our cones detect color. Cones require more light than rods to become active. This is why objects appear colorless in dimly lit situations; without enough light, our cones cannot function. Interestingly, light is comprised of three primary colors, red, blue and green. Of these, the cones in our eyes are most sensitive to the latter. This means the first color we are able to detect is usually green.

Astronomical telescopes are essentially used for two purposes: (1) to help separate distant, closely spaced objects and (2) to collect a lot of light. For example, the world's largest telescope, the Grantecan located off the northwest coast of Africa on the Canary Island of La Palma, has a light-gathering mirror 34 ft(!) in diameter that would enable an observer to see each headlight of a car located half a world away in Australia!

However, were it possible to attach an eyepiece and look through this gigantic instrument, the observer would be disappointed to find that the color of galaxies and nebulae would appear greenish-gray. This is because large telescopes produce large magnification, and as magnification increases, the apparent surface brightness of the object being viewed decreases. As a result, objects seen with very large telescopes permit the observer to view tiny structures in greater detail but not with enough brightness to show vivid colors.

The rods and cones in our eyes are light-collecting buckets capable of gathering light for about 1/16th of a second. After that period, they empty themselves and send a signal to the brain telling it how much light each one gathered. The brain transforms this information into our perception of vision. The time period of 1/16 of a second is not a very long exposure length, so it's no wonder that our cones need quite a bit of light to detect color.

Cameras, however, do not have this restriction, because it's possible to hold their shutter open over a much, much longer period of time.

Yesterday's cameras relied on film coated with an emulsion that contained crystals sensitive to each of the three primary colors of light. The ubiquitous color digital cameras we enjoy today use millions of microscopic red, green or blue filters to cover each of their tiny light sensors, known as pixels. Although each manufacturer uses its own proprietary filter placement pattern, it should be noted that only a portion of the total pixels in modern digital cameras are dedicated to the detection of a specific color. Regardless, because all pixels are equally sensitive to light and color, this helps digital cameras create full color pictures even under low light conditions.

Solid state astronomical cameras go one step further – they use every pixel for each color.

Electronic cameras specifically designed for taking deep space images are unsurpassed for detecting very faint light, but they have one drawback – they can only produce black and white images. To create a full color picture, astronomers, both professional and private, place a red, green or blue filter in front of the camera so that every pixel is used to detect one specific color. For example, to create a full color picture, the astronomer exposes multiple images taken through red, green and blues filters, then digitally combines or stacks them using commercially available software.

As a result, digital astronomical cameras are capable of producing deep space pictures with very high color fidelity.

Astrophotographers also ask questions among themselves. For example, "How can I make the color of a galaxy or nebula more vivid in my pictures?"

Unfortunately, placing filters in front of the digital camera's imaging sensors reduces the amount of signal detected by about 66 %. So, raw color images are fainter and much noisier than exposures of the same duration obtained through a clear filter or no filter at all.

Known as luminance exposures, clear or non-filtered images will overwhelm and washout the color data when the exposures are digitally combined.

To overcome this problem, we'll discuss several techniques you can implement to effectively intensify color information and make your deep space images go from drab to fab; from mundane to memorable and from typical to terrific.

Exposure Duration

Before we begin our discussion of color intensification, you need to consider the capture of high quality color exposures as a fundamental prerequisite for producing evocative images instead of a unbeloved chore best performed during poor seeing.

For long focal length configurations, a minimum average of 120 min per color channel is desirable. If you have a fast system, then 1 h per color channel should yield workable unbinned results. However, if you have the patience, even longer total exposure lengths are recommended. Additional color information will usually translate into pictures that are easier to process and help you accomplish more memorable results.

Luminance Layering

At the dawn of digital astrophotography, and for several years thereafter, colorful images were produced by digitally combining red, green and blue filtered exposures. Unfortunately, this produced pictures with lower contrast, higher noise and fewer faint structures than apparent in luminance images of similar exposure lengths.

Then, at the beginning of the last decade, a technique known as "luminance layering" was separately introduced by Dr. Kunihiko Okano and Robert Dalby. Their innovation used binned color exposures as tint for luminance pictures.

They argued that the higher signal strength of luminance images could provide the clarity absent in the color images produced at that time. They also sought to harness the sensitivity increase obtained by binning adjacent pixels in the camera's sensor chip. Luminance layering traded color details for improved color vividness, and the results were striking.

It should also be remembered, their technique was introduced during an earlier time when the largest affordable sensor chips were less than a mega-pixel in size and long exposure lengths were measured by fractions of an hour in total duration. Today, larger, more sensitive chips, the willingness to take multiple-hour total exposures and new processing techniques enable the astrophotographer to capture sufficient color information without the need to bin their images.

Regardless, luminance layering with binned color exposures has held sway over the astrophotographic community for over a decade. This is unfortunate because significant detail is contained in unbinned color exposures.

However, now it's possible to combine unbinned color data with luminance exposures and produce a deeper final image overflowing with eye catching color. Several procedures and techniques capable of producing high fidelity color pictures without reliance on binned exposures are discussed below.

The Color Saturation Tool

Any discussion about enriching the color of astronomical images would be remiss without mentioning the ubiquitous saturation tool found in most picture processing applications.

Color images have two properties that distinguish them from colorless, or gray scale, pictures: hue and saturation. *Hue* describes a color itself and is based on its

dominant wavelength. *Saturation* describes the purity of the color's hue. A strongly saturated color will have a narrow set of strong wavelengths. For example, primary colors are highly saturated. Conversely, the more gray there is in a color, the less saturated it is. Reduction of color saturation will eventually result in a gray scaled image.

Using the color saturation tool boosts the strength of the dominant colors in an image regardless of their initial intensity. This often results in the magnification of color noise that is present but unnoticeable until the color undergoes intensification. If the saturation of an image is increased beyond the signal strength of any color, the image will display a distracting granular appearance that reduces the apparent clarity of the picture.

Sole reliance on the saturation tool should be avoided when producing astronomical images because they inherently have low color signal strength to begin with.

Adobe *Photoshop*

The following sections make significant reference to one of the most powerful image processing tools available on the market, Adobe *Photoshop*. Although it is possible to produce outstanding astronomical images using many other image processing applications, for the purposes of our discussions, use of Adobe *Photoshop* will dominate.

Blurred Saturation Layering

There were several early proponents of luminance layering as discussed above. This color enrichment method was developed when several prominent astrophotographers recognized luminance layering, even with binned color exposures, still produced pictures with anemic color saturation.

Blurred saturation layering represents an effective, relatively easy technique to significantly increase color saturation without adding significant color noise. To perform this technique, you should have already created your master luminance (gray scale) channel image, your master RGB (full color) channel image and aligned them.

Step 1: Initiate *Photoshop* and open your master RGB (full color) channel image. Open the Layers window from the *Photoshop* navigation menu [Window →Layers]. A thumbnail of the master RGB channel image will be displayed and labeled as the "Background" layer.

Step 2: Create a new layer from *Photoshop*'s navigation menu [Layer →New→Layer]. This will open a New Layer dialog box with a default

Adobe *Photoshop*

Fig. 1 The Gaussian blur tool

name of "Layer 1." Click the OK button and a second layer will appear in the Layers window.

Step 3: Paste a copy of the aligned master luminance (gray scale) channel image into Layer 1.

Step 4: Change the Layer Blend Mode of Layer 1 to "Luminosity" by selecting this option from the drop down menu in the Layers window.

Step 5: Duplicate Layer 1. *Photoshop* will label the new layer as "Layer 1 copy." At this point, your project should have three layers, from bottom to top: Background (featuring your RGB master channel); Layer 1 (containing your master Luminance image); and Layer 1 copy (containing a copy of your master Luminance channel image).

Step 6: Select the top layer and make sure its Layer Type is "Luminosity," then hide this layer by clicking on the "eye" icon appearing to the left of the layer's thumbnail image.

Step 7: Select the middle layer, Layer 1.

Step 8: To reduce the unintentional introduction of color noise into the image, apply a mild Gaussian blur to this layer by selecting "Filter" from *Photoshop*'s top navigation menu [Filter→Blur→Gaussian Blur]. This will open a Gaussian Blur dialog box. Set blur level to somewhere between 0.5 and 1.0 pixels by adjusting the horizontal slider, then click OK. This will slightly blur the image in Layer 1. (see Fig. 1)

Step 9: Change the opacity of Layer 1–50 % by selecting the Opacity drop down menu in the Layers window and adjusting the slider.

Step 10: Merge the image in Layer 1 onto the Background image from *Photoshop*'s navigation menu [Layer→Merge Down].
Step 11: Open the color saturation tool from *Photoshop*'s navigation menu [Image→Adjustments→Hue/Saturation] and adjust the saturation to somewhere between 15 and 35, based on the quality of the color image. Note that setting the color saturation to high will introduce color noise and reduce the usefulness of this technique.
Step 12: Re-select the top layer of your project. This is the layer labeled "Layer 1 copy." Now you can view the final result. Your image will retain the clarity of the master Luminance channel image with more saturated colors and very little additional noise.

You can further increase the color saturation of your image by repeating this process, using your newly saturated image as the background layer for the second pass. This process can be repeated until the color saturation begins to display color noise.

The Shadows/Highlight Tool

Photoshop is a virtual treasure chest of image enhancing tools, each one designed to help the user bring out the best in their picture. Sometimes, it's also possible to use one of these tools to accomplish a task its designer never foresaw.

For example, the Shadows/Highlight tool (see Fig. 2) was introduced as a painless method for correcting lighting in traditional photographs. It enables the user to correct over- or underexposed areas in the picture. This command works well with backlit subjects that consequently have a dark foreground. The adjustment is also helpful for bringing out the detail in harsh shadow areas with subjects shot in bright, overhead light. This command doesn't really correct overall exposure. Instead, it lightens or darkens pixels according to the luminance (brightness) of the surrounding pixels, technically called a *local neighborhood*.

The Shadows/Highlight command also has a Midtone Contrast slider, Black Clip, and White Clip options for adjusting the overall contrast of the image. Significantly, the Shadows/Highlight tool also has a Color Correction slider that increases the picture's saturation.

Open this tool from *Photoshop*'s navigation menu [Image →Adjustments →Shadow/Highlights...] and a dialog box will display with a variety of controls. It's important that most of the sliders be set into a position that will neutralize their effect and prevent you from altering the exposure or contrast of the picture.

So, set the sliders as follows:

- Shadows amount, Tonal Width and Radius should be zero;
- Highlights Amount and Tonal Width should be 50 %; Radius should be 100 %
- Midtone Contrast should be zero

The Shadows/Highlight Tool

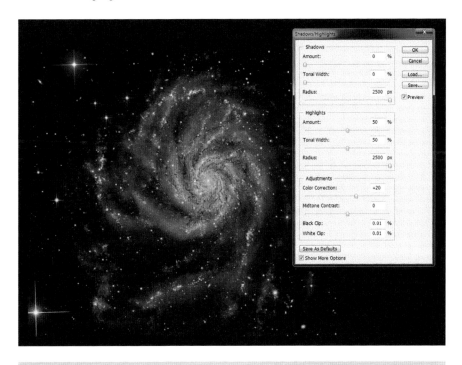

Fig. 2 The shadows/highlights tool

Color Correction should be set to a positive number. Avoid increasing the slider too much or you will introduce color noise. The best results are achieved when this tool is used while stretching your RGB master channel prior to blending it with the master luminance channel.

Soft Light Layering

Soft Light layering is another example of using *Photoshop*'s capabilities in a manner never targeted by the application's creators.

The Soft Light blend mode is intended to boost the contrast range of a picture by creating a subtle lighter or darker result based on the brightness of the blend color. Blending colors that are more than 50 % brightness will lighten the base image and colors that are less than 50 % brightness will darken the base image. Pure black will create a slightly darker result; pure white will create a slightly lighter result, and 50 % gray will have no effect on the base image. Interestingly, doing this blending also increases the saturation of the image without adding significant color noise.

You can leverage this effect to boost the color intensity of your astronomical images without affecting their contrast.

Step 1: Open a full color image in *Photoshop* as a base layer, then duplicate the layer twice so you have three layers, each containing the same picture.

Step 2: Change the Layer Blend Mode of the upper layer to "Soft Light" by selecting this option from the drop down menu in the Layers window.

Step 3: Change the Layer Blend Mode of the middle layer to "Color."

Step 4: Select the upper layer then merge it down with the middle layer by selecting Layer →Merge Down from the *Photoshop* navigation menu. Now you will only have two layers. The upper layer will have a blend mode of "Color" while the lower layer will be defaulted to "Normal."

Step 5: Apply a mild Gaussian blur to the upper (Color) layer by selecting "Filter" from *Photoshop*'s navigation menu [Filter→Blur→Gaussian Blur]. This will open a Gaussian Blur dialog box. Set blur level to somewhere between 0.5 and 1.0 pixels by adjusting the horizontal slider, then click OK. This will slightly blur the image in upper layer.

Step 6: Flatten the image by selecting Layer →Flatten from the *Photoshop* navigation menu.

If this does not produce sufficient results, repeat this process.

Color Burn Layering

Color burn layering is similar to Soft Light layering, but the results are significantly more intense. Typically, the color burn blend mode is used to add density, contrast, and color to a picture. It exaggerates contrast and boosts the intensity of dark colors.

Generally, astronomical images become overwhelmingly too dark if the color burn blend mode is used as it was designed. However, you can harness its ability to intensify colors by using the following steps:

Step 1: Open a full color image in *Photoshop* as a base layer, then duplicate the layer twice so you have three layers, each containing the same picture.

Step 2: Change the Layer Blend Mode of the upper layer to "Color Burn" by selecting this option from the drop down menu in the Layers window.

Step 3: Change the Layer Blend Mode of the middle layer to "Color"

Step 4: Select the upper layer then merge it down with the middle layer by selecting Layer →Merge Down from the *Photoshop* navigation menu. Now you will only have two layers. The upper layer will have a blend mode of "Color" while the lower layer will be defaulted to "Normal."

Step 5: Apply a mild Gaussian blur to the upper (Color) layer by selecting "Filter" from *Photoshop*'s navigation menu [Filter→Blur→Gaussian Blur]. This will open a Gaussian Blur dialog box. Set blur level to somewhere between 0.5 and 1.0 pixels by adjusting the horizontal slider, then click OK. This will slightly blur the image in upper layer.

The Shadows/Highlight Tool

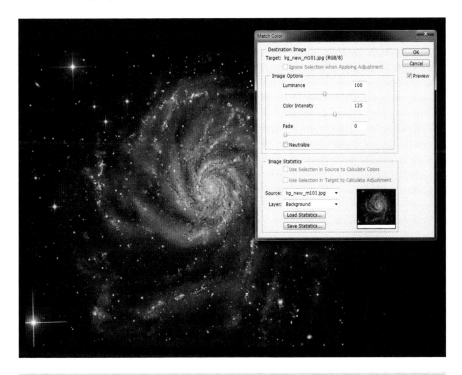

Fig. 3 M-101 (the Northern Pinwheel) the match color tool

Step 6: If needed, adjust the opacity of the upper (Color) layer to control the amount of added color saturation then flatten the image by selecting Layer → Flatten from the *Photoshop* navigation menu.

The Match Color Tool

Originally introduced to help photographers maintain color balance among multiple images in a panorama mosaic or allow them to blend colors from one image into another, the Color Match tool also enables you to increase the color intensity of a picture when it is matched against itself.

Step 1: Open a full color image in *Photoshop* as a base layer then duplicate the layer so you have two layers, each containing the same picture.
Step 2: Select the upper layer and change the Layer Blending Mode to "Color."
Step 3: Open the Color Match tool from the navigation menu [Image → Adjustments → Match Color]. (see Fig. 3)

Step 4: Set the sliders so the Luminance is 100 and the Fade is zero. Raise the value of the Color Intensity slider but avoid increasing it above 150 in a single pass. You can watch the affect of this control on the image if you check the Preview box. When you are satisfied with the enhancement, click "Ok."

Step 5: Apply a mild Gaussian blur to the upper (Color) layer by selecting "Filter" from *Photoshop*'s navigation menu [Filter→Blur→Gaussian Blur]. This will open a Gaussian Blur dialog box. Set blur level to somewhere between 0.5 and 1.0 pixels by adjusting the horizontal slider, then click OK. This will slightly blur the image in upper layer.

Step 6: Flatten the image by selecting Layer →Flatten from the *Photoshop* navigation menu.

If this does not produce sufficient results, repeat this process.

The Vibrance Tool

Photoshop CS 4 introduced a new, simple tool for enhancing color called Vibrance. This tool works similar to the Saturation tool, but it was designed to have less impact on skin tones. For astronomical images, this means it's great for boosting the intensity of blue stars and refection nebulae but gentle on objects that tend toward red.

Using this tool is very easy:

Step 1: Open a full color image in *Photoshop* as a base layer then duplicate the layer so you have two layers, each containing the same picture.

Step 2: Select the upper layer and change the Layer Blending Mode to "Color."

Step 3: Open the Vibrance tool from the navigation menu [Image →Adjustments →Vibrance].

Step 4: This will display a dialog box with two sliders for Vibrance and Saturation. The saturation slider enables you to adjust red tonal areas if needed.

Step 5: Adjust the Vibrance slider. If you click the Preview box, you can observe the affect on the image. Again, don't go beyond increasing above +50 in one pass. You can always add more vibrance by repeating these steps, later.

Step 6: Apply a mild Gaussian blur to the upper (Color) layer by selecting "Filter" from *Photoshop*'s navigation menu [Filter→Blur→Gaussian Blur]. This will open a Gaussian Blur dialog box. Set blur level to somewhere between 0.5 and 1.0 pixels by adjusting the horizontal slider, then click OK. This will slightly blur the image in upper layer.

Step 7: Flatten the image by selecting Layer →Flatten from the *Photoshop* navigation menu.

If this does not produce sufficient results, repeat this process.

Lab Color Mode

Perhaps the most powerful method of enriching color is to make adjustments using *Photoshop*'s Lab Color mode. Unlike the RGB color, Lab color is designed to approximate human vision and enables you to separate adjustments to color from those that affect luminosity.

This is not an often used color space, and it isn't available in most other programs. However, Lab has been around in *Photoshop* for years.

In RGB color space you work with the red, green and blue channels. In CMYK color space you work with cyan, magenta, yellow and black channels. But in Lab you only have three channels – "L", "a" and "b". The L channel is the lightness channel and it \adjusts the luminosity of the image without changing the color. The "a" and "b" in Lab color space represent the color information. The "a" channel controls green and magenta, whereas the "b" channel manages blue and yellow. Separating lightness from color enables you to make adjustments that would be difficult or time consuming in any other color space.

Step 1: Open a full color image in *Photoshop* as a base layer then duplicate the layer so you have two layers, each containing the same picture.

Step 2: Select the upper layer and change the Layer Blending Mode to "Color."

Step 3: Change the Color Mode of the image to Lab from the upper navigation menu [Image →Mode →Lab Color]. A dialog box will be displayed asking if you want to flatten the image. Click the button labeled "Don't Flatten."

Step 4: Intensifying color in the Lab color space is best managed using the Curves tool which is opened from the navigation menu [Image →Adjustment →Curves]. This will display a dialog box containing the Curves Tool.

Step 5: Select the "a" channel from the Channel drop down menu. This will display the histogram for green and magenta.

Step 6: Place your cursor on the diagonal line at a point near Input −64 and Output −65. The Input and Output values will automatically display when you click on the diagonal line. Adjust the curve so the Input is set to −50 and Output is set to −75.

Step 7: Click on the diagonal line again. Choose a location on the other side of the histogram. Set the Input to 50 and the Output to 75. Before you click the "Ok" button, select channel "b" from the Channel drop-down box. This will display the histogram for blue and yellow. Now, repeat Step 6 and 7 using the "b" channel. When you are finished, click "Ok."

Step 8: Apply a mild Gaussian blur to the upper (Color) layer by selecting "Filter" from *Photoshop*'s navigation menu [Filter→Blur→Gaussian Blur]. This will open a Gaussian Blur dialog box. Set the blur level to somewhere between 0.5 and 1.0 pixels by adjusting the horizontal slider, then click OK. This will slightly blur the image in the upper layer.

Step 9: If you are not satisfied with the increased color intensity, repeat Steps 4 through 8.

Step 10: Change the Color Mode of the image to RGB from the upper navigation menu [Image → Mode → RGB Color]. A dialog box will be displayed asking if you want to flatten the image. Click the button labeled "Don't Flatten."

Step 11: If you are satisfied with the final result, flatten the image by selecting Layer → Flatten from the *Photoshop* navigation menu.

Practical Considerations

Now that we've discussed several effective methods to make images more colorful, we should step back from the trees, survey the forest as a whole and answer a few practical questions that will have a large impact on the final impression your picture leaves with others who view it.

For example, what is the correct color intensity for an astronomical image; how do you manage the accuracy of the hues; how do you control color saturation throughout the image; and what can you do to mitigate color noise if it creeps into your picture?

Making Colors Pop

There are two broad strategies for expressing color in astronomical images. One, called white light or natural color, uses broad-wavelength red, green and blue camera filters. This approach attempts to replicate the hues of planets, stars, nebulae or galaxies as they would appear to our eyes.

The other tactic, known as false, narrowband or mapped color, requires special camera filters that only pass the glow emitted or reflected by specific molecules or elements. This method is generally used for scientific purposes to reveal the topographical distribution of chemicals captured by the camera.

True white light color pictures are restricted to the hues appearing in nature's color pallet, whereas false color images are only limited by the photographer's creativity. For example, mapped color pictures often display a surprising range of vivid hues that can give familiar subjects an unexpected and occasionally unrecognizable appearance.

However, as we mentioned earlier in this chapter, our eyes are incapable of discerning the true color of distant nebulae or galaxies because, even with the largest optical instruments, their dim glow cannot excite the cones in our eyes. So, if you want to create a precise naturally colored image of a deep space subject, it would have very little color intensity, if any at all!

Therefore, all white light color images of deep space objects are metaphors that exaggerate the intensity of the subject's true hues.

So, what is the correct color saturation for an astronomical image? As much as you want so long as you avoid introducing color noise into the picture. We'll discuss

methods for avoiding or reducing noise later on, but for the moment we would recommend the use of terrestrial images featuring familiar subjects as your benchmark for assessing the correct amount of color saturation for astronomical images.

For example, which picture appears more interesting? An old faded photograph or one that was recently produced? For most individuals, pictures with fresh, vibrant colors are far more appealing than a vintage yellow tainted photograph.

So, don't be shy about the amount of color saturation appearing in your image, since any amount of color makes the subject appear "unreal" by making it far more colorful than it will ever appear to visual observers. There is no "correct" amount of color saturation for astronomical images – it's a discretionary decision. More can increase the interest of your picture rather than less.

Achieving Color Fidelity

One of the most challenging aspects of astrophotography is making sure the hues are correct. There are several factors that can introduce color bias into any image. Color bias is a term that describes the emphasis of a color wavelength that creates an unnatural or undesirable imbalance in the picture's color histogram.

The problem can originate from several sources such as the color sensitivity of the camera's primary sensor. For example, most digital imaging chips are more sensitive to one or more color wavelengths. So, when the master red, green and blue channel images are combined, the master full color channel will often require adjustment.

Extinction can also introduce unwanted color bias to the image. Extinction is the atmospheric effect observed when the sun reddens as it sets. Caused by dust particles suspended in the air, this reddening also affects the colors of deep space objects as they move from the zenith to the horizon. Transient high thin clouds, occurring during the exposure of one or more color channels, can also introduce a color bias to the picture's background regions when the master color channel images are combined.

Another less familiar source of unwanted color bias is the presence of interstellar dust. Our galaxy is filled with the remnants of ancient supernova explosions and surrounded by vast rivers of flotsam released by satellite galaxies as they were absorbed by the gigantic spiral we call home. If the target of your exposures is situated behind one of these lingering curtains, or if the image is trained on a concentrated region of dust, such as an emission nebula, then the picture will take on a noticeable bias shifted towards the red end of the spectrum.

Regardless of its origin, color bias should be removed from your images so the picture presents your subject's true hues with the highest color fidelity your data can muster.

There are several methods for correcting the hues in astronomical images. For example, *Maxim DL,* the popular image processing and telescope control software produced by Diffraction Limited, provides a tool that enables the user to click on any pixel or group of pixels that are intended to be white. Typically, the selection is made on a bright star that is known to be colorless. *CCD Stack,* another highly versatile image processing software package, offered by CCDWare, includes a

similar method for obtaining true color balance throughout the image by enabling the selection of either bright or dim stars.

Another method for obtaining high-color fidelity is accomplished by adjusting the quantity and/or length of color exposures based on the inherent color bias introduced by the entire imaging train – telescope, camera and filters. Known as the G2 method, this attempts to enable the production of accurate full color images by analyzing color images of stars similar to our Sun.

In short, identical length exposures of known G2 stars are taken through red, green and blue filters while they are at or near the zenith. Once the RGB images are combined, the resultant star color characteristics can be measured, compared with precision stellar color charts, and the variances used to calculate adjustments to exposure lengths or exposure quantities that will reduce or significantly reduce the color bias present in the imaging system.

Some imaging orchestration applications, such as CCD Autopilot, can accomplish this analysis automatically and enable appropriate adjustments for future exposures.

Unfortunately, none of the above procedures produce consistent results. This is because color bias can be spread inconsistently throughout astronomical images (for example, by high thin clouds appearing during the exposures of a given filter). Similarly, achieving G2 balance can reinforce the color bias introduced by intervening interstellar dust and give the final picture a ruddy over wash.

Since the color of white light astronomical images represent a metaphor for expressing the subject's natural hues through the exaggeration of saturation levels, their scientific value is severely diminished from the outset. That is to say, full color astronomical photographs are of little scientific value other than their representation of the subject's topographical characteristics as seen in white light. That means the types of color images discussed throughout this chapter are interpretations.

As a result, the presentation of hues is also subjective in nature and at the sole discretion of the photographer.

Thus freed from the common misperception that full color white light images must be scientifically accurate, acceptable color fidelity can also be achieved by balancing the color histogram of the image. For the purposes of our discussion, a balanced color histogram is one where the individual red, green and blue spectrums display identical starting and ending points across the histogram's horizontal axis and similar, although not necessarily identical, shapes throughout its vertical axis.

Adjusting the color histogram to bring the colors into balance can be challenging. But, with practice, it will become a straightforward process. Fortunately, *Photoshop* enables interactive manipulation of the color histogram.

As mentioned earlier, interstellar dust clouds or material surrounding emission nebulae often impart a significant reddish bias to astronomical images. This bias can be removed, and an unexpected rainbow of hues revealed, when the color histogram is brought into balance. (See Figs. 4 and 5.) Of course, some may consider the neutralizing of intervening hues imparts an unnatural appearance to familiar subjects. To those we would ask, "What is the target of your picture? The distant nebula (or galaxy) or the dust that intervenes?"

Practical Considerations 65

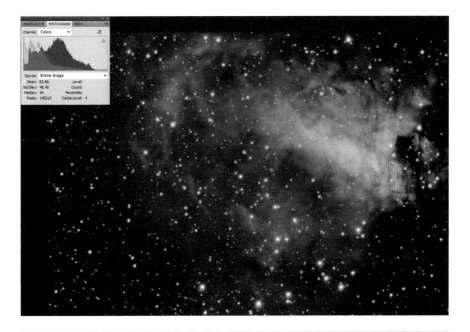

Fig. 4 M-17 (The Omega nebula) histogram of color exposures prior to color balancing

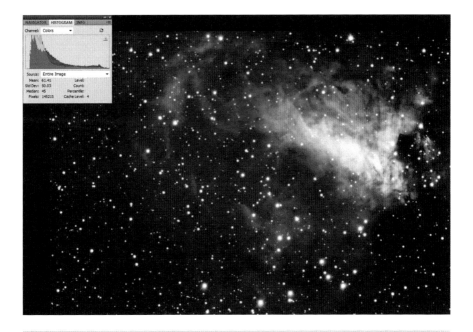

Fig. 5 M-17 (The Omega nebula) histogram of color exposures after color balancing

If the target of your image is an object obscured by dust, we recommend you attempt to balance the color histogram, then decide for yourself.

To balance the color histogram, follow these steps:

Step 1: Open the full color image in *Photoshop*, then duplicate the layer and change the Layer Blending Mode of the new layer to "Color."

Step 2: Select the new layer, then open the Histogram Window from *Photoshop*'s navigation menu [Window → Histogram].

Step 3: Expand the histogram's view by selecting "Expand View" from the histogram window's control button located in the upper right of the window.

Step 4: Select "Colors" from the Channels drop-down menu in the histogram window. This will display the color histogram with individual color variance displayed in their corresponding hue.

Step 5: Open the Curves tool from the navigation menu [Image → Adjustments → Curves…] This will open a dialog box displaying the Curves tool. The default Channel is RGB, but each of the primary color channels can be selected from the Channel drop-down menu.

Step 6: Select a color from the Channel drop-down menu. This will enable the direct modification of the histogram for the selected hue.

Step 7: Click on the Curves tool, hold and drag the cursor while watching changes in the Histogram window. Over time, you will be able to correlate changes made with the color tool curve and changes in the histogram's shape. The goal is to reduce or eliminate any variances between the curve of the selected color channel and those of the other colors so the histogram appears black.

Interestingly, manipulation of a given color channel will affect the curves for other colors, too. Thus, this procedure requires patience and practice.

Out, Out Darned Spot!

Like everything else, no astronomical image is perfect. Perfection tends to be a figment in the mind of the perfectionist, and since every picture is a rendition, few match the expectations of their creators. Similarly, no image is perfectly imperfect, either. Each contains areas that approach visual nirvana, but most have places where a bit of make-up would work wonders.

Throughout this chapter, we have approached the modification of images on a global scale, where the ratio between the value of a given pixel compared to its neighbors are respected. But processing pictures globally can break as many parts as it fixes.

For example, to intensify the color of a galaxy, the photographer may accidentally over saturate one or more already colorful stars. Maintaining a global processing perspective ultimately leads to the need for compromise, which can result in a sub-optimal final picture.

Practical Considerations

Fig. 6 The Photoshop Tools menu provides numerous methods for spot fixing areas with color problems

This is where spot fixing can be efficacious because it involves processing specific parts of the image differently than the rest.

Photoshop offers a variety of tools and methods for spot fixing color-related areas. Whenever using a *Photoshop* tool, copy the target layer, then change the new Layer Blending Mode to "Color," so your modifications will remain within the picture's color space. We'll discuss how to blend the new layer into the original after the following list of the most useful *Photoshop* implements (see Fig. 6):

These tools place a fence around portions of the image, so color modifications will be restricted to the area selected:

- **Magic Wand** The Magic Wand is used to select portions of an image based on color. Sections of the same color are selected when the wand is touched on the desired color and the mouse is left clicked.
- **Lasso** The Lasso tool is used to select a 100 % freeform-shaped portion of the image. The Polygonal Lasso Tool allows you to click from point to point to gradually build a selection. Selections made with this tool are purely comprised of straight edges. The Magnetic Lasso Tool is a cross between the Polygonal Lasso Tool and the Magic Wand Tool. It allows you to build your selection

incrementally, but in a fairly automatic fashion. Simply move your mouse along an edge, and the MLT will give its best guess for outlining that edge.
- **Marque** The Marque enables the user to select rectangular, circular or oval shaped areas within an image. The areas can then be copied or cut and then pasted into new layers.
- **Color Range** Color Range is accessed from the navigation bar [Select → Color Range…]. It allows the user to quickly target a range of colors within the canvas. This tool tends to affect all portions of the image that have identical color characteristics.

These tools enable the modification of color and saturation:

- **Dodge, Burn and Sponge Tools** The dodge and burn tools can be used to significantly increase the intensity of colors. The dodge tool works best with brighter hues, the burn with darker colors. You can also limit the correction to various tonal ranges – shadows, mid-tones, or highlights. You also can adjust the amount of correction that's applied by specifying an exposure percentage. Just be sure to keep this set low because both tools are very powerful. The sponge tool enables you to increase or decrease the color saturation. You can specify the size and softness of each tool by selecting from one of the many brush tips.
- **Clone Stamp** The Clone Stamp works by copying the color from a reference point and pasting it over a new point. The key is the brush that's selected. A soft-edged brush will copy and paste a soft-edged selection, blending it in to the surrounding image better. The brush size can also be changed.
- **Healing Brush** The Healing Brush tool is like a smart Clone Stamp. Instead of simply dropping a selection from one part of the image onto another, it blends the selection with what's already there at the point you're editing, often making for a smoother transition. Use the Healing Brush the same way: chose a reference point, then paint over the area of the image you want to edit.

Image modifications that are limited to specific areas within the picture are best made in a separate layer that is subsequently blended with the original layer. Layers are one of *Photoshop*'s most powerful features because it lets the user control how changes are introduced to the picture.

A layer is simply one image stacked over another. Layer opacity controls the visibility of the upper layer. For example, if an identical object appears in two stacked layers with the only difference being one is tinted yellow and the other appears blue, and if the Layer Opacity for the upper layer is adjusted to 50 % then the object will appear green. The Layer opacity control permits the user to regulate what the final image displays.

Unfortunately, the Layer opacity control affects the entire image. If we want to blend only a portion of the image, we need a different solution. Fortunately, there are other methods for blending layers and influencing the blended opacity. These are called layer masks.

Layer masks are another *Photoshop* innovation. They enable the user to modify the same part of an image over and over and, if the result is unsatisfactory, return

to the original image. If the term "mask" sounds confusing, replace the word "mask" with "transparency" because a layer masks enables the user to adjust the transparency for any part of a layer.

For our discussions, we will employ the paintbrush tool as our method of controlling the layer mask transparency because this tool offers tremendous flexibility:

Step 1: Open a full color image in *Photoshop* as a base layer, then duplicate the layer so you have two layers, each containing the same picture.

Step 2: Select the upper layer and change the Layer Blending Mode to "Color."

Step 3: Increase the color intensity of the upper layer (or introduce any color modification we have discussed in this chapter).

Step 4: Cover the upper layer with an opaque Layer Mask from the navigation menu [Layer →Layer Mask → Hide All].

Step 5: Select the paintbrush tool from the Tools menu. The Tools window can be opened from the navigation menu [Window → Tools].

Step 6: Set the foreground color of the brush to white. The foreground color picker can be accessed from the Tools menu.

Step 7: Re-select the paint brush tool and right click with the mouse. This will open a dialog box with brush controls. Select a round brush from the menu, set the hardness to zero, then set the Opacity and Flow to 25 % using the appropriate sliders. Flow sets the color application rate as the brush is moved over an area. Opacity sets the transparency of applied color (in this example, the color is white). When finished, click "OK."

Step 8: Place the brush on the image and begin painting by holding down the left mouse button. As you paint, you will notice the layer mask, visible in the Layer window, shows the path your brush is taking, and the image in the upper layer will blend with the picture in the lower layer at the rate set by the Opacity and Flow controls. Repeated brushing over the original path will intensify the blending effect. Further adjustments to Opacity are possible by reducing the opacity of the upper layer itself.

Reducing Noise Pollution

Noise is the bane of any image. The best way to deal with noise is to try and avoid it in the first place. Portrait photographers solve this problem by shining light on their subject, but astrophotographers are always forced to work in the dark.

Color noise is particularly challenging since color filters reject two-thirds of the subject's incoming light before it hits the camera's imaging sensor. Noise is generally limited to the faintest parts of the luminance portion of the picture. However, since color exposures are usually dim to begin with, color noise can be widespread.

There are only a few reliable techniques for reducing the effect of color noise in astronomical pictures. Of these, binning sensor pixels and long exposure lengths

Fig. 7 Blue channel color noise

are the most common. However, neither of these methods is completely effective when color is intensified.

Color noise gives the picture a harsh appearance. It can be inspected with *Photoshop* by selecting the Channels window. Clicking on each color channel will reveal the quality of your color data. If it appears grainy or blocky, you have a color noise problem (see Fig. 7).

There are three approaches to controlling color noise.

- **Noise filters** Most astronomical image processing applications include one or more noise filters. *Photoshop* also includes several of these, too. Additionally, there are dozens of *Photoshop* plugins for reducing color noise.

Unfortunately, noise filters permanently alter the image's pixel structure and affect the quality of the image should further processing be required after the filter is applied. This places a limit on the picture's enhancement potential. So, if you intend to use a noise filter, do it at the end of processing.

- **Blurring** This references the use of a blurring tool to expand the area of coverage for each color pixel. Interestingly, smoothed color channels do not have much effect on the resolution contained in the luminance channel.

Throughout the step-by-step instructions presented in this chapter, the application of a one pixel Gaussian blur to the color layer has been advised. This is intended to reduce the amplification of color noise as the color is enhanced.

Occasionally, the strength of the blur may need to be increased, based on the quality of your color exposures.

Please note we recommend the use of a Gaussian blur versus the application of other blurring approaches because Gaussian blur bases its effect on the values of nearby pixels and thus affects the image in a predictable manner that produces the fewest artifacts.

- **The History Tool** The *Photoshop* history tool can be your best friend when increasing the intensity of the image's color information because it enables the user to experiment with and throw away failed attempts without losing everything good that had preceded it. We recommend an inspection of the color channels after every few changes to the image's history. If a processing change accidentally introduces artifacts that significantly increases the visible color noise in any of the color channels, delete the steps until you return to a point where the color noise was acceptable.

Conclusion

The techniques discussed in this chapter are equally effective with new images and older images that have unexciting color. In fact, we recommend you experiment with these procedures using pictures you've already completed. Your familiarity with the previous images will enable you to immediately recognize the difference these techniques impart.

So, which process is the most effective for your next image? Since every image contains its own unique set of challenges due to the subject of the picture, the sky conditions under which it was exposed, the camera's electronic characteristics and the quality of the telescope's optics, no single process discussed in this chapter represents a silver bullet for bringing out the best color.

Instead, we recommend you consider using several of these methods instead of relying on only one. For example, when first combining your master luminance and RGB channel images, blurred saturation layering is an effective tool for initially bringing out color in your picture. Later in your processing, you can add more color with the Color Match or the Vibrance tool. Then, when you are almost finished, apply Lab color.

When used in combination, you'll quickly discover your images have far more color information than you ever suspected.

Revealing Small-Scale Details

Ken Crawford

Astrophotographers face amazing challenges in their pursuit of acquiring high quality data and then turn that data into beautiful images that viewers admire. We carefully set up our imaging systems with amazing precision so each exposure contains well focused sharp sub frames. For every exposure there exist a myriad of variables that can work against us to potentially degrade the details of the celestial objects we record. Some of these variables are within our control and some are not. Even the variables beyond our control can often be compensated for by processing adjustments for maximizing the potential of our images. My goal is to share some of the methods I have found useful in recovering those elements that bring clarity to our pictures.

Blurring

Ground-based imaging systems all have the same challenge. As if imaging a very faint, distant moving target over several hours was not challenging enough, we have to factor in that the atmosphere was probably churning away during the process. And to add make matters worse, slight changes in focus during temperature changes, guiding errors, and wind vibrations compound the problem further.

Blurring is the smearing of details and smaller structures of an image as the data is being collected, and it happens to all ground-based imaging systems to some degree. Even corrective calibration frames such as flat fields have some curvature to them, which results in a slightly different result at the outer wings away from the center of chip. We can however recover or de-blur the image enough to reveal the details and interesting features without producing artifacts or magnifying noise.

Global Versus Selective

Although there are many sharpening methods that you can use on your data that will bring out the details, these same sharpening tools can also produce unsightly artifacts. Bright saturated stars, transitions, and backgrounds are affected and noise can be amplified in the lower signal to noise areas. There doesn't seem to be one sharpening system that works perfectly across the entire image. The solution I would like to present is to sharpen the details, then blend in the sharpened structures that are noise and artifact free, thus leaving the artifacts and noise behind. I am not talking about "fixing" the noise but rather not allowing it to surface to begin with.

Deconvolution

The first sharpening tool that I like to use is a method called deconvolution. Deconvolution theory is discussed in more detail in this book by Stan Moore, this discussion will focus on its use during the image processing workflow. I begin with deconvolution as one of my earliest processing steps because I believe it is one of the best ways to reverse the process of blurring that occurred during acquisition of the data, also known as convolution. I like to use this tool before any other type of sharpening is applied. The challenging part about deconvolution is that by adjusting the sharpening settings to reveal the finest details of your subject, the background, faint areas, and brighter stars can get hammered in the process. No matter what type of deconvolution you use if you really want to reveal the finest details in the high-frequency data you have to accept the fact that the effects will be too strong for the weaker areas of your image, and these effects will need to be adjusted or eliminated later in the workflow.

Selective processes give us the ability to surgically separate unwanted artifacts and noise that result from the sharpening process. A process I have developed helps to effectively apply different strengths of deconvolution. I do this by globally applying varying degrees of deconvolution to separate copies of the luminance data. One copy will have a very mild strength of positive constraint deconvolution as supplied with the program *CCDStack*. To a second copy I apply a very strong application of deconvolution that dramatically brings out the small scale details in the data. After providing a consistent stretch to each of the copies, I then use masks to selectively combine the best results of each of the copies into one master sharpened luminance. I call this process multi-strength deconvolution layer blending.

Determining What Needs Sharpening

We will use the subject NGC4565, the Needle Galaxy, to illustrate some of the concepts of selectively bringing out the details. The first step you should do is analyze your image for its quality and to separate the components of the image into

Determining What Needs Sharpening

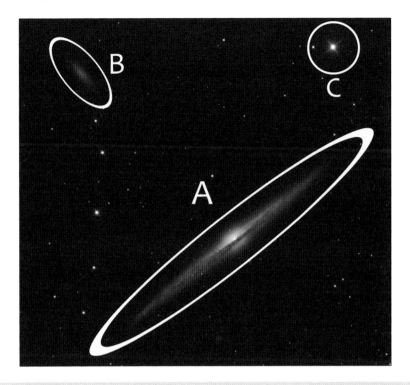

Fig. 1 Breaking the image down into sharpening versus protection

areas that will require degrees of sharpening while also recognizing areas that will most likely develop unwanted artifacts or excessive noise. I will zoom into an image to carefully examine the quality of the data and to search for possible interesting structures lurking within. I will also zoom out to see the overall image to determine what areas to protect from aggressive sharpening.

The galaxy (NGC4565) shown in luminance in Fig. 1 contains several areas I want to sharpen and several areas we need to protect from noise and artifacts. The main subject (A) is an edge-on spiral with its equatorial dust lane that contains many interesting features. We want to reveal the fine features while providing a smooth flow between the sharpened details and the transitional areas of the softer halo and fainter arm extensions. There are several background galaxies (B) that contain details as well, but we want to avoid sharpening the brighter stars like (C) that are also in the area. If you over sharpen the stars, serious artifacts can occur that make it more difficult to later allow the color data to blend in and show through. You also want to avoid over sharpening the background, which can amplify and reveal existing noise in those low S/N areas. Now that we have an idea of the areas we wish to sharpen and those we want to avoid we can move on to building a deconvolved sharpened master luminance.

The Selective Process: Using Masks

To separate the nicely sharpened areas from any noise or artifacts we will use a selective process called masking. *Photoshop,* especially CS5 or later, has very powerful masking refinement tools that allow precise control over the mask itself. The real benefit of *Photoshop* is its layers panel and the ability to blend a stack of layers in real time. Masks live in the Channels panel and are always made up of a gray scale image. In fact, *Photoshop* in color RGB mode functions as a gray scale editor of at least three gray scale images that are blended and channeled together. These gray scale images are called channels. You can think of channels like pipelines that flow the color information of each gray scale image into a complete color image. Instead of defining color information masks are separate channels that convey selection and transparency.

Selections in *Photoshop* help you define or separate areas of an image. You can then turn your selection into a mask and then leverage to full power of *Photoshop* through the mask. Once the selection is saved as a mask then the mask refinement tools allow you to blend the results to a highly accurate level.

To better understand the basics of masking we can look at Fig. 2. I have created a simple mask that simulates a stencil of letters "THE SUN" showing the mask channel itself. I am going to use the mask just to allow color from a paint brush to show through to the image of the Sun below.

As you can see the letters of the "stencil" are pure white and the background around the letters is pure black. The easy way to think about masks is in the

Fig. 2 Black conceals, *white* reveals

Pre-stretching 77

Fig. 3 The mask results

following rule. "Black conceals while white reveals." In this case, anything I do to the image that is linked to the mask on the top layer will be managed by the mask. Whatever is white on the mask allows pixels to flow through to the base image below and is thus revealed. The areas that are black are protected, and pixels are not allowed through so they are concealed.

In this demonstration (Fig. 3) I have used a paint brush to paint a stripe across the image almost like you would use a can of spray paint. The white areas of the mask act like a stencil, and the results are that only the areas of white show the results of the paint brush. We could then adjust the mask in the channels panel by manipulating the mask with several types of tools. If we control the intensity of the mask with different shades of gray scale we can adjust the information stream channeled from the top image to where it lands on the base or bottom layer.

Learning to master basic selection and masking methods will allow you to focus the power of *Photoshop* directly where you want it.

Pre-stretching

Part of the process of building the Master Sharpened Luminance image is that we need to take the luminance images that contain varying degrees of sharpening and pre-stretch them so they match brightness values. Only then will the results of two

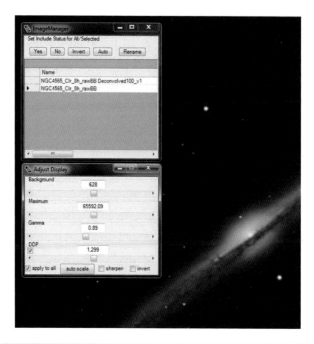

Fig. 4 *CCDStack* adjust display for creating matching scaled images

or more layers blend properly. I normally use *CCDStack* for this type of "pre-stretching," as it handles several images nicely and has great control of the stretch with its DDP function. You can also use the Fits Liberator plug-in tool for this process, and I am sure other processing programs can accomplish a pre-stretch as long as you can save the date in its stretched form in least a 16bit TIFF file.

Using *CCDStack* I will adjust the Background, Gamma, and DDP functions until I get approximately 50–70 % of the final stretch that I want to achieve. While making these adjustments I watch the background and star profiles as I am brightening the fainter areas. I want to make sure that I do not allow the stars to over brighten and develop too fuzzy of an edge or halo. I also monitor the histogram and adjust the background until I get plenty of shoulder room on the left side of the histogram pedestal to prevent clipping. Once everything is just right I will click the "apply to all box." This function applies the Adjust Display settings to the complete stack of images. I then save each image in the stack as a scaled 16-bit TIFF file with the "save scaled data" function under the file menu. Now I can then bring these scaled images into *Photoshop* for final blending (Fig. 4).

Now we use the masking concept to blend the sharpened details of our deconvolved galaxy into the unsharpened galaxy image with smooth transitions. I will open both scaled 16-bit images of the galaxy in *Photoshop*. I will place the sharpened image in a layer on top of the unsharpened galaxy by copying and pasting it

Pre-stretching

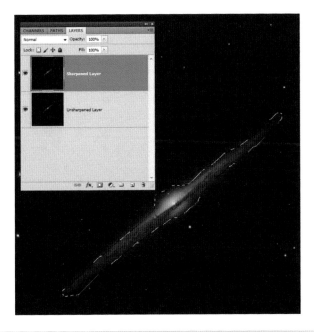

Fig. 5 The area around the entire galaxy is selected

into a layer. Then I begin the process of blending the sharpened areas of the top layer into the bottom layer.

1. Create the selection to define the areas we want to turn into a mask.
2. Create the mask and save it as an Alpha Channel.
3. Refine the mask to get the blend you want.
4. Adjust opacity to taste.

First, with the sharpened layer selected I used the "Quick Selection" tool by clicking and dragging it along the length of the middle of the galaxy. You can also use the Color Range tool or the Lasso tool to define the main galaxy area. While the selection is active you will see it as the outline of the so called "marching ants." You can add to the selection by clicking the quick selection tool alongside of the current selection as long as the "Add to Selection" box is checked in the "Add to Selection" settings. The main concept here is to draw the selection outline around the entire edge of the galaxy, as in Fig. 5.

Once you are satisfied with the outline of the selection we will turn our selection into a mask.

There are a several ways of doing this but one of the easiest is simply to click the "Add Layer Mask" icon at the bottom of the Layers panel while the selection is active (Fig. 6).

You should see the layer mask appear next to the icon along with the linked symbol. You can look at the full size mask by Alt+Clicking on the mask, but more importantly let's get used to looking at the channels panel where the mask really resides.

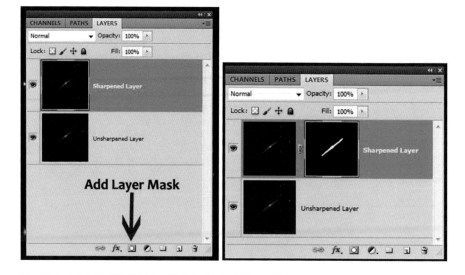

Fig. 6 Add Layer Mask icon

Fig. 7 Layer mask in the channels panel

Enter the channels panel and you will see that currently the mask is contained as a layer mask as shown below. You should see two channels, one is the gray scale image and the other is the layer mask. You can look at either full size by selecting the channel icon.

The problem to avoid with this step is if we wish to use this mask later on, and we will for several reasons, we don't want to flatten the image or delete the layer containing the layer mask or our mask will disappear forever (Fig. 7).

So what we need to do is save this mask as an alpha channel so we can call on this mask any time we want. The simplest definition of an alpha channel is a

Pre-stretching

Fig. 8 Creating an alpha channel

channel that contains a mask. You can pretty much have an unlimited supply of alpha channels, as they take up very little storage space.

Remember with masks and alpha channels, black conceals, white reveals, or to think of it another way, white represents selected and black represents protected.

To store our mask in an alpha channel you simply need to select the layer mask channel, then right-click, then select duplicate the channel. This method allows you to name the new alpha channel before creating it. Give the new alpha channel a name that gives you a strong hint as to its function, then click OK (Fig. 8).

Once the new channel is created it is now an alpha channel that is storing the mask. So the alpha channel, simply put, is a mask container. We can use this mask any time we want, and once you get used to the idea you will have several types of masks stored as alpha channels in your image.

Just make sure that you have the alpha channels box checked along with the Layers box in the "Save" options when you save the image (Fig. 9).

Now that the mask has been saved in an alpha channel we can use it by adding it to a Layer Mask and then refine it to blend in the details.

Adding the mask is pretty simple; it just means adding white or black depending on the areas we want to reveal or protect. I want to sharpen details of the equatorial dust lane of the galaxy and the larger background galaxies. Back at the layer panel I will select the layer mask and then use a soft paint brush with white selected as the color I will paint with. Although not required it is much easier to make highly accurate mask adjustments with a tool like a Wacom Tablet and a Stylus pen.

Fig. 9 The mask is now in an alpha channel

Fig. 10 The main galaxy and the background galaxies are selected

Zoomed in we can carefully paint over the larger background galaxies, which will remove the protection and reveal the details from the sharpened data and allow those details to come through the mask channel.

Once I have painted over those areas where I want the sharpening to be revealed the mask will look something like this (Fig. 10):

Pre-stretching

Fig. 11 Right click the layer mask for this menu and select Refine Mask

The next step is to refine the mask for fine control and smooth transitions. If you Right-Click on the layer mask, the Layer mask options menu will appear. From here you can perform several masking functions including adding, subtracting, or intersecting the current mask from or with a selection. These are all powerful adjustments but right now we want to concentrate on the Refine Mask function. The refine mask tools have been upgraded in CS5 with several useful adjustment options (Fig. 11).

The first thing we want to think about when using the refine mask toolbox is, do we want to see the mask as we adjust it, or the results (Fig. 12)?

The Refine Mask View Mode allows you to select how you want to view the mask as you adjust it. The two that I use the most are Black & White, which shows the mask in its true form and "On Layers," as then I can see the results of the mask adjustments to the final image in real time. This is very useful for judging the quality of the transitions and other masking properties.

The Show Radius checkbox beside the View box works with the Edge Detection controls in the box below. Using Smart Radius you can define the edges of the mask in detail. The Refine Radius tool, which looks like a brush on the left side of the Edge Detection control box, can add or subtract from the Mask Edge (Fig. 13).

For the purposes of this mask I will leave the "Show Radius" unchecked and set the View Mode to "On Layers" so I can watch the adjustments in real time. We will concentrate on the "Adjust Edge" control box. Here we can use the combination of fine adjustments to the mask edge by using the Feather control along with the Shift Edge control. The feather control works by softening the edge of the Mask outward. The Shift Edge control can expand or contract the reach of the mask edge. The Contrast control darkens the edges from the outside. Together you can effectively control the transitional edges of this composite between the sharpened data, and the unsharpened data.

Fig. 12 View Mode selected to see the mask in *black* and *white*

Fig. 13 Show Radius check in the View Mode, then adjust the radius of the mask

Fig. 14 Control the output of the mask refinements

The Output control box allows the refinements you have made to the mask to be applied in several different ways. They are all useful to some degree, but I normally will use two of them. I like to either Output the refinements to the Layer Mask I am working on or preferentially to a New Layer with a Layer Mask generated with the refinements (Fig. 14).

You will notice that this mask in the figure allows the sharpened details to channel through to the unsharpened image below it. This leaves the background and the stars untouched and artifact free. We now have a nicely pre-sharpened luminance that we can add our color data to. De-blurring the luminance before adding color makes a big improvement and is a critical first step. However if we really want to get everything out of the data we can, there is information we can use in the full RGB composite to bring out the details even further.

Using Color and Contrast to Reveal More Details

Seeing Detail in gray scale is very useful, but to really enhance the potential of the final image managing color and contrast are essential components of the workflow. Astrophotography is really a technical art form, and we do have substantial control over the intensity and balance of the color data and how that affects the display of

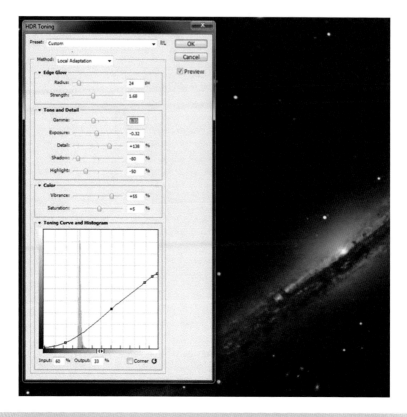

Fig. 15 The HDR Toning tool

small-scale detail. How well the smaller scale details are seen can be strongly affected by color definition. If the color smears and creeps around the details, this can have the negative effect of blurring. In our galaxy example there are dust lanes that have interesting vertical structures. There are also details of the disk embedded in the halo of the galaxy. HII regions and blue star clusters peek through or alongside the gas and dust.

We can use sharpening along with color and contrast to better define these interesting and beautiful features. *Photoshop* has several color boosting and enhancement tools along with blending modes that will boost color and contrast. One that I will use early in my workflow is the HDR Toning tool that was introduced in *Photoshop* CS5. I cover this tool in more detail in the High Dynamic Range processing chapter of this book, as it is very powerful but also requires some practice to master.

One of the benefits of the HDR Toning tool is that you can adjust contrast, color, and sharpening all at the same time. The best way to use this tool is to duplicate your image and apply the HDR Toning tool adjustments to the duplicate copy. Then blend the adjustments into the original image using masking, opacity, and blending modes (Fig. 15).

We are not trying to make a perfect image here; we are just making the adjustments to the areas we want to enhance. You can push the results to the edge as you

Other Sharpening Tools

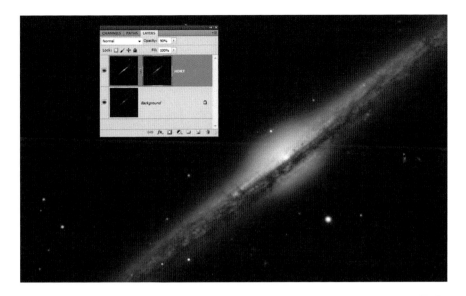

Fig. 16 The mask is applied to the HDR Toning Tool results image

dial back the opacity to blend to taste later. You can save the settings as a preset in case you need to return for further adjustments. Once you are ready click OK to apply the adjustments and then copy and paste the resulting image on top of your original image as a layer.

The next step is to use the alpha channel that contains the mask for the galaxy that we built earlier. Again, there are several ways to do this, but one of the easiest is to select the alpha channel that contains the mask and Ctrl+Click the mask icon. You will see the "marching ants" indicating that the mask has been selected. You then move to the layers panel, and with the top layer selected press the Add Layer Mask icon at the bottom of the panel. Your new layer mask can now be refined, feathered, and the opacity of the layer adjusted to taste (Fig. 16).

Using these selective processes and concepts, we can use masks with other sharpening tools and color adjustments to further bring out small-scale structures and details.

Other Sharpening Tools

There are several sharpening tools inside *Photoshop* that can each yield good results and are worth trying, depending on your subject and quality of data. Some of my favorite ones are Smart Sharpen, High Pass filtering, and the Sharpen Tool. There are also several *Photoshop* deconvolution plugins that I use with very nice results. I will use some form of selection or masking process with each of these tools.

Fig. 17 Smart Sharpen settings

Remember that we always want to reveal the details while leaving the noise and artifacts behind.

Smart Sharpen is one of the Filters in *Photoshop* that has been around for quite a while. It can yield very nice results if used correctly. Its success depends on the fact that it can sharpen based on the brightness values of the image. It separates the image into three components: shadows, mid-tones, and highlights. The trick is to make sure you have checked the advanced tab and selected the Remove Lens Blur. That seems to be the best sharpening algorithm for deep sky objects. The More Accurate box should be checked, as this is like a second pass or iteration. The sharpen amounts and the area or radius are then adjusted until you see the desired effects in the preview window. Be sure to zoom into the area of interest while applying the sharpening adjustments. I will normally zoom in 300 % or more so I can really see the results up close and in real time (Fig. 17).

Once I have the amount of sharpening I want, I will move to the Shadow and Highlights Tabs to remove the sharpening by adjusting the tonal range (width) and the Fade Amounts. I will zoom into a star that is in the targeted sharpening area so I can make the adjustments until the dark ring effect is minimal. You want to pull most of the sharpening out of the brightest highlights and protect the shadows. Stars are a good way to monitor these settings and verify you have minimal sharpening artifacts. Smart Sharpen allows you make these adjustments using its own internal selection process based on brightness values.

Fig. 18 Sharpening is removed from the shadows until there are no dark rings around the star present

Remember to always apply these filters to a duplicate layer on top of the original. That way you can blend the results with selections, masks, and blending modes that focus the results where you want them (Fig. 18).

High Pass Filtering

While we are focusing on small-scale structures the larger areas may need to be looked at also. With High Pass Filtering and a couple of layer masks we can adjust both at the same time. High Pass filtering is an edge filter that has control over how far away it detects edges and suppresses surrounding areas so it acts a like a frequency selection.

First, select the background layer and drag it down to the "Create a new layer" icon at the bottom of the layers panel. This will duplicate the layer. Name this new layer "High Pass Small," as we will use this layer to enhance small-scale structures. There are three blending modes that I like to use the most with the high-pass filter: Overlay, Soft Light, and Hard Light. Each has different results and is useful in its own way. For the "High Pass Small" layer I will choose the Overlay blending mode for its strong edge sharpening and contrast for smaller details. Once I have set the

Fig. 19 High Pass Filter with the galaxy core centered and a small radius selected

blending mode to Overlay and the layer is selected, I go to the Filter menu and select Other/High Pass. This will bring up the High Pass Filter control and preview box.

You can click in the preview box to drag the area of interest into view. In this case I am interested in the disk details that are embedded in the halo, so I have centered the galaxy halo in the preview box. You can also adjust the zoom if need be. Adjust the Radius sliders until the smaller scale features just begin to show next to the surrounding gray area. This is normally somewhere around 4–7 pixels, depending on the scale of your data and size of the details you are targeting. Once properly adjusted click OK, and you will see that the results have been applied to the entire image. What we care about are the smaller scale structures, and my goal with this galaxy is to define the complete disk within the halo (Fig. 19).

Now we need to apply a "hide all" layer mask by having the "High Pass Small" layer selected then Alt-Click the "Add Layer Mask" icon at the bottom of the layer panel. This will create a blank black mask. Because black conceals, none of the pixels of this layer will channel to the base layer because the mask is completely black.

Next we need to duplicate the background layer again by dragging it to the "Create a New Layer" icon at the bottom of the layers panel. With the new layer selected choose the Soft Light blending mode from the drop-down menu. Drag this layer to the top of the layer stack and then select the High Pass filter. Name this layer "High Pass Large," and with the blending mode of Soft light we will be able to define the large structures and at the same time apply a darker color contrast.

High Pass Filtering

Fig. 20 High pass filter with a large radius to define the halo and galaxy edges

This time we want to look at the halo and outer edges of the galaxy itself so we need to select a large radius of around 28 pixels or so. The idea is to adjust the radius until the larger structures begin to appear (Fig. 20). In Fig. 21, I have zoomed out the image in the preview window so I can easily see the halo of the galaxy. Make the radius adjustments until you can see the entire galaxy and halo and then click OK to apply the filter to this layer.

The next step is to apply Hide All Masks to each of the new layers. To do this we need to select each layer (one at a time) and then Alt+Click the "Add Layer Mask" icon at the bottom of the layers panel. This will produce a blank black mask linked to the image in the layer. Because black blocks all of the layers' pixels from channeling through, it has the name "Hide All" layer mask. We need to do the same thing to both high pass filtered layers.

There are a couple of ways to now adjust the mask and what we are seeing. We could load up a previous mask from an alpha channel we created earlier, or we can build a new mask with a brush.

Using a brush works best if you have a stylus and tablet type tool for precise control, but you can use a mouse. Select a soft paint brush with little or no hardness to its edge. Then select the foreground color for your paint brush to be pure white.

Fig. 21 Layer masks added to both high pass filtered layers

White reveals, so the idea is to paint white on the black mask to reveal the pixels contained within that layer. But we don't want to reveal them all at once, so adjust the opacity and flow of the brush below 50 %. With the "High Pass Small" layer mask selected (the black box) push your paint brush along the dust lanes only and the very small structures that are around the dust lane. Adjust the brush size so you can easily control where you are "painting" on the mask. Once you have the areas defined adjust the opacity of that layer to taste.

Then select the "High Pass Large" layer and adjust your brush to a larger size. Brush along the edges of the galaxy and around the halo. You will see the results right away as the halo, plus the galaxy edges are defined and contrast is applied. Once complete adjust the opacity of the layer so the galaxy and halo are nicely defined, but don't overdue this. You just want the galaxy to pop and have more of a three-dimensional appearance without looking harsh.

If you accidently brush over a star or area that you did not want to sharpen just change the foreground color to black to conceal. Adjust the brush, opacity, and flow to the desired amounts and brush over the areas to protect it from the high pass filter.

Experiment with the high pass filter with different radius sizes and blending modes, and you will find one you will use for each purpose.

The Sharpen Tool

The Sharpen Tool has been reworked in CS5 and can be very useful for touch-up sharpening. It has been forgotten because the legacy Sharpening Tool just did not work well, and it created nasty artifacts. This brush-based, pressure-sensitive tool is pretty amazing for selective sharpening. It will now allow you to nicely sharpen those hidden details with ease. To use it, duplicate your layer, then zoom into the area you wish to work on. I always duplicate the layer just in case I go a bit too far

Fig. 22 The Sharpen tool

and need to dial back. The Sharpen Tool is in the Blur and Smudge tool group, and once you select it you will be presented with a brush. This is great because you can have control over the size of the brush and the hardness of the brush edges, making it almost like a self-masking application. I normally will use a soft edge brush from smooth transitions. You can try different blending modes, but I think you will find the normal mode to be most effective. Dial the strength from about 25 % to 50 % and be sure to have the "Protect Detail" box checked. Then size the brush to fit nicely around the details that you want to bring out. Lightly brush over the areas; if you are using a tablet you will have precise control with pressure and number of passes for the sharpening to reveal those little details (Fig. 22).

I am finding that this wonderful tool may work better than the Small Radius High Pass Filter for smaller areas, and if you are careful you will not need to apply a mask to blend in the results.

Sharpening Plugins

At the time of this writing there are several image processing programs that have excellent deconvolution tools and other types of sharpening. *PixInsight* is quickly gaining popularity as a powerful processing platform with deconvolution and

wavelet type algorithms. There are sharpening programs that are written to work with *Photoshop* as a plugin that are also worth a look.

Nebulae

You can use some of these same methods to reveal structures in nebulae. Clouds of dust and gas contain mainly larger scale structures, but some smaller scale details are also present. You have to be careful with some deconvolution routines as they can have issues with separating nebulosity from the background particularly at the faint transitions of large, diffuse nebulae. For that reason I will normally use a mild deconvolution application and apply it only to areas that are particularly well defined. Mild High Pass filtering with a larger radius can give large-scale structures greater definition. The challenge as always is to avoid over sharpening the stars. I don't like to over sharpen stars so I will normally build a mask to protect the major star groups. As nebulae fields typically have lots of stars this can be a bit time consuming, but it is well worth the effort. You can also use this star mask to control the brightness, color, and contrast of the stars while you protect the areas around them.

The HDR Toning tool can be very useful with nebulae, and I have successfully used the sharpening and contrast adjustments to tighten up smaller scale details such as the Herbig Haro object (HH 555) that has opposing irradiated jets revealed in my 20″ RC data. Compare it to the 4-m KPNO data of the same target area in Fig. 23.

I am grateful there are so many processing tools available to us today, and I believe no imager can have too large a processing toolbox! This smorgasbord of image processing tools comes with a price, though, and these programs and their uses can have steep learning curves. However, with patience and practice you will be able to produce images that you can take pride in and the viewers will admire (Figs. 24 and 25).

Fig. 23 HH555 *top image* Ken Crawford 20″ NB – *bottom image* Bo Reipurth

Nebulae

Fig. 24 Completed image of NGC4565

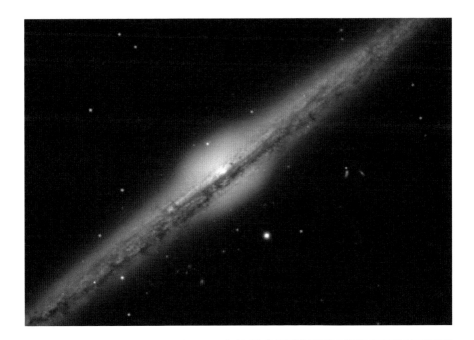

Fig. 25 NGC4565 core details

Bringing Out Faint Large-Scale Structure

Rogelio Bernal Andreo

What are faint large-scale structures and why would we be interested in bringing them out in our images?

When we capture deep sky data, particularly of wide field areas greater than 3° across, the main objects in the image usually have enough signal to pop easily with simple non-linear histogram stretches, DDP or curves. We then focus on the small details and try to enhance them up with some post-processing techniques such as deconvolution or sharpening.

This picture however may be missing a more silent, yet very interesting, character. It is silent because it is faint and therefore often so close to the noise floor that it is very hard to make it pop without also revealing a lot of noise that was also hiding silently. It is interesting because due to the difficulties in making it visible, when we finally succeed, it often provides views that we either have rarely ever seen or perhaps even did not know they were there.

In this chapter I will be discussing some post-processing techniques to assist us in bringing out those faint large-scale structures in our astroimages.

Some prerequisites are in order. Bringing out signal that sits barely above the noise floor requires a good deal of quality data. Shooting from dark skies is a must, as well as capturing at least 4–5 h of luminance data, preferably three or four times

as much. Of course, this is true for any astroimage, but it becomes crucial when one of your goals is to bring out faint large-scale structures from your data.

Now that we've acquired a fair amount of data from dark skies, let's get to work!

For this chapter we will be using data that I captured back in May 2010 of the very elusive Angel Nebula. This nebula is formed exclusively by integrated flux nebula, also known as IFN. We will be working with a master light frame that is the result of combining 20 frames of 15 min each (5 h total), captured indeed from fairly dark skies that showed SQM readings at the zenith between 21.5 and 21.8 throughout the imaging sessions. The data was captured with a Takahashi FSQ106 telescope and its 0.7× focal reducer. For our post-processing we will be using the astroimage processing software *PixInsight* from Pleiades Software.

Before we get started, to get a sense of how faint the data we want to reveal is, let's understand what exactly the IFN is.

In simple terms, the IFN is dust clouds. However, unlike most known nebulae, they do not reflect, scatter or fluoresce due to the radiation of any individual star or cluster of stars, but do so from the integrated flux of all the stars in the Milky Way Galaxy. In other words, the IFN is illuminated by the glow of our own galaxy.

Because of this, the IFN is extremely faint, so much so that almost every image taken of regions populated with IFN would either show no IFN dust clouds at all or, at most, a barely perceptible hint of it. Steve Mandel once said that the IFN was like photographing something through a dirty window, the IFN being the dirt on that window, except that the "dirt" itself is beautiful to behold.

We start by opening our fully calibrated master light image in *PixInsight*. As expected, since the image is still in linear form, all we get is a dark image (Fig. 1).

For now we are going to work on this image without altering its linearity, but we need to see what is in there. This is easily accomplished by simply pressing Ctrl-A (Windows) or Command-A (MacOS), which will do an automatic Screen Transfer Function (STF for short) or screen stretch on the image, that is, a strong stretch of the image as presented on the screen but without actually modifying any data in the image (Fig. 2).

Although the data in the image is still exactly as it was before the STF, we now have a better visualization of the contents of the image.

The first step we need to perform is to crop out any misaligned edges that might have resulted from dithering, etc. For that we use the DynamicCrop module (Process>Geometry>DynamicCrop), then select the area in the image we want to crop by clicking and dragging the mouse. We can later make adjustments to this area before we click Execute – the green check-mark in the DynamicCrop dialog box – by dragging the edges of the selected area. When we are done, we click on the Execute icon and close the DynamicCrop module.

Now we are ready to start a crucial part of astroimage processing that is even more relevant when one of our goals is to bring out very faint data from the background: gradient removal.

Bringing Out Faint Large-Scale Structure 99

Fig. 1 It's difficult to visualize the contents of a linear unprocessed image

Fig. 2 The ScreenTransferFunction allows us to see what's in the image without modifying it

Although this step is not as critical when shooting with large focal length 'scopes, it is of utmost importance when our field of view covers 2° across or more, as is often the case when we attempt to reveal very large-scale structures from our data. Yes, even from very dark skies we are going to have gradients when capturing a large area of the sky.

Traditionally, gradient removal has been a rather destructive process in astroimage processing. It has usually been done when the image has already been stretched with tools such as Histogram/Levels, curves or DDP, and more often than not, the operator has been more concerned about removing any visual hint of gradient in the final image than limiting the task to purely gradient removal while leaving intact real faint data sitting just above the background. Although this approach will fulfill some specific goals, it usually will not work well for the task we have at hand. This means we need to use a methodology that mathematically removes the gradients from our data, nothing less, nothing more.

The DynamicBackgroundExtraction – or DBE for short – from *PixInsight* is the ideal tool for this task. The way DBE works is by analyzing the image, creating a background model from specific sample points we place in the image, and subtracting this model from the data. A simple concept, but at the same time, not as easy as it seems to do it correctly.

It is important that we apply DBE to linear data. Gradients are of additive nature – unlike for example vignetting which is of multiplicative nature – so clearly, the logical way to remove a gradient is by mathematically subtracting the gradient for the image. Once an image is no longer linear, the math will not work, and our gradient removal effort will likely start to remove more – or less – than just the gradient.

We start working with DBE on an image by opening the DBE dialog box (Process>BackgroundModelization>DynamicBackgroundExtraction) and then clicking anywhere in our image to activate the DBE session for that image. Notice that the moment we activate DBE for one image, we cannot use DBE on a different image until we are done working with DBE on that first image. This is not a limitation but the expected behavior from processes that must be linked to an image in order to work. *PixInsight* only has a few of these types of processes. This in fact is not very different, although still more flexible, than the modal interface of other applications where virtually all processes need an image to do their job and we cannot do anything else until we are done with that process (Fig. 3).

One of the most critical aspects of DBE is the placement of samples. These samples are small squares placed across the image from where the DBE tool will read the data that it will later use to define the background model that will be subtracted from the image.

The DBE tool can place a predefined set of samples automatically for us. We do this by expanding the "Generation" subsection in the DBE dialog box and clicking "Generate." By default, DBE will try to place 10 samples per row.

At first one may be tempted to place a high number of samples in the attempt to define an accurate background model. However, unless our image suffers from horrible gradients, this is often a mistake. In fact, even in images with a large field of view, when correcting gradients, starting with 5 or 6 samples per row will result in

Fig. 3 The DBE dialog box may be intimidating at first, but it's much easier to use than how it seems

a much more efficient background model than 10 or 20 samples per row, as we shall see in a moment.

In addition to the automatically placed samples, we can add samples manually by single-clicking on the image in the spot where we want a new sample, or delete

Fig. 4 An irregular background model is a sign that we're over-correcting

a sample by clicking on it and hit the Delete key. We will not add or remove samples just yet.

When we're done placing samples, we expand the TargetImage Correction subsection, and change the Correction option to Subtraction. Remember, gradients are of additive nature, so what we want is to subtract them from our image.

With that done, we can click on the Execute green check-mark, or simply drag the NewInstance icon (small blue triangle at the bottom-left corner of the DBE dialog box) over to the image to apply the DBE. This will produce two new images, the background model and the corrected image. Since they too will be in linear form, let's not forget to screen-stretch them by selecting the images and clicking Ctrl-A (Cmd-A in MacOS). Now, let's see what we would obtain if we had selected a high number of samples, say, 30 per row (Fig. 4):

The image on the top left is our original image showing all the spots where we have placed samples. The image on the bottom-left is our background model, and the image on the bottom-right is our resulting image. All images have been screen-stretched.

We can see that the original image has a strong gradient, being brighter in the top area and darker in the lower parts of the image. Our background model reflects that, and our resulting image looks much flatter. However, look carefully at our background model. Does that look like a gradient to you? It is irregular, lumpy and almost displaying some structures. Indeed, all of these are hints that we have over-

Bringing Out Faint Large-Scale Structure

Fig. 5 Fewer samples often result in better gradient modeling

corrected our image. In fact, if we look at the corrected image, it is so flat that we can barely perceive any structures.

We should not pay attention to the resulting image or whether it looks good or not. Where do we look instead? We look at the background model. If we want to correct a gradient, the background model itself should look like a gradient, smooth, and gradually fading from one direction to another. Therefore, when you first attempt to correct a gradient in your image, always look at the background model first!

Now, let's see what happens when, rather than 30 samples per row, we only select 6 samples per row (Fig. 5):

Now our background model looks a lot more like a real gradient, and we can see that faint structures have been preserved in our corrected image. Still, the background model does not look perfect in the sense that it still shows some very large structure variations. While gradients could indeed produce this, particularly if data has been captured over different nights at different sites or at very different parts of the sky, our goal is still trying to produce a more gradual background model.

For example, notice the top-right area in our background model is significantly brighter than the rest. We may choose not to adjust our background model any further, but it is always a good exercise trying to do so. How should we proceed? By going back to our original image and either add or remove some samples to produce a different background model.

Fig. 6 A smooth background model is a sign we're closer to defining an accurate gradient

In this case, we probably want to remove some samples from the areas that seem to have caused this over-correction, as well as moving a few samples from areas that also seem a bit under-corrected. Knowing the exact strategy comes with practice, but you can certainly learn a lot by removing one or two samples, applying DBE again and comparing the results, not just in the corrected image but especially in the background model. Once we have removed a few samples and relocated a few others, this is the result (Fig. 6):

We can continue refining the background model at this point. In fact, it is unlikely that we will ever come up with a model that is exactly identical to the gradients that were added to our data. However, this model looks fairly decent, and at this point it seems like a good compromise.

Notice that during this gradient removal process we have barely paid any attention to whether our corrected image looks good or not. This is important because it makes our gradient removal process not dependent on how we want the structures in the image to look like. When we are chasing very faint data for which we do not know in advance how it will be distributed across the image, by focusing on the gradient model instead of the image, we obtain a more faithful result.

Keep in mind that gradients do not necessarily need to have a top-to-bottom or left-to-right appearance. They can have an oval shape, be very strong in just one corner of the image, etc. The key is to identify the approximate shape of the gradient in our source image, and produce a model that resembles that shape as accurately as possible.

Bringing Out Faint Large-Scale Structure

Fig. 7 We can do extremely precise histogram adjustments with the Histogram Transformation tool

Now, the fun part starts!

With the gradients out of the way, we can perform a first non-linear stretch with the HistogramTransformation module (Process>IntensityTransformations>Histogr amTransformation). First, let's deactivate the STF (screen-stretch) by selecting our image and clicking Control-F12, which will bring our image back to its dark appearance, typical of linear astroimages.

We then tell the HistogramTransformation tool (HT for short) to display the histogram data from our image by selecting the image and then clicking on the blue check mark in the HT dialog (second icon on the bottom-right corner). With that done, we activate the Real-Time Preview window by clicking on the spinning top-like icon (third from the left on the bottom-left corner) so we can monitor the changes we are about to make.

We now can see the histogram graph and can start dragging the midtones slider to the left while seeing the results in the Real-Time Preview window as we make the changes. As a general rule, we should move the midtones slider as close as possible to the area where the histogram graph falls down. Once we've done that, we can zoom in the histogram graph by increasing the values in the horizontal and vertical zoom boxes either using the spin controls or by entering the zoom scale numbers manually (Hint: the mouse wheel may also zoom in and out of the histogram graph.) (Fig. 7).

In the above image you can see that I have made a single but very precise histogram adjustment, thanks to the zoom features in the HT tool as well as the information it displays. For example, I can see that despite moving the black point dangerously to the right, I am only clipping 190 pixels in the image. Indeed, when looking for very faint details in our image we must be careful not to clip too many pixels. 190 pixels in an image that contains well over 10 million is a very

insignificant number −0.0019 % in fact, a number also given by the HT tool – that guarantees we are still preserving all of our significant data intact, which is what we want when we aim at bringing out faint data.

Let's not forget we were only making visual changes. We need to apply them now to the image, by dragging the NewInstance icon to our image.

Up to this point all we've done is a standard, although careful and necessary, gradient subtraction, and a histogram adjustment. Traditionally we could apply DDP-like techniques, or other S-shaped curves to our data to bring detail in the darker areas without blowing up bright structures. However, by using some of *PixInsight's* powerful multi-scale tools, we can get the job done in a more creative (aka fun) and successful way.

There are many ways to approach this problem. I will describe one of the many workflows that often works very well. Once you get comfortable with these tools, it should be easy for you to come up with your own variations.

In short, this is what we are going to do:

- Create a star mask of the more prominent stars in the image.
- With the mask in place, apply a morphological transformation via an erosion filter to dim the brightest stars.
- Use multiscale median transformations to break the image with the dimmed stars into two different scales, one with large-scale structures and the other with just small-scale structures..
- Make histogram adjustments to the two images, particularly to the image with the large-scale structures.
- Add them up together for a final result.

So let's get started!

To create a mask that targets only the largest stars, we open the StarMask module (Process>MaskGeneration>StarMask) and we adjust the parameters in order to target mainly bright large stars.

First, we assign a value of 0.5 to the Threshold parameter. The threshold parameter is meant to isolate noise from valid structures, but because a higher value will discriminate smaller structures, raising the 0.1 default a bit may help us not only to avoid noise but also to exclude the smallest stars from our mask.

The Scale and Small parameters help us define the type of stars we are after, so we set the Scale parameter to a value of 8–10, and the Small parameter to zero. We set Smoothness to 10 for a fair but not overwhelming smoothing, and leave Growth and Comp with their default values, which is 2 in both cases. We check Binarized to force a rather strong mask, and last, we adjust the histogram transform values for the Shadows and Midtones both to 0.9. This helps the structure detection to "stretch down" the image, equivalent to moving the midtones and shadows in the histogram of the star detection process to the right, which usually results in less stars being detected.

After the star mask has been created, we create a duplicate of the star mask. We create a duplicate of an image by either clicking on the Image menu option and select Duplicate, by clicking on the Duplicate icon in the task bar, or by dragging the ID tab in the image frame to anywhere in the workspace.

Fig. 8 Producing the ideal star mask often requires combining and adjusting several different star mask images

The purpose of creating this duplicate is to have a modified version of the original mask that will protect a larger area around the stars. We create such a mask by using the MorphologicalTransformation tool (Process>Morphology>MorphologicalTransformation). Without going into great detail at this point, we set the following parameters in the MT tool like so:

Operator: Dilation
Interlacing: 1
Iterations: 2
Amount: 1
15 × 15 structuring element (225 elements, circled shape)

And apply them to our star mask duplicate image.

Now that we have both star masks, we add them with PixelMath (Process>PixelMath>PixelMath), making sure the "Rescale Result" option is checked. Since our two mask files are named star_mask and star_mask_clone, all we have to enter in the RGB/K box in PixelMath is

$$star_mask + star_mask_clone$$

The result may look a bit coarse, so we smooth it with the Convolution tool (Process>Convolution>Convolution). For the convolution parameters we will set StdDev to 25 and Shape to 6, and apply it to the image we just produced with PixelMath.

Let's look at the four star masks we've produced in the previous steps (Fig. 8).

The image on the top left is our original star mask. The image next to the right is the second star mask we created right after applying the Morphological Transformation. The image on the bottom left is the result of adding with PixelMath the two images on top, and finally, the image on the bottom right is the same image after being convoluted.

If this is the first time you have created star masks with *PixInsight,* the process may feel overwhelming at first. That is partially because you are not familiar yet with all the parameters to define proper star masks, and also possibly because of the apparently redundant task of having to add different star masks. However, once you follow a similar workflow a dozen times, it becomes second nature.

The truth is that there are simpler ways to achieve very similar results. However, the purpose of describing this workflow is not only to produce the type of star mask we are going to need for our next step, but also to show you a workflow that might give you some ideas in the future when you are trying to construct the perfect star mask for a particular situation.

At this point we can do some cleaning and delete all opened images from our workspace, except for our gradient-corrected and stretched image and our final star mask.

Now we create a duplicate of our working image and we apply the mask to it. We apply a mask by either selecting our image, clicking on the Mask menu, Select Mask and select the image that will act as a mask, or by simply dragging the ID tab from the mask image to the area under the ID tab of the image to which the mask will be applied until the mouse cursor looks like a double square.

With the mask in place, we now apply a MorphologicalTransformation (MT) to the duplicate of our working image. Our goal here is to considerably reduce the glow of the brighter stars in our image. We do this because later we are going to enhance the large structures of our image, and we do not want the bright stars to influence too much the definition of such large-scale structures.

So we invoke the MT tool again, but this time we will select the Morphological Selection as the operator. This operator allows us to define how much dilation and erosion we want to apply, by changing the value of Selection. In this case we set that value to 0.20, meaning the morphological filter will apply a 20 % of dilation and an 80 % of erosion. We also select a large structuring element (9 × 9 seems large enough) and click on the small blue sphere icon to define a round kernel. We also set the Iterations parameter to **5**, as we want to be somewhat aggressive, while leaving the Amount value at its default value of 1.

We apply the MT to our masked image, and the result should be an image with the brighter and larger stars greatly dimmed (Fig. 9).

We can now remove the mask from our image by selecting our image, going to the Mask menu, and click Remove Mask.

Bringing Out Faint Large-Scale Structure

Fig. 9 Always apply MorphologicalTransformation with the proper mask in place

It is time now to break this image into small- and large-scale structures. We will use the MultiscaleMedianTransform tool (MMT), which is a module introduced in *PixInsight* v1.7 that uses multiscale median transforms as opposed to wavelet transforms. We could use the wavelets tool for the purpose of separating different scale structures, as the main benefits of median transforms over wavelets are better smoothing, sharpening and the absence of certain artifacts that are unavoidable when doing wavelet transforms such as ringing, neither of this being fundamental in breaking an image into different scale structures, but either tool works well for this purpose, and the MMT tool is a more modern implementation at this moment.

First we invoke the MMT tool (Process>MultiscaleProcessing>MultiscaleMedian Transform), we increase the number of layers to 5, and we deselect all layers but the "R" (Residual) layer. We also change the Target to Lightness (CIE L*), leave all other parameters with their default values and apply it to our image – that is, the image we just modified with the MT tool, not our original working image (Fig. 10).

We can see our image has been significantly modified, by leaving only the largest scale structures visible. The brightest stars are still visible, but are not as bright as they otherwise would be should we not have dimmed them earlier. Notice that a couple of small galaxies – that were not masked out originally – are right now the brightest objects in the image. That is okay.

To produce now an image of the smaller scale structures we subtract this image from our original working image. Since the name of this image is L_DBE2_clone,

Fig. 10 Large-scale structures appear inherently blurred due to the lack of small details

and our working image is L_DBE2, we enter the following in the RGB/K box in PixelMath:

$$L_DBE2 - L_DBE2_clone$$

Once again, be sure that the "Rescale result" option in PixelMath is checked. This time, also make sure that the "Create new image" option under the Destination subsection in the PixelMath dialog is checked, instead of the "Replace target image" option. Then, apply PixelMath by dragging the NewInstance icon to either of the two images, or simply click on the Apply icon (or press F5 on a PC) and our small-scale structures image will be created.

At this point it might be advisable to rename all our working images to more meaningful names. We will rename our original working image from L_DBE2 to O for Original. L_DBE2_clone will be renamed to LSS for Large-Scale Structures, and the image PixelMath just produced will be renamed to SSS for, you guessed it, Small-Scale Structures. You can rename an image by double-clicking on its ID tab and entering the new name.

The next step may seem a trivial one, but it must be done carefully. We are going to stretch both LSS and SSS with the HistogramTransformation tool. The stretch on LSS will be more aggressive than the one on SSS because we want to enhance the contrast in the large-scale structures, but we must make sure that we do not clip one single pixel, especially when adjusting the LSS image. For illustration purposes, here is an image that on the left shows the two original LSS and SSS images, and on the right, the same images after being adjusted with the HT tool (Fig. 11).

Bringing Out Faint Large-Scale Structure 111

Fig. 11 *Left*: original large and small structure images. *Right*: adjusted images

At this point we could try many other things as well. We could apply some wavelets to enhance the structures of either of the images. We could use curves or PixelMath to intensify the contrast in these structures, etc.

This is not to say we should go crazy. In fact, we should try to keep any modifications at this point rather subtle. The point is that we have a plethora of tools we can use that might help us achieve our goals, and that is part of the fun in astroimage post-processing: that we can experiment with these tools to see which ones help us reach the goals we aim to achieve.

For now we limit the processing to the histogram adjustment we just did, meaning, we are ready to put everything back together. How is this done? Remember that originally we created the SSS image by subtracting the LSS image from the O image with PixelMath. The way to put everything back together again is by adding LSS and SSS, which is done by entering the following expression in the RGB/K field in PixelMath, and as usual, leaving the "Rescale result" and "Create new image" options checked:

$$LSS + SSS$$

We rename the new image to R for Result, and this is what we get (Fig. 12):

At this point it is convenient to evaluate whether the new image can handle a new histogram adjustment. Usually this is the case, as the new image presents a

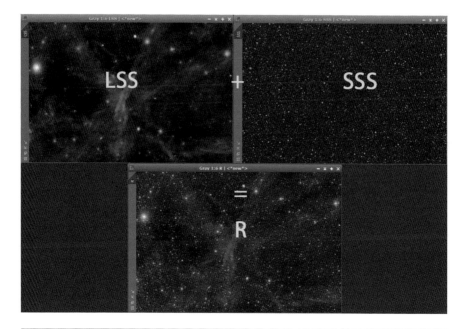

Fig. 12 We produce our new working image by adding our adjusted large and small scale images

histogram based on "new" data. If you would rather use curves or other intensity transformation tools instead of the HT tool, that is okay. As always, we try not to clip any data.

After that, depending on what our data is telling us, we could apply some noise reduction, sharpening, and other more mundane post-processing techniques, but we will not cover those processes here. Also beyond the scope of this tutorial is the processing and application of color data. Still, assuming we have also captured color data to our image, once the color data has been calibrated and processed – not necessarily using any of the techniques described here except possibly the gradient subtraction process – after a proper LRGB combination has been applied, this would be our final image (Fig. 13):

While the image may not display any more nebulosity than what we are used to seeing in many other astroimages of more typical nebulae, let's remember that the structures we see here are very faint, yet we have succeeded in bringing them out to the point of appearing as if they were just an ordinary nebula.

As mentioned earlier, this is just one method that can help us bring out faint large-scale structures that not only covers multiscale processing but also a particular application of star masks. As we become comfortable with the processes

Fig. 13 Our final image once color data has been added

described here and the tools we have available, it should be easy to come up with interesting variations of the work flow described in this chapter or even expanding it to include more novel approaches.

Narrowband Imaging

Don S. Goldman

Introduction

The Hubble Space Telescope (HST) captured the attention of the world when it released its astounding image in 1995 of the Eagle Nebula (Messier 16) often called "The Pillars of Creation" (Fig. 1). It contained dark, billowing towers of gas and dust rising majestically into a background of glowing radiation. It told a story of new star formation.

What captured the interest of astrophotographers with considerably smaller budgets than NASA's was how this image was created using only narrowband filters. Intense ultraviolet radiation from nearby hot stars causes certain elements to emit light of a specific color, somewhat like a glowing neon sign. Narrowband filters are designed to select a specific narrow range of color for each element, exclude all others, and pass them on to the monochrome CCD detector. This process of wavelength selection and exclusion dramatically increases contrast, bringing out nebular structure much more than conventional RGB (red, green and blue) broadband filters.

This is evident in the images of the Dumbbell planetary nebula (M27) in Fig. 2. The narrowband image (left) was taken by the author with H-a and OIII filters and processed to produce a "natural" color, as will be discussed in a later section. The extended reddish "halo" surrounding the familiar bright core of M27 is clearly evident in the narrowband image. In contrast, the extended halo is very faint or absent in the RGB image (right). Both images are presented at the same scale and orientation. It is

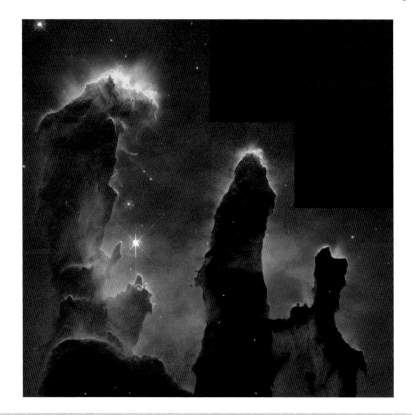

Fig. 1 HST's Pillars of Creation (NASA, ESA, STScI, J. Hester and P. Scowen of Arizona State University)

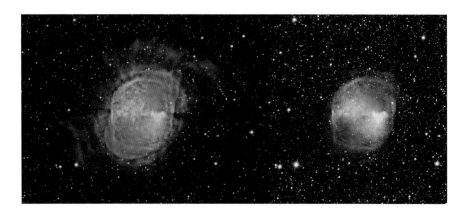

Fig. 2 Extended halo surrounding M27 (*left*) brought out with narrowband filters compared to an RGB image (*right*, courtesy of Rob Gendler)

the high contrast of the narrowband filters that brings out these fainter structures. The blue-green areas in the halo in the narrowband image are rich in oxygen and the reddish areas in hydrogen. Thus, we can even see differences in the energetic processes that occurred during this expulsive event from the proginator central star. This type of information leads scientists to a better understanding of how the nebula reacted with the surrounding interstellar medium. Scientists using larger telescopes and narrowband filters make a variety of measurements of these extended halos to better define the history and energetic processes of the planetary nebula. In some cases, there are multiple halos extending in different direction, representing multiple episodes in the evolution of the star.

Getting back to the "Pillars" image, the resulting monochrome image from each narrowband filter was then colorized in the computer and combined with the other colorized elements to produce a beautiful, highly structured color image. The "Pillars" image was taken with sulfur (SII), hydrogen (H-alpha or H-a) and oxygen (OIII) narrowband filters. This creates a problem. It is obvious how to combine RGB images. The image taken with the red filter is colorized to red, and so on. However, SII and H-a are different shades of red, and OIII is a blue-green or teal color, so some other colorization protocol is required to uniquely display each element. The authors of Fig. 1 decided to colorize them to red, green and blue, respectively; a colorization scheme now known as the "Hubble Color Palette" (HCP). This is sometimes referred to as a "false color" or "mapped color" image for this reason.

Another palette is the Canada-France-Hawaii-Telescope (CFHT) palette, where SII, H-a and OIII are colorized to blue, red and green, respectively. As a result, the amber shock fronts in the HST palette from H-a and SII (green+red) become magenta (red+blue) with the CFHT palette. Regardless, the goal is to use color to emphasize structure in an aesthetically pleasing manner. We have left the world of science, and the end result becomes "technical art." Astrophotographers create "technical art"; we are landscape photographers on a cosmic scale.

Astrophotographers in the late 1990s began taking images with H-a filters and blending the resulting high-contrast narrowband data into their RGB data to enhance the structural content. This is referred to as "hybrid imaging" and will be covered in another chapter in this book. The first amateur narrowband images taken with the HCP occurred in 2003 and have since become very popular.

Narrowband filters reject all other light except that of the elements of interest. This means that they help to reject moonlight and terrestrial light pollution. They extend the use of our equipment, allowing us to image when the Moon is up. Conventional RGB imaging is done on a dark night without the Moon. Furthermore, narrowband filters allow us to image from light-polluted locations if we do not have access to a dark imaging site. Narrowband filters significantly reduce the most common form of light pollution, which is from yellow sodium street lamps. Because they eliminate most other light except for a few wavelengths, they go a long way toward reducing light pollution from broadband sources, such as backyard incandescent flood lamps. For many residing in cities or urban areas, narrowband imaging is the only practical option.

This chapter describes the steps to create an image like the "Pillars" from H-a, SII and OIII data using Adobe *Photoshop*™ software. It covers colorization, combining color, multi-scale detail enhancement, "natural" vs. "false" color, and blending RGB data into narrowband data. It begins with finished "master" images from each narrowband filter and ends with a beautiful colored image. The processes used to create these "master" images, including calibration, registration and combining, are covered in other chapters of this book.

Layering and Colorizing

We start with three "master" narrowband images of an emission nebula in the southern constellation of Ara, NGC 6188, shown in Fig. 3. They have been previously registered.

We next create a single *Photoshop* file with three layers containing these narrowband images. To do this, we open all three images. I will use PC shortcuts (MAC users will use the Command button instead of the Control -CTRL- key). Select the OIII image, **CTRL-A,** and then copy **CTRL-C**. Paste (**CTRL-V**) this image into the H-a image. Repeat for the SII image. Now we have all three "master" images in one file in different layers. These master files are generally created as 16-bit grayscale TIFF files. However, we will next colorize them, so they must be in the RGB mode. Select **Image/Mode/RGB Color** and choose **Don't Flatten** in the popup screen. Double-click in the text of each layer and label them appropriately. Our layers palette should now look like Fig. 4. Select **Save As** and save this file with a new name as a PSD *Photoshop* file type.

Fig. 3 NGC 6188. H-a (*left*), OIII (*middle*), SII (*right*) "master frames"

Layering and Colorizing

Fig. 4 Layers palette with three "master" frames

We will be creating and saving many new files as we proceed to ensure that we can always go back a step or two if something goes wrong. Similarly, we will often create a duplicate layer, perform a procedure and determine if we like it. If we do, we can flatten the image into one layer (**Layers/Flatten Image**) and save the changes as a new TIFF file. If not, we can simply delete the duplicated layer. Saving frequently is critical for success in order to prevent lost time in going back to the beginning.

We will now colorize each layer based upon the HCP, starting with the top (SII) layer, where we will:

1. Create a **Hue/Saturation** adjustment layer.
2. Click on **Colorize** in the **Hue/Saturation** adjustment window.
3. Set **Saturation** to 100.
4. Set the **Hue** and **Lightness** per Table 1.
5. Right click and select **Create Clipping Layer** to clip this adjustment layer only to the specific narrowband element.
6. Change the **Mode** of the narrowband element to **Screen.**

Repeat for the other two elements.

With the SII layer active, click on the adjustment layer icon highlighted in yellow in Fig. 4. Select **Hue/Saturation** from the popup menu. This adjustment layer will be added to the layers palette and appear above the SII layer as shown in Fig. 5.

When the adjustment layer is highlighted, the adjustment palette shows the **Hue/Saturation** controls (Fig. 6). Before adjusting the controls, click the **Colorize** box highlighted in yellow in Fig. 6. Use the following table as a guideline for the HCP. Then adjust the controls, which are shown for SII in Fig. 6. Set the **Saturation** control to 100 for all elements.

Table 1 Colorization settings

Element	Color	Hue	Lightness
SII	Red	360	−50
OIII	Blue	240	−50
H-a	Green	120	−60

Fig. 5 Adding a Hue/Saturation adjustment layer

Fig. 6 Hue/Saturation controls for SII

We now need to apply this colorization in the adjustment layer only to the SII layer below. We do this using a clipping mask. Right-click on the adjustment layer and select **Create Clipping Mask**. A small left down-arrow will appear to the left of the Hue/Saturation box in the Adjustment Layer, showing that this layer is clipped only to the layer immediately below, in this case, SII. Any adjustments in Hue or Intensity in this adjustment layer will only affect the SII image.

The last step is to change the blending mode of the SII layer to **Screen**.

Repeat this procedure for the OIII and H-a data in the layers palette. The result will appear as in Fig. 7. (we will discuss the curves mask below).

Layering and Colorizing

Fig. 7 Clipping layer mask

The **Screen** blending mode works as if we had three independent projectors, projecting a different color (red, green or blue) from each colorized element on the wall. The projections are superimposed. The result is a full-colored image. **Save As** again as a new *Photoshop* PSD file.

Changing the **Lightness** control in the SII adjustment layer would be equivalent to changing the brightness of the SII projector, changing the red color, since SII is colorized red. Slight adjustments in **Hue** can also be made. This can be done at any time, which makes this clipping layer mask method very powerful. Alternatively, you could assign the "master" frames to red, green and blue and combine them into one layer using **Merge Color** in the **Channels Palette** in *Photoshop*. RGB images are typically combined in other programs and brought into *Photoshop* as a single, colored 16-bit TIFF file. However, once the data are combined into one layer, you cannot directly go back and independently change the Hue and Lightness of each element as you can with the clipping layer mask method.

Photoshop "knows" that there is a clipping layer mask attached to each narrowband layer. Thus, if you add a different adjustment layer, *Photoshop* will automatically add it as a clipping layer mask. With the SII layer highlighted, click on the adjustment layer icon at the bottom of the layers palette as before and select **Curves**. *Photoshop* adds a Curves adjustment layer above SII as a clipping layer mask, as shown in Fig. 7. We can then adjust the curve to emphasize or de-emphasize the intensity of the red SII data in the shadow or highlighted regions in the image. Perhaps the dark dust region near the bottom right of the image is too red, for example. Simply bring down the SII curve to reduce this effect. Curves can be added to the OIII and H-a data and adjusted similarly giving us incredible flexibility. Figure 8 shows the results of these adjustments, including curves for all elements.

This is the basic procedure to arrive at a beautiful, colored image using the clipping layer mask with the HCP. But we are not done. The image in Fig. 8 could stand on its own, but there are enhancements that make it better. The remaining sections will focus on these enhancements.

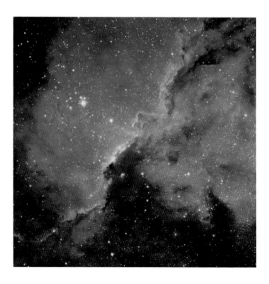

Fig. 8 Initial colorization with curves adjustments

Adding a Luminance Layer

In RGB imaging, high-resolution, lower noise "luminance" data are taken with a colorless filter that passes all red, green and blue light together. This lowers noise, or granularity, in the image. The RGB data are then blended into the luminance data to produce a colored image. This is the most common way images of galaxies are made.

Something similar can be done with narrowband data, since they are typically noisier due to the much weaker signals than RGB. We can take the three "masters" in Fig. 3 and combine them into a "super-luminance" image. This is best done in other programs that have file math capabilities and can add or manipulate multiple files, such as CCDStack (CCDWare, Inc.) or MaximDL (Diffraction Ltd.). This has been done, and the resulting image is shown in Fig. 9. We will perform contrast enhancements and noise reduction on this image as described in other chapters of this book, because we will be blending in the color that we have previously created from Fig. 8.

One important enhancement is to shrink the size of the stars in the "super luminance" image using a technique referred to as "deconvolution" with programs as listed above. Star color and size are critical to the aesthetic appeal of an image. We will be discussing star color in the next section, where we will blend "natural color" RGB stars into the narrowband data. Making stars smaller with deconvolution in the "super-luminance" image before adding the RGB data helps in this regard.

Select (**CTRL-A**) and Copy (**CTRL-C**) the "super-luminance" image. Select the top layer in the narrowband image and paste (**CTRL-V**) it on top of the layers shown in Fig. 7. The results will appear as in Fig. 10.

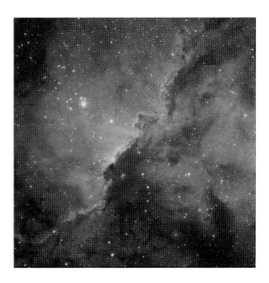

Fig. 9 Narrowband "super-luminance"

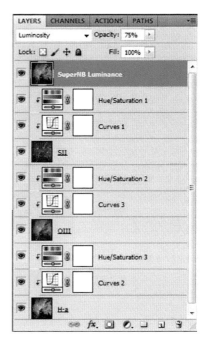

Fig. 10 Adding luminance to the layers

Change the blending mode to **Luminosity** as shown in Fig. 10, and adjust the **Opacity** to taste. Typically the Opacity will range from about 35 % to 75 %. **Save As** a new PSD file.

"Natural" Color: Is It Real?

It is important to have a brief discussion about color in astrophotography. If narrowband images are "false color," what is "real" or "natural" color? Many people ask – is it "real"? What color would we see if we approached it in a spaceship?

I think the best way to answer this fundamental question is to say that it is what you would see if the object were bright enough to activate the color receptors (cones) in your eyes. Unfortunately, our color vision is too weak to see full color through our backyard telescopes. Some greenish hues can be seen in meter-class professional telescopes, but not the full gamut of colors that you see in most astrophotographs. Nevertheless, it is real. It just needs amplification with our sensitive CCD (charge-coupled device) astronomical cameras and specialized computer programs to see it in its full glory on our monitors. By analogy, the ocean is full of sounds, most of which we cannot hear because of the way our hearing evolved on land. However, sensitive underwater hydrophones can pick up these sounds. Similarly, butterflies have markings on their wings that can be seen in the ultraviolet, hidden from our view, unless we use ultraviolet cameras. Lastly, macro lenses provide the means for us to see the exquisite complexity of flowers or insects that we cannot see with the unaided eye. In all of these cases, the color or structure is real, but mostly beyond our unaided sensory capability.

The same is true when we amplify color signals too weak for our color vision in astrophotography. A spaceship will not improve the situation. The object would spread out as we approached it so that the color signal would get weaker and weaker, and we would again likely not see the full gamut of colors that we see in our astrophotographs. So, it is indeed a conundrum that no one has seen these objects in full color, but the color we see in astrophotographs is "real." It just needed amplification.

In posting narrowband images among the various Internet groups and giving workshops and talks over the years, it became apparent to me that many astrophotographers do not like the HCP or "false color" images. They prefer "natural color" images as would be taken with broadband RGB filters.

The clipping layers mask method allows us to convert from the HCP to a more "natural" color appearance. We can do this quickly by changing the **Hue** slider for H-a to 350–360, converting it from green to red or red/magenta, and for OIII to a blue-green (teal) color near 200. We will need to readjust the **Lightness** values. This was done for the HCP image in Fig. 8 to produce Fig. 11. One very important benefit is that we achieve natural color, while incorporating the enhanced structural detail due to the high contrast of the narrowband filters. It cannot replace an RGB image, however, because blue reflection regions will not be fully captured, for example. One solution is to blend the RGB data into the narrowband data, as will be shown in the next section for star colors.

Most of my images of planetary nebula (Helix, Dumbbell), Wolf-Rayet bubbles (Crescent) and supernova remnants (Veil) are taken only with H-a and OIII filters, and processed this way for "natural" color. The Dumbbell Nebula in Fig. 2 was taken this way.

Fig. 11 NGC6188 narrowband in "natural" color

Star Color

Stars generate light across the full color spectrum. Hence, broadband RGB filters can produce the huge range of brilliant star colors in our images. However, narrowband filters cannot do this, since we are using one or two red narrowband filters and a blue-green narrowband filter. Star color is one of the disadvantages of narrowband imaging. Often times we see a magenta star and you sense that it is not "real." Its appearance degrades the aesthetic appeal of the image. Notice the bright, magenta-colored star in the "Pillars" image in Fig. 1. Magenta occurs due to the fact that the SII (red- colorized) and OIII (blue-colorized) signals are almost always much weaker than the H-a (green-colorized) signal. Hydrogen dominates in elemental abundance in the cosmos. As a result, we stretch (amplify) the weaker OIII and SII data to prevent H-a from overwhelming and producing a green image. We create magenta (red plus blue) stars in this process.

One way to add "properly colored" stars into a narrowband image is to take a series of short RGB exposures, combine them based upon a widely accepted white-point (e.g., G2V, which is a Sun-like star) and blend them into the narrowband data. Figure 12 shows a total of 30 min of RGB data combined into one image. So, our next chore is to blend these strong star colors into the deep (>10 h of data) narrowband data.

There are many ways to do this, but the key is to desaturate the narrowband star colors so that the RGB star colors will dominate in the layer blending process.

One way to do this is to take our completed narrowband image with the super-luminance blended in and flatten it (**Layers/Flatten Image**). Save the file with a new name as a PSD file. Duplicate the layer (**Layer/Duplicate**) and select

Fig. 12 Combined RGB data for star colors

the stars in the duplicated layer. We will be working on the duplicated layer. This can be done by **Select/Color Range/Highlights**. It will select the stars, since they tend to be the brighter objects. Expand the selection to ensure that the magenta rims around bright cores are also selected by **Select/Modify/Expand** and then choose an appropriate value, such as 2 pixels. We will see the selections enlarge. Next feather the selections by 2 to 3 pixels to avoid sharp edges by **Select/Modify/Feather**. We may have to take the **Lasso** tool and deselect (by pressing **ALT**) any bright (non-stellar) parts of the nebula that the **Highlight** tool selected.

We will end up seeing the *Photoshop* "marching ants" selections around the stars, as shown in Fig. 13.

We can now use one or a combination of tools to desaturate the stars. One is **Image/Adjustments/Hue-Saturation.** Adjust both the **Saturation** and **Brightness**. You can even affect only magenta by changing **Master** to **Magenta**. As you decrease the brightness, be sure to examine the entire image, and make sure that you are not creating dark rings around the stars. You can temporarily hide the "marching ants" by **CTRL-H** to better see the result of your adjustment in real time.

Another tool is **Image/Adjustments/Selective Color.** Select **White** and then move the **Magenta** slider to the left. This helps to remove a magenta hue from a mostly white star, including the core.

Deselect the stars (**CTRL-D**) when you are happy with the changes. You can either **Flatten** the image or experiment and blend most, but not all, of the duplicated layer into the original using **Opacity** in the **Layers** palette. **Flatten** the image.

Open the RGB image (Fig. 12), select and copy it (**CTRL-A, CTRL-C**) and paste it into our star-modified image. Figure 14 shows three layers with the modified stars blended mostly into the original below and the RGB stars layer above. With

Fig. 13 Selecting magenta stars

Fig. 14 Adding RGB stars

the RGB stars layer selected, select **Lighter Color** as the blending mode, as shown in Fig. 14. *Photoshop* will select the stronger colors present in your RGB image and blend them into the narrowband image below. We can change the **Opacity** to change the degree of blending until you arrive at acceptable star colors. Save this file as a new *Photoshop* PSD file.

Detail Enhancement

One of the limitations of our images is that they are flat and two-dimensional. One of the ways by which we can create a three-dimensional (3-D) appearance is to sharpen objects that we want our viewers to perceive, as in the foreground. The **High-Pass** filter in *Photoshop* is ideal for this purpose.

Duplicate the PSD file and **Flatten** the layers. Create a duplicate layer and select **Filters/Other/High Pass** with a setting of 7–8 pixels to go after fine structure, such as shock fronts or filaments. Change the blending mode to **Overlay** (strongest effect) or **Soft Light**. We will now see the entire image sharpened, including the stars, which now have a harsh appearance. In the layers palette, we will see a gray icon in the duplicated layer. We need the means to sharpen only those features to

Fig. 15 High Pass filter

Fig. 16 Sharpen with high pass filter

promote a 3-D look. To do this, we will add a layer mask (**Layer/Layer Mask/Hide All**), which will put a black icon on that layer to the right of the gray box, as shown in Fig. 15. The sharpened image is now hidden. With the mask icon selected, we will use the **Paint Brush** to selectively paint in the sharpened detail created by the **High Pass** filter, making sure that the **foreground color** is selected (white box) near the bottom of the **Tools Palette**. I like to rename the layer, in this case, to HiPass8, to distinguish it from the coarse **High Pass** filter that we will create next.

Select the **Paint Brush**, adjust the size of the Brush to match the features that we intend to sharpen, set the **Opacity** to 100 % and start painting in detail on the image as shown in Fig. 16. Be sure that the Layer Mask icon is selected. This process is akin to providing a surgeon with a sharp scalpel, so that only restricted areas are operated upon, and everything else (e.g., stars) is left alone. As we paint with the white foreground selected, you will see white areas develop in the black Hide-All layer mask, as shown in Fig. 15. We can change the overall Opacity of the HiPass8 layer to control the degree of sharpening. It is set to 86 % in Fig. 15. We can further see that only the diagonal ridge in the image was sharpened at this fine scale in the Layer Mask icon.

Lastly, we will repeat the above procedure, but at a coarser scale by duplicating the bottom layer again, and applying the High Pass filter at a scale of 45 pixels or so. Rename the new layer, such as HiPass45, as shown in Fig. 15. This tends to bring out coarser features in the background. As such, the size of our brush will be larger than what we used to select fine features. I tend to use the Soft Light blending mode for the coarse High Pass layer. We can see from Fig. 15 where the coarser structure was brought out. Again, set the Opacity to an acceptable level. We now have completed a multi-scale, selective sharpening of our image.

Other Enhancements

There are additional processing steps that enhance the aesthetic appeal of the image. Stars are typically quite small when imaged with meter-class telescopes taken at professional observatory sites away from light polluton and with excellent "seeing" (small amount of star twinkling or motion). Amateur astrophotographers are generally not so lucky. As a result, stars become larger and often distract from the nebula or galaxy of interest. This can be considered as "optical clutter." There are methods to select the stars and make them smaller, such as the Minimum Filter in Filter/Other/Minimum. This is covered in other chapters of this book.

To further the point, there are always a small number of larger stars that can shift attention away from a nebula or galaxy. Later versions of *Photoshop* have a new tool called Liquify (Filter/Liquify) where each star can be shrunk on an individual basis and to a controllable degree.

Lastly, to produce an astrophotograph, we have considerably "stretched" the original data, and in the process we have introduced noise. Noise reduction is beyond the scope of this chapter and has been covered in other chapters in this book. Briefly, you can use Filter/Noise/Reduce Noise in *Photoshop*. Alternatively, you can purchase a variety of software plug-ins, such as *Noise Ninja* (PictureCode) or *Noiseware Professional* (Imagenomic). Regardless of which one you use, perform your noise reduction in a duplicated layer, blend it in at a desirable Opacity and use a Layer Mask if needed.

Final Image

Once you are satisfied with your image, you will duplicate the final PSD file, flatten it, crop it, and save it as a high-resolution TIFF file. Often we will be working in Adobe 1998 color space due to its wider color gamut that is better for printing. However, we may want to convert to sRGB color space for posting the image on the Internet. If so, we will duplicate your TIFF file, convert it to sRGB color space, change the mode to 8-bit and save it as a JPEG file.

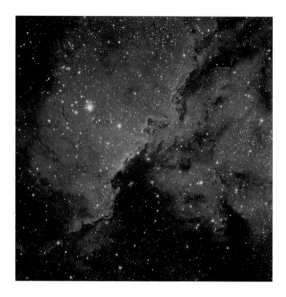

Fig. 17 NGC6188 final process image

You can see from our long process that it involved many duplicated files and captures our processing sequence so that you do not have to start all over if you later decide to reprocess the image. As a result, you will need a computer with a large hard drive because many of the PSD and TIFF files may exceed 100 MB. Save your work as you go!

I hope that you take joy in creating colorful masterpieces using narrowband filters and appreciate the enhanced structural detail that they provide. The final image of NGC6188 from all of these processes is presented in Fig. 17.

About the Author

Don S. Goldman, Ph.D. has been imaging for over a decade. He is the founder and President of Astrodon Imaging which develops and provides, LRGB, narrowband and photometric filters for astrophotography and research. He has given many talks and workshops at astronomy conferences, has been widely published in astronomy magazines, was a co-founder of the prestigious Advanced Imaging Conference (AIC), and has been selected many times for NASA's Astronomy Picture of the Day (APOD). He operates remote observatories in California and Australia for imaging. See more of his images at www.astrodonimaging.com.

Widefield Imaging: Selected Strategies for Processing Light-Contaminated Data

Stephen A. Cannistra

Introduction

The beauty of nebulae, galaxies, and star clusters takes on new meaning when portrayed in a widefield view, where familiar objects that are commonly seen in isolation are now shown in relation to one another. Through the use of high quality, short focal length optics combined with large, commercially available CCD chips, it is possible to capture broad regions of sky that an older generation of astrophotographers could only dream of.

Not only are seasoned astrophotographers drawn to widefield imaging as a way of portraying familiar objects from a fresh perspective, but many beginners are attracted to it because of the favorable image scales used (often in the range of 3–4 arcseconds per pixel), which place fewer demands on seeing conditions, tracking, and autoguiding accuracy. This chapter will discuss selected image processing techniques that have particular utility for the widefield imager, with a special focus on processing light-contaminated data. Some general principles will be reviewed that are generic to widefield imaging, including image acquisition strategies, because such considerations are invariably tied to the processing steps that follow. Although most of the discussion is based upon a working knowledge of Adobe *Photoshop,* the principles outlined in this chapter should be applicable to any equivalent image processing program.

General Principles

The quality of widefield images acquired at light-polluted sites is limited by two main problems. The first relates to the fact that light pollution creates gradients that differ in both intensity and spatial distribution between color channels. This problem is of particular concern in widefield images, where the large field of view reveals even the smallest of gradients in glaring detail. The second is due to the fact that light pollution limits the signal-to-noise ratio that can be achieved over a given exposure duration. Several steps can be taken during image acquisition to minimize such problems, making subsequent image processing of light-contaminated data more effective.

For instance, starting the imaging session when the target is at least 30–40° in elevation will reduce but cannot eliminate the impact of gradients on the final widefield image. The use of a proper subexposure duration to minimize the effects of read noise is a critical aspect of improving signal to noise (theoretical considerations describing the effects of subexposure duration on image quality may be found at http://www.starrywonders.com/snr.html). Imaging with a sequence of red, green and lastly blue broadband filters for a rising object is also important to reduce the suppressive effects of atmospheric extinction on signal intensity. Dithering of subexposures, in which the image is shifted slightly between exposures, is a powerful way to identify and eventually reject outlier signals that result from excessive dark currents (hot pixels).

Finally, acquiring narrowband filter data is essential for widefield imaging of emission nebulae at light-polluted sites, and special processing considerations for handling such data will be discussed in detail. Table 1 summarizes selected good practices during image acquisition, including those designed to mitigate the effects of light pollution and facilitate subsequent processing of widefield images.

Considerations related to image scale are also relevant to processing widefield images. Most widefield imaging is performed at short focal lengths, which typically yield an undersampled image with image scales as high as 3 to 4 arcseconds per pixel. The term "undersampled" relates to the fact that the image scale is not able to effectively capture all of the data available for a given range of seeing conditions, resulting in detail being collapsed into an individual pixel (and therefore not recoverable through subsequent image processing). Nonetheless, for widefield vistas that portray macroscopic detail, and which do not require the scrutiny of high resolution inspection, such undersampled images are still well suited to the widefield format.

However, certain limitations must be kept in mind when processing undersampled data. For instance, binning such data during image acquisition, such that the image now suffers from even greater undersampling, is not advisable due to loss of resolution that will compromise the final result. This is especially true for the commonly used strategy of binning color data with the ultimate goal of combining it with unbinned luminance data, which may be an acceptable approach for a well sampled image but can lead to loss of valuable color information when the image is already on the verge of being critically undersampled, as is typical of many widefield images.

General Principles

Table 1 Selected principles for improving the quality of widefield images

Technique	Comments
1. Choose a proper subexposure duration	Camera read noise is an important source of noise that can be minimized through the choice of a proper subexposure duration. Details may be found at http://www.starrywonders.com/snr.html
2. Image only when target is > 30–40° in altitude	Most light pollution gradients, especially in red light, are most prominent when imaging near the horizon due to contamination by distant city lights
3. Use sequence of red, green, and lastly blue filter for rising objects	Red light is more resistant to the effects of atmospheric extinction, compared to green and blue light
4. Dither subexposures	Dithered subexposures facilitate identification of outlier signals by imaging processing software such as MaximDL or CCDStack, that ultilize mean or sum combine techniques with sigma rejection
5. Do not bin undersampled images typical of widefield work	Most widefield images are undersampled, often in the range of 3–4 arcseconds per pixel. Further deterioration of the image scale by binning often results in unacceptable degradation of image quality
6. Do not use deconvolution techniques on undersampled images	Deconvolution is only appropriate for images that have captured enough small scale detail to be enhanced by this specialized algorithm. It is generally not appropriate to use deconvolution for the undersampled images typical of widefield work
7. Avoid the use of interpolation algorithms during image alignment	Interpolation algorithms such as bicubic resampling can introduce an additional loss of detail in an already undersampled image and should be reserved for well-sampled images

The other important consideration for undersampled, widefield data relates to the use of deconvolution algorithms, which are available in most image processing programs such as *MaximDL* and *CCDStack*. Deconvolution is a process designed to reconstruct detail that is present in the image, but which is "convolved," or blurred, due to the effects of poor seeing. Thus, a well-sampled image in the range of 0.5–1 arcseconds per pixel lends itself to deconvolution, since sufficient detail was captured at this image scale to serve as the starting point for further refinement using this technique. In contrast, it is generally not appropriate to apply deconvolution to the undersampled data typical of widefield images, because no post-processing technique is able to reveal small scale detail that was not captured in the first place.

The final consideration for processing undersampled, widefield data relates to common techniques for combining subexposures using software such as *MaximDL, CCDStack,* and similar programs. Such programs have routines that permit proper alignment of subexposures to one another and offer the choice of several interpolation algorithms (such as bicubic resampling) during this process. Such algorithms are often useful because they provide a best guess estimate for filling in missing data as a result of the alignment process, but they are to be avoided when combining widefield subexposures because such images are already undersampled and are therefore prone to substantial degradation in image quality when such interpolation strategies are used.

Correction of Light-Pollution Gradients in Widefield Images

Light-pollution gradients are most noticeable in the large field of view characteristic of widefield images. In order to facilitate subsequent gradient correction, special attention must be given to identifying and excluding those subexposures with extensive light pollution gradients (e.g., those that extend across the entire image), such that it is impossible to distinguish gradient from background. Although we strive to achieve long cumulative exposures, it is better to discard subexposures that were taken at low altitude, where light pollution from the horizon has introduced severe gradients and has compromised faint signal, than to indiscriminately contaminate the image with poor quality data. Once the best-quality subexposures are identified, these are typically aligned and combined in a program such as *MaximDL* or *CCDStack* using mean or sum methods with outlier rejection, avoiding the use of interpolation algorithms when dealing with undersampled data as noted above, followed by the use of a ddp (Digital Development Processing) stretch without sharpening. Aligned data from separate red, green and blue filtered images are combined into a composite RGB image using software such as *MaximDL,* with appropriate weights applied to each channel based upon techniques such as G2V calibration, explained elsewhere in this book. The combined image(s) will represent the starting point for further discussion in this chapter.

The greatest source of artificial light pollution near the horizon is from mercury (Hg) and sodium (Na) lamps, which emit in the red and green ranges of the visible light spectrum. Specifically, Hg emits at two main wavelengths (546 nm and 623 nm, green and red, respectively), and Na emits at 590 nm (green). This is why gradients due to manmade light sources are most prominent in images taken through red and green filters. Figure 1 shows a typical example of this phenomenon in a widefield image of IC1396, which demonstrates a dominant red gradient, an obvious but less intense green gradient, and a substantially less noticeable blue gradient.

It is also important to appreciate differences in the spatial distribution of such widefield gradients as a function of filter, as indicated by the regions outlined in white in Fig. 1. This shift in spatial distribution occurs as the 'telescope changes orientation during the course of an imaging session, in which all of the red exposures were obtained first (for a rising target), followed next by the green exposures

Correction of Light-Pollution Gradients in Widefield Images

Fig. 1 *Evaluation of individual RGB gradients in a widefield image of IC1396 acquired at a light polluted site.* Gradient intensity and distribution vary as a function of filter as well as telescope position during the imaging session. In this example, the gradient intensity is strongest in red light, intermediate in green light, and weakest in blue light, associated with a counterclockwise shift in spatial distribution as the mount tracked throughout the imaging session

and ending with blue exposures. The differences in both gradient intensity and spatial distribution as a function of filter require a processing strategy that treats each channel separately during gradient correction.

One of the most popular programs designed to correct light-pollution gradients is *GradientXTerminator*, although other software packages such as *MaximDL, CCDStack* and *PixInsight* offer effective algorithms as well. However, the use of such programs for correcting the spatially complex light-pollution gradients in a one-step manner can sometimes be unsatisfactory due to inability to completely compensate for differences in gradient intensity and spatial distribution between each channel. Thus, a more effective strategy for gradient correction in widefield images is to isolate each channel, empirically determine the best parameters to apply to each individual channel and then recombine the corrected channels to form the gradient corrected RGB composite.

The first step in using *GradientXTerminator* in *Photoshop* is to define the regions of the individual color channel that should be *excluded* from the process of gradient correction. This is necessary because indiscriminant use of gradient correction can have a destructive effect on faint detail contained within targets and thus should only be applied to background regions. As shown in Fig. 2a, this is best accomplished by first using the Lasso tool to select critical targets that should be excluded from subsequent gradient correction (such as IC1396 in this example). If there are additional targets that should be excluded, such as separate galaxies or nebulae in other parts of the image, these can be selected by pressing the Shift key (on a PC) while using the Lasso tool.

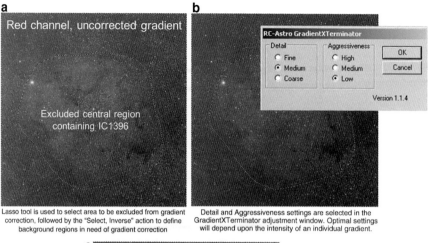
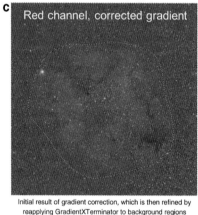

Fig. 2 *Gradient correction of an individual color channel using GradientXTerminator.* Three general steps are involved in gradient correction using GradientXTerminator: (**a**) identify regions most affected by gradients; (**b**) apply a first pass gradient correction to these regions, after setting the strength of gradient correction parameters; (**c**) apply a second pass gradient correction to regions that are identified through the use of the Magic Wand tool. Additional details may be found in the text

Once all targets have been selected, it is then necessary to choose the Select, Inverse action from the menu bar. This action inverts the selection, effectively outlining only the background areas in need of gradient correction and sparing targets that should be excluded from this process (Fig. 2a). *GradientXTerminator* is then chosen from the Filter Menu of *Photoshop* (Filter, RC-Astro, *GradientXTerminator*), revealing an adjustment window that consists of two parameters, detail and aggressiveness (Fig. 2b).

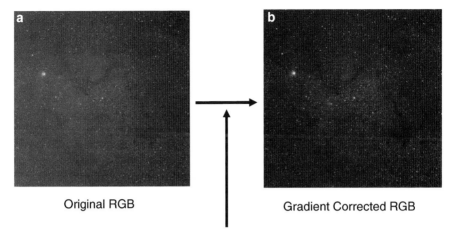

Fig. 3 *Gradient correction of a severely light contaminated widefield image.* (**a**) Shows an RGB image that suffers from severe light pollution gradients. (**b**) Shows effective correction of these gradients by tailoring the aggressiveness of gradient correction to the needs of each channel individually

The goal of initial gradient correction is to normalize large-scale imbalances in the background, without affecting small scale structure that might be desirable to preserve. Choosing a setting of medium for detail, and a setting of low for aggressiveness, is the most conservative approach to accomplishing this goal (Fig. 2b), yielding a partially corrected result can often be quite satisfactory (Fig. 2c). As a final step, it is usually advisable to refine the gradient correction by first using the Magic Wand tool (tolerance of 10–50, contiguous mode) to identify a background region in the image that is devoid of detail. Any targets inadvertently trapped within the regions defined by the Magic Wand tool should be deselected by pressing the Alt key (on a PC) while using the Lasso tool to outline and exclude such regions. This is followed by applying *GradientXTerminator* once again, but with an aggressiveness setting of medium or high, depending upon the severity of the remaining gradient. Additional details regarding the use of *GradientXTerminator* may be found at http://www.rc-astro.com/resources/GradientXTerminator/tutorial.html. The final result of using this procedure is shown in Fig. 3, which demonstrates that it is possible to correct even severe light pollution gradients in widefield images if gradient correction parameters are tailored to the needs of each color channel individually.

The Use of Narrowband Data to Restore Signal in Light-Contaminated Widefield Images

Emission nebulae are popular targets for widefield astrophotography due to their characteristically large field of view. Unfortunately, because the signal from such nebula is often faint and therefore suppressed in light-contaminated exposures, such targets require special considerations during image processing.

A very effective method for improving signal to noise ratio in widefield images of emission nebulae is to add data acquired through the use of narrowband filters. Narrowband filters mitigate the effects of light pollution because they selectively permit passage of the desired narrowband wavelength (656 nm in the case of hydrogen alpha, Ha) while suppressing broadband sky flux from light pollution. Although simple in concept, the methods used to incorporate narrowband data into widefield images taken at light-polluted sites vary in effectiveness and complexity.

Standard Method for Incorporating Ha Data into the RGB Composite of Light-Polluted Widefield Images

The standard approach to incorporating Ha data into an RGB composite is to allow the Ha signal to boost the red-filtered channel (i.e., a new red channel is created, comprised of a mixture of Ha and R), while at the same time using Ha as a luminance layer to enhance image detail. The end result of this process can be represented as Ha:(HaR:G:B), where the first term (Ha) refers to the luminance signal, and the second term (HaR:G:B) refers to the color component (Fig. 4).

In image processing software such as *Photoshop,* the Ha luminance channel would typically be placed as a top layer assigned to luminance mode, usually with a reduced opacity in the 30–50 % range, with the (HaR:G:B) color layer placed underneath. Reducing the opacity of the Ha luminance layer creates a better fit between the Ha data and the underlying color data, in an attempt to avoid a luminance-color mismatch that can result in muted, washed out colors. In order to create the HaR channel in the color component noted above, Ha and R monochrome images are combined in *Photoshop* using layers, with Ha on top, assigned to lighten mode, and R on the bottom assigned to normal mode. The Ha layer is assigned to lighten the mode for this purpose in order to permit underlying star signal from the red channel to be appropriately represented. The opacity of the Ha channel is then adjusted so that it does not dominate the HaR channel and yet still provides enough signal enhancement in the final image.

Variations on this theme include performing an iterative process in which the newly created Ha:(HaR:G:B) construct is used as a more robust color layer, combining it with Ha luminance at progressively increasing opacity (since the more

The Use of Narrowband Data to Restore Signal in Light-Contaminated Widefield Images 139

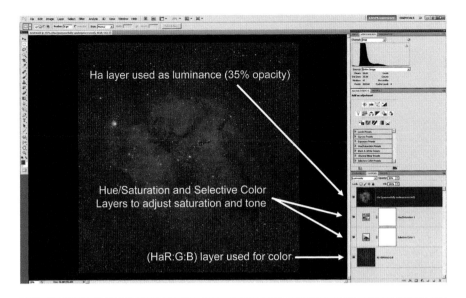

Fig. 4 *Ha:(HaR:G:B) construction in Adobe Photoshop.* Narrowband data are commonly used to enhance signal in light contaminated broadband images of widefield emission nebulae. The use of Ha filtered data to boost the red channel, as well as to provide additional detail to luminance, is conceptually straight-forward but technically challenging, due to the potential for Ha signal to overpower the image

robust color data are now able to support a greater luminance signal). More details regarding the standard approach for combining Ha with RGB data may be found at http://www.robgendlerastropics.com/HARGB.html.

Overcoming Pitfalls in the Standard Method for Combining Ha with RGB Data

There are two main problems that limit the utility of the Ha:(HaR:G:B) approach described above. The first is related to the common temptation of applying an aggressive curves stretch to the Ha image prior to incorporating it into the final Ha:(HaR:G:B) construct. Although curves enhancement of Ha data may create a more pleasing, stand alone Ha image, the use of an aggressive non-linear curves stretch often creates inhomogeneity of intensity throughout the image, resulting in a luminance-color mismatch that cannot be corrected simply by reducing the opacity of the Ha luminance channel (Fig. 5a, b).

In order to avoid this artifact, it is advisable to use a partially processed, muted Ha image that has not been subjected to an aggressive curves stretch but has instead undergone mild ddp processing. Such an Ha image may not appear pleasing as a

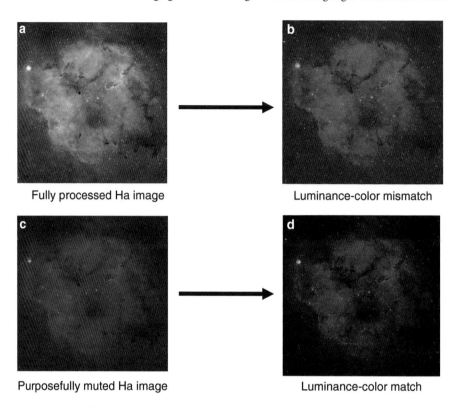

Fig. 5 *Comparison of two approaches to using Ha data as luminance.* The use of a fully processed Ha image for luminance (**a**), including an aggressive curves stretch to enhance detail, results in a washed out final image (**b**) that cannot always be corrected by reducing the opacity of the luminance layer. In contrast, the use of a muted Ha image in which only a mild ddp stretch is applied (**c**), without additional curves stretching, creates deeper color due to a better luminance-color match (**d**)

stand-alone result, but it is well suited to being combined with the red channel to form an HaR composite, and also being used as luminance in the final construction of the image, yielding a richer, more saturated result (Fig. 5c, d).

The second problem with the Ha:(HaR:G:B) technique occurs because enhancing the red channel with Ha signal can sometimes result in a dominant, monochromatic red color to the image (Fig. 5d). This is partly due to failure to account for the presence of H-beta emission, which has a wavelength of 486 nm and would normally contribute a component of blue light to the image, especially within the central portion of star forming nebulae such as the IC1396, IC410, NGC281, and the Rosette Nebula.

Of even greater importance is the presence of OIII emission that is predominantly located in central regions of star forming nebulae, contributing a subtle teal coloration within such targets. Although it is difficult to reconstruct H-beta signal because such narrowband filters do not usually exist for astrophotography use, the use of OIII data can effectively restore spatial and color balance in such images. The technique for integrating OIII signal into the final image will be described in the next section and represents an important strategy for enhancing the central signal in selected emission nebulae acquired from light-polluted sites.

Incorporating OIII into Widefield Images of Emission Nebulae

Unlike Ha emissions, which are typically associated with a strong signal that can easily overpower the composite image if stretched too aggressively (Fig. 5b), the OIII signal in most emission nebulae is relatively weak by comparison. Thus, OIII images typically require long cumulative exposures and aggressive curves stretching before the image can be applied to an RGB composite. As the wavelength of OIII emission is 501 nm, it straddles between the light captured by both green and blue broadband filters and therefore must be added to both G and B channels in order to faithfully render proper color and spatial information. The resultant composite can be represented as Ha:(HaR:OIIIG: OIIIB) and is summarized in Fig. 6.

A representative method for assembling the OIIIB component in *Photoshop* is shown in Fig. 7, in which the blue filtered image is placed on the bottom of the layer stack, the OIII image is added next (in lighten mode) and a curves adjustment layer is added as a clipping mask linked to the OIII image, thereby permitting enhancement of central detail in OIII without affecting the blue layer below it. In this example, OIII was assigned to lighten mode with 50 % opacity, although the opacity as well as the aggressiveness of the curves stretch varies depending upon the degree to which the imager chooses to reveal the OIII signal.

A similar technique is used to incorporate OIII signal into the green channel (not shown). The final result is shown in Fig. 8, in which the addition of OIII data to the widefield image has restored the central signal that would have been otherwise muted by the effect of light pollution. As a final refinement, it is possible to convert the entire Ha:(HaR:OIIIG:OIIIB) construct into a monochrome (black and white) image in *Photoshop,* using it in subsequent iterations as a new luminance channel (instead of using the straight Ha channel). This permits better representation of the OIII component in the luminance channel, thereby avoiding a luminance-color mismatch with the underlying color data.

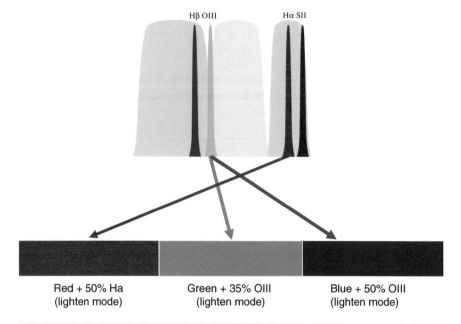

Fig. 6 *Use of narrowband data to enhance color in light contaminated widefield images of emission nebulae.* Figure of visible light spectrum adopted from http://starizona.com/acb/ccd/advimnarrow.aspx

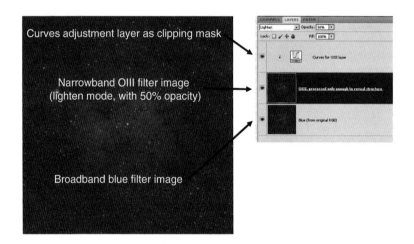

Fig. 7 *Adding OIII data to the blue channel in Adobe Photoshop.* OIII is combined with *blue* at an opacity of 50 % in lighten mode, in order to restore signal in the central portion of the emission nebula. Because OIII emission is typically weaker than that of Hα, special attention must be given to enhancing the OIII signal using a curves layer as a clipping mask (so as to only affect the OIII layer). By adjusting the degree of curves stretch, as well as the opacity of the OIII layer, it is possible to achieve the desired amount of central enhancement in the blue channel. A similar approach is used to restore the OIII component in the green channel (not shown)

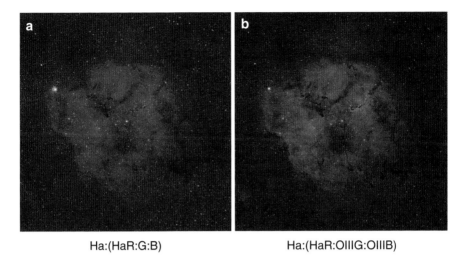

Fig. 8 *OIII data can restore color and spatial information in widefield emission nebulae.* OIII (**a**) shows deep color in IC1396, but the nebula is uniformly red because the inclusion of Ha data in both the luminance and red channels has overwhelmed the relatively weaker blue-green signal from OIII emission. (**b**) shows how proper use of OIII data can restore color and spatial information to emission nebulae such as IC1396, the Rosette Nebula, NGC281, and IC410

Restoring a Faint Peripheral Signal

The most effective widefield images reveal how objects relate to one another and to their environment. In this regard, there are very few targets in astrophotography that have well-demarcated boundaries; most are immersed in a sea of faint nebulosity created by reflective dust particles or by ionized gases emitting narrowband light. Since this surrounding nebulosity is characteristically faint, it is most vulnerable to being suppressed in light contaminated data. This section will discuss a straightforward technique to recover such signal and produce a more realistic and pleasing widefield image.

The first challenge in restoring a faint peripheral signal is to realize when it is missing. Fig. 9a shows an Ha widefield image of IC1396, which at first glance appears to be well processed with good central detail, no histogram clipping and minimal noise. However, careful inspection reveals that the surrounding faint nebulosity is not well represented, partly because it has been suppressed by light pollution but also because the aggressive use of contrast enhancements during image processing has inadvertently suppressed faint signal in the low end of the histogram. The technique to restore a faint signal depends upon the use of the Shadows/Highlight tool in *Photoshop,* which can be adjusted to permit a controlled curves stretch of faint detail without excessive enhancement of midtones and highlights. The Shadows/Highlights tool is typically found in the menu bar of *Photoshop* under Image, Adjustments, Shadows/Highlights (Fig. 9b).

144 Widefield Imaging: Selected Strategies for Processing Light-Contaminated Data

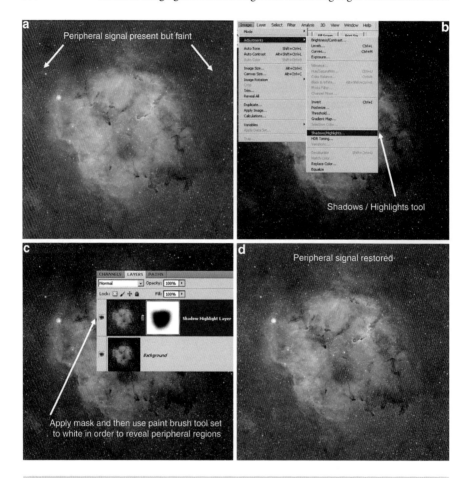

Fig. 9 (**a**) Shows an Hα image of IC1396 with good detail in the nebula itself but subdued faint peripheral signal in the rest of this widefield view. This situation arises partly because faint signal is particularly vulnerable to the effects of light pollution, although it can often be restored with the use of the Shadows/Highlights tool in Photoshop. In (**b**), the layer is duplicated, and the Shadows/Highlight tool is selected. Once selected, the sliders for choosing shadows and highlights values should be set to 10 % and 0 %, respectively, as reasonable starting points for further adjustments. As shown in (**c**), a mask is then created to hide the top (adjusted) layer, and the paint brush tool set to *white* is used to reveal only peripheral areas in need of enhancement. (**d**) Illustrates the final image, which reveals substantially more peripheral detail when compared to the starting image in (**a**)

Although there are a variety of advanced adjustment options that are available in the Shadows/Highlights tool, the use of the basic slider adjustments are sufficient for this technique. As a starting point, the shadows slider should be set to 10 % and highlights to 0 %; these can be further adjusted to the needs of the image, based upon the desired level of peripheral enhancement, while ignoring the effects of this

adjustment on the central target itself. A black mask is then applied to the top layer to hide it, in preparation for revealing only those areas of interest using the paint brush tool (Fig. 9c).

The paint brush tool set to white is applied only to those peripheral areas of the mask that the imager wishes to reveal, setting the feather appropriately to avoid sharp edges to the painted regions. As shown in Fig. 9d, proper application of this technique results in enhancement of only the peripheral areas containing the faint signal, while protecting the central target from artifacts induced by the Shadows/Highlights adjustment. As a final step, the opacity of the top layer may be varied to taste, in order to make fine adjustments in the degree of peripheral enhancement achieved.

Although the use of the Shadows/Highlights tool offers a convenient method for enhancing peripheral detail in widefield images, another approach involves using a highly detailed and aligned Ha image for this purpose. For this method, the Ha image is used as a top layer, set to luminance mode and with an opacity in the range of 5–10 %. A curves adjustment layer is applied as a clipping mask linked to the Ha luminance layer, in order to enhance peripheral detail as desired. The subsequent steps involve creation of a mask, followed by the use of the paint brush tool set to white in order to reveal only the peripheral regions, similar to what is shown in Fig. 9c. Care must be taken to avoid aggressive curves stretching of the Ha layer with this technique, because doing so will introduce a luminance-color mismatch that can result in muted colors in the peripheral regions of the image. By carefully adjusting the degree of curves stretch as well as the opacity, it should be possible to avoid this problem and achieve good enhancement of peripheral detail while preserving underlying color.

Controlling Noise in Light-Contaminated Widefield Data

It is beyond the scope of this chapter to describe noise reduction techniques in detail, since these will be discussed elsewhere in this book. However, a few comments are relevant to the subject of reducing noise in widefield data. Noise is the uncertainty in the true value of a pixel, introduced by a variety of sources, including camera read noise, dark current, insufficient cumulative exposure time and sky glow. Many of these noise sources are under the control of the imager, either through selection of proper subexposure duration (to reduce the effects of read noise), choice of CCD chip cooling parameters (to reduce dark current) and obtaining as many subs as possible to obtain a long cumulative exposure. The one variable that is not directly under the imager's control is sky glow, which introduces noise into the data that makes a faint signal difficult to appreciate. In an attempt to reveal such detail, aggressive curve stretches are typically applied, further compounding the problem because it is difficult to enhance signal without also enhancing noise.

Many software programs such as *Noise Ninja, Neat Image,* and *Photoshop* are capable of reducing noise in digital images. Unfortunately, none of these programs can reliably distinguish noise from a faint signal, and their indiscriminant use to

remove noise, including noise introduced by light contamination, can inadvertently suppress the faint signal that the astrophotographer has worked so hard to capture. In addition, the aggressive use of noise reduction can lead to an oversmoothed, unnatural, waxy look to the image that is especially noticeable in a widefield view. Nonetheless, if noise reduction is deemed to be necessary, the following simple technique using the median filter in *Photoshop* can be effective if used in a targeted manner, especially in regions of widefield images that are not spatially complex, such as dark dust clouds within a nebula.

The most straightforward approach to using the median filter for noise reduction is to duplicate the image layer, assign it to lighten mode, and then apply the median filter directly to this duplicated layer (the median filter may be found in the menu bar of *Photoshop,* under Filter, Noise, Median). Although some experimentation is necessary, it is best to start with a median radius setting in the range of 1–2, because stronger radius values can create artifacts that compromise image quality. Both the median filter radius as well as the opacity of this layer can be adjusted to maximize the degree of noise reduction while at the same time preserve underlying detail and avoid an artificial, smoothed appearance. As a final step, this layer is hidden with a black mask, and the paint brush tool set to white is used as previously described, in order to reveal only those areas of the image that are in need of noise reduction, thereby sparing the entire image from the global effects of the median filter. Although this technique is not mutually exclusive to the others mentioned elsewhere in this book, it represents an effective method for noise reduction because it is relatively sparing of faint detail and avoids overly aggressive smoothing that can compromise an otherwise pleasing widefield image.

Summary

A good understanding of the ways that light pollution affects image quality is essential to selecting the most appropriate processing techniques to use for widefield images. Light pollution can create substantial gradients in widefield images that differ in both intensity and spatial distribution between color channels. This problem is best addressed by performing customized correction of the light pollution gradient in each channel using a program such as *GradientXTerminator.* Attempting to simultaneously correct gradients in the original RGB image as a one-step process, as opposed to sequential correction of each individual channel, is not as effective and can lead to frustrating residual gradients that become obvious during subsequent processing.

Once gradients are corrected, the suppressive effects of light pollution on the signal-to-noise ratio can be overcome by integrating high quality narrowband Ha and OIII data into the final image. Although this strategy is only useful for boosting the signal-to-noise ratio of emission nebulae, such objects are popular targets for the widefield imager due to their large size.

Summary

There are a variety of techniques for integrating narrowband data into broadband color data, although the most successful recognize the need to preserve the spatial distribution of OIII signal in the central portions of star-forming nebulae. Thus, it is often not sufficient to simply use Ha to boost the red channel and to serve as luminance. In order to achieve the maximum effect, it is necessary to use an approach that systematically integrates the OIII signal into green and blue broadband channels. As a last step in minimizing the effects of light pollution on widefield images, it is valuable to recover faint peripheral signal through the use of tools such as the Shadows/Highlights adjustment in *Photoshop*. Finally, specialized methods for noise reduction, such as use of the median filter, must be applied sparingly and in a targeted manner to only those areas that have the greatest need. Learning how to integrate these techniques into the image processing workflow will minimize the effects of light pollution and should allow the imager to achieve the full visual impact of the widefield format.

Noise Reduction Techniques

Tony Hallas

Camera Raw

There are two distinct kinds of noise – structural and color. Each requires a specific method of attack to minimize. The great challenge is to reduce the noise without reducing the faint and delicate detail in the image. My most-used and favorite noise suppression is found in *Photoshop CS 5* Camera Raw. If I cannot get the desired results with the first choice, I will use *Noise Ninja*, which has certain advantages in some situations that we will cover.

Assuming that you have a completed 16-bit TIFF file and wish to reduce the noise via camera raw, the first step is to convert this file to Camera Raw. With the file closed, choose "open as" instead of "open," and pick "Camera Raw." When you open your TIFF file it will be converted to camera raw. Note that anything that you do in Camera Raw is 100 % non-destructive; in other words, if you don't like what you have you can cancel out without degradation of the image. Simply reopen the file as a TIFF again.

Once you are in Camera Raw you will notice lots of great adjustments and retouch tools. We are specifically interested in the sharpening and noise suppression tools. In camera raw click on the third icon at the top of the menu bar to open this dialogue box. Note that I normally will include a weak sharpening to any file that I noise suppress.

Camera raw noise suppression has three major components – the attack, the fine tune, and a contrast adjustment.

The Attack

This is the top luminance slider. Moving the slider to the right increases the noise suppression across the image. It is important to enlarge your image to 100 % to get a good look at what is going on. Make sure you have "preview" checked "on."

Fine Tune

Start this slider at a value of 50. This slider controls the depth of the attack and can be used to limit the noise suppression to just the most coarse noise. If you want more attack, REDUCE this number, less attack, INCREASE this number. Think of this as a "relaxation algorithm" that limits the severity of the attack. For example, if you have small background galaxies and the noise suppression is attacking them, increase this setting to restrict the aggressiveness of the noise suppression.

Contrast

Noise suppression can reduce the contrast of an image by dulling the most coarse (and black) pixels. You can increase the contrast to return to the original contrast with this tool.

Below the luminance sliders are the color sliders. Color noise suppression looks for extreme color contrast values and attempts to reduce them. Most color noise appears as "aberrant" color pixels, which this algorithm seeks out and attempts to blend with the surrounding colors. The sliders work much the same way. Color noise suppression increases as the slider is moved to the right, and color detail seeks to refine the selection process. Since contrast is an element of the luminance, you won't find this slider included in the color. Try applying this color noise suppression to your RGB before combining as an LRGB. When used on a completed image, camera raw is basically separating out the luminance from the RGB.

Once you have applied the noise suppression to your image, and perhaps made use of some of the other refinement tools, it's time to bring the image back as a 16-bit TIFF file. Besides revealing how to do this, there are some presets you should know about.

Look at the top of the Camera Raw menu bar. Just next to the rotational controls you will see three dots and lines. This is the preferences icon. Click on it. Leave all the items in the "default" state and look at the bottom where it asks "JPEG and TIFF handling." They should say "disable TIFF and JPEG support." If you click any of the "automatically open" choices, every time you click on a TIFF or JPEG in *Photoshop* it will open in Camera Raw! This can be great if you have a project that necessitates it, but sometimes Camera Raw gets into this preference, and it can

Camera Raw

Camera Raw Sharpen and Noise Reduction Filters

Best results come from a slight sharpening combined with careful noise reduction settings. Start with the luminance to set the strength, then adjust the detail to fine tune the attack. Follow with a modest contrast increase to maintain contrast and finally adjust the color noise suppression.

Fig. 1 Camera raw

drive you crazy trying to undo it. This is where you control it. For our purposes, better to leave this turned off and only access Camera Raw via the "open as" command.

Exit preferences. Now look below your image. There should be a blue information line. Click on it and it will open "workflow options". All the choices are self explanatory. This is where you set up how the final image will be saved. Color space, bit depth, size, and resolution are prescribed right here. When you have set them, click "OK."

Finally, on the bottom left, is the "save image" icon. Click on that and it opens the dialog box. You can choose where to save the image, the file name of the image, and the format of the image (TIFF, JPEG, PSD, etc.). Save it as a TIFF to your desktop and return to *Photoshop*, where you can now open it as a TIFF file again.

If you are working with separate luminance and RGB files and find that after this process the stars do not align perfectly, I would recommend a quick trip to *RegiStar* to realign. It does a fantastic job with TIFF files.

As a footnote, even though Camera Raw is non-destructive, I always save my data post camera raw with a new name that has "CR" in it to let me know that these are the files that went through the process. This way I can blink the before and after to compare and decide if I achieved my goals (Fig. 1).

Noise Ninja

I use the "plug-in" version of *Noise Ninja* so that I can use some of the *Photoshop* controls with it, as opposed to the "stand alone" version. Open *Noise Ninja* and click "profile image." *Noise Ninja* will automatically seek out "empty" portions of your image where it can sample the noise. Note that unlike Camera Raw, *Noise Ninja* needs to actively sample the noise.

You can add to the selection by clicking on the icon at the bottom that resembles a bar graph. Use your mouse to move the cursor to the desired area you want *Noise Ninja* to sample and, holding down the left mouse button, draw a rectangle around the area. *Noise Ninja* will now add this to the noise sample profile. You can repeat this process until you are sure *Noise Ninja* has a large sampling of your noise. I typically go after the empty background areas in the "shadows" where the noise is the worst, but also hit some smooth highlight areas so *Noise Ninja* knows the level of noise in the highlights.

Next, click on "filter". As in Camera Raw, you can adjust the amount of attack and the depth of attack. *Noise Ninja* also tries to resharpen the blur effect of noise suppression with some unsharp masking. Default settings of "10" are usually too strong. Click the blue arrow under the three magnifying glasses to see an instant before and after. The settings for the filter are as follows: Luminance Strength is how much attack you want applied. This is essentially the strength of application of everything else that you have set as parameters. Smoothness is a misleading term. It is actually similar to the Camera Raw control that fine tunes the application of the noise suppression. This is where you can direct the suppression to only the coarse noise and leave the faint detail like background galaxies alone. Toggle the "blue arrow" while adjusting this parameter to set the aggressiveness of the noise reduction. Contrast and Unsharp Masking are pretty much self-explanatory. They attempt to build back the appearance of "sharpness" after noise suppression has been effected. You can adjust these parameters to suit. Color is basically the same as the luminance except as in Camera Raw, it is looking for extreme color jumps.

Finally, there are some tools in *Noise Ninja* that allow you to modify the final result in the form of a "paintbrush." If *Noise Ninja* blurred already smooth areas, you can negate the application of the software by painting with the paintbrush in the affected area.

Using the plug-in version, once you accept the results, you are right back in *Photoshop*. This allows you to use the "fade" tool to reduce the overall action, or saving the *Noise Ninja* version with "NN" in the name, open the original file and using layers and masks apply *Noise Ninja* only exactly where you want it. You can also control the strength by percentage of opacity this way.

Noise Ninja is also sensitive to a selection when used in the plug-in mode, allowing the user to predefine where the noise suppression should take place.

Since I always use *Noise Ninja* as a layer with a mask on top of the original file, I tend to apply a very strong noise suppression to make sure the deepest shadows come clean. Then I limit the noise suppression as it advances into the not-so-noisy areas such as the brighter parts of the image, where it is apt to blur delicate detail (Fig. 2).

Fig. 2 Noise Ninja

Tony's Green Pixel Gun

Years ago, in the interim period between pure film and CCD cameras, we used to scan film and digitize it. This allowed significant opportunities to increase signal-to-noise as these scanned negatives could now be averaged together. Even so, color film was notorious for noise, especially green pixels! I developed a method in *Photoshop* to address this problem, and when I shared the technique with my Mount Pinos "Rat Packers" one of them gave it the name "Tony's Green Pixel Gun," TGPG for short.

There are two basic steps, selection of the offending pixels and neutralization. The primary tool for TGPG is select>color range. This function of *Photoshop* will allow you to pick individual pixels and set the degree of "inclusiveness." Let's approach this extremely powerful noise suppression technique step by step.

1. Open your image. Click on the eyedropper tool in the tools palette and make sure that it is in the "point sample" mode! If you pick the average of several pixels this isn't going to work because you are no longer "pixel specific."
2. For a PC, hold down the control+spacebar keys to get the enlargement tool, and holding down the left mouse button, draw a small square in the area of bad pixels. You should now see individual pixels. If you do not, repeat this process until the pixels are large enough for you to click on individual ones.

3. Go to select>color range and set the fuzziness to 30–40. Go to a green pixel and left-click the eyedropper on it.
4. Next, in the color range palette, click on the "+" eyedropper. From now on, any further selections will be added to the library of green pixels that you will be building.
5. Go through the pixels and pick any that look "green" including dark green, light green, gray green, yellow green, etc. This technique assumes that you are not color blind!
6. As you make these selections, keep your eye on the "selection image" in the color range palette. Make sure you have chosen "selection" as the viewing mode. Be aware that as you click happily away, if the image suddenly "lights up" you have hit a common color pixel by mistake. Immediately hit control>Z to undo your selection. The selection image will return to your green pixels. Note that you can only do this for a single mistake at a time. Hitting control>Z twice will not take you back two clicks.
7. Once you have built up your "green pixel library," press OK and you will see "marching ants" surrounding all those nasty green pixels. You have isolated them from the rest of your image, and it's now time to neutralize them.
8. Press control>H to hide the marching ants and open curves. Select the green curve and pull down on the middle of the curve (to decrease the green in the pixels and add magenta) until the pixels blend with the surrounding colors. If the pixels get too dark simply go back to RGB after the green reduction and pull up on the curve slightly.
9. When you think you have neutralized the green pixels, press control>0 (zero) to see the whole image. Press control>Z several times to toggle a "before and after" comparison. If there is still a slightly green caste, repeat the curves until you see a nice blend of colors.
10. When you are happy with your result and those nasty green pixels have been zapped by TGPG, press control>D to deselect and save this new file with TGPG in the name so you know what you did. A few added notes: you can save that selection in case you want to go back and work on those pixels some more, and most important, this technique works on any color. This should be a big "aha" moment for you as you now have a tool to control virtually any color in your image via specific pixel selection!

In my opinion this method of dealing with color gradients is superior to any automated process because most automated processes sweep up "innocent" pixels and convert them. If, for example, you have a green gradient, the TGPG technique will select only the green pixels, not throw a magenta blanket over all the pixels in the area. You can also use the TGPG technique at whatever strength you need by changing the strength of the "fuzziness." TGPG is one of the most powerful techniques to achieve truly smooth color (Fig. 3).

a *Selecting a library of Green Pixels*

In this example we see the eyedropper in POINT SOURCE mode being used to select a variety of green pixels with the eyedropper in the " + " accumulate mode. Fuzziness is set to 40 to encompass a large sample.

b *Green Pixels Selected*

This freeze frame shows the green pixels selected after accumulating a "library of green pixels" using the select > color range tool.

Fig. 3 (a–c) Green pixel library

c ***Tony's Green Pixel Gun Technique***

In this example note how only the green pixels have been modified following a targeted selection and modification process.

Fig. 3 (continued)

Philosophy of Noise Reduction

We find noise objectionable because in real life our vision sees things in a "smooth" texture. If we looked at the Moon and it was permeated with a myriad of colored dots we would no doubt run for our eye doctor. In other words noise is not a part of a normal image, unless it's an astronomical image. Then we have noise creeping into the deep shadows where we have inadequate signal. Note that in most astronomical images, the bright parts are relatively free of noise. It's in the mid-tones and especially the shadows that noise becomes a problem.

Where does the noise come from? It is primarily the result of stretching data to the "noise floor," which is the asymptotic boundary where all the electronic residue of our imaging and processing steps resides. You can reduce noise by building S/N through cumulative exposure, but typically there will be some stubborn residual noise in low S/N areas that requires removal with some sort of noise filtration. I have given you three ways to filter noise. How you apply the filters is important.

Here is my favorite method to apply them. Take your image that has the noise and apply the filter of your choice to it until the noise in the deep shadows has been reduced. Most likely this strength of filter will soften the detail in the brighter parts of your image.

It's extremely difficult to set the strength and attack of the filter to affect only the deep shadows and not affect other parts of the image. Save the filtered image with a different name than the original image. If you are filtering M45 for example, save the filtered image as "M45 NR" for "noise reduction." Open both the original and the filtered images and put the noise-reduced image on top as a layer. In layer masks, add a mask in the "reveal all" mode. Now remember that the brighter parts of M45 will not have much noise, so we would like to block the effect of the noise filter in these areas. Set the default color to black, select the paint brush tool, make sure the mask has been highlighted (it has a white frame around it in the layers palette), set the strength of the brush to 50 %, and start painting on the image where you want the noise filtration reduced. Go over this area several times to achieve a smooth application of "paint." Now click the "eyeball" on and off of the filter layer to see your progress. You want to paint as far towards the shadows as need be to prevent excessive filtration.

In the end you should have shadows heavily filtered and highlights without any filtration. Once you are happy with the results, flatten your image. One final note, noise can create a natural "texture" to an image. If you make an image appear too smooth it won't look real and will actually lose some of its definition. There is a fine line between acceptable noise and an image without definition. So do keep a little of your noise. This "texture" can be a component of the image you want to keep (Fig. 4).

I hope these techniques will help you deal with noise.

Clear skies!

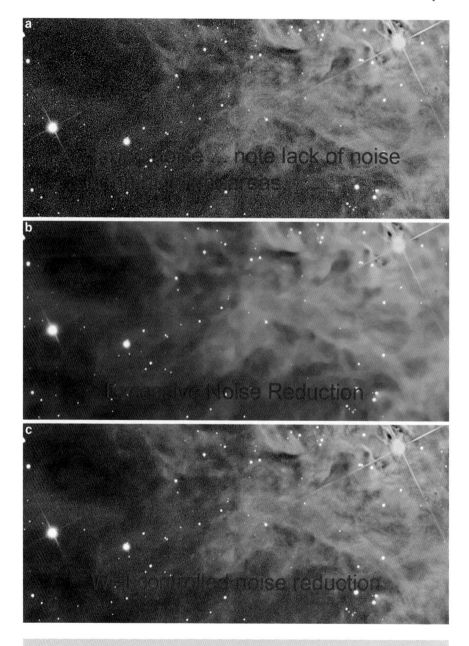

Fig. 4 (a–c) Noise reduction

Deep Sky Imaging: Workflow 1

Adam Block

Astronomical image processing is as much an art as a science. Today's contemporary science is a quantum theory in which the graininess of reality is characterized not by certainty but instead by probabilities and possibilities. The quantum of an image is a pixel that has traits of brightness and color (instead of spin, mass, and charge). Thus how a pixel is expressed in final form depends exquisitely on the thoughtful choices the image processor makes. It is akin to the "collapse" of an image wave function; out of the myriad of possibilities a pixel, and the collective total of pixels, settles into one definite state and renders the final completed image.

Location	Mount Lemmon, AZ USA
Optics	0.8 m Schulman telescope
Camera	SBIG STX 16803 (ABG)
Filters	AstroDon 65 mm LRGB
Software	*CCDStack, Maxim DL, Pixinsight, Photoshop*

However, the evolution of a pixel, and how it interacts with its neighbors, is fraught with challenges. Attaining aesthetically pleasing color saturation, contrast and overall appeal is difficult due to the interconnectedness of pixel traits. Simply brighten an image and the color saturation changes. The Workflow I shown here follows a very particular tack that emphasizes incremental processing. By making small adjustments I avoid permanently etching the image with artifacts for which, at a later point in time, there is no salve. It takes patience to make changes that are small improvements but still do not display the result I see in my mind's eye. The avoidance of making it "look good" early in the manipulation of pixels allows

the cumulative effect of small changes to bring out all of the attractive elements the scene contains.

Consequently I must have specific goals in mind when beginning to process the data. I evaluate the incremental adjustments as being beneficial by considering whether each adjustment is heading towards these goals. Different kinds of objects may have different kinds of attributes which I strive to display. For example a globular star cluster with its 100,000 or more stars scintillates on the screen when stars are colored vibrantly from the center to its outermost reaches. In addition the overlap of stars in the center requires careful contrast management to maintain the resolution of its constituents. Since these objects are generally devoid of tenuous wisps of gas they can be brightened aggressively while at the same time increasing the contrast dramatically by raising the black level. On the other hand a typical planetary nebula (PNe) has different attributes that would not fare well by using the processing choices indicated above. Instead a PNe typically has a central star surrounded by an envelope of gas and perhaps by an even fainter halo beyond. Maintaining a small stellar profile of the central star, applying liberal effects to color the nebulosity and smoothing the image after successive methods of brightening it (which usually show the effects of noise) are the types of considerations specific to this kind of object.

Identifying the salient details of an object and monitoring each element throughout the creation of the image is critical to successfully taking full advantage of the hard won data. Other stylistic choices also factor into these steps and are monitored from the beginning to end. For example one element of an "Adam Block" image is the adherence to maintaining certain "truths" of the captured targets. Galaxies are generally brighter in their centers than their outer arms. Clouds of dust in the foreground of many nebulae are not opaque; instead there is variation in the amount of light that filters through them. The normalizing color ratio derived from G2V star measurements remains the same from image to image.

These choices inevitably inform and create a style and "look" to the astronomical images I produce. The resulting palette of color and brightness profiles for objects yield results that I feel are "natural." If you can tell what I did to achieve a particular effect then I feel I did not do it very well. Of course what follows are the behind the scenes steps taken to produce a high-quality image. There is a risk to laying it all out in a book. It is something like the deductions Sherlock Holmes made. His remarkable conclusions seemed less so when he revealed each simple observation he made before coming to a seemingly astounding insight. In the same way I hope you will appreciate not only the small steps of the process but also the entire workflow and the powerful pictures that result.

At the time this chapter was written my core image processing took place using *CCDStack* (by CCDWare) and *Photoshop CS5* (by Adobe). Other programs are often used in addition to these (*PixInsight* will feature briefly here also), but 95 % of the work I do to produce an image comes from these two programs. And so the story begins with creating master calibration images.

Master Biases, Darks and Flats

Images are only as good as the calibration files that are used. The "imprint" of poorly calibrated data wreaks irrevocable havoc on astronomical images. Each time a picture is taken, be it for calibration or observation, it is a single measurement. Furthermore each measurement can be associated with a single pixel. If ten images are taken every pixel has ten measurements and ten values. The more measurements taken the more certainty one can place in the average of pixel values. However, given enough measurements it is possible to ignore values that are likely "outliers" and not expected due to instrumental or transient events. All calibration data are taken at the proper binning state of the CCD.

Bias frames are by far the easiest to take. Since they are zero second exposures that simply characterize the state of the electronics, the time required to generate them depends only on the download time from camera to computer. In a handful of minutes you can usually acquire 50 or more measurements. Bias frames are used for two purposes. First they are subtracted from flat field images (to be generated in a moment). Secondly they are also used to scale darks to subtract from observation data. CCD camera electronics can sometimes exhibit a bias drift. Thus I refresh biases more often if I suspect this is an issue.

Dark frames are a little more difficult to generate because of the time involved. They must be taken at the same temperature to properly characterize the electronics of the CCD. I usually operate at two different temperatures throughout the year. So there is a warm operating temperature of $-25\ °C$ and a cold seasonal temperature of $-35\ °C$. Each time "seasons" change new master darks are created which last 4–6 months. I acquire 40–50 dark frames that are 1,800 s each and take them on cloudy nights when it is dark.

Images are combined creating master bias and master dark frames using the Minimum and Maximum value clipping method (min/max). Instead of taking the average of 50 pixel values, a small set of the highest and lowest values are discarded. The resulting average is a much better representation of the instrumental performance. Cosmic rays (especially in the 1,800 s dark exposures) are an undesirable source of noise.

In astronomy transient events, such as cosmic rays, tend to add to the signal rather than subtract from it. Thus an asymmetric clipping technique can be employed. For a set of 50 measurements, I clip bias frames (2,3) (Fig. 1). This means the two lowest values and the three highest values are ignored and the remaining 45 values are averaged to create the master frame. Remember this is done on a per pixel basis such that ignored or rejected values do not all come from the same image. The asymmetry (max of 3) here is useful since cosmic rays can show up during the download of a bias. Likewise for the darks I choose (2,4). I am a little more aggressive since there are more cosmic rays hitting the chip in 1,800 s. A cosmic ray and a subsequent one may hit the same pixel (in different images), and the exclusion of the other two high values takes care of the normal random variations. The average of the remaining values leads to a high quality master dark frame that characterizes the dark current

Fig. 1 Min/Max clipping in *CCDStack*

extremely well. A master dark created in this way can be used for many months. However, it will not characterize the hot pixel population of the chip so they will not subtract from newer data. Hot pixels should not be used to evaluate the quality of a dark frame (as is often done), and they will be rejected later, so long as the data is acquired by dithering the signal on the chip.

Finally flat field masters are created by subtracting the bias frame from each image and then averaging the values. This is automated in *CCDStack* (it asks you for a bias/dark to subtract from the flats). I generate flat field images by using an electroluminescent panel instead of twilight flats. This means there are no stars in my images, and the light level is constant and uniform. The justification for taking a simple average is that the signal from the source (panel, sky, etc.) completely overwhelms and is much greater than the signal that comes from other sources of noise. For any change in the optical system including filter, position angle, mechanical adjustment and focus position I take new flat field images and organize them by date. This allows flats to be matched temporally since the observations also have the date in the file name (or FITs header) by convention.

Fundamental Processing

Now that the calibration data are ready to be used the data processing can begin in earnest. *CCDStack* uses a relatively new tool called the job processor. A list of tasks is defined and programmed, and once completed, the script can be run. Another nicety of this task list is that it is trivial to share (and demonstrate to others) *exactly* what steps are performed, in what order and with what parameters. First, here are the fundamental steps as a human would read them:

1. Calibrate Images
2. Examine Images
3. Apply Hot/Cold Pixel Filter

Fundamental Processing

Fig. 2 Script for luminance data

4. Debloom Data (if necessary)
5. Register Images
6. Normalize Images
7. Apply Statistical Data Rejection
8. Combine Images Using Mean (Average)

That is it! This simple list of tasks is the kind of work that computers are very good at completing. The spiral galaxy NGC 5033 makes a fine example of data I captured to process and demonstrate a workflow. I used the 0.8 m Schulman Telescope and an STX 16803 CCD camera atop Mount Lemmon to acquire this data. Figure 2 shows the job script that will perform the steps in the list above for luminance data (the grayscale/unfiltered component of the image). Unlike the human readable version above, some of these steps are broader tools that have multiple functions and require the determination of additional parameters. Ignore the column called "Settings." This refers to the number of internal settings *CCDStack* requires to complete a task, not the number of things you need to input.

The workflow that follows highlights steps that make differences in the outcomes of images. Unfortunately due to the limitations of space all steps cannot be demonstrated, which would show how to use the software. When the arrow-shaped play button is pressed the execution of the script begins with Step 1 and opens the selected files. The data I have acquired is located in a single directory on my computer.

There are a number of different methods for selecting files to open, but in this case I take advantage of my file-naming convention and program it to open all files

that have the word "clear" in them. During Step 2 you will note the "pause" option is checked. In *CCDStack* images are opened directly into RAM memory and as such is a dynamic resource that you can add or subtract images from in real time. In this case before the data is calibrated I will look at all of the individual images and throw out ones that are obviously poor due to the seeing, clouds, twilight, bad tracking and a host of other issues. The set of images that remains is then calibrated using the master biases, darks and flats created earlier. *CCDStack* matches calibration data with observation images in such a way that the user need only point the program to the location of the calibration files.

Steps 3 and 4 are the application of the hot pixel filter. Step 3 identifies the hot pixels in the image and the Step 4 interpolates by substituting a new (better) value based on the values of the neighboring pixels. Using the 0.8 m Schulman Telescope (focal length of 5,600 mm) the images are significantly oversampled. It is not recommended to apply this step on undersampled data where stars are pixel-like in size. This is why dithering the acquired data is so important, as will be shown, since the statistical rejection methods are the primary way hot pixels are addressed.

The STX 16803 CCD is an anti-blooming chip so there are no blooms to remove. The next step (Step 5) is to register the images. *CCDStack* has a robust plug-in that aligns images based on stars, which permits putting it into this automated processing routine. The main consideration is the resample algorithm that is to be used. This choice makes a significant difference in the result. After the computation of how to align the images is completed, the resample algorithm "warps" the image and creates new pixels by mapping them in such a way they match a reference image. However for large numbers of images a better solution can be to use the Nearest Neighbor (NN) method (Fig. 3).

This method only shifts images to the nearest pixel and does not generate new pixels by interpolation. The interpolation of data fundamentally blurs the resampled images, such as when the more common Bi-Cubic method is used. Instead NN can be used when there exists a large number of images that have the same scaling and rotational attributes. I have found the best results with 20 or more pictures. The reason NN is so useful is that it does not blur hot pixels, cosmic rays, satellite trails or any other pixel-like artifact since no interpolation is taking place. Consequently when rejection of these pixels takes place later, their values are rejected entirely rather than having some of the information deposited in neighboring pixels, leaving the artifact faintly visible. The typical alignment that NN achieves can have 0.5 pixel errors. This can be better than the blur imposed by the Bi-Cubic method and with large numbers of images the errors average out, resulting in little loss of overall resolution in the combined image.

Step 6 once again pauses the automatic execution of the script. Some elements of processing require a brain to make a decision rather than a computer, which does not "understand" the intent of the task. Here the manual normalization of images requires the user to select the background representing sky values and a "highlight" area for the object signal values (Fig. 4a, b). Normalization of images is a mandatory, prerequisite step to moving on to statistical data rejection. In order to reject pixels (values) images need to be compared by having the same background levels

Fundamental Processing 165

Fig. 3 Nearest neighbor resample method

Fig. 4 (a) Normalization, select background area. (b) Normalization, select signal area

Fig. 4 (continued)

and the same signal levels. The user draws rectangles on an image to sample the same areas in each image in the stack.

Once the computation is complete, not only are the images normalized but the inverse of the scaling factor necessary to equalize the signal values yields the weight (Fig. 5) assigned to each image! When *CCDStack* combines images, it computes the weighted mean. Poorer data contribute less to the overall result. Images with low weights can be removed from the stack at this point if desired as well. Typically a weight of 0.5 or less is removed from the stack (0.75 is a much more conservative value). This is another part of the processing workflow that significantly improves the stacking of images. Data that might normally be thrown away because it is slightly lower quality can remain in the stack with the assurance it will only go towards the result for as much as it is worth.

The final step before combining the images is to reject outlying values that come in the form of cosmic rays, hot pixels, satellite trails and even asteroids. The NGC 5033 luminance data set contained 56 images. Each pixel then has 56 values, which can be analyzed statistically. Since this is a large number (less than 15 is small) of measurements the Standard Deviation (sigma) rejection method can be used to great effect (Fig. 6). As shown in figure 6, 2.2 standard deviations from the computed mean is the threshold for rejection. If the value is "farther" than this from the mean it will not be used to compute a new mean from the remaining values. At most two values will be rejected with an iteration limit of 2. Thus 54 values will be used to compute the final weighted mean.

Fundamental Processing

Fig. 5 Weights assigned to images in the right-hand column

The reason that 2.2 is special is because it tends to reject between 1 % and 2 % of outliers in a set of measurements. *CCDStack* graphically shows the rejected values as pixels highlighted red (not shown). Visually the user can see that this tends to be the minimum level of rejection that still finds cosmic rays and the other offenders listed above. However during the execution of the script this task is performed without pause and immediately concludes with the output of the mean values, which forms the final combined image. Figure 7 shows a small portion of the field. Note the smooth result with little pixel to pixel variation due to potential noise sources.

The red, green and blue data (RGB) are processed in a similar way. What follows highlights the differences and the reasons for them. The RGB data set is usually

Fig. 6 Standard deviation sigma rejection method

Fig. 7 Combined luminance image

Fundamental Processing 169

Step	Action	Settings	Pause	Notes
1	File OpenSelected	45 Settings	☐	Open Red Files
2	Process Calibrate Calibrate	46 Settings	☑	
3	Process DataReject	45 Settings	☐	hot pixel
4	Process DataReject	45 Settings	☐	hot pixel
5	Stack Register	7 Settings	☐	Bi-cubic
6	Stack Normalize Control Both	0 Settings	☑	Manual operation only
7	Stack DataReject	11 Settings	☐	Poisson
8	Stack Combine Mean	0 Settings	☐	combined Red
9	ImageManager RenameImages	1 Settings	☐	renames image
10	File SaveData Included	3 Settings	☐	saves images
11	ImageManager Remove Included	0 Settings	☐	comb Red remains
12	File OpenSelected	45 Settings	☐	Open Green Files
13	Process Calibrate Calibrate	46 Settings	☑	
⋮				
33	File OpenSelected	45 Settings	☐	Opens Luminance
34	Stack Register	43 Settings	☐	Bi-cubic, Lum is ref
35	ImageManager Remove This	0 Settings	☐	removes Lum
36	File SaveData All	3 Settings	☐	saves R, G, B
37	Color Create	8 Settings	☐	creates RGB

Fig. 8 RGB task list

comprised of fewer images taken in the binned 2×2 format. It is an overgeneralization to assume that all color data is acquired in this binned format. However for dim galaxies and nebulae binning the detector can yield significant time savings by lowering the read noise and making the camera act as if it is more sensitive. The binned RGB data is critically sampled (as opposed to the luminance data, which is oversampled) when using the STX and the Schulman telescope.

Figure 8 shows a portion of the script that is run for the RGB data set. The same steps are performed for each color channel and a few extra tasks are added at the end in order to prepare for manipulating the images in *Photoshop*. Only the steps for RED are shown. One nice benefit to the automation of these steps is that as each final red, green, and blue combined image is made, they remain in memory to create the RGB TIFF image, which will be imported into *Photoshop*.

The opening of the files and calibration steps are identical to the luminance script. It is when it comes to the registration that the first variation is found in the process. This time images will be resampled using the "Bicubic B-spline" method. I rarely have more than 15 images in each color (generally less than 10). Thus the Nearest Neighbor (NN) choice is not a good one. Using NN with too few images can lead to blocky edges of stars. It is difficult to perceive in grayscale images; however, when combining three color channels, the errors of NN show up dramatically as

multi-colored halos of stars. In addition by using the Bicubic method the importance of the hot pixel filter is greater in these steps than it was in the luminance set of steps because these pixels are smeared during the resampling and may not otherwise be rejected. If the hot pixels are not removed the result is a faint confetti of color in the background that is undesirable.

The other variation in the procedure is the method for identifying outlier values. Cosmic rays, satellite trails and hot pixels still need to be removed from color data. Unfortunately small-number statistics is in play, and the Standard Deviation (sigma) rejection method is less effective. Instead, the Poisson rejection method is employed. Once again 2.2 is used as a sigma multiplier and is effective in removing values associated with the noise marauders listed above. Interestingly the reference frame the Poisson method uses as a "gold standard" for its computation will have *more* rejection than the other images. This is because all of the other images are smoothed due to the Bicubic resampling whereas the reference frame is pixilated and looks noisier by comparison. The effect is small and accepted as part of this automated processing.

The last automated steps (beginning with #33 in Fig. 8) open the luminance image and automatically resize the final RGB data to match the dimensions of the luminance image. These four files are registered, using the Bicubic method, with the luminance image as the reference. Finally the luminance file is closed (unchanged), and the three color images are blended to form a single RGB color image that is saved as a 16-bit TIFF file to be imported into *Photoshop*. The normalizing coefficients for the white balance were achieved through the measure of a G2V sun-like star, and these values are fixed for all images I produce. (N.B. The RGB TIFF image is not scaled or stretched. When opened in *Photoshop*, it will initially appear dark.)

We now have a single combined luminance image and an RGB image. Before any other processing takes place gradients caused by flat field errors or sky glows are removed while the images are still in their "linear" (unstretched and not modified by DDP) form. A good tool for performing this particular task is found in *PixInsight*. Figure 9 shows the screen capture of *PixInsight's* dynamic background modeling tool. It allows the user to create an array of sample areas covering the picture; this array measures the background values. The images that result have less variation in sky color and brightness, which leads to greater contrast for the objects of interest in the digital image.

Preparation for *Photoshop*

Everything accomplished so far is considered standard processing. Now each subsequent step takes us more and more into the realm of art. The choices now made decide the look and feel of the resulting image. For me each image presents a story that is told in the interplay of brightness, contrast and color. Whether it is the inner tumult of a burgeoning nebula or the faint delicate star streams surrounding a majestic

Preparation for *Photoshop*

Fig. 9 *PixInsight* dynamic background modeling (with resulting correction model)

galaxy, the goal-oriented approach of cherishing these attributes in the final rendering is what elevates astrophotography beyond simply a picture of space.

It is safe to say that our eyes and brains are sensitively tuned to seek out detail in the things we look at. The sharpening of an image through deconvolution is usually the next step in the processing workflow and caters to this desire. Deconvolution requires a little bit of forethought, especially with regards to the goals mentioned above. Not all objects need to be sharpened and if overdone the resulting artifacts taint even the most pristine data. With this in mind there are three basic elements of a luminance image affected by the sharpening process. First, the dimmest features of the image will suffer the greatest usually by "curdling" the background. Second, the parts of the object that have significant signal will fare better, and it is this element that needs close monitoring while sharpening. Lastly anything that is overexposed, such as the bright stars, will show remarkably ugly artifacts such as "ringing," which creates dark circular halos.

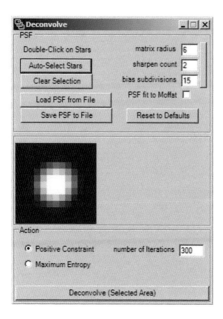

Fig. 10 Deconvolution Dialog in CCDStack

There is no one set of parameters that can be suggested for deconvolution since the result depends sensitively on the data itself. However, Fig. 10 shows the settings used on the NGC 5033 data set, which are typical values. The radius should be 1 or 2 pixels larger than the FWHM stellar profiles in the images. The sharpen count adjusts the "sharpness" of the stellar profile model (tool/kernal). This does not change the degree to which the image is sharpened. Instead it adjusts the tool that does the work. Usually small values are appropriate and minimize certain artifacts.

Finally the bias subdivisions controls how far into the wings of the stellar profile the tool will act. Larger values are usually more aggressive. The deconvolution process is applied to the entire image, and the important parts of the object are monitored until the greatest improvement is obtained without making it appear overdone. The process is usually stopped before reaching the iteration limit specified. This kind of processing is truly incremental. When blinking the images the effect is dramatic. However, it may not come across well in print. Please see Fig. 11, which shows a small section of the original and sharpened images. Portions of the galaxy and small stars show the greatest benefit of the sharpening. In terms of resolution this brought the intrinsic resolution of the original data of 1.5 arcsec down to 1.0 arcsec. However, close examination of the sky reveals the expected curdling as well as the odd halo artifact introduced to the bright star. These undesirable effects will be hidden shortly by using *Photoshop* and masks.

Before bringing these two images into *Photoshop* (plus the RGB image that is waiting in the wings), the sharpened and unsharpened versions of the luminance

Preparation for *Photoshop*

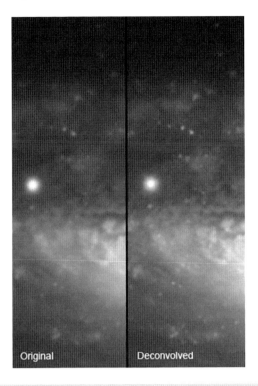

Fig. 11 Deconvolution comparison

image must be displayed in precisely the same way. In *CCDStack* the "apply to all" (Fig. 12) box is checked in order to match the display settings for multiple images. In order to "freeze" the result that is on the screen and permanently stretch the images, they must be scaled and then saved (a single action in CCDStack). This will open the image in *Photoshop* to appear exactly as you have chosen the settings in *CCDStack*.

It is absolutely critical not to over-brighten the images. This is the error that many beginning astrophotographers make. There is a tendency to make the image "look good" at this stage. However, an appeal to the idea of incremental processing must be made at this point since the brightness of the image determines how easy or difficult it will be to color it in *Photoshop!*

Computer monitors are 8-bit display devices and output 256 brightness levels (0–255). However for a fixed color, as a pixel becomes brighter its color will appear muted and less saturated. The upper bar of Fig. 13 shows the yellow-orange color of a star. The second bar is the gradient of brightness levels from 0 to 255 representing a luminance image. The bottom bar shows the blended result as it will appear in *Photoshop*. Note that in the blended result the color is "strongest" (most apparent) in the middle. Above a certain luminance value the color fades until at a value of

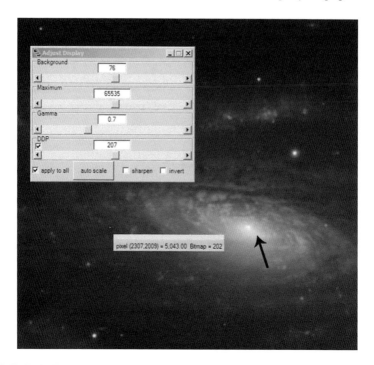

Fig. 12 The adjust display dialog

Fig. 13 Luminance and color blending

255 the output color is white regardless of the input color. The value at which this fading occurs significantly is around 200 brightness units.

These screen or "bitmap" units can be monitored when adjusting the display of images so that no interesting part of an object exceeds these values. This ensures that once in *Photoshop* this blend is not impossible. Inspecting Fig. 12 again shows how this is accomplished. The image is kept gray and not over-brightened by manipulating a combination of the DDP and Gamma sliders. Indeed I usually try to achieve a particularly attractive result with DDP and then "gray" the image using the gamma slider. The arrow in Fig. 12 points to a particular pixel near the brightest

part of the galaxy that has a bitmap value of around 200. The final step (not shown) is to adjust the background so that has a pedestal value around 15–50 bitmap units so that nothing in the image is black clipped when it is scaled.

Stylistically the choices above lead to signature renderings. Stars, for example, will always look white in their centers because I am not monitoring the stars but instead the galaxy's or the nebula's brightest portions. Stars will have colored halos, and the objects will be colorful throughout. In addition the images still do not take a form that is close to their final result. Many more incremental steps in *Photoshop,* including brightening, contrast adjustments, and noise reduction, will all be necessary to reach the afore stated goals.

To summarize the above, the basic steps to transition to *Photoshop* include:

1. Deconvolving the Luminance image.
2. Setting the Adjust Display to "apply all" so the images are synched.
3. Adjusting the display so that bitmap values of the brightest elements of the object are less than or equal to 200 using the DDP and Gamma sliders.
4. Adjusting the background so that sky values are around 15–20 bitmap values.
5. Saving these as "scaled" (permanently stretched 16-bit TIFF) images.

Using *Photoshop*

The luminance image still exists as two separate entities in a sharpened and original form. These two images need to be blended in *Photoshop* in a way that shows only the best parts of both versions. This is accomplished using an object mask. First both images are opened and the sharpened image is copied and pasted on top of the original, making two layers. Then the original layer (or sharpened, it doesn't really matter) is copied and put into memory. A new layer mask is invoked on the upper sharpened image and the copy of the object itself is pasted into this layer mask. (Hint: To enter a layer mask in *Photoshop,* you Alt-left-click on the layer mask icon in the Layers Palette.). The result you obtain looks like Fig. 14a followed by b.

Fig. 14 (a) Press icon to invoke new layer mask. (b) Paste object image into layer mask

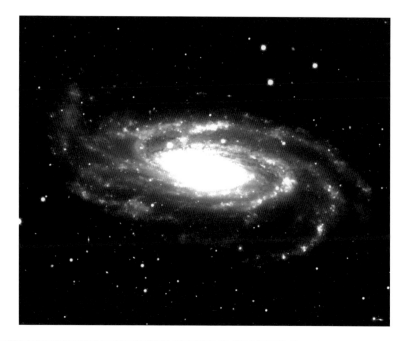

Fig. 15 Adjusted layer mask

Remember the image that is displayed in the layer mask is NOT being used as a regular image. It is adjusted in such a way as to reveal or hide portions of the sharpened image. Using Levels the object mask is brightened and black-clipped to look like Fig. 15. Every part of the mask that is white will reveal (at 100 % opacity) the sharpened layer. All black parts of the mask hide this upper sharpened image and the bottom original image is seen. This means that the center of the galaxy is sharpened at 100 %. Arms of the galaxy will show modest effects of the deconvolution since they are gray.

All stars above a threshold brightness of the sky will also reveal the sharpened layer. When values in the sharpened image (mask) are less than the desired brightness, the upper layer is hidden, and the smooth, uncurdled original image is displayed. This encapsulates the best parts of both sharpened and original layers. This is true with one exception. As you might recall the brightest stars in the image show odd effects of the sharpening. Since they are not improved by the deconvolution, it is best to show the original versions of these brightest stars. Selective processing and manipulation of the mask is now necessary. With the paint brush tool the very brightest stars are painted black on the mask, hiding the sharpened artifacts. Figure 16a, b demonstrate the result that is similar to Fig. 11 (deconvolved) but with improved stars and a smooth, uncurdled background.

The two layers are flattened together to produce the working version of the luminance image. Now the color image can be combined with this grayscale image to produce an LRGB rendering. Copy the luminance image and paste it onto the

Using *Photoshop* 177

Fig. 16 (a) Show original star by painting on mask. (b) Original star and sharpened galaxy

Fig. 17 Luminosity blending mode

opened RGB image. Reversing this order of operations sometimes confuses people. A grayscale image that is pasted on to a color image will be converted to a color image. If the color is pasted on to the grayscale image it will lose its color. Finally the luminance layer is blended with the color layer using the "Luminosity" blending mode. The layer configuration will look like Fig. 17. Note that the color image opens completely dark. It has not yet been stretched. This is the critical step to be undertaken next.

Shadow/Highlight Tool

At this point the blended result shown on the *Photoshop* desktop will not have any substantial color. The RGB image must be brightened so that its values are commensurate with the brightness values in the luminance layer, above, in order to properly color them. Thus it is the marriage and coupling of these two layers that determines the result on the desktop. As the RGB layer is brightened only the blended result is monitored instead of the RGB layer itself. Indeed the RGB layer can look bizarre; but as long as it colors all of the pixels in the luminance layer above, then our goals are satisfied. Beginning with Levels the RGB layer is made brighter by lowering the white point (dragging the rightmost slider left) until the brightest features of the object become nearly white clipped. This is the greatest adjustment that can be employed linearly on the RGB layer. All other adjustments from here on use non-linear brightening methods. The reason is because when the brightest things in the RGB layer become very bright all color is lost in the blended image. Only dimmer values in the RGB layer need an additional boost. The non-linear adjustment of Curves is generally used for this reason. However, even it still brightens the brightest parts of the RGB layer.

The method I have used for the past decade leverages the behavior of the Shadow/Highlights tool. Shadow/Highlights, first released in 2003, can be used to brighten only the "shadows," the bottom third of brightness values, in an image. The "highlights" functionality of the tool is not used. Figure 18 shows default settings I use. Of course there are no particular numbers or settings that are the same for different images. Instead this is a starting point, and I manipulate the "Shadows Amount" and "Color Correction" sliders.

The resulting image is bizarre, as is shown in Fig. 19. The image appears to be a grayish washed-out galaxy with little contrast. In addition there are dark circles around bright stars and a strange banded gradient across the field. The interesting thing is that not only is this result intentional, it is extremely desirable.

The artifacts mentioned above, although terrible in polished images, do not significantly affect the blending of the color data. The Luminance image controls the brightness levels of each pixel of the blended result, and since the effects above are artifacts in brightness of the RGB layer they are not critical. Figure 20 shows the initial blended result of the luminance with this interesting color layer. Note that I always blend the luminance at 100 % without sacrificing any of its salient details. The colors are beginning to show, and this is yet one more small incremental step in the workflow.

Contrast of the Color Layer

We have now reached what I consider the highlight of this chapter. An understanding of how the colors of images respond to changes in brightness in either the color channels or the Luminance component is a powerful tool to creating the most

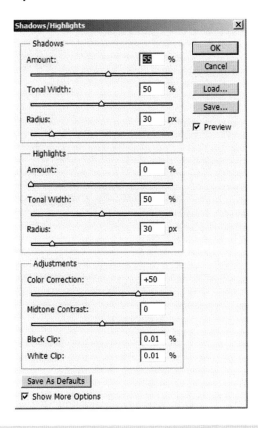

Fig. 18 Shadow Highlights tool with Adam's default settings

vibrant image possible. Consider a non-linear stretch, such as Curves, on any single-layer color image. As the image is brightened the contrast decreases and the colors lose saturation. The reason is because a non-linear (brightening) adjustment tends to make dimmer pixels *nearly equal to* brighter ones according to the specified output relation. This is why there is a decrease in overall contrast. Now also consider just the color space for these pixels in this situation. As the red, green, and blue channels are made nearly equal to one another the output color becomes more white, leading to a decrease in saturation. Thus a good rule to remember is:

> When performing a non-linear stretch to a color image, increasing the color saturation will be necessary in order to bring it back to a similar degree of color intensity from which you started.

This is why the Shadow/Highlights tool has the "Color Correction" slider. This slider affects the color saturation of the brightened pixels! Of course the brighter the image becomes the more difficult it is to do this (Fig. 13). Note once again that brightening an image reduces the contrast and dilutes the color. So, what does *increasing* the contrast of the color channels do?

There are two ways to change the contrast of an image. The white point can be lowered or the black point can be raised. As most astrophotographers know, when

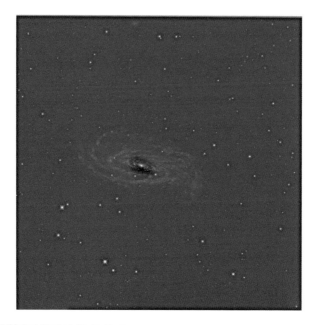

Fig. 19 Result of Shadow/Highlights on RGB layer

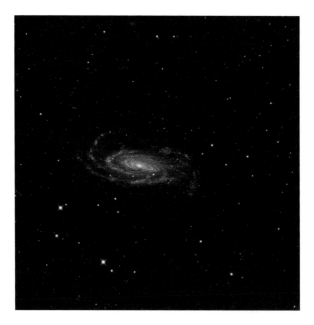

Fig. 20 LRGB (luminosity blend) using RGB layer made from Shadow/Highlights

working on an LRGB image the RGB layer can be brightened by using levels to lower the white point and increase the color saturation of the blended result. However the surprising part is the technique less commonly used, *raising the black level of the RGB layer, which also increases the color saturation of the blended (LRGB/desktop) result*. This is how I take advantage of the strange color layer I created with Shadow/Highlights. I do not touch the white point at all. Instead I raise the black point to increase the color saturation as shown in Fig. 21a, b. The color saturation of the fainter and mid-level pixels increases dramatically while the brightest parts of the image remain relatively unchanged.

I continue to adjust the brightness of the luminance layer and RGB layer until I attain an image that is bright enough with everything of interest being colored properly. It is the interplay between these two layers that I use instead of monitoring either one of them separately.

High Pass Filter

From this point there are a handful of operations that require the L and RGB layers to remain separate. By far my favorite tool is the High Pass filter enhancement of images. This technique increases the contrast of an image at a user-defined spatial size. Please examine the steps from left to right in Fig. 22.

The first step of the process is to make two copies of the original layer. Next, in step 2, apply the High Pass filter at a desired spatial scale to highlight aspects of

Fig. 21 (**a**) Original LRGB blend. (**b**) Raising black level on RGB layer increases color saturation

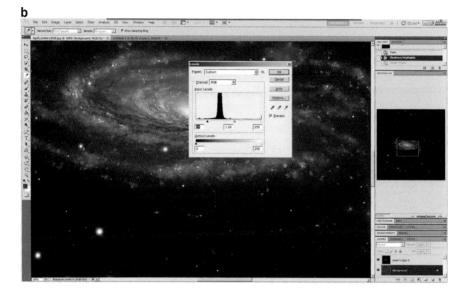

Fig. 21 (continued)

Fig. 22 Steps for using the High Pass filter

interest. Using this tool to accentuate small details is typically its strength. Contrast adjustments of the largest structures are generally better accomplished by using the Unsharp Mask and very large radii. The difference in the result between the High Pass filter method and the Unsharp Mask is the resulting "graininess." The Unsharp Mask tends to be too aggressive in this regard for small spatial scales.

A typical result of the High Pass filter is shown in Fig. 23 using a 5 pixel radius kernal that detects HII regions and dust lanes of the galaxy. This image is used as a tool to determine which aspects of the underlying layer will be enhanced. Anything that shows up in this High Pass filter image that is brighter than the mid-gray value will be brightened, and those pixels less than 50 % gray will be darkened. The blending mode that accomplishes this is Overlay (see Fig. 22, step 2). In step 3 the High Pass layer and the underlying copy of the luminance are merged

Cleaning the Image

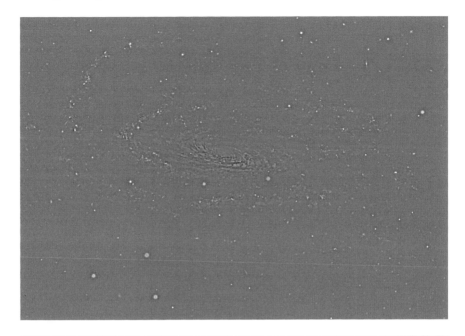

Fig. 23 High Pass filter applied

and a (hide/black) mask is created to be painted on. Step 4 is an intermediate step indicating the mask is adjusted either with a threshold mask (such as an object mask) or by painting on the mask by hand. For objects that fill a field of view a threshold mask is the best solution, since it reveals the enhancement based on the brightness values within the image and can be applied globally. However, if the object is a tiny fraction of the field, simply painting on the mask by hand is certainly a quicker, though more selective, process. Finally step 5 shows that these layers are merged to produce an enhanced final image blended with the color layer (now visible) using the luminosity blending mode.

Cleaning the Image

Before making the decision to flatten the image I usually spend time removing various kinds of artifacts, especially those affecting stars. Strange halos, misshapen stars, and color errors are a few of the many distracting elements of the image that I attempt to de-emphasize or eliminate. Due to the fact that these artifacts can reside exclusively in either the luminance or the color layers, it is easier to work on them while the layers are still separate. Figure 24a, b show the correction of a color error that is typical for galaxies with a very bright nucleus.

Fig. 24 (a) Color error with smudge tool (before adjustment). (b) After smudge adjustment

When the RGB layer was brightened, areas near the nucleus became white clipped and the luminance layer shows no color in this region. Instead what appears is an area of odd gray with a color fringe at the boundary. Keep in mind Fig. 23 is zoomed in 500 %, and this particular error is quite small. But a good philosophy is

to "make every pixel count!" The smudge tool is shown in Fig. 24a with the RGB (background) layer being active. The areas near to the colorless zone are pushed (smudged) into the nucleus until the result looks like Fig. 24b.

Since the adjustment only affects color, no details of the luminance become blurred.

If stars have color halos a similar methodology can be used to minimize them. While it is possible to use the smudge tool on every star in an image; the tedium of visiting every star requires extraordinary patience. Instead, operating on just the RGB layer can be beneficial. The steps for making this correction are as follows:

1. Select the brightest stars in the RGB layer using the Color Range Tool and the "Highlights" option.
2. Expand the selection by a small amount (4–5 pixels) and then feather it (3–4 pixels).
3. Now that the brightest stars are selected in the RGB layer, apply either a Gaussian Blur or the Minimum Filter by 1–3 pixels.

LAB Color Space Adjustments

Once I am done cleaning the image, I am ready to commit to flattening the layers together to make a single image. I need to do this in order to operate in the Lab Color space and continue with one of the most fascinating adjustments in the workflow. Operating on the "a" and "b" channels of this color space can increase the vibrancy of an image and provide extra color separation for many aspects of astronomical objects. The "a" channel controls the red (magenta) and greens in an image. The "b" channel manipulates the blues and yellows of an image. It is somewhat like being able to adjust two colors simultaneously, not expressed by a single slider in the world of RGB, which results in a pleasing effect. For most objects the "b" channel does most of the work and is appropriate for NGC 5033. However, nebulae that suffer from sallow appearances may need the assistance of the "a" channel to flush the cloud with the expected pinks and reds.

In order to operate on a particular channel (once you have converted the image mode to Lab Color) you need to set up the visibility of the channels to look like Fig. 25.

Only the "b" channel is active, and a grayscale view of this channel will be shown. In this image a "gray" pixel means the pixel in the original color image has equal amounts of blue and yellow. Darker pixels have more blue and brighter pixels more yellow. Note how prominent the bluish spiral arms of NGC 5033 stand out. In order to create this more vibrant image the blues need to be darkened and the yellows brightened by equal amounts in this grayscale representation. Not doing so will drastically change the color balance of the image. Thus, once again, it is increasing the *contrast* of a color channel that provides the desired result!

The contrast of the "b" channel can be adjusted with the Contrast command in *Photoshop*. However, using Curves provides a way that adjusts the contrast with considerably more finesse. In order to see the effect, the original color image must

Fig. 25 The "b" channel representation of NGC 5033

Fig. 26 The "b" channel active with all full color image shown

be visible while only operating on a single channel (Fig. 26). Finally Curves is used in a symmetric "S" shape with the inflexion point being at the origin (0,0). The Curves graph in Fig. 27 shows a typical shape. Figure 28a, b attempt to show the effect of this adjustment. It is subtle and exaggerated for print purposes.

LAB Color Space Adjustments

Fig. 27 Curves adjustment of the "b" channel

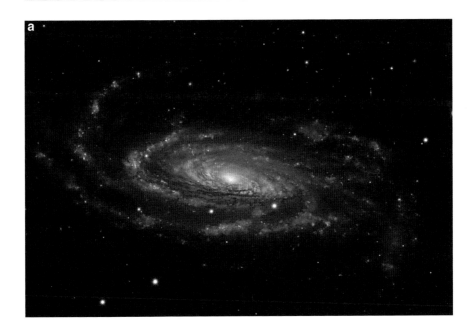

Fig. 28 (**a**) Before lab adjustment. (**b**) After lab adjustment

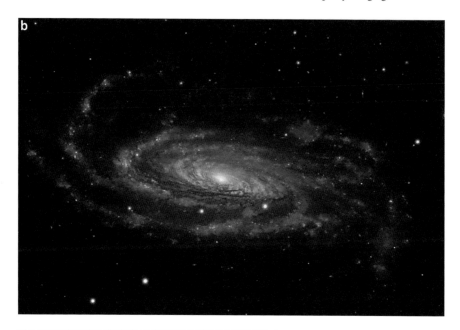

Fig. 28 (continued)

Noise Reduction

The final steps of producing an eye-catching image that withstands close scrutiny involves the minimization of the blocky or grainy appearance in the image. There are a wide variety of tools that do this task admirably, including *Photoshop*'s Reduce Noise and *Noise Ninja*. A well constructed inverted object mask accomplishes multiple goals in noise reduction.

The process begins by making a copy of the original color image and invoking a layer mask. The image itself is copied and pasted into the mask. Finally the color of the mask is inverted so that the object is dark and the background is light. Levels is applied to this mask, clipping the background mostly white and the object as mostly black, as shown in Fig. 29. This mask protects the brightest parts of the galaxy from being smoothed due to the noise reduction while at the same time permitting 100 % of the effect to show in the background (sky). A nice trick uses the "output" slider of Levels to moderate the white and black points. Perhaps it is necessary for some images to have 100 % smoothing on the background and 30 % smoothing on the galaxy. Figure 30 shows that by adjusting the "output" slider in levels you can change the maximum or minimum value that is outputted. In this case the galaxy is made slightly grayer to permit a little bit of the smoothing to show.

The final finishing touch to an image is to determine a black point setting. Nowhere in the workflow above did I adjust the black point of the luminance

Noise Reduction

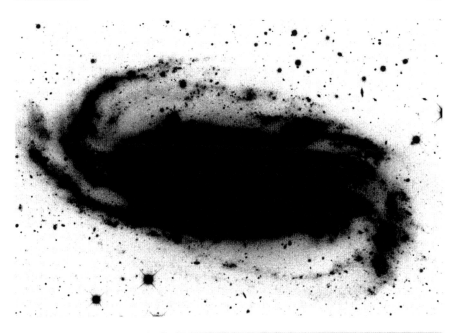

Fig. 29 Inverted object mask

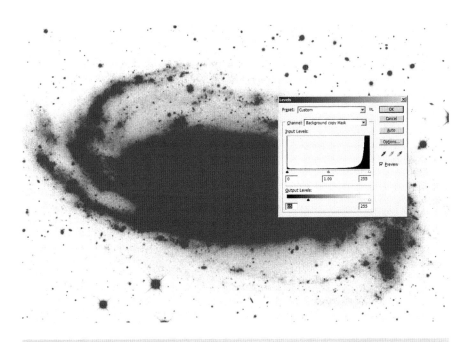

Fig. 30 Output of levels changed on layer mask

Fig. 31 Final black point

image! Keeping the pedestal value makes it easier to see all artifacts and noise products when processing the images, and nothing is "hidden" in the blacks. I generally bring the black point up to within 2–3 counts of the sky value as displayed in levels. Figure 31 shows a typical resting value for the black point. There is a small gap (pedestal) between this black point and the sky values, which peak 5–6 counts to the right (brighter).

Summary

The summary of steps from the above *Photoshop* discussion are:

1. Combine the Original Luminance and Sharpened Luminance using an object mask and show original features where artifacts are present.
2. Paste the Luminance image on to the RGB layer and blend with luminance.
3. Brighten the RGB layer using Levels only so far as no important detail becomes clipped.
4. Apply Shadow/Highlights to further brighten the RGB layer. Color will begin to appear in the LRGB blended result on the desktop.
5. Adjust the contrast of the RGB layer, especially the black point, to enrich the image with more color.
6. Apply the High Pass filter to enhance various spatial scales of the object.
7. Clean the image and minimize artifacts and visual distractions in each layer (L and RGB).
8. Flatten the layers, resulting in a single color image.
9. Change the color mode to Lab and manipulate the channels.

Summary 191

10. Revert back to the RGB color space and reduce the noise in the image using an inverted object mask.

The workflow that begins with the fundamental steps that began this chapter as well as the *Photoshop* processing constitute 85 % of the rendering of a complete image. Other techniques are usually applied to different types of objects or various kinds of artifacts. However no matter how practiced these steps are, it is the quality of the data that ultimately determines how effective the workflow above can be. Given data with good Signal-to-Noise and few artifacts, I hope you find the steps demonstrated in this chapter are a robust and consistent way to produce captivating color images.

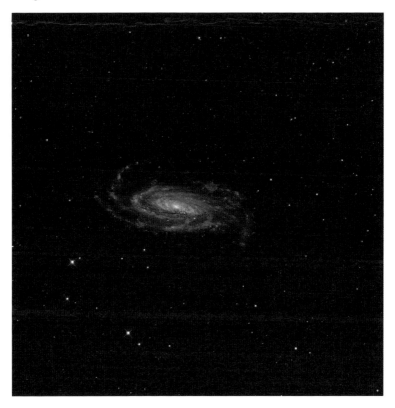

NGC 5033

Deep Sky Imaging: Workflow 2

Johannes Schedler

Introduction

As astrophotographers we are living in a golden age. In recent years CCD technology and the quality of amateur telescopes have reached a level of perfection, giving amateurs the chance to produce images rivaling those taken from mountaintops by large professional systems as recently as two decades ago. However hardware and good imaging location is only a part of the game. A high level of skill with image processing can offer amateurs an edge and provide a chance to compensate for the limited aperture of our telescopes.

This chapter will guide the reader through all major steps of deep sky image processing. The process begins with optimum calibration of raw data. Next I will discuss combining and defect removal. Last I will discuss more advanced enhancement using Adobe *Photoshop* to effectively reveal the hidden treasures of our sky. If we carefully avoid the traps and pitfalls, and master the important steps, the path from image acquisition to the final image can be extremely rewarding and inspiring.

How to Generate Optimum Raw Files

The best way to obtain high quality CCD images is to produce high quality raw files with sufficient exposure time. Key elements to image acquisition include imaging on dark and transparent nights, accurate focusing, and achieving good temperature

equilibrium between your telescope and the environment by forced ventilation. You should also use a rock-solid mount for your setup that has the ability to accurately track your 'scope with only minimum corrections by auto guiding. And last but not least, you should collect as much exposure time as you can, as it will make your processing easier and will improve your final image quality. In my experience for a somewhat light-polluted area a total LRGB exposure time of 10 h or more per target is well invested.

For image acquisition it is very important to dither the exposures (check box in *Maxim DL*). This means the position of the camera pointing is moved 1–2 pixels in random direction from one exposure to the next. The effect is that the light from our targets such as stars and galaxies is filling different pixels. Dithering helps reduce CCD inherent irregularities as hot pixel defects can be easily eliminated later.

The image acquisition will result in a batch of files consisting of red, green and blue filtered raws (RGB), typically luminance filtered files (L) and if desired narrowband files such as H-alpha (Ha), Oxygen-III (O-III) and Sulphur-II (S-II). Each of these files are in 16-bit FITS format as this standard astronomical format also includes information about the date/time, camera, telescope and sky position data.

Preprocessing

Calibration Files

In Fig. 1 you see the irregularities introduced by the KAF-16803 CCD itself as general offset, amplifier glow in the edges and a hot column caused by a badly leaking pixel, visible in the bias file taken at zero exposure time to the left. In the middle you see the irregular light streaks from the cosmic rays that strike the CCD surface at random positions for each exposure. Also some hot pixels (white dots) have built up during the exposure, typically at fixed positions. To the right you see the uneven illumination of the CCD caused by the light fall-off at the edges of the field and the shadows of dust and fibers, so called dust donuts. These are semi fixed but may move, disappear or reoccur within a short time. All these irregularities have to be removed completely to be able to stretch the light images aggressively without recognizing any significant image defects. Therefore calibration files have to be used to remove all these irregularities from our light frames by subtraction (bias and dark frames) and division (flat frames) (Fig. 2).

Dark and bias files can be updated at longer intervals such as several months. Flats should be updated during each image session, as the dust pattern on the CCD chamber and the filter surface can change from day to day. Dark and bias files are taken with closed CCD window and closed telescope, typically not on a clear night. Flatfield files can be taken by using a flat field box or preferably a luminescence foil covering the full aperture of the telescope in a relatively dark environment.

To preprocess the generated light- and calibration images we can use different programs. I choose *CCDStack,* a widely known program by CCDware. All calibration files have to be acquired in multiple frames to avoid noise introduction. At first

Preprocessing

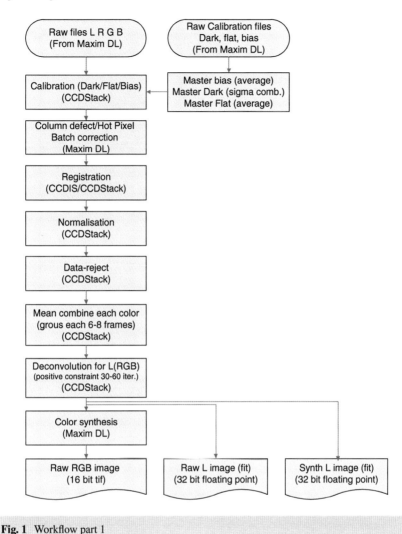

Fig. 1 Workflow part 1

the calibration files are combined. Darks should be sigma-combined. Flats and bias files can be averaged, typically 10–20 files each for dark and bias. Five files for the flats are recommended. If sky flats are taken during dusk or dawn, the files should be median-combined to eliminate all the stars. Do not forget to dark subtract the flats, as this will provide the optimum correction. All master bias, dark and flat files should be saved in 32-bit floating point FITS format. *CCDStack* can be used to produce these calibration file stacks by selecting the menu "process/calibrate/make master flat (dark, bias)." For procedure "clip min/max Mean" can be chosen. The stacked calibration files (master files) exhibit much less noise than the single files, and cosmic streaks in the darks are averaged and clipped out.

Fig. 2 *Left:* stretched bias file. *Middle:* crop of stretched dark file 15 min. *Right:* stretched flat field file

If bias files are used, only one master dark file is required for different exposure times. The calibration program is internally subtracting the bias from the dark and then scaling the darks during the calibration procedure.

Calibration Procedure

It can be done in different programs, but *CCDStack* is my preferred program. If the calibration files are of high quality and up to date, nothing should go wrong. The calibrated files should be checked for a smooth background. Calibrated raws of bad quality (fog, clouds, dew, major guiding errors) should be eliminated from further stacking, as these may pull down the overall quality of a large image stack.

Batch Image Defect Removal

The calibrated images will typically show some systematic and erratic defects caused by the properties of the CCD array. Bad columns are not calibrated out well during dark and flat calibration, so the bad columns and also hot pixels can be removed using a batch procedure in *Maxim DL*. Open a master dark file in *Maxim DL* and check carefully for column defects. Move the cursor over the defect column and note the number of the column. Repeat the procedure for further defect columns. Then open the "process/remove bad pixels" menu, select "column" in the left menu and insert the first number of the bad column, then click on the button "add"; the bad column will show up in the list. Insert further bad rows, and then click on the "save map" button.

Next open the view/batch process window, then click the red "record sequence" button. Then select "process/remove bad pixels" and click "process." The previously

Fig. 3 Maxim batch process window

generated map will be used to replace the bad columns by the neighboring columns. Typically this will work very effectively. Then select "filter/Kernel Filters" and select the "hot pixel" button at 5 % or 10 % threshold and check the preview, then chose "ok." Dark pixels normally are not visible, so filtering is necessary; now you can press the "stop recording" button. Press "Save the sequence to file" and enter a file name (Fig. 3).

Then close the FITS file without saving and select the >> button to choose the files for the batch processing. Click "files" and select all calibrated light files you want to process. In the disposition window you may decide if you want to overwrite the existing files or save as a new name (add prefix or specify sub-folder). Then press the "play sequence on multiple images" button. All selected images will open automatically, the defects will be removed and the files will be saved after that as specified.

Registration and Averaging

I highly recommend using *CCDStack* for preprocessing the raw files. This is valid for RGB and luminance as well as for narrowband files. Alternatively the software *Registar* is very accurate in aligning images precisely even when using different focal lengths. This can be very helpful in particular for creating mosaics and hybrid images.

Fig. 4 Data reject menu *CCDStack*

The procedure for using CCDStack is described here. Depending on the memory and the size of the CCD array the maximum stack for registration is limited between 8 and 20 images. For my STX I typically use stacks of 6–8 raws to process, I typically have more files, so I combine the smaller stacks later to one master stack. The calibrated raws are loaded into CCDStack, then the registration is the first step. I prefer to use CCDIS, an add-on for CCDstack that is very accurate and powerful. You can use the default values for this step. The accuracy then can be checked by viewing the registered files in series at 100 % size using "select/blinc". After registration the files have to be recalculated in the apply menu using typically "bicubic B-Spline".

The next very important step is the normalization. This is important to bring the files to equal background and intensity. If there is no flaw in the image the entire image in "auto" mode can be used as reference; otherwise a rectangle can be drawn to select the reference area, i.e., galaxy.

The next step is the stack/data reject menu. For this procedure select "poisson sigma reject" from the drop-down window. This selection is my recommendation and will work effectively with 3 raws and even better with 5–8 raws. I usually use a factor of 1–2 and 1–3 iteration limits (Fig. 4).

The rejected pixels are marked as red in the preview after starting the calculation with the "apply to all" button. The background area should not be rejected, as extra noise would be introduced. This method will eliminate satellite streaks, cosmic ray

hits, hot pixels and other CCD defects as well as guiding errors, the last if not too many raws are affected. For best efficiency in this step dithered raws need to be used, so fixed errors are occurring at different positions and thus can be eliminated by the rejection procedure. Even plane, satellite and asteroid streaks can be eliminated by careful adjusting the factor and limits. See Fig. 3. If the result is acceptable one can move to the next step.

The last step of the stacking process is combining. Mean combining should always be chosen to avoid any clipping. The averaged file should be saved in 32-bit floating point format to retain all image information. This processing sequence is the same for all types of raws, L-R-G-B and narrowband filtered images. For example; with 24 luminance raws from my STX-16803, three stacks of 8 raws are averaged to obtain the total stacked image. After saving the FITS file in the "adjust display" window the DDP box should be activated; then the "auto scale" button should be clicked on. This will expand the scaling. For safety reasons the white point should be set to 65,000 units and the black point is set so that the darkest part is safely above zero, typically 50 counts below the proposed value. The DDP slider should be moderately used. Then the result should be saved as "scaled image" in 16-bit TIFF format.

RGB Combining

The three combined stacks for red, green and blue are loaded into *Maxim DL*. Then from the menu "color synthesis" is chosen. The opened window shows the three files to select for each color, with the proper scaling factors to be filled in. Depending on the camera model and the filter type the ratios are specific. For the STX-16803 with Baader filters the R:G:B ratio typically is 0.6:0.8:1.2. Additionally the changing sky conditions, transparency and altitude angle may influence the ratio, so the preview for the full image should be used to fine tune the ratio and check for an optimum color balance for stars and the main object. Sky background equalize should be active. When you are satisfied with the preview the destination file name should be entered. The 16-bit TIFF format should be chosen.

If the factors are set to values below one, no additional scaling is necessary to fit to 16 bit depth. If you want to use a G2 calibration by using standardized "white" stars for color balancing, there is a well explained procedure available at the homepage of Bernhard Hubl: http://www.astrophoton.com/tips/color_balance.pdf (Fig. 5).

To get high quality RGB images the star diameter (FWHM value) in the three channels should roughly be the same; otherwise the stars will have colored seams.

Typically the seeing deteriorates when moving from red to green and blue, so the star diameters often will not match between the color channels. One solution is to deconvolve the worst combined files until the FWHM value is matched for each of the RGB stacks. The procedure is described in the section "Luminance Files" following.

Fig. 5 RGB combine in *Maxim DL*

Photoshop Processing

The following details the typical workflow I use to achieve good star colors even for brighter stars. The 16-bit TIFF image is imported into *Photoshop CS5*. Only some bright stars will be visible. First increase the saturation by approximately 20 % to preserve the star color of the brighter stars. Then choose the adjustment/levels menu and use only the middle slider to increase the midrange brightness up to a value of 4. This will implement a non-linear brightness increase without affecting (clipping) the brightest areas. Repeat this in several steps and check the color saturation. Sometimes repeated iterations of this step can further improve the result. The background noise may begin to reveal itself, and color gradients will become more apparent. Alternatively the adjustment/shadow-highlights menu can be very helpful to bring up the background without losing information in the brightest parts. During this process you should always observe the histogram of the overall image. There should be approximately 25 counts to the left of the black point. Also the narrow peak on the white side should be kept to a minimum. The center of galaxies and bright nebulas must not be saturated in either color channel (Figs. 6 and 7).

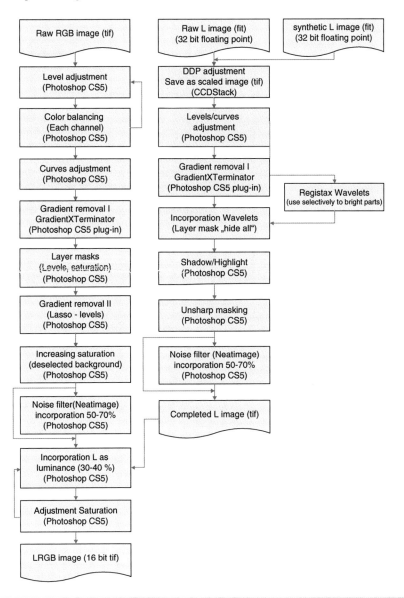

Fig. 6 Workflow part 2: level adjustment

Gradient Removal

The deeper our images the more they will be affected by gradients. At exposures of several hours per channel brightness boosting can be very effective to bring out faint signal; however gradients will soon reveal themselves. The darkest possible

Fig. 7 Level adjustment (histogram)

skies are obviously the best measure to avoid the problem of gradients, but this is often not in the imager's control. Due to my light-polluted sky I have to resort to special tools to eliminate most of these background effects. The first step typically is the application of a special filter created by Russ Croman known as GradientXterminator that can be integrated as a *Photoshop* plug-in. This filter automatically reduces the gradients in the background while keeping the information unchanged in the brighter parts. To achieve better control of the actions of this filter I duplicate the layer and apply the filter to the front layer typically in medium detail and aggressiveness. "Balance background color" should be checked. The layer opacity then can be optimized to approximately 70–90 %. The major portion of the gradients should be successfully removed by this, but often the image background remains far from perfect at this stage.

Photoshop offers a very powerful tool to visualize information about minor background irregularities (Figs. 8 and 9).

Select an adjustment layer using "levels" and move the center slider to the left and the left slider to the right to increase significantly the visibility of gradients in the darker areas. Then pull up a second layer mask and select "hue/saturation." Increase the saturation by approximately 30–50 %. Next you need to select back the *original* image layer and are then free to manipulate the image by using the feathered lasso tool or by using the color range tool to selectively improve the

Photoshop Processing

Fig. 8 Layer mask selection in PS

Fig. 9 Level and saturation mask applied in PS

Fig. 10 "Magnified" image after manual corrections applied

background. The two adjustment layers are acting as a strong magnifier for many kinds of irregularities in the image. You also can use the clone tool to remove faint satellite streaks and color halos from brighter stars. It can also be helpful to select the color channels separately to check for noise and irregularities such as residual donuts from imperfect flats. All corrections are done to the original image.

By hiding the adjustment layers the improvements can be checked in the original image. If the gradients are satisfactorily corrected in the magnified image, the adjustment layers are deleted, and the original RGB image will look much better even in a dark environment when displayed on high contrast TFT screens. The same procedure can also be repeated later in the workflow to check a final LRGB image for background or star-halo corrections (Fig. 10).

Color Adjustment

To check the colors you should use a calibrated monitor. This helps immensely to achieve an excellent color balance on more than just your own monitor. I personally use the Spyder4 pro hardware to calibrate my monitors. Before using this system I had to judge the image by viewing on several different monitors to get a feel for good color balance. You will be surprised how much improvement is possible by using such a simple hardware calibration and profiling system. The included

software will guide you through the necessary steps. You can compare the original color with the calibrated one. The profile is loaded automatically during each start of the computer. See also the section "Color Management and Profiling."

The color range tool is very helpful to correct selected parts of the image. First the background should be selected and feathered 1 pixel, followed by a mild gaussian blur of 0.3–0.5 pixel. Next the saturation can be reduced in the background to decrease the visible color noise. If there is still considerable noise in the image, the TIFF image can be brought into "Neatimage" and a noise filter can be applied effectively. Again the smoothed image should be brought back to *Photoshop* in a 1-bit format and blended to the previous version at reduced opacity to retain some traces of noise.

A good color balance can be achieved by selecting the individual color channels and observing the histograms. In newer *Photoshop* versions a color histogram is available that shows the distribution of the individual brightness of each color channel. Be aware that you should respect a distance of 20–25 units from the black point; otherwise you might lose background information by clipping that later on can no longer be recovered. Also on the white side of the histogram you should carefully check that only the brighter stars are reaching saturation. All other areas should not reach the white point for each of the color channels. Typically the saturation can be increased in this step, and after selecting the background, the color saturation in the dark areas can be reduced a bit to suppress color noise. However the final color tuning should be done after combining the luminance with the RGB image.

Noise Handling

Noise handling in deep sky images is a critical issue. I have seen many images ruined by excessive noise reduction. Noise reduction is done by blurring the image. In consequence fine details of the image may disappear. The overall impression of an image with excessive noise reduction can appear unnatural and more like a painting than a photographic image.

Noise is inherent in all original astronomical images as the square root of the light signal. This is the major source of noise that we are trying to reduce. Electronic noise from the CCD can be controlled by optimum cooling and proper calibration, as described earlier. Due to the fact that our targets are very dim, the darker areas have to be stretched very hard to reveal the hidden structures. Therefore we should learn to accept noise as a reality in a good image, but the level of noise should be controlled in a way that it does not distract from the content of the image. Noise in raw images can show up in multiple frequencies or scaling, mostly visible at the scale of a few pixels across.

Photoshop provides an internal noise filter that can be adjusted in many ways to eliminate noise. However a more sophisticated routine is provided by the program

Fig. 11 *Neatimage* noise filter profile

Neatimage that can be used as *Photoshop* plug-in or as a stand-alone version. I will describe the stand-alone version that will work both on monochrome luminance and on color RGB images. Open the 16-bit TIFF image in *Neatimage,* change the scaling to 100 % and go to the "Device Noise Profile" tab. Draw a rectangle on a part of the image that does not show too much fine structure. Click the button "rough noise analyzer," and then optionally the button "auto fine tune." A noise profile will be calculated (Fig. 11).

Now move on to the tab noise filter setting, click the "preview" button and adjust the values of "noise filter amounts" so that a good reduction of the noise is reached. Then select the tab "output image" and click the button "apply." Finally store the result as a 16-bit TIFF file (Fig. 12).

The filtered image itself should not be used for further processing. Rather it should be pasted onto the original image as a new layer and the opacity should be adjusted to approximately 50–70 %. This will allow some residual noise to come through so the appearance of the image will be more natural. The finest details in bright areas do not need noise reduction at all because of their high S/N, so these areas can be recovered 100 % by using the eraser tool selectively on the above *Neatimage* treated layer.

The lower the local brightness the more the noise reduction may be used without being disturbed. The bright parts should show the finest details with typically no degree of noise reduction or blurring.

Fig. 12 *Neatimage* noise filter amount preview

Luminance Files

Luminance layering is especially important for dim and distant targets. Typically for most galaxies and faint nebulae the main information for the image can be extracted from the luminance files. Typically we use the most exposure time for collecting luminance filtered images. Even 10 h for pure luminance is not atypical for data acquisition. If possible luminance files should be acquired during the best transparent and moonless lights and not too far away from the meridian crossing. The entire image will benefit if the luminance frames are acquired during the best possible seeing conditions and sky transparency that will translate to the highest possible signal to noise ratio. Doubling the total exposure will increase the S/N ratio by 1.4, so 16 h of total exposure will improve the S/N ratio by a factor of approximately 4 compared to 1 h. The more exposure is collected the more important are very good calibration files. The registration of the luminance files is done according to the previously described registration procedure.

Synthetic Luminance

In some situations we might have a set of RGB frames of high quality in 1×1 binning mode and no time to acquire luminance files. In these cases it is very helpful to average the registered red, green and blue stacks to produce a synthetic

Fig. 13 *Left:* RGB image of Trifid Nebula. *Middle:* processed synth. Lum. *Right:* final synth.-LRGB image

luminance image. To achieve the highest quality possible the noise in the three color channels should be roughly the same. This can be reached by properly choosing the exposure time per channel according to the filter weighting. The registered red, green and blue stacks are loaded into *CCDStack* and combined as straight average. The combined file is saved in a 32-bit floating point FITS format. It will show much less noise than the original color stacks.

Next this file can be further processed like a normal luminance stack. First deconvolution has to be applied to reduce the star diameter; then high pass filtering and also wavelets typically can be applied. The incorporation of the RGB image follows the same procedure as for the normal luminance. Investing more time into RGB than the luminance is especially preferable for dimmer emission and planetary nebula images where the subtle color shades of O-III and H-beta contrast against the often dominating H-alpha emission areas. If exposure time is limited for targets such as colorful nebulae then all the available time should be dedicated to the RGB channels. See the dramatic effect of such a synthetic luminance incorporation on the central part of the Trifid Nebula (M20) shown (Fig. 13).

Deconvolution

A large stack of luminance (or synthetic luminance) files will typically have a good S/N ratio and therefore can be enhanced by a deconvolution procedure. The effect of deconvolution is a narrowing of the star profile and the enhancement of small scale details. This procedure can be easily performed in *CCDStack*. The combined file is opened, and "process/deconvolve" is chosen from the menu. No other files should be open, as considerable memory is needed for the calculation. A less than 50 % saturated star in the background area is selected. Then the "positive constraint" calculation is selected. Thirty to sixty iterations will reduce the FWHM to the desired value.

Fig. 14 High pass filtering in *Photoshop*

The calculation takes several minutes for large CCD areas. Approximately 0.5 to 1 pixel FWHM reduction can be achieved at a focal length of 4 m applying one deconvolution run. If too many iterations are chosen the background will become grainy. Opposite to other deconvolution programs *CCDStack* will not harm the star shape or produce ringing effects. Again the deconvolved image should be layered into the original image at reduced transparency. The background can then be excluded by color range selection before copying.

High Pass Filter

The high pass filter in *Photoshop* is a powerful tool to increase the contrast at intermediate and fine scales and produces fewer artifacts than unsharp masking. It is especially helpful for enhancing brighter nebula details and internal structures of galaxies such as dust banding. Use the color range tool for selecting the areas to be improved. Deselect the stars and feather 1 pixel and copy and paste as a new layer.

Next change the layer mode to "soft light" followed by selecting the filter/other/high pass filter. The radius chosen should be 3–8 pixels for smaller scale details within for galaxies and 8–20 pixels for larger structures such as nebulae. The opacity of the enhanced parts can then be adjusted between 50 % and 100 %. The procedure can be repeated and the final effect can be dramatic, but be careful to maintain a natural appearance. Stars should not be enhanced, as ringing effects may occur (Fig. 14).

Fig. 15 Wavelet filtering in *Registax*

Wavelet Filtering

Good luminance stacks often have a very high S/N ratio, especially in the bright areas of the image such as within the bright parts of galaxies or close to the center of planetary nebulae. Originally designed for planetary image processing there are programs such as *Registax* that use a very strong Fourier-transform algorithm that can reveal the finest details buried within the original image. Store a cropped image of the galaxy in 16-bit TIFF RGB mode and open it in *Registax* (Fig. 15).

Do not stretch the intensity levels. The program will move to the wavelet setting page. Choose mainly the 1:1 layer and move the slider up to values between 10 and 50 units depending on the S/N ratio. The preview will be visible for the center area. If the preview seems correct, some fine grainy appearance may be OK. Push the "do all" button and then the "save image" button. Do not worry about the grainy background. This can be removed later. Import the filtered image into *Photoshop* and select the enhanced brighter areas with the "quick selection tool," then feather with a few pixels. Copy and paste the selected area to the original full image, align it manually and blend it into the main layer to the desired amount. A Gaussian blur at 1 pixel radius will remove artifacts from the noisier parts.

Fig. 16 Sky glow

Luminance Versus Clear Filtered Images

The question of whether luminance-filtered frames (400–700 nm band pass) or clear filtered frames (no cut-off on both sides of the spectrum) should be used to achieve the maximum S/N ratio can be reasonably answered – it depends on the target. Modern full frame CCD cameras are sensitive also in the near IR range up to 1,100 nm, so there is significant light that can be collected in those wavelengths. However it is not always known if the sky background is progressively bright towards longer wavelengths. This is caused mainly by airglow generated in the upper atmosphere (i.e., OH excitation). Airglow is dominant, especially at dark observing sites (Fig. 16).

Comparing a clear versus luminance-filtered raw frame at same conditions from a dark site in Namibia supplies the following result.

Type of image	Background (ADU)	S/N star	Net star peak brightness (ADU)
Luminance filter	520	371	4,794
Clear filter	1,060	334	6,093

The star brightness increases by 27 %, but the background by 104 % when using unfiltered light, so the overall S/N ratio decreases by 10 % for the unfiltered image.

However there are exceptions where unfiltered light might improve the signal. Highly red-shifted objects such as quasars are typically much brighter in the infrared than in the visible band. Also in dusty areas the infrared light penetrates deeper and reveals more stars than visible light. These are typical situations where unfiltered luminance can be very helpful.

Luminance Incorporation

This is a critical step in the processing sequence, as it has to be done in a way to avoid data loss from either the RGB or the luminance components. Also it depends on the relationship of the relative exposures used for the RGB or luminance. The background noise should be brought to a similar level in both the RGB and luminance image. This is accomplished by proper stretching. The noise statistic can be read from the information window in *Photoshop* when selecting a window containing no stars but only background information. Doing such stretching will result in a darker RGB image and a brighter luminance image for the mid range.

The RGB image is opened in *Photoshop* as a background layer. Then the registered luminance file is pasted as a new layer. The layer property is selected as luminance and the opacity is adjusted to approximately 30–40 %. This will lift up the faint information without boosting the brightest parts and sacrificing the color. After flattening both layers the color saturation should be typically increased by 15–20 %. This luminance incorporation should be repeated 2–4 times in the same way. The better the luminance quality, the more strength should be given to the luminance part. This step by step procedure will give optimum control of the color during the luminance incorporation procedure.

H-Alpha and NB Incorporation

An H-alpha filtered image typically contains many fine details in relatively high S/N ratio. The signal is so much stronger than the information from an RGB image that it will not produce an aesthetically pleasing result when we use the H-alpha as luminance in an RGB image. The resulting image will be of muted color, with pink shades dominating. A better method is to add the H-alpha signal to the red channel. This will produce a more saturated image but will result in the red channel dominating with suppression of the H-beta/O-III hues. Therefore the RGB image should be shifted partly towards the blue-magenta direction before starting the blending procedure. This is done by the following procedure: Open the RGB image as a background layer. Then copy and paste the H-alpha image as a new layer.

Choose adjustments/levels, and from the channel drop-down menu select the green channel and move the black point from the left side totally to the right side. Then do the same while the blue channel is selected. A purely red layer will remain. Then set the blending mode for this layer to "screen."

By adjusting the opacity of this layer you can adjust the strength of the H-alpha blending into the RGB layer. Additionally it can be helpful to modify the H-alpha layer by using the adjustment/curves menu, pulling down the medium bright parts of the histogram. This can improve the overall color balance but will also reduce the weakest parts of the H-alpha and will allow the other colors to shine through. Most important for the blending procedure is not to sacrifice the overall RGB balance of the final image. The star colors typically will not be disturbed by this blending procedure.

Using the same procedure an O-III channel can be used to improve an RGB image. Use the adjustments/levels menu again and from the channel drop-down menu select the red channel and move the black point from the left side totally to the right side. This will result in a totally cyan image that contains the information for the green and blue channel. Then set the blending mode for this layer to "screen" and adjust the opacity according the best visual impression. Again the star colors typically will not be disturbed.

Final Retouches

After incorporation of the luminance or synthetic luminance the image should be carefully checked in full resolution. If the noise level is in the optimum range, this means it should be visible but not dominant. A smooth image without any noise will look artificial and a bit unrealistic. A low level of noise (fine graininess) will help the eye to detect small scale details (Fig. 17).

A full-size image typically shows up to 4,096 pixels in one direction. For presenting in Web applications a size of 2,000–2,500 pixels in one direction corresponding to 50–60 % size should not be exceeded. Also smaller versions should be available for Web presentation to get the image loaded quickly and to have an overview of the whole image area. The reduction of the image size should be done in *Photoshop* using the "bilinear" resampling method. This helps to keep the star sizes as small as possible. After reduction of size typically a light unsharp mask using a radius of 0.6 pixel, 0 threshold and 10–15 % amount should be applied to improve the crispness of the image. Orientation can be portrait or landscape. Landscape will provide the optimum use of screen dimensions. That said, portrait format can be particularly attractive in certain situations. Orientation and presentation is discussed more extensively in another section.

Enhancing procedures described in the RGB section can be applied as well in the final LRGB image such as high pass filter, unsharp masking, or noise handling. Final color balance and saturation should be judged on each image size separately. The smaller the image size, the sharper the image will appear, but the less

Fig. 17 Workflow: part 3

small-scale details can be recognized. After finishing your processing save and back up your data. Then come back the next day for final judging on the image. A good rest and relook at the final image with fresh eyes is an important step.

Color Management and Profiling

The primary goal of color management is to obtain a good match across color devices such as digital cameras, scanners, monitors and printers.

The International Color Consortium (ICC) is an industry consortium that has defined color profiles, so-called ICC profiles. An ICC profile is a set of data that characterizes a color input or output device, or a color space. So each device that captures or displays color can be profiled; some manufacturers of such devices supply ICC profiles within their software for color management. In color theory, the gamut of a device is that portion of the color space that can be represented, or reproduced.

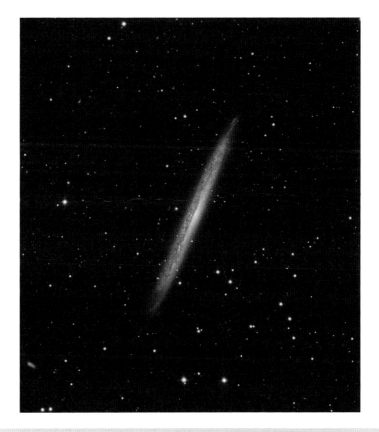

Fig. 18 Final LRGB image of NGC 5907; total exposure 15 h

Image formats such as TIFF, JPG and PNG may contain embedded color profiles. This is important for devices that use the image for displaying or printing. Several working color spaces have been defined, such as adobe RGB, sRGB or ProPhoto with increasing gamut.

The selection of the color space depends on the use of the produced photos. If Internet publication is the main purpose the s-RGB color space should be chosen. This allows the narrowest gamut of colors; however the sRGB profile is integrated in all relevant browsers except Google Chrome and should show correct colors and brightness if monitors are calibrated. Monitors that are not calibrated may clip the dark or white end of an image or may clip deep colors.

If printing is planned as the main purpose, the adobe RGB color space should be chosen as it allows a larger gamut of colors. For printing a color profile should definitely be used. Typically the sRGB gamut meets or exceeds the gamut of an inkjet printer, however some high quality digital printers can produce artifacts from images based on sRGB profiles (Fig. 18).

Useful Links

http://panther-observatory.com (author's homepage)
http://www.astrophoton.com/tips.htm (Bernhard Hubl)
http://astroanarchy.blogspot.co.at/2009/11/power-of-tone-mapping.html (J-P Metsavainio)
http://www.ing.iac.es/Astronomy/observing/conditions/skybr/skybr.html (sky brightness by ING)
http://www.adobe.com/designcenter-archive/creativesuite/articles/cs3ap_colorworkflows_06.html

Deep Sky Imaging: Workflow 3

Steve Mazlin

Before You Pull the Trigger

Image processing starts before the first photons are collected. If that rings true, please remember to credit me with saying it; if not, well, I'm sure another imager must have said it first. Truthfully, it is essential to study our prey before pulling the trigger. Reviewing professional images will give a good idea of what can be achieved when hardware, seeing, and light pollution aren't limiting factors, despite the fact that professional images aren't always processed with aesthetics in mind. Amateur images, on the other hand, will give more realistic expectations, and hopefully spur us to do better! However there is a balance. Spending too much time obsessing before processing, in my opinion, is a bad idea – preconceived notions of what a galaxy or nebula *should* look like tends to stifle creativity.

There's another reason to stop and think before opening the shutter. When a processed image stares back at me on the screen, I sometimes contemplate rotation to enhance the visual appeal. Isn't it more logical to plan for this before acquiring any data? Granted, there is always the potential that a scarcity of guide stars will necessitate a certain orientation of the camera, but many times, especially in wider field imaging, guide stars are plentiful. That's the time to carefully consider image orientation. Maybe a 30° rotation of the camera will bring into view an interesting grouping of stars? Bright stars, especially with prominent diffraction spikes, in my opinion really help to anchor the deep sky object in space and add immeasurably

to the visual "punch" of the final product. (All other things being equal, laymen prefer images with spikes – and we're not only creating images for our own amusement, are we?)

Pruning Data

At CTIO in Chile, our imaging group (which also includes Jack Harvey, Rick Gilbert, and Daniel Verschatse) remotely operates a 16″ RC, in conjunction with the Astronomy Department at UNC Chapel Hill. Jack Harvey worked tirelessly to arrange this Pro/Am collaboration, and I am very grateful for the opportunity to image at this world-class site. The amateurs are in control for 2 weeks per month (when the Moon is down), unless a GRB (gamma ray burst) forces the pros to commandeer the 'scope. The weather tends to be good at CTIO, and I estimate that we only have 25 % down time for wind/clouds or poor seeing over the course of an average year. In the past we also imaged with an FSQ, which was far more wind and seeing resistant, so the time spent idle was even less. Since we only shoot one or possibly two targets per cycle, we end up with a ton of data. If image quality trumps all else, then this is surely the way to go. It also gives us the luxury of ruthlessly pruning the data.

I use *CCD Inspector* to provide me with a numerical examination of the files, and based on the numbers, I delete at least 10–15 % of the frames for either poor resolution (FWHM > 2.0″) or poor aspect ratio (star elongation). I delete another 10 % for low contrast. However, I will never be "instrument rated" – I always fly by "visual flight rules," and look at *every* frame! Some images that appear great "by the numbers" are still subpar. For instance, thin clouds may obliterate nebulosity but still allow stars to show through. A double exposure effect can occur if the guider locks on to another star during the exposure. In both cases the data from *CCD Inspector* may look deceptively normal. Of course, airplane/satellite trails will not show up in CCD Inspector either, but these frames often can be retained, especially if a robust data rejection algorithm is employed during image integration.

If the luminance imaging had unexpectedly bad seeing, then I keep all but the absolutely worst frames. I make two master Lum frames, one with all of the data, eventually to be used for the dimmer portions of the object and surrounding background, in an attempt to maximize the SNR in these regions. The second Lum master selectively contains the frames with the best FWHM – which is only a fraction of the data but may be enough to use in the high SNR regions of the object (such as the bright portions of a galaxy), and will maximize the *resolution* in those areas. The peripheral areas from the first frame and central areas from the second frame are easily combined in *Photoshop*.

I am less critical of the RGB data and can tolerate much lower resolution, but only if there will be a luminance layer "above" the RGB layer in *Photoshop* (in luminosity mode). If you have never tried this, please open an LRGB image

in *Photoshop* that still has separate L and RGB layers. Now blur the RGB layer to see how far you can go before the image shows any sign of deterioration. Surprising, huh?

Even though RGB data is more forgiving than Lum data for LRGB imaging, and the reduced resolution with 2×2 binning won't be noticeable in most LRGB images, we still shoot everything unbinned. The improved SNR from binning the color 2×2 isn't an issue when so much data is collected anyway, and unbinned data is much more flexible. Unbinned RGB data can be kept grayscale and combined to make a synthetic Lum master, or it can be integrated with the Lum data for a semi-synthetic Lum master. Maybe a portion of the image (or even the entire image) looks better as a straight RGB, and luminance data isn't needed in that portion (or the entire image) at all?

A final word about binned data. Many think that binning 2×2 automatically doubles SNR, but in reality the benefits of binning are reduced as light pollution increases.

By the way, poor aspect ratio (oval stars) is a problem we have battled over the last few years at CTIO. In a sense, we are victims of our own success. We routinely achieve FWHM of 1.1–1.2″ in 15–30 min frames. When the stars are so tiny, they tend to show any deviation from a perfect circle (conversely, bloated stars are less likely to demonstrate aspect problems). Imaging at a focal length of over 4.5 m makes our system very sensitive to even a slight wind, which probably accounts for the intermittent appearance of the oval stars. However, there are some excellent ways of managing this during processing (to be discussed later).

Master Production

Master production begins with image calibration. Dark and bias frames are like fish – they stink if they get too old, so we frequently update our dark/bias library and make master calibration frames using data rejection software; I generally use *Maxim's* SD masking. Making good flat frames is an art unto itself, and beyond the scope of this chapter. After stretching the data, if I see residual dust motes and weird gradients, they are red flags for bad flats. Even in the absence of same, the inability to see subtle details in dimmer areas after stretching could be due to flat fielding errors.

I use *Maxim* for dark subtraction and flat fielding. Everything is batch processed. Then I quickly run through several frames and visually confirm that the dark subtraction was successful. Next, I produce a bad column map in *Maxim* – our camera has about 60–80 obvious aberrant columns. Unfortunately, many of the bad columns seem to change from month to month, so older bad column maps don't necessarily work. The bad column map is also applied through batch processing, and I examine several "before and after" frames from each filter to verify that the column repair worked. This is a hobby, I am not in a rush, and I enjoy obsessive attention to detail – you wouldn't be reading this book about processing unless you, too, had your share of obsessive traits!

I used to register the images in *Registar*, but now use *PixInsight's* star alignment tool exclusively for this purpose. The default settings always seem to work just fine. Finally, I recently started using *PixInsight's* blink tool to examine all of the dark subtracted, flat fielded, column repaired, aligned images one last time before integration. There's often a bad frame or two that gets yanked at this late stage. (Jack Harvey has been part of the *PixInsight* team for several years, and largely though his tutelage, my processing style is now a marriage of *PixInsight* and *Photoshop*.)

A good image integration algorithm is the best way to eliminate 95 % of the cosmetic clean-up that would otherwise be necessary at the end of processing. I now use *PixInsight's* version, which can be customized to a ridiculous degree. Perhaps those with a better grasp of mathematics than me can appreciate (and use) this tool to its fullest potential. The basic idea is a mean combine that also compensates for different background levels, automatically weights the frames based on a calculation of SNR, and performs rejection of outlier pixels. The large data sets we have (often more than 150 frames after pruning) are perfect for the winsorized sigma clipping algorithm. (Those in the peanut gallery may lament that we are "winsorizing" any non-sidereal phenomena, like asteroids, into oblivion. Too bad we can't do it for real.)

PixInsight has several other algorithms, including percentile clipping and averaged iterative sigma clipping for small data sets of less than 10 images.

Of course, data rejection works best when dithering is used during the data acquisition process. Dithering refers to a slight movement of the 'scope by a few pixels in x, y, or x and y between exposures. This causes hot or cold pixels to jump around on successive images (relative to the stars and deep sky object). These aberrant pixels are then easy prey for the data rejection software (as are cosmic ray hits, airplane trails, satellites, asteroids, etc.) Dithering and data rejection usually eliminates the need to use any hot/cold pixel filters.

All masters are saved as 32-bit FITS files with *PixInsight*. I also make 16-bit TIFF files for use in *Photoshop CS2*. (Yes, I still use *CS2*. Why mess with a classic?) For everything that follows, I will assume a basic understanding of the histogram, definitions of linear and nonlinear stretches, definitions of "black point" and "white point," use of the "levels" and "curves" tools, and the mechanics of assembling individual L, R, G, and B frames into an LRGB image in *Photoshop*. For those just starting out, Adam Block and Warren Keller have each produced wonderful tutorials on basic (and advanced) *Photoshop* techniques.

Color Combination

When I first started color processing over 10 years ago, I was quite anxious. I was certain that one day the "Color Police" would raid my dome and confiscate the equipment. Fortunately, although I am less neurotic (?) these days, I can still appreciate the difficulties of figuring out combine ratios when dealing with camera chips that have wavelength-dependent QE's, and RGB filters that are not necessarily produced to normalize that QE curve. I played around with G2V balancing when I

imaged from my backyard, but no longer do so. I just didn't think the ends justified the means, especially when considering the additional variable of elevation-dependent atmospheric extinction. (I remain sensitive to the fact that other highly talented imagers enthusiastically endorse the G2V technique.)

These days I just use my judgment. A good friend has reminded me of the famous Will Rogers quote, "Good judgment comes from experience, and a lot of that comes from bad judgment." I start by making an RGB in *Photoshop* and performing a series of linear stretches (dropping the white point with the levels tool). I know about how much asymmetry there needs to be when stretching (blue>green>red) in order to achieve an initial color palette that looks, well, natural – red in HII regions, blue in reflection nebulae, neutral background fields populated by blue and yellow stars, etc. Of course, the background won't be neutral unless the left side of histogram is equalized across the color channels by raising the black point, as necessary, with the levels tool.

The next step, while the data is still linear, is to assess for any color gradients. It may be necessary to (temporarily) brighten the image to visualize them. Another trick is to lasso an area of the background devoid of stars – look at the histogram to see whether one channel is right-shifted. Also, I check online for wider field images of the target to ensure that the presumptive gradient isn't really nebulosity, unless it is green, which almost ensures a light pollution issue. However, at CTIO light pollution gradients are minimal, so unless we (carelessly) shot the blue or green frames with the Moon up (red is more resistant), most gradients are from bad (sky) flats. I consider it a challenge to repair the gradients in *Photoshop* by hand, but I am not always as successful as I would like, especially with more complex gradients. Recently I have been using the "dynamic background extraction" (DBE) tool in *PixInsight* to take care of these.

After gradient repair, I usually continue the color processing with a nonlinear stretch, using the curves tool. I stop before any areas are oversaturated.

Luminance Processing

My 32-bit master luminance frame undergoes linear stretching, then LR Deconvolution in *Pixinsight* prior to any other processing. Remember that deconvolution operates on the PSF, which should be relatively uniform across the image – it doesn't vary with brightness. If nonlinear stretching is employed prior to decon algorithms, then the PSF is no longer uniform. To help prevent any star ringing artifacts, I use a star mask and the de-ringing option.

Not every deep sky object benefits from deconvolution, which can add noise and other artifacts to the image, and the improvement in resolution may not be worth it, such as in a nebula (or even galaxy) devoid of fine structure.

I apply curves in *PixInsight* just to the point that dimmer areas begin to show mild noise. Then I convert the image to 16 bits and continue processing in *Photoshop*. It makes sense to keep the data in 32 bits until the last possible moment.

If there are oversaturated regions (such as galactic cores), I create another layer (on top of the first) that is stretched less aggressively, lasso the region of interest, invert the selection, feather, delete, and flatten. Sometimes I think I can rule the world with the lasso and feather tools in *Photoshop*. I know many other imagers use far more advanced *Photoshop* techniques, including layer masks, but I have never felt the need to do so.

At this point I also try to use selective application of the high pass technique. This is essentially an edge sharpening tool that can have dramatic results in improving contrast in galaxies (dust lanes) and nebulae (ionization fronts). In short, create a duplicate layer on top of the original and select filter/other/high pass; then choose a radius – I use 10 pixels as a start, but experiment with both higher and lower; change the blend mode to overlay and inspect the result. Stars and other bright regions usually look over sharpened, while the background and other very dim areas become too noisy. I usually end up deleting this data from the high pass layer before flattening.

Unsharp masking, judiciously applied to areas of high SNR, is still an excellent tool as well. I may bring the image back into *PixInsight* for an application of "wavelets."

Assembling the LRGB

When the luminance image is placed in a layer above the RGB image using the luminosity mode in *Photoshop,* the initial image can be discouraging. Usually the colors are very under-saturated, even if the RGB image by itself looks OK. Now is the time that I increase saturation in *Photoshop*. The match color tool is sometimes better than the saturation tool, but only trial and error will decide. Increasing saturation too far, however, will cause a garish appearance, and only experience dictates how far is too far. Furthermore, enhancing saturation, like other image refinements, can be applied in a selective manner. I try to avoid saturating the background; otherwise previously undetected color gradients and/or noise may suddenly become noticeable.

As the color becomes richer, color noise also increases. I use *Neat Image,* a *Photoshop* plug-in, as my primary noise reduction software. A noise profile of the image is made first. I make separate profiles for the RGB and luminance layers. On the advanced tab for the noise filter settings, there are multiple choices. Generally I use the "remove half of stronger noise" for the RGB layer and "remove half of weaker noise" for the luminance layer. Remember that significant noise reduction or just plain (gaussian) blurring can be applied to the RGB layer without sacrificing any of the resolution in the final image. However, if the *Neat Image* result looks too smoothed, then edit/fade reduce noise can be a handy tool, or I can apply *Neat Image* to only specific parts of the image (using the lasso and feather tools, of course).

Noise reduction on the RGB layer may mute the colors slightly, requiring a tweak of the saturation tool again. At this point I may also play with the color

balance tool, paying attention to whether I am altering data in the "shadows, midtones, or highlight" areas of the image. Only rarely do I ever mess around with the hue adjustment.

Got Narrowband?

If you are considering using Ha or OIII data to enhance your RGB nebulae, consider our situation in Chile. We image at f/11.3, so a target better throw off enough narrowband photons to justify the hours needed to obtain an acceptable SNR. Many times the benefits of narrowband imaging are just not there, especially when imaging from really dark skies. The same goes for Ha imaging of galaxies to enhance the HII regions. Generally speaking I don't find it time well spent. On the other hand, if I have good Ha or OIII data, I will try to incorporate it in the final image. Many methods have been employed over the last decade.

Using the Ha as a luminance layer over an RGB image is *not* advised. It tends to produce salmon-colored nebulae and ruin the stars. Instead, I separate the RGB image into individual channels and put the stretched Ha data in a layer above the stretched red image, changing the blend mode to lighten. This should hopefully retain the enhanced contrast of the Ha image while bringing through the stars from the red image. This Ha/red composite is flattened and then recombined with the green and blue channels for a new RGB image. Then I do another Ha/red composite, this time leaving the blend mode normal, but reducing the Ha layer opacity to about 50 % before flattening. I use this as a luminance layer over the (Ha+R)GB, or perhaps first combine it at 50 % opacity with the stretched luminance data. I always compare the end result with a straight LRGB, RRGB, etc., to see whether it benefits (or not) from the narrowband inclusion.

In a similar manner, OIII data can be combined with the blue channel in lighten mode (or both the blue and green channels at different opacities, usually B>G). In this manner I end up with an RGB that is hopefully in actuality (Ha+R)(OIII+G)(OIII+B) showcasing the narrowband's superior contrast with the RGB's superior stars. Then, if the Ha and OIII data are of sufficient quality, I may try to combine them and create a luminance layer on top of the (Ha+R)(OIII+G)(OIII+B), dialing back the opacity of this luminance layer to allow the RGB stars to show through. This was the basic method used to create the image of Thor's Helmet, NGC 2359.

Cosmetic Enhancements

The image is almost done, but invariably when I analyze it at high magnification, I see "ugly" bloated, oval, or otherwise irregular stars. There are stars that have darker rings around them, stars with spiky edges, or stars of predominantly one color that have off-color regions. The dim background portions of the image may contain

splotches of aberrantly colored pixels, or areas of noticeable graininess. Obviously, some of these problems can be traced to optical issues or tracking/guiding errors, others from chip defects, and still others from over-aggressive processing techniques (especially in areas of low SNR). Fortunately, there are multiple methods to neutralize the aesthetic impact of these problems. Is this cheating? Not unless it's also cheating to wear glasses if you have astigmatism, at least in my opinion.

Here are two of my favorite methods, though I claim no originality in employing these.

Oval stars are fixed using the radial blur filter in *Photoshop*. Lasso the offensive stars one at a time with the elliptical marquee tool; enlarge the selection by a few pixels; feather; choose filter/blur/radial blur; then on the radial blur window move the slider to about 70–80 and select spin and best.

The above is great for fixing a few large bright irregular stars, not dozens of small oval stars. If that's the case, use the pixel offset technique. First, rotate the image so that the major axis of the elongated stars is either vertical or horizontal; create a duplicate layer above the original; select the stars in the duplicate layer using the color range tool; enlarge the selection by a few pixels; feather; select filter/other/offset and choose 1 or 2 pixels in horizontal or vertical direction; change blend mode to darken; flatten; and finally, de-rotate.

Bloated stars are fixed using the spherize filter. Once again, select the offensive stars one at a time, feather, choose filter/distort/spherize, and try moving the slider about 3/4s of the way to the left. In my version of *Photoshop CS2,* this method requires the image be converted to 8 bits, but at this stage of processing, the loss of data is inconsequential. Note that the radial blur technique will cause some bloating, so the two methods are a natural to use together.

Final Tweaks

I thoroughly scan the image at 400 % looking for any reasons to use the clone stamp tool – colored bloopers, residual traces of bad columns, etc. (Jack Harvey always warns me not to clone out "real science," mistaking it for artifact.) I reduce the magnification and experiment with making minor tweaks of the brightness, contrast, or color. I usually resample the image at 1.5–2× to help eliminate any pixelation artifact.

So we have come full circle, back to the beginning of the chapter, when I was staring at my monitor, wondering whether to rotate the image, or maybe crop it slightly. Cropping is a poor man's way to eliminate field curvature effects (literally, since field flatteners can be very pricey) and even gradients. Many imagers post both full field and cropped versions on line, and others allow Web visitors to use nifty zoom functions. I still print many images, and cropping (then enlarging) is necessary to reveal details in small objects that are otherwise invisible.

I don't follow any absolute rules regarding rotation, but in general, I like my galaxy images to impart a kinetic quality. Face-on (or nearly face-on) spirals with clearly defined arms will automatically create this effect. Edge-on spirals or irregular galaxies without prominent arms will need some help. The long axis should be tilted from the horizontal by about 30–45°. Nebulae are a more heterogeneous group, but I still experiment with rotation, or horizontal/vertical flipping to see whether these different perspectives give a greater sense of action. Maybe repositioning an infrequently imaged nebulae will reveal a previously unrecognized resemblance to something (or someone), and you will be credited with the "discovery"! (As far as I can tell, I was the first to "see" the Statue of Liberty in NGC 3576, but please contact me if you know otherwise.)

Overview of Thor's Helmet Processing

Here is a quick summary of the processing I used on Thor's Helmet, minus the data pruning and image calibration/integration steps (Figs. 1, 2, 3, 4, 5, 6, 7, 8, 9, 10 and 11).

Fig. 1 R,G, & B Masters merged into RGB image in *Photoshop,* and linearly stretched with levels; unbalanced histogram corrected by raising black point of red (and then green) channel until background is neutral

Fig. 2 Additional nonlinear stretches of RGB with curves (and remanipulation of black point to keep background neutral) produces recognizable image of Thor

Fig. 3 In *PixInsight*, Ha master is stretched with levels, then star mask applied to "protect" stars while LR deconvolution is performed. Same procedure done to OIII master

Overview of Thor's Helmet Processing

Fig. 4 Additional stretching of Ha (and then OIII) in PS with curves, but a brighter area in image is excluded from the selection

Fig. 5 Ha (and then OIII) undergoes high pass filtering in PS, but dimmer areas in image as well as background are deleted from the high pass layer

Fig. 6 Ha and OIII data are combined by placing the OIII above the Ha layer in PS, then changing blend mode to lighten

Fig. 7 RGB is split into R, G, and B channels. Blue and OIII data are combined by placing OIII above the blue layer in PS, then changing the blend mode to lighten. In similar manner, green is also combined with OIII, and red with Ha

Overview of Thor's Helmet Processing

Fig. 8 A new RGB is reassembled, actually a (R+Ha)(G+OIII)(B+OIII)

Fig. 9 Ha/OIII composite is used as a luminance layer above the (R+Ha)(G+OIII)(B+OIII) layer, with blend mode changed to luminosity; additional brightening and color saturation performed; opacity of the top layer reduced to allow the RGB stars to show through

Fig. 10 Noise reduction performed on both layers referred to in Fig. 9, using *Neat Image* in PS

Fig. 11 Oval stars corrected using Pixel Offset in PS. Note that the degree of elongation has been exaggerated for teaching purposes

b

Fig. 11 (continued)

Final Words

Wow! Back in 1997 I took my first grainy unguided 3 min black and white exposure of M51, and I have never since lost interest in this hobby. Have I become frustrated? Plenty of times, but tired or bored – never. Sure, I sometimes wish I had more money for bigger/better equipment, and even more often I wish I had better grounding in many of the mathematical aspects of data acquisition and processing. But there's no time to go back to school, because raw images are piling up on my hard drive. So, good luck developing a workflow that works for you, and now if you will excuse me, I think I have some processing to do…

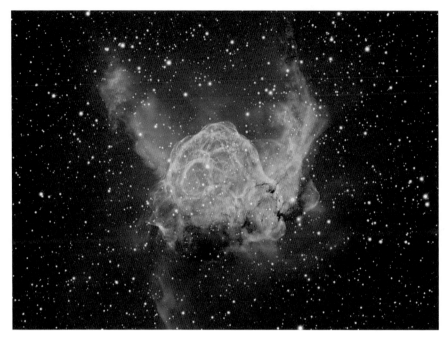

Thor's Helmet

High Resolution Lunar and Planetary Imaging

Damian Peach

Introduction

Photographing the Moon and planets has long been a mainstay of both amateur and professional astronomy. It wasn't so long ago that images from Voyager were wowing astronomers and scientists while amateurs struggled away working with photographic film attempting to capture clear images of our nearest neighbors – and I think it's fair to say falling well short of not only what spacecraft were recording but also of what visual observers were recording with pencil and paper.

Since these times a revolution has occurred within this field of Astronomy. Gone are the days of blurry and fuzzy photographs showing little in the way of fine detail. Major leaps forward in technology have enabled the amateur astronomer of today to produce imagery far better than the best film photographs obtained with the world's largest telescopes.

Choosing the Right Telescope

Telescopes come in many designs, shapes and sizes and selecting the right telescope for the purpose of high resolution imaging is very important. You'll often read about how important it is to have a small central obstruction or the very finest

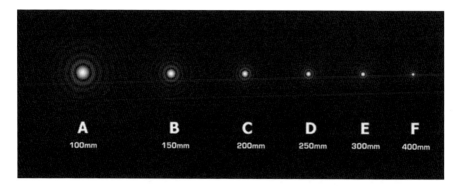

Fig. 1 Theoretical airy disk sizes of varying apertures based on observations by W. R. Dawes. In reality this limit can be exceeded on extended objects such as planets, especially when equipped with modern high speed CCD cameras and sophisticated image processing techniques (Photo by the author)

optical quality or how refractors have better contrast and certain telescope designs are "no good for planetary work." Let's examine the most popular designs in more detail (Fig. 1):

Refractors

The refracting telescope has always been a favored choice of planetary observers, especially during the era dominated by visual observers. Refractors come in two designs – achromatic and the more expensive apochromatic. In simple terms an unobstructed telescope (such as a refractor) with very high quality optics will deliver a high level of image contrast and resolution at its theoretical limit (seeing permitting). So we could say a large aperture refractor with top quality optics would be the best choice and indeed it would be – in theory.

Sadly high quality refractors in apertures over 18 cm (7″) cost considerable sums of money beyond the scope of many observers, and apertures below this deliver insufficient resolution to really exploit the capability of modern imaging equipment (no matter how good the optics might be). Although refractors in the 10–15 cm (4″–6″) range can certainly produce good quality imagery they cannot come close to competing with the imagery delivered by large reflecting telescopes. Achromatic refractors also suffer with chromatic aberration making them difficult to use for planetary imaging.

Of course one great aspect of the refractor is that it is largely maintenance free and typically cools down very quickly if brought from indoors to the outside environment. Refractors also don't usually require any collimation of the optical elements, as this is often done by the manufacturers themselves. A refractor would be a good choice for those who must set up their telescope each time or do not have a permanent site for their telescope.

Newtonian Reflectors

The Newtonian reflecting telescope is by far and away one of the most popular and affordable telescope designs around. Reflectors come in a wide variety of aperture sizes and can be mounted in a variety of ways. Apertures from 20 cm (8″) to 40 cm (16″) are well suited to the task of high resolution imaging work, though of course telescopes toward the larger end of this range will almost certainly require a permanent site.

Unlike refractors the Newtonian reflector requires rather more patience and knowledge to get working well. They require careful collimation of the optics and will also require a sturdy mount to handle the often quite long tube. Large apertures also require some kind of cooling system to help the primary mirror reach ambient temperature; otherwise the telescope performance could be seriously compromised.

The main downside of the Newtonian is that it is more complex to get working well compared to many other telescope designs (collimation of the optics can be a time consuming and confusing process to those not familiar with Newtonian collimation). The eyepiece can also end up in very awkward positions, and with larger apertures a ladder may well be required at times.

This said many observers today use Newtonians to image the Moon and planets, and they offer the amateur observer excellent image quality with large aperture sizes at an affordable price.

Schmidt Cassegrains

The Schmidt Cassegrain (SCT) is another very popular telescope design primarily made available through two manufacturers – Meade and Celestron. Aperture sizes range from 20 cm (8″) to 40 cm (16″). The telescopes come in a wide variety of packages from simple German equatorially mounted telescopes to complex GOTO systems with sophisticated software.

Unlike refractors or Newtonians, SCTs are typically supplied with a focal ratio of F10 or greater at prime focus. This may sound good, but as they are a folded optical system the primary is typically figured to F2, making them very sensitive to collimation and also quite difficult to manufacture to a high level of optical quality. Quality can vary from unit to unit, though I have looked through many more good than bad ones. SCTs offer a wide range of focus and the ability to use a wide range of different accessories. They are also highly transportable in smaller apertures, and a 20 cm (8″) SCT would be a great choice for those on a limited budget or that have no permanent home for a telescope.

The downsides of the SCT are really their critical collimation requirements and cooling/thermal problems that can occur in the large aperture models. They can also suffer mirror shift problems as the primary is moved during manual focusing, further adding to the importance of checking telescope collimation regularly.

Fig. 2 My own primary telescope – a Celestron 36 cm SCT on a German equatorial mount (Photo by the author)

That said my own primary telescope is a 36 cm (14″) SCT, and I have nothing but praise for this telescope. It remains a fact that among the finest images of the planets ever taken from the ground are with large aperture SCTs in experienced hands (Fig. 2).

Other Designs

There are several other types of telescopes that have become popular in recent times. Designs such as the Maksutov, Ritchey Chrétien (RC) and Dall Kirkham (DK) are now widely in use by many amateurs.

In general RC's are not well suited or widely used for high resolution planetary imaging due to their often excessively large central obstruction and high cost. Maksutovs, however, are in common use in apertures below 20 cm (8″) and are well suited to the task. I would strongly recommend against Maksutovs larger than 20 cm (8″) aperture, as most are prone to serious problems in reaching ambient temperature from typical amateur sites where the temperature swings from day to night can be significant. Indeed, I have personal experience of using a 25 cm Maksutov that simply never reached thermal equilibrium (even after many hours outside).

The Dall Kirkham design has been made popular primarily through the Japanese manufacturer Takahashi and their Mewlon range of telescopes. These are very well-

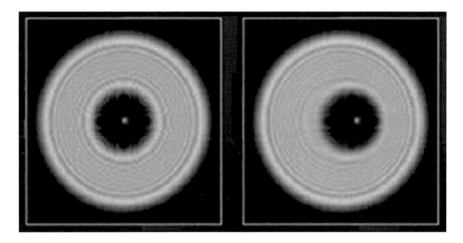

Fig. 3 The view of an out-of-focus star in a properly collimated (*left*) and badly collimated (*right*) telescope. Using a telescope in a poorly collimated condition will result in it performing well below its true resolving capabilities (Photo by the author)

made instruments that are well suited to planetary imaging. They are available in 18 cm (7″) up to 30 cm (12″) aperture. The biggest downside is that they are very expensive in larger apertures.

Regardless of what telescope you choose to use there are several important points that apply:

- Collimation of the Optics – This is vital, especially with reflecting telescopes. Many guides are available online and indeed are often provided with the purchase of a new telescope. Also keep in mind it is a good idea to check the telescope collimation regularly, especially if it is being moved outside each time.
- Thermal Equilibrium – The telescope must be allowed as much time as possible to reach thermal equilibrium with the outside air, especially with larger apertures.
- Focusing – Do not battle with an inadequate focusing mechanism (such as the standard focusing knob on an SCT). Invest in a decent motorized system that allows very fine focusing adjustments without having to touch the telescope.
- Usability – Overlook this at your peril! There is nothing worse than ending up with a telescope that is difficult and cumbersome to use. Choose something that you think you'll be able to use easily and frequently (Fig. 3).

Choosing the Right Camera

Camera technology is a fast-moving area and is the one primarily responsible for the vast leaps in image quality that have taken place in this field of astronomy over the last decade. Gone are the slow transfer rates of old CCD cameras, where

Fig. 4 Two of the most popular high end cameras in use at present – the LumeneraSKYnyx 2.0 M and Point Grey Flea3 (Photo by the author)

perhaps only one image every few seconds could be obtained. The best cameras in use by amateurs today are able to shoot at rates of more than 100 fps (frames per second). All typically operate from similar software packages that allow control over various important settings such as exposure, frame rate and gain.

Unlike the cameras used for deep sky work, which require dark frames and flat fields, this is not the case with imaging the planets. Also cameras used for planetary work are not Peltier-cooled like their deep sky counterparts. Since exposure times are very short and the field of view very small problems with dark current or vignetting are not at all intrusive as they often are with the long exposure and wide fields of view in deep sky imaging.

The majority of noise in modern planetary cameras comes from readout, although cameras in use such as the Flea 3 produce a very smooth raw output in either 8-bit or 16-bit and in a variety of image formats. A small sensor size such as the 640×480 array used in most planetary cameras is plenty enough for imaging the planets, though those interested more in lunar work may want to take a look at cameras with larger sensors.

There are several camera choices available ranging in price. Below I detail the most popular models and their pros and cons:

Phillips ToUcam Pro/SPC900

This camera caused a revolution within planetary imaging back in 2001–2002 when observers first started using it. It is basically a cheap consumer webcam with a small 640×480 color CCD chip that runs via USB2 and is capable of delivering good image quality up to 10 images per second. Although these are no longer made many appear on the second hand market for very low prices, and they still make an excellent choice for those looking to start out in imaging the planets (Fig. 4).

Imaging Source DMK21AU618

The DMK range of cameras have been in popular use for several years now and a wide range of models are available. The 21 AU618, however, is perhaps the one best suited to planetary imaging at the time of writing. It offers frame rates up to 60 images per second, and with a very sensitive monochrome 640×480 CCD sensor at its heart, as with the ToUcam, operates via USB2. This camera would be a great choice for those looking to upgrade from a one-shot color imager like the ToUcam. Though a lot more expensive it offers considerably better image quality.

LumeneraSKYnyx 2.0 M/C

Lumenera Corporation, as with Imaging Source, produces a wide array of cameras that are well suited to the task of imaging the Moon and planets. The most popular camera among the imaging fraternity is the SKYnyx 2.0 M or 2.0C (monochrome or color) imaging camera. This well-made camera operates via USB2 and is equipped with a 640×480 CCD sensor and offers frame rates of up to 60 images per second. Lumenera also offer larger CCD chip sizes in their cameras such as in the 2-1 M, which is ideally suited to imaging the Moon.

Point Grey Research Flea 3

The Flea 3 from Point Grey is at the time of writing the best camera available for planetary imaging purposes and also one of the most expensive (especially compared to DMK and Lumenera counterparts of the same CCD sensor size.) Unlike the other cameras this one operates via a firewire hook-up, so it is essential your imaging computer is equipped with firewire capability. The camera is also equipped with a very sensitive 640×480 sensor and offers frame rates of up to 120 images per second. The camera head itself is also small and light, making it well suited to imaging the planets.

Image Processing Software

Those involved in planetary imaging are fortunate to have two excellent pieces of image processing software at hand to deal with the often large amounts of data generated by these cameras. *Registax 6* and *Autostakkert 2* (both available for free download) cover almost every aspect of processing lunar and planetary image sequences, and I've used both extensively. *Registax* came out at around the same time as the Phillips ToUcam and was instrumental in helping to push image quality

forwards and remains the most popular piece of software in use today by planetary observers. It can deal with image sequences in a wide variety of formats and takes the user through to the stage of producing a final sharpened image.

Autostakkert 2 is a more recent piece of software, and although not offering as many features as *Registax 6* it does offer some very effective image alignment routines that are well worth trying. Both software packages operate in a similar way and are quite user friendly. I cover in more detail image processing specifics with these programs later in this chapter.

Astronomical Seeing

Astronomical seeing (the steadiness of the atmosphere above the observer) is without doubt the single biggest limiting factor in how good ground-based planetary images will be. It is an often variable and complex phenomenon that belies any simple or straightforward attempt at prediction.

Earth's atmosphere is an extremely complex and chaotic creature. When one considers that we are looking through a ~20 km deep ocean of air, it's a wonder that we ever see a stable image through our telescopes. Almost all of the effects imparted by seeing are as a result of the mixing of air of different temperatures within Earth's troposphere.

The layer of air within the first few hundred meters of the surface is where the vast majority of atmospheric turbulence occurs (quite contrary to most that assume it is the high altitude jet stream to blame). This low layer is strongly affected by surface obstructions such as buildings, hills, mountains, etc. The drag created with air moving over typical land surfaces generates both vertical and horizontal mixing within this low layer. Differential heating of the varied surface terrain typical at many locations also generates this kind of mixing; however, the effects of drag and mixing over uniform terrain are much less, especially over open water (Fig. 5).

Nearby houses or tall buildings can have adverse effects on air at this altitude, and the vast majority of turbulence experienced in amateur telescopes occurs within this layer of air, extending only a couple of hundred meters up. Extensive atmospheric seeing monitoring programs conducted at various astronomical observatories confirm that much of the turbulence experienced occurs fairly close to the surface.

However, as many may well know, turbulence can also be the result of phenomena occurring high in Earth's atmosphere. At this altitude the air is very thin, but this is where we find the fast moving river of air known as the jet stream. The effects this feature imparts on neighboring air masses (typically strong horizontal and vertical wind shear) can have significant repercussions on the seeing conditions experienced down at the surface.

As already mentioned, the jet stream resides in this region – a fast moving ribbon of air that varies widely in latitude and is stronger in the winter months than in the summer. It is driven primarily by the strong difference in temperature between the polar/tropical air masses (which of course are stronger in winter

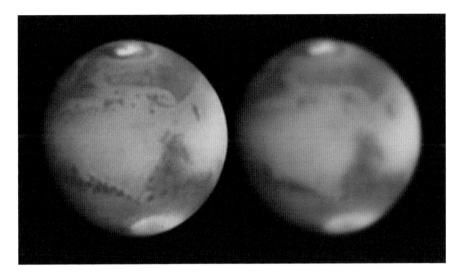

Fig. 5 Two images of Mars taken with the same telescope/camera and processing configuration. The difference in quality is entirely due to the quality of the seeing conditions at the time of capture (Photo by the author)

months when the far northern and southern latitudes become very cold while the tropical temperatures remain much the same all year round). It affects the temperate latitudes worst of all. Latitudes within approximately 20° of the equator rarely ever see the effects of this phenomenon, so immediately these regions of Earth become favorable locations for high resolution imaging.

Fortunately there are many forecasting tools available online today that can be used to monitor Earth's atmosphere. Detailed forecasting models and satellite imagery is widely available through a multitude of web pages. Forecasting models are especially useful for monitoring/predicting atmospheric seeing (Fig. 6).

Although forecasting tools are useful it still remains the case that the only real way to know what the seeing is doing is to go outside and look through the telescope. Methods such as the observation of star twinkling by the naked eye are often woefully inaccurate, so I advise against using this. Though good seeing can occur anywhere certain locations are far more favored than others. Coastal sites with onshore winds are the most favored places to experience good seeing, while sites surrounded by mountains will likely suffer with frequent poor seeing. The best sites of all are to be found at locations where the prevailing winds have crossed a vast expanse of ocean before reaching the observer and the jet stream is absent. It's no coincidence that the world's foremost observatories are all located at such sites, and indeed my own favored overseas site at Barbados meets this requirement.

In general, though, keep watch for regions of high pressure on the weather forecast. These systems are the most likely to bring good seeing. Also be sure to try and minimize the effects of local turbulence. Locate the telescope well away from the house and try not to look at anything placed low over rooftops.

Fig. 6 Modern forecasting charts are very useful to help gauge potential seeing conditions. This chart from the NOAA Global Forecast System (GFS) model shows the wind speed at the 10 km level over Europe. Many websites with forecast information are available online (Image courtesy of NOAA)

Capturing the Images

In this section I detail how to actually capture imagery of the Moon and planets. In general you'll need to increase the focal length of your telescope using some kind of amplification system (such as a Barlow lens or eyepiece projection system). You need to aim to achieve a focal length of between F25–50, depending upon the object (with really only Mars tolerating the upper end of this scale well).

Another important consideration here is focusing. This is an area about which I am often asked what are the best methods. The simple answer is really whatever you find works best for you; however, there are some general rules that apply:

1. Upgrade your telescope focuser to a motorized unit than can be operated without having to touch the telescope. This is *vital* for this kind of astrophotography!

Imaging the Moon

Fig. 7 A motorized focuser that allows focusing without having to touch the telescope is an essential piece of equipment for planetary imaging. This JMI unit pictured is a popular choice among observers (Photo by the author)

2. I focus on the planetary disk itself, and go back and forth through focus until you get a feel for the system. Also refocus for each filter you use.
3. Focusing in poor seeing is extremely difficult, so don't be discouraged. In good seeing focusing precisely can be fairly straightforward.
4. Use areas of good contrast to gauge focus (such as the Cassini division in Saturn's rings.)
5. Focusing carefully is a very important step in obtaining good images. The best advice here is simply time and practice. The more you do it, the more you'll get a good feel for the system you use. However do not battle with manual focusing via a knob where you have to touch the telescope. This is hopelessly inadequate for high resolution imaging (Fig. 7)!

Imaging the Moon

The Moon is without doubt one of the night sky's most captivating targets for telescopes of all sizes. Even small telescopes will reveal a wide array of detail across its surface. With modern imaging equipment coupled to typical amateur-size telescopes it is now possible to take extremely detailed imagery of the lunar surface rivaling the photography of early lunar orbiter probes.

Focal Length and Sampling

These are two important points to consider. To stand a good chance of your telescope resolving detail to its theoretical limits (astronomical seeing permitting) we need to consider an appropriate image scale at the focus of the telescope. As a general rule using the typical cameras in popular use (such as those outlined earlier in this chapter) you'll need to be operating at a focal ratio of between approximately F30–40 or an image sampling of around two pixels covering the theoretical Dawes resolving limit of the telescope (so for an 20 cm telescope a sampling of around 0.28 arcsec/pixel would be appropriate.) The formula for calculating this is:

$$206 \times CCD \text{ } pixel \text{ } size \text{ } (um) / \text{ } focal \text{ } length \text{ } (mm)$$
$$= image \text{ } scale \text{ } in \text{ } arc \text{ } seconds \text{ } / \text{ } pixel \text{ } on \text{ } the \text{ } CCD \text{ } chip.$$

So for example with a 25 cm telescope at F30 and a CCD chip with 5.6um pixels the image scale would be 0.15″ per pixel ($206 \times 5.6/7620 = 0.15$).

Achieving the right focal length can be attained through the use of a good quality Barlow lens or eyepiece projection system (many of which are available).

Field of View

One of the trickiest aspects of imaging the Moon is the limited field of view. Most large craters will not fit into a single field of view, especially when using large apertures at high focal lengths. This means we must take a mosaic of images to cover the area we want and stitch these together in the later stages of image processing. This is something I've done with much of my own lunar work over the years, and with practice it actually works really well. Those using cameras equipped with larger sensors probably won't need to do this, thus making the process of capturing certain lunar features less time consuming (Fig. 8).

Filters

Color filters are a great way to help improve image quality. Red and IR filters work well on the Moon as they help steady the seeing. (Long wavelengths are less affected by our atmosphere.) Large apertures will find such filters especially beneficial.

Capturing the Data

You'll typically be operating the camera at between 30 and 60 frames per second, capturing a minimum of 1,000 frames. Try and keep the camera gain setting well

Fig. 8 The famous crater Plato is a favorite target of lunar observers. This view clearly shows countless small craterlets littered across its floor, many smaller than 1 km across. 36 cm SCT. Flea3 camera (Photo by the author)

below maximum. If capturing a mosaic of a feature be sure you don't miss a section of the feature. If you are unsure as to whether you have captured a particular region shoot it again. It is all too easy to start putting your jigsaw together at the end only to find a piece is missing!

Lunar Lighting and Phases

Many lunar features change dramatically as the lighting changes throughout the month. It can be very rewarding to return to familiar features regularly to watch how they change, so don't just stick to shooting the Moon at the classic times of first or last quarter!

Mercury and Venus

The Solar System's two inner most planets are fairly neglected targets (especially Mercury), primarily due to their limited periods of visibility. Mercury is a very challenging object never appearing more than 28° from the Sun (and most of the

time less). It also presents a small angular diameter much of the time, further adding to the difficulty.

Venus, however, is quite the opposite. The most brilliant object in the sky (apart from the Sun and Moon) it is an easy target for imagers during favorable elongations from the Sun. In visible wavelengths Venus appears rather bland and featureless; however, with the right filters employed its ever changing atmosphere can be captured, changing in appearance from day to day.

Filters

The most important aspect of imaging these planets is to employ filters. Both planets have a very high surface brightness, so a wide range of filters can be easily employed. Mercury IR filters are ideal, since you'll almost certainly be imaging the planet while it is very low in the sky (unless you can find it during daylight hours). IR filters help to steady the seeing and improve contrast and detail on the planet's surface.

With Venus we move to the other end of the spectrum. Violet or UV filters are ideal for bringing out the classic dark and bright swirls in the upper atmosphere famously captured by the Mariner space probes. Most cameras have poor sensitivity in these wavelengths so you'll need to use slower frame rates or reduce the focal length for a brighter image. The upper atmosphere of Venus seen in UV imagery rotates once every 5 days so the cloud patterns you see will clearly change from one evening to another (Fig. 9).

Deep IR filters (above 750 nm) are also very interesting to employ. These often reveal light and dark streaks deeper within the Venusian atmosphere. Specialized 1 micron IR filters now in use by some observers reveal the night side thermal glow of the planet during times when Venus is a slender crescent.

Capturing the Data

With Mercury in a typical 700 nm IR filter you'll easily be able to achieve 30 frames per second or more. The planet rotates very slowly, so you have plenty of time to capture a large amount of data. Don't just shoot ~500 frames and put that into an image, as it will likely be too noisy to be useful. Take several minutes worth of frames and try and use at least ~2,000 of them for a final raw image.

Venus is highly dependent upon wavelength. In UV you'll be limited to perhaps a maximum of 30 frames per second and a high gain setting. Since the upper atmosphere of the planet rotates slowly you have plenty of time to capture an adequate number of frames for a smooth result. In IR things are much easier, and you'll easily be able to achieve high frame rates toward the maximum capability of the camera. With deeper IR filters you'll be more limited, and those wishing to attempt to

Fig. 9 Venus through a UV filter. Note the streaky cloud patterns that can be seen to change from day to day. 23.5 cm SCT. SKYnyx camera (Photo by the author)

capture the night side thermal glow will need to wait for Venus to attain less than 20 % illumination and the Sun to have set (or before rising). Even then exposures of several seconds will be required (which will completely burn out the visible crescent).

Mars

The Red Planet has long been a favored target for astronomers and still remains one of the most interesting and captivating planetary targets. Unlike Jupiter and Saturn, Mars only comes into opposition in our skies every 2 years and during most apparitions only remains close to Earth for a relatively short period.

Some oppositions are far more favorable than others, with those occurring when Mars is near perihelion being the most favorable in terms of apparent disk diameter (the next one to occur will be in 2018). Sadly perihelion on Mars also frequently brings large dust storms that sometimes encircle the entire planet (such as in 2007) that can wipe out the visibility of the famous dark markings rendering the planet almost featureless. These oppositions also occur when Mars is low in the sky for northern hemisphere observers, which can make obtaining good images difficult.

Oppositions that occur when Mars is more distant are often more interesting (despite the smaller apparent disk diameter), as localized clouds and haze are much

Fig. 10 From left to right. Mars through red, green and blue filters. Red light shows the dark albedo markings clearly, while blue light shows the bright clouds and hazes within the Martian atmosphere. 36 cm SCT.Flea3 camera (Photo by the author)

more common across the planet and these alter in appearance almost by the hour. The famous giant volcanoes are also often shrouded in bright clouds that can make for a dramatic sight on good nights.

Filters

Perhaps more than any other planet, filters are really essential for imaging Mars. For those using color cameras an IR blocking filter placed in front of the camera is essential. This helps maintain correct color balance and avoids the image becoming "polluted" with IR signal (to which CCDs are most sensitive). You could also try operating your color camera in mono mode with separate RGB filters (as this may produce a better result) (Fig. 10).

However it's for those using mono cameras where filters really become useful. Using red and infrared filters give the greatest contrast on the dark albedo markings. They also give the most interesting and detailed view when capturing and are less affected by the deleterious effects of astronomical seeing. Blue filters on the other hand show the delicate clouds and hazes in the Martian atmosphere to good effect. Green filters are especially important when making color images to correctly render the delicate and complex color tones often present across the planet.

I advise imagers to adopt the straight R-G-B technique for constructing color imagery. Using techniques such as the red image as luminance data completely obliterates the true color of the planet as well as the delicate features of the Martian atmosphere. Other techniques such as synthesizing a green image from a red and blue filtered image can work well to construct a color image if for some reason a green filter image isn't possible.

Capturing the Data

Mars rotates fairly slowly so the time window within which to take data is fairly long. (Ten minutes total time for an RGB capture is probably the upper practical limit.) It's a good idea to use a higher effective focal length than with other objects, as Mars is a bright high contrast and high surface brightness target. Aim for around the F/40–50 mark with most telescopes. Another great idea is to shoot overlapping sequences such as R-G-B-G-R. This way you have the option of making two color images while utilizing a single blue filter run (which is typically the most time consuming filter). For R and G filters you'll typically be running at more than 60 fps, while probably around half this rate in the B filter. You'll want to capture plenty of data so it's a good idea to shoot at least a few thousand frames for each filter. Also do not rush the blue filter imagery. This is an important component to getting a nice color result, and the blue filtered images are typically of most interest to those studying the Martian weather.

Jupiter

The Solar System's largest planet is for me the jewel of the night sky. It is one of the few truly dynamic astronomical objects that can be closely studied with amateur equipment. Its huge size means it presents a large apparent disk diameter as seen from Earth, and this means even small telescopes can show considerable detail. It also rotates rapidly (9h 55m), meaning you can see much of the planet over just a single night.

The first thing you notice about Jupiter is its banded appearance split into light and dark horizontal regions known as belts and zones. These can change dramatically from 1 year to another, being prominent 1 year and faded the next. Jupiter's most famous feature, the Great Red Spot, follows a similar pattern often varying in color and prominence from 1 year to another. Another Jovian treasure is its four largest moons. They can often be seen transiting the face of Jupiter casting a dark shadow onto the cloud tops below. One especially great aspect of imaging Jupiter is that amateurs can make a real contribution to the scientific study of the planet. In recent years many discoveries have been made through amateur work from events as dramatic as SL9 style impact events to monitoring the varying wind speeds of the planet's jet streams (Fig. 11).

Capturing the Data

Jupiter's rapid rotation makes it a challenging object to photograph. The time window available before rotation begins to smear detail is quite short compared to the other planets. For those using large apertures in good seeing conditions 60 s is

Fig. 11 The wealth of detail that can be captured on Jupiter with amateur-size telescopes is quite considerable. Here is the view in visible light, which shows considerable fine detail, while at left the view in 889 nm methane band shows the level of sunlight absorption due to methane (with darker areas being more methane rich and lower in altitude.) 36 cm SCT. Flea3 camera (Photo by the author)

probably the upper limit per single capture. For an RGB sequence 3 min is the upper time limit before too much rotation occurs between the color channels. Having a slick and smooth routine in place is really important to utilize every second of time for RGB imaging of Jupiter, and this only comes from practice.

You'll be looking to work at around F20–35 with Jupiter. In terms of frame rate in red and green around 60 fps should be easily achieved while somewhat less in blue. As with the other planets it is best to stick to a proper RGB routine to help render the colors and tones of the planet accurately.

Other more specialized filters can produce valuable data. Narrowband filters that focus on methane absorption within the Jovian atmosphere at 889 nm are extremely valuable. The filters are typically quite costly but a worthwhile investment for those with a keen interest in the giant planet. Exposure times with these filters are typically quite long, with perhaps only 1 frame per second being achievable. Also resolution in these images is much lower than in visible light so longer time windows can be employed with 2–3 min being ideal.

More recently sophisticated processing techniques such as image de-rotation allow much longer capture times than previously possible. This is covered in more detail later in this chapter.

Saturn

With its captivating ring system Saturn is without question one of the most spectacular sights visible in any telescope. With larger amateur scopes a wealth of detail can be recorded across the globe and rings. Minor storms are typically quite frequent occurrences, appearing as small bright spots. Rarer huge storms also erupt on the planet such as during the recent 2011 apparition when observers were treated to a huge planet encircling storm, the largest seen on Saturn in more than 20 years. The ring system also shows many interesting details such as brightness variations and occasionally the famous spoke features can be seen. During times when the rings are presented edge on to Earth shadow transits of the Saturnian moons can be easily captured in large aperture telescopes.

Capturing the Data

Photographically Saturn is a challenging object. Although it does present a generous angular diameter its low surface brightness means that larger apertures (20 cm or more) are really needed to get detailed results.

As with Jupiter you'll want to aim for a focal ratio of around F20–35. Sadly because of the aforementioned low surface brightness the frame rates achievable are well down compared to its brighter cousins. In typical RGB filters frame rates will range from around 15–25fps. Blue light work can be especially frustrating as it takes quite a long time to obtain enough frames for a usable result. Color cameras work well with the planet, and around 30 fps should be achievable. For those doing RGB imaging a good way to help speed things along is to take a white light luminance image as the frame rates are much higher and the resulting shorter exposure time can help produce a sharper result (Fig. 12).

Saturn rotates rather slowly compared to Jupiter, and being only half the apparent angular diameter (not including the rings) a far more generous capture window is available. For a single capture 3–4 min is possible, and for a total RGB capture twice this works fine. It can help to take a series of images over a ~30 min period to help show any small spots or features that move with rotation as sometimes these features are not immediately apparent.

Uranus and Neptune

The distant ice giants have been two largely neglected worlds in terms of amateur study, though this has started to change in recent years. Being so distant they present only very small disks even in large telescopes. Both planets exhibit interesting

Fig. 12 Saturn is always a spectacular sight in the telescope. This view from 2011 shows the giant planet-encircling storm that was discovered by amateur observers. 36 cm SCT. Flea3 camera (Photo by the author)

activity, with occasional bright storms appearing, though any hope of capturing such events is reserved for those using large apertures.

Capturing the Data

Both planets are very challenging objects to photograph well at high resolution. Both are faint objects, and just finding Neptune can be quite a challenge. In terms of focal ratio you need to aim for around the F30–40 mark to obtain sufficient image scale on the CCD chip. Frame rates are extremely limited due to their dim nature, with perhaps only a few frames per second being possible. RGB or color imaging serves little purpose with these planets, as much of the transient activity or indeed even the belt/zone patterns are best seen in near IR wavelengths. With both planets being so distant and both rotating fairly slowly time windows of ~15 min are usable for single captures (Fig. 13).

A good filter for use on these planets is a 600 nm red light long pass filter or for large apertures an IR700 nm filter. These filters stand the best chance of picking up atmospheric detail while still delivering a bright enough image to be realistically usable with amateur-size telescopes.

Processing the Data

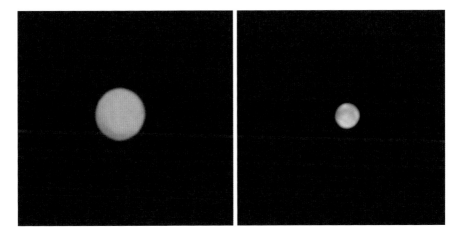

Fig. 13 Uranus and Neptune are challenging objects even for large amateur telescopes. Uranus at *left* shows little detail despite the excellent seeing conditions. Neptune at *right* shows some grossly resolved darker and lighter areas. 36 cm SCT. Flea3 camera (Photo by the author)

Processing the Data

This stage is perhaps the most fun part of the whole process, as you finally get to see what surprises those often rather bland-looking raw captures have in store. Image processing is an area where one can spend hours experimenting with different techniques; however, there are several basic routines and principles that work well for high resolution imaging. As already mentioned the most popular programs for processing planetary images are *Registax 6* and *Autostakkert 2,* while *Photoshop* is extremely useful for processing beyond the stage of a simple sharpened raw image. Other software such as *WINJUPOS* is also useful for more complex processing such as image de-rotation.

Your image sequence will generally be a video file in either AVI or SER format, though some choose to work by capturing batches of single FITS images. The software mentioned is geared to dealing with all the most popular formats generated by today's cameras.

Image Alignment

This is really the first stage in the process in programs such as *Registax 6*. The software will align all the frames in an image sequence with respect to each other.

Fig. 14 The image alignment screens of *Registax 6* at *left* and *Autostakkert 2* at *right*. Note the multiple alignment boxes placed on the images ready to begin alignment of all the frames (Photo by the author)

It will also grade their quality and produce an image quality graph to help you discard the frames that are blurred due to seeing, etc. Both packages offer two alignment modes – single point and multipoint. Single point alignment is where you simply click one align point on the center of the image and then click the align button. This is the simplest form of image alignment and often works well on small planetary targets (Fig. 14).

The other type of alignment is known as multi point alignment (MAP.) This involves clicking multiple align points over the image. You can also set the alignment box to varying sizes (the area within this box is what the program will attempt to align based on that align point.) This method works especially well on lunar imagery where seeing effects can distort the geometry of features within the field of view. MAP helps considerably to improve image sharpness by separately aligning localized portions of the image and then recombining them back into a complete image during the frame stacking phase. It can also help with planetary targets, though one must be careful here because if done incorrectly it can actually degrade the image quality.

As a general guide to using this type of alignment:

- Lunar – Approximately 100 align points across the entire image. Do not place align points ion areas where there is no appreciable contrast.
- Mars – A single align point can work well with Mars because of its small size; however using MAP is worth experimenting with.
- Jupiter – Around 10–20 align points, avoiding areas close to the limb of the planet. Again try not to place points where there is no contrast.
- Saturn – Similar to Jupiter with 10–20 points, placed around the rings and globe.

You'll notice that I mention not placing alignment points on areas of poor contrast. Doing this can lead to smearing of detail and strange-looking join marks appearing in the resulting stacked image.

Fig. 15 Three views of the same image. *Left:* A single raw frame. *Center:* 2,000 frames averaged. *Right:* Sharpened result. 36 cm SCT. Flea3 camera (Photo by the author)

Stacking the Frames

This part of the process is where your final raw image is generated. By stacking many frames together we increase the signal to noise ratio, making the resulting image less grainy and less prone to artifacts. The number of frames to stack varies depending on the seeing conditions. With good seeing many frames from a sequence can be stacked (maybe 75 % or more), but in poor conditions this goes down to maybe 30–40 %. Don't be fooled into thinking just selecting the ~100 best frames will work. It may well deliver a sharper result, but it will be hopelessly noisy for later processing (unless the images were taken at a low camera gain setting) (Fig. 15).

Once you've determined how many frames you want to stack you can then go on and click the stack command. The program will then average all of the frames into a final unsharpened result. Once this has been completed, save the image file. This way you always have the option of returning to the raw image if later processing goes awry.

You'll immediately notice the stacked result looks a lot smoother than the raw frames but still rather fuzzy. It is at this stage that you can move on to the part where you finally get to see what all your hard work has delivered!

Sharpening the Stacked Result

Finally we have arrived at perhaps the most fun part of the entire process. This is where we finally get to see all of the hidden fine detail the image contains. For sharpening far and away the most popular tool is the wavelet processing section of *Registax 6*. This feature of the program works great for the sharpening of raw images. In general the default settings work well, and you have six sliders to control

that offer varying degrees of enhancement. Slider 1 enhances very fine detail while slider 6 performs a much grosser enhancement, with the other sliders giving varying levels between these two extremes. Which slider used depends on various factors (the object, seeing quality, level of noise, image scale, etc.). In general however sliders 2 and 3 are the most widely used for sharpening lunar and planetary images.

However a word of caution is in order. Be careful not to over sharpen your images. This only results in false detail and sharpening artifacts becoming apparent. A delicate hand is needed, and this is something that comes with practice. Image processing can never make up for mediocre quality raw data, and applying more and more sharpening will not generate resolution and detail where none really exists (only false detail that sometimes can give the illusion of an improved image).

Further Image Processing

Beyond aligning, stacking and sharpening your images there are many more techniques you can use offered by other software packages. Adobe *Photoshop* is probably the most popular piece of image processing software in use today and is a mainstay of any serious photographer. For lunar and planetary imaging it is useful for a wide range of processing techniques, the most useful of which I discuss in more detail following.

Noise Reduction

Noise (graininess over the image) is without doubt one of the most destructive elements to the aesthetic and scientific quality of an image. It can introduce all kinds of potential artifacts. Luckily we have some good tools within *Photoshop* to help smooth this graininess out. Gaussian blurring and De-speckle are probably the two most useful commands for noise reduction. Play around with both of these commands and see what settings work best for you, as this will depend on how noisy the image is.

RGB and LRGB Compositing

Photoshop is ideal for assembling your RGB color images or making an LRGB composite image. This is done through the layers and channels panel. For RGB composite we can select merge channels, and the three separate images will be combined into a color result. LRGB can offer further enhancement of detail over RGB composites. A successful LRGB composite requires a high quality white light image that is smoother and sharper than the RGB result. The LRGB is created by

adding another layer and selecting luminance as the blending mode. We paste the white light image into the newly created luminance layer, thereby giving a sharper and smoother color image.

R(G)B

This refers to creating a synthetic green image by averaging a red and blue filter image together. This can work well as a shortcut to produce a color image and is easy to do. Simply open your red image and paste the blue into it as a new layer and then set the layer opacity to 50 %.

Color/Tone/Brightness Balancing

Within the dropdown "Image/Adjustments" menu is contained many useful tools. Balancing the histogram levels in an image, adjusting the color balance or the hue and saturation of various colors can all be performed. These tools really help to balance the tones and colors of an image well, and it's worth having a good play around to gain a better understanding of the effects they have on an image.

Other more sophisticated processing routines such as de-convolution can be performed in certain software packages, though I have never been a fan of these myself. Image processing, particularly within *Photoshop,* is really like a laboratory where you experiment to see what works and what doesn't. Much can be learned from simply experimenting.

WINJUPOS Image De-Rotation

The freeware *WINJUPOS* program is also a powerful tool for planetary observers and fairly recently a new section of the program was introduced whereby it can compensate for the effects of planetary rotation. Giving an in-depth guide to how this works and how it is performed would be a chapter on its own, so only an introduction to the process is detailed here.

WINJUPOS is a program that was used for many years by those interested in monitoring the motions of features within the Jovian atmosphere by measuring the positions of those features and logging that data to a measurement file. *WINJUPOS* can de-rotate measured images (or even an AVI capture straight from the camera) to a mid-point of the exposure time. So for example if we have an RGB capture spanning 15 min it can counteract the rotation effects and output an image without incurring any smearing of detail due to planetary rotation. This is a powerful tool and works wonders for planets such as Jupiter and Saturn, where the capture times are quite limited due to their rapid rotation.

In-depth guides can be found online for using *WINJUPOS* and the many features and tools it has to offer.

Not Just Pretty Pictures

Unlike the majority of deep sky work, which is primarily aesthetic in its appeal, this is not the case with planetary images. Amateur work on planets such as Jupiter remains of considerable interest to professional researchers, and many discoveries have been made from such imagery. Image quality today is so good that detailed papers have been written on the atmospheric dynamics of Jupiter based purely on analysis of amateur data (Fig. 16).

Significant contributions can be made to the study of Mars and Saturn, too, and the vast majority of the coverage of Saturn's great storm in 2011 was from amateur imagery (and indeed it was discovered in amateur images). Mars is also of great interest, and there are very active organizations involved in studying the Red Planet from amateur data. Recently, during the 2012 Mars apparition, an unusual high altitude cloud was discovered on Mars from amateur imagery that generated considerable interest.

The two primary organizations that exist to which I strongly encourage observers to submit their work to are:

Fig. 16 Jupiter only 1 year apart but showing dramatic changes in appearance. Longer term study of the planets by amateurs remains of great value. 36 cm SCT. Flea3 camera (Photo by the author)

- British Astronomical Association (BAA.) Active observing sections exist for the Moon and planets with regular detailed reports published.
- Association of Lunar and Planetary Observers (ALPO.) Again various observing sections and mailing lists exist with regular reports on activity.

Other organizations also exist that are well worth looking into, such as the International Society of Mars Observers (ISMO) and the ALPO Japan branch, both of which are very active.

Conclusions

It is amazing to think just how far amateur planetary imaging has progressed in the last 25 years. Gone are the days of blurry photographs and analysis being based on visual drawings. The imagery taken today by amateur telescopes is of the highest quality and reaching levels of resolution that observers once thought to be impossible. Images are also more numerous than ever, giving an almost nonstop coverage of a planetary apparition from observers around the globe.

The science being done from amateur images is also more detailed and credible than it has ever been, and amateurs continue to make significant discoveries and contributions to studying our nearest neighbors.

Secrets to Successful Earth and Sky Photography

Babak A. Tafreshi

In the absolute silence of a desert night, surrounded by an arena of celestial beauties, a gentle breeze shifts the tiny grains of sand around me. There is a patchy glow of light visible all across the eastern horizon. It is gradually ascending over the sand dunes. The glow represents billions of stars in our home galaxy rising above the horizon of our planet. I have seen such dream-like starry scenes from many locations; from the boundless dark skies of the African Sahara when the summer Milky Way was arching over giant sandstones, to the shimmering beauty of the Grand Canyon under moonlight, and the transparent skies of the Himalayas when the bright stars of winter were rising above where the highest peak on Earth (Mt. Everest) meets the sky. These are forever-engraved moments in my memory. Astrophotography is not only about recording the celestial world. It can lead you to a life of adventure and discovery (Fig. 1).

Capturing scenes of Earth and sky in one frame, using basic equipment, became my main passion in photography when I was a teenager in the early 1990s. The first successful image of the sky came after months of effort with a simple SLR camera, trying to find the right film, the correct exposure, and a reliable developing laboratory. Today, thanks to the introduction of digital SLR cameras, suitable for low-light imaging, delicate Earth and sky images appear on your camera screen during the first night of shooting. Suitable equipment led to a rapidly growing interest in nightscape photography. This interest was further fueled by international astronomy outreach programs that gave rise to a new generation of astronomy enthusiasts.

One of the most popular outreach programs in existence today that globally promotes Earth and sky photography is "The World at Night" (TWAN). I founded this program in 2007 based on the effort of an international team of photographers

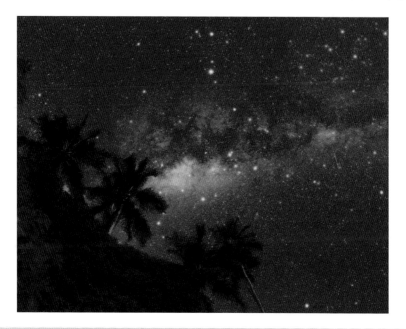

Fig. 1 The bright bulge of the Milky Way in the constellations Scorpius and Sagittarius appear above palm trees in Brazil

who specialize in this style of sky imaging. TWAN produces and presents the world's most diverse collection of nightscape photos that include time-lapse videos featuring unique landscapes and historic landmarks of all cultures against the night sky, highlighting the astronomical diversities of Earth's sky. In this chapter I refer to several links on the TWAN website (www.twanight.org) that further illustrate the topics I will discuss.

Landscape Astrophotography

Imaging night-time terrestrial environments in general is known as "nightscape photography." It includes a wide range of terrestrial subjects from cityscapes to architectural wonders to nature at night. Nightscape photography specializes in compositions that include the night sky above interesting landscapes. These specialized imagers plan for their images in a way that expresses the principles of practical astronomy. The art of stargazing is often illustrated in the framed views and iconic celestial targets visible by unaided eyes. Shooting may be planned at a time and location so that a celestial phenomenon is recorded over a night time landscape. Therefore a better definition of "nightscape astrophotography" is landscape imaging with an astronomical focus. Another common term you may see used is "starscape" photography (Fig. 2).

Fig. 2 Equipment for landscape astrophotography is light and simple to allow easy traveling and imaging at remote locations. Here TWAN photographer P-M Heden shoots the aurora borealis in Lapland, northern Sweden (© P-M Heden)

Learning basic nightscape imaging can be quick and easy. However, pointing a camera toward the sky to capture some stars above a foreground does not necessarily make a landscape astrophoto. It is a common misconception among both beginners and professional photographers from other fields that all nightscape images with a component of the sky should be considered landscape astrophotos. Although there are a large number of nature and architectural photographers with an interest in nightscape a minority make these images with an astronomical focus.

Besides technical abilities success in this field requires an artistic sense of framing and some knowledge of the night sky. This is essential for planning and creating engaging landscape astrophotos. The celestial subject should be highlighted in the image, correctly framed and exposed, and displayed in a natural composition. In recent years I have seen many images presented as nightscape photos, with an artificially colored Milky Way, excessively contrasted stars, or carelessly framed compositions with overly cropped constellations. These kinds of careless practices are as ineffective as doing wildlife photography without a knowledge of the animals or being unable to recognize the species. The results are scenes that miss or crop the main highlight of the image or possibly even violate the rules of nature!

Carefully made landscape astrophotos can be immensely useful for astronomy popularization. The recognizable terrestrial landmarks in these night sky images

provide a context that many people can relate to. They not only remind us of the cosmic standpoint of our planet, but also define the night sky as an essential part of nature, and not just an astronomer's laboratory. Introducing the night sky in this broader medium with a connection to nature, art, and culture opens many doors in communicating science with the public. These images are often specifically related to a time and a location, especially when a celestial event is recorded over a famous landmark. For this reason they retain their value, as well as their artistic and documentary character, and therefore possess a timeless quality.

Earth and sky photos not only illustrate practical astronomy, they remind us that viewing the night sky with nothing but the unaided eye can be a sublime experience. Although humankind has been inspired by the starry sky for millennia, in modern times most city skies are virtually devoid of stars. The night sky has sadly become a forgotten part of nature in urban areas. Almost two-thirds of the human population today live under light-polluted skies that are not dark enough to see the Milky Way. Astrophotography in all forms, whether done with a simple camera on a tripod or with a sophisticated set of telescopic equipment, helps to reclaim the forgotten beauty of night sky.

Nightscape Versus Deep Sky

Deep sky and landscape astrophotography each has its own challenges. Sophisticated and heavy-duty equipment based in a backyard or an amateur observatory is an essential part of serious deep sky imaging. Besides long exposures to reveal faint objects, considerable time is necessary for image processing. For nightscape the reverse is true. Processing is rather "light" as you try to present images that evoke a naked-eye visual experience (although many of the newer nightscape photos are fairly deep in recording faint magnitudes and details). Portable equipment is essential and requires only the most basic gear – a camera and a tripod. These simple requirements will enable many astronomy enthusiasts and general photographers to attempt nightscape imaging (Fig. 3).

The chance of success in landscape astrophotography relies on being in the right place at the right time. This does not occur by accident. One may use Google Earth, planetarium software, or stargazing maps to plan a particular project. Some spectacular celestial events are related to new discoveries and may not appear in recently published software. These events may include the accurate peak of meteor showers, new bright comets, Earth-directed solar eruptions that generate great aurora activities, and so on. So you may need to follow online news concerning celestial events on sources such as spaceweather.com or skyandtelescope.com.

The main challenge here is night-time adventure possibly in a remote location, looking for a special landscape and composition at just the right moment. Personally I like being as compact as possible. Even If you can afford to have several DSLRs with you it does not guarantee success. Being compact not only helps you move around during the night to find the right compositions, it also allows you to enjoy your time under the starry sky. My usual load of photo equipment is two cameras,

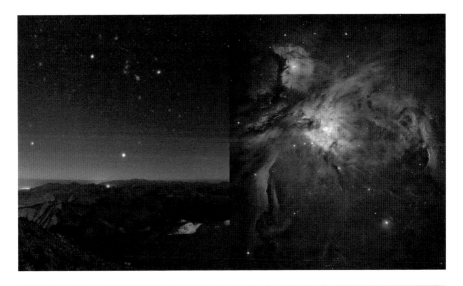

Fig. 3 A widefield nightscape photo of the constellation Orion above the moonlit landscape of Zagros Mountains in Iran reveals the great Orion nebula as just a small glow, similar to what unaided eyes can resolve. In contrast the nebula covers the whole field of view of a telescope for a deep sky photographer. The deep sky nebula image is from the Hubble Heritage project (Courtesy NASA and the Hubble Heritage team (STScI/AURA))

one for still images and another for time-lapse sequences. Other than the tripods, everything should fit inside my mini trekking backpack (Fig. 4).

Although deep sky imagers are challenged by moonlight, seeing, transparency, and clouds in the sky, landscape astrophotography can be accomplished under most conditions, even under a full Moon or during a mostly cloudy night. Besides weather and moonlight, factors such as geographic location, altitude and temperature, local topography, and light pollution must be considered in preparing for a photo session. Many things can go wrong at night with equipment and environment. Learn about your imaging location before you travel, and inform someone about where you are going. Always arrive before sunset and get familiar with the scenery and obstacles around you.

When nightscape photographers travel to remote sites they can be thwarted by other unpredictable problems with accessibility, government restrictions , and public unawareness of a friendly astrophotographer who might be mistakenly recognized as a wandering vampire or a lost alien with a "red laser" coming out of their head! At such times you often realize you are in the wrong place at the wrong time! The risks can be controlled more effectively if you arrive at the site earlier in the day. Astrophotography in small teams of 2 (and maximum 3) people is the most efficient. Avoid doing night photo sessions alone in remote locations that you are visiting for the first time. Very large groups can create other problems such as too many tripods, similar image results, and moving flashlights in your photos.

Fig. 4 Teams of very large groups can create other problems such as too many tripods, similar image results, and moving flashlights in your photos

Although a sense of art is an important component of landscape astrophotography there is also a good deal of science in some of the images. True, starscape imaging does not contribute to high resolution astrophotography, which is based on telescopic, widefield photos. However, you can often detect surprising astronomical or atmospheric phenomena in these compositions, impossible to record in the small field of view of telescopes. You can find examples of such images on the Internet on the The World at Night Mystery page (see Twanight.org/mystery).

Cameras

Serious landscape astrophotography is not practical with compact "point and shoot" digital cameras. Their average night-time imaging quality is poor. The right choice is a digital single-lens reflex camera (DSLR). These systems have truly revolutionized nightscape photography. Their high sensitivity to light, the changeable lens system, the ability to control exposure and lens aperture settings, the bulb exposure mode (which enables any practical exposure time), and the recording of

Fig. 5 A DSLR camera equipped with prime lenses is a favorite setup for a nightscape photographer. A remote cable and extra batteries are essential accessories in this style of imaging

RAW file format – which stores all the image data – are all essential in sky imaging. Newer DSLR cameras have "live view," which allows you to do live on-screen focusing. It can display the brightest stars at night. This is a great advantage for astrophotographers to achieve accurate focus quickly when out in the field. (The infinity mark on the lens focus ring is generally not accurate) (Fig. 5).

DSLRs provide high ISO (sensitivity of camera to light). For a dark starry night ISO1600 is an astrophotographer's favorite. Depending on the camera performance higher ISO might cause loss in dynamic range (ability to record both faint and bright areas in the scene) and star colors, as well as generating more noise. This is still 16 times more sensitive than the basic ISO 100 (for bright day-time imaging) and technically reduces the necessary exposure length by a factor of 16. At twilight, under bright moonlight or considerable light pollution, or when shooting star trails, a lower ISO of 100–800 is recommended. The lower ISO records fewer stars and records fewer faint features but results in less noise (higher signal/noise ratio), high dynamic range, and more star colors.

Remember ISO is not the true sensitivity of the camera sensor. The sensitivity or so-called native ISO is a fixed value for each sensor. The camera processor boosts the gain in high ISO, and this is amplifying the signal and not collecting more photons. This electronic amplification creates more noise as well. The true sensitivity depends on factors such as the sensor quantum efficiency (QE). This is the percentage of usefully recorded photons compared to the total that strike the detector. For example QE of human eye is between 1 % and 5 %, while for commercial astronomical CCD cameras the highest QE in visible light ranges between 40 % and 90 %. That means up to 90 times more photons are recorded at a time compared to human eyes, and this is why CCD has revolutionized astronomy in the last few decades. A rough estimate for the peak QE of newer DSLR cameras range between 30 % and 40 %, still much more than the human eye and comparable to

some of the monochrome CCD cameras. Note that the QE changes across the spectrum and heavily depends on the wavelength of the striking photons. In DSLRs it also varies in each of the RGB color channels.

Another factor for camera sensitivity is the size of individual pixels in the sensor. These tiny wells collecting photons are like buckets collecting raindrops. The larger they are the more photons will be collected in each pixel before it gets full or saturated. For example a popular crop senor (APS-C) camera with a sensor of over 20 megapixel sounds astounding when compared to the discontinued models of only 8–15 megapixels, but that's not the case for an astrophotographer! They all have the same sensor size, and in the newer models smaller pixels are used to produce a higher resolution image. The high mega pixel camera captures sharper details (for instance in telescopic planetary imaging) but lacks the sensitivity of the older model, and the pixels becomes quickly saturated in long astronomical exposures. A common problem of such saturation is colorless white stars across the field and low dynamic range when using high ISOs. So don't be fooled by megapixels!

In the upper class of DSLRs the Nikon D3s is an excellent choice, a full frame camera with a sensor size equal to 35 mm film frame (24 mm × 36 mm). This high-end camera has only 12 megapixels, like a compact pocket camera! The larger pixels translate to less noise, higher ISOs, and more dynamic range. The peak QE of this camera reaches above 50 %. The highest suggested ISO for astrophotography with this camera is 6400, compared to 3200 in my beloved Canon 5D Mark II or 1600 in many budget DSLRs. This was the first of a new generation of cameras that elevates low-light photography to a new level. NASA astronauts on board the ISS have used D3s for several years. Breathtaking photos made from space of stars and aurora over Earth are all made using this commercial camera.

That said, Nikon D3s or Canon 5D may not be affordable for many sky enthusiasts working with a limited budget. Under a dark sky using a good wide-angle lens, only a 30 s exposure at ISO 1600 records a surprising view of the Milky Way. Therefore landscape astrophotography is possible with many lower cost DSLRs. I have used the Canon 5D Mark I (released in 2004) for a long time, and some of my most popular images were made with this old camera. The cropped sensor DSLRs with sensors 50–60 % smaller than the full frame cameras are the most popular and budget friendly ($500–$1,500).

All digital cameras have an IR-cut filter that blocks the red end part of the visible spectrum, including the H-alpha band. Therefore they block most of the light from all the emission nebulae in the sky. Most astrophotographers who use DSLRs for deep sky imaging replace this filter with an astronomical one (provided by several companies). This modification markedly improves camera performance for capturing many faint celestial targets. However it totally changes the camera's white balance calibration, which makes it difficult to use for day-time imaging. For nightscape photographers this modification is not necessary, although it's helpful to capture rich details in the wide-field views. In 2012 Canon released the EOS 60 Da with a modified filter for astrophotographers. The white balance of the camera is also calibrated in a way that it works fine for daytime use, too.

Lenses and Essential Accessories

Even the best DSLR might disappoint you if used with the wrong lens. It is wise to Invest in prime lenses with fixed focal lengths. Zoom lenses are not desirable for most kinds of low-light photography. Although ultra zooms such as 18–200 mm offer you both wide views of constellations and close-up Moon shots, their many optical layers reduces significant starlight collected by the lens objective. Budget zoom lenses lack optical quality and do not offer a wide aperture, which is essential in sky photography (Fig. 6).

The basic lens for nightscape photography is a wide-angle lens ranging from 15 to 35 mm for full frame cameras. The equal field of view in the crop sensor DSLRs is achieved by 10–24 mm lenses. Fast lenses are critical for success in low-light photography. A lens with a larger maximum aperture (smaller minimum f-number) is a fast lens because it delivers more light intensity and reduces the needed exposure. If the aperture starts from f2.8 or lower it's fast enough. With a fast 15 mm f/2.8 lens, a 30 s exposure at ISO 1600 will reveal faint nebulae and star clusters within the Milky Way. When shooting with lenses faster than f/2.8, stop the aperture down one or two f/stops to achieve the sharpest focus and to reduce coma at the corners. For example a good 24 mm f1.4 lens should be used at f2 or higher to retain optical quality (Fig. 7).

To shoot close-up landscape views of celestial objects, such as conjunctions of the Moon and planets or solar and lunar eclipses a telephoto lens in the range of 85–200 mm is required. Longer fast telephoto lenses are quite expensive.

Fig. 6 A fast 24 mm lens with a widest aperture of 1.4 is an ideal standard lens of nightscape photography

Fig. 7 The field of view of a 24 mm wideangle lens is over 70° long on a full frame camera, equal to the field of view of a 15 mm lens on crop sensor (APS-C) cameras. This gives you a large enough area to include several constellations in the frame. The 50 mm lens (30–35 mm on crop sensors) is good enough to isolate one constellation in the sky with considerable detail but is harder to frame to include the landscape. With the 200 mm telephoto it's possible to reach some serious deep sky details in the image

A small 70–80 mm apochromatic refractor telescope tube with a focal length of between 400 and 600 mm is more than adequate and less costly for an astrophotographer (Fig. 8).

Using filters is a question of taste in sky photography. Some prefer purely natural-looking sky, while others use star filters to create artificial diffraction spikes on stars. I personally use a diffuser filters for some of the images. A common problem of wide-field sky images taken with digital cameras, especially with small pixel-size sensors, is the inability to reveal the diverse colors and brightness of the stars. They capture a nice field full of sharp white stars. But many of those stars are not really white nor at the same magnitude. In the long exposures the tiny pixels get

Fig. 8 Being at the right location and distance, a single-exposure photo using a 400 mm telephoto lens allowed the author to capture this moonset view over the famous Arc de Triomphe and in Paris

saturated by starlight. When these photon collecting wells become full by a brighter star no more data will be collected from the pixel, while pixels which are collecting light from fainter stars continue to operate. Therefore the faint stars become gradually brighter and similar to naturally brighter stars that can no longer affect their related filled-well pixels. Diffuser filters, which are primarily made for skin softening in portrait photography, helps with scattering the starlight to be collected by more pixels. This preserves star colors in the image and better shows their magnitude difference. The Cokin P830 diffuser has been my favorite diffuser. To keep the natural-looking sky I try to use it only for few seconds of the whole exposure by holding the filter in hand in front of the lens (Fig. 9).

Investing in a portable high quality tripod is a good decision. I often use a ball head on my Manfrotto tripod to quickly frame a nightscape. To level the horizon the ball head is essential when using the camera on a star-tracking mount or piggybacked on a telescope. Very heavy-duty tripods are not practical for landscape astrophotography because of your movements during the night. To prepare for wind and unwanted shaking, always take a bag. Fill it with stones or other weighty things around you, and hang it from the tripod's legs connection.

A remote switch or controller (similar to a cable release for film cameras) is a must for a nightscape photographer. Applying any exposure on bulb mode is easy

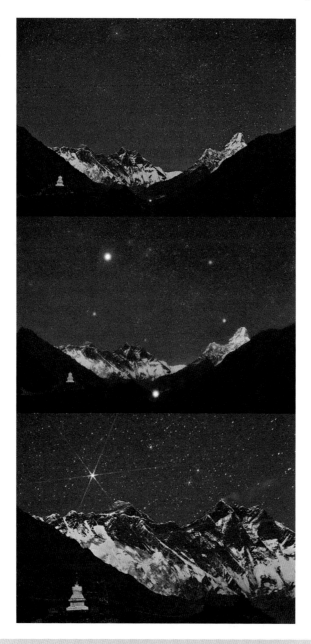

Fig. 9 These set of images show the bright star Capella above Mount Everest in the Himalaya. Compare the view without any filter at *top* to the effect of a diffuser filter (*middle*) and star spike filter (*bottom*)

now with the shutter lock on the controller. A timer remote control allows you to set exact exposure time or make a sequence of images with a specified delay between each frame, which is very practical for star trails, deep sky imaging, and time-lapse videos. I don't recommend wireless controllers because of the battery consumption and the possibility of disconnection while you are moving with the controller too far from the camera.

Extra camera batteries and a battery grip (which runs two batteries in parallel) are very helpful. For long sequences of hundreds of photos on a cold night a higher amperage external battery is the best choice. Adapters are available to connect DSLRs to an external power source. Doing long sequences also requires larger capacity memory cards. If you are imaging at high altitudes, cold temperatures, and other extreme conditions I highly recommend avoiding cheap generic memory cards. Also the slow cards might cause longer delays between the frames in a photo sequence.

Have a red/white LED flashlight. I recommend a headlight so you can have your hands free. Keep lens cleaning tissues with you as dew on a lens is a common problem in night-time photography. Take a pen and notepad to record the experience. Record your camera settings for each image on the EXIF file that comes with your image, and you will have access to it both on the camera screen and later on your computer.

Frame the Sky

Let's start with setting up the camera. Set your image quality to RAW with a small JPEG preview. Avoid saving only JPEGs. For low-light images JPEG compression will result in losing a substantial part of the data with diminished possibilities in post processing. Set the white balance to daytime (Sun icon) or manually set custom white balance to 4,500–5,500 K depending on the conditions. Bringing down the Kelvin much below this range will result in blue-shifted images that nicely color the background sky in light-polluted conditions, but be aware that you have altered the natural look of night sky! The resulting image, although a creative work of art, won't be an accurate landscape astrophoto in term of colors (more about this at the end of the chapter). Shooting in RAW enables you to precisely correct the white balance in the post processing that is especially helpful when using modified cameras (Fig. 10).

Although sharp focusing is not as critical as with deep sky imaging it's still an important factor for nightscape photographers. Sharp focus not only maximizes the resolution but also increases the signal/noise ratio. Autofocus systems don't work accurately in low-light conditions. For a quick rough result it might work if you autofocus on the Moon or bright lights at the horizon and then set the lens to manual focus. But focusing manually on live view is the best. You can point to brighter stars and then use 10×digital magnification to see the best focus; many fainter stars become visible with this magnification. For older cameras without live view several short exposures of stars are needed to correct the focus and achieve the best result (Fig. 11).

Fig. 10 The manual camera setting is necessary on many occasions with nightscape imaging. Store images in RAW, and remember three golden numbers 30 s exposure, ISO 1600, and f2.8

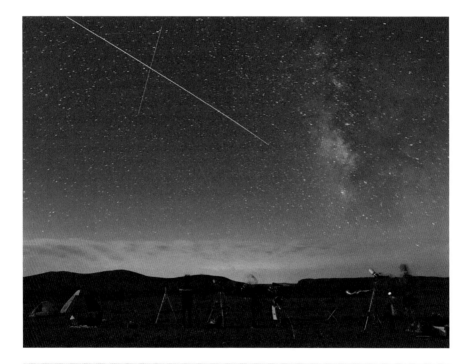

Fig. 11 The International Space Station (ISS) passes above a group of amateur astronomers. Three fainter satellites are also captured in this morning twilight view

Now set your camera to manual mode and remember three golden numbers in starscape photography as your base settings: 30 s exposure, ISO 1600, and f2.8 for the lens. Playing around with these numbers helps you find the best setting for your equipment and the celestial target. Start with twilight and constellation photography. Plan to capture the crescent Moon in the evening or morning sky (preferably

in conjunction with bright planets). Even the light-polluted sky of metropolitan areas is beautifully colored in deep blue twilight. Photograph prominent constellations using a wide-angle lens.

Celestial events are some of the best occasions for Earth and sky imaging. They are unique in time, and with a landmark in the foreground the scene becomes unique in location as well. Meteor showers, the appearance of bright comets, and eclipses are some of the most inspiring events. Expand your images to offer unaided eye attractions in the sky. Plan for the zodiacal light or photograph various atmospheric phenomena such as a distorted Sun or Moon near the horizon, lunar and solar halos, and majestic aurora displays. Bright satellites can be an amazing sight, too. The International Space Station crosses the sky and occasionally makes flares brighter than the planet Venus. Even more dazzling flares can be recorded of Iridium satellites (predictions available on www.heavens-above.com).

Rotating Sky

From the very first night of shooting you will realize longer exposures capture prominent star trails because of Earth's rotation. Although star trail imaging has its own beauty, in order to "freeze" stars as fixed points exposures must be limited. For an average resolution DSLR camera this equation gives the exposure limit in seconds: 500/F (the lens focal length in millimeter). When using a crop sensor DSLR the F should be multiplied by the crop factor of the sensor (For most of the models use 1.5 for Nikon and 1.6 for Canon). For example the effective focal length of a 15 mm fisheye lens will be $15 \times 1.6 = 24$ mm. If your field of view is far from the celestial equator (either to the north or south) you can further increase the exposure. For instance mid way between the equator and Polaris, you can exceed the exposure to 40 % and up to 70 % for the Big Dipper near the celestial pole (or for the Southern Cross and the Magellanic Clouds near the south celestial pole) (Fig. 12).

You can also freeze the sky-rotation by placing your camera on a tracking mount. Small portable mounts are manufactured by various companies, and they sit on the top of normal photo tripods. One of the best made for nightscape imaging is a hand-size star tracker known as Polarie by Vixen in Japan. This mount has several tracking modes, including ½ speed, which is the best mode for landscape astrophotography. Long tracking exposures result in ground motion and a blurry landscape, so the ½ speed balances tracking between stars and the motion of the landscape. Using this speed you can double the exposure limit based on the given equation. Using high ISO, a fast wide-angle lens, and a minute exposure under dark sky will result in an astonishing starry view.

Shooting star trails has its own value. An hour-long exposure on a fixed tripod creates colorful star trails. Of course light pollution and noise in the digital camera limits such long exposures today. Most sky photographers create star trails by putting together a sequence of digital photos with shorter exposures, using a remote shutter release for your DSLR. For example the shooting could be a sequence of

Fig. 12 A portable star tracking mount such as Polarie is a very helpful accessory to reach more sky details in landscape astrophotography

300 shots, each a 30 s exposure, with only a second interval between the frames. This will result in a long looking star trail with a total exposure of 2.5 h, or you can create a 12 s time-lapse video of this at the rate of 25 frames per second. Stacking the images together is very easy using freeware such as *Star Trails* (www.startrails.de) or *StarStaX*. Digital star trails not only reduce the long exposure noise problem; they dramatically reduce the light pollution effect on the image compared to a single long exposure image. With this technique of creating star trails even under heavily light-polluted metropolitan skies is possible, which was an impossible challenge for film photography. However a major issue in the digital age is how to create natural-looking star trails, avoiding a sky packed with trails or colorless white-dominated stars (caused by high ISO photography). This is discussed later in this chapter (Fig. 13).

Shooting photo sequences (time-lapse photography) can create many exciting results. You can use the whole sequence for long trails or use a more interesting part of it, or just a single image of the sequence that has the best illumination if, for instance, a bright meteor is captured. Such simple sequences can turn into stunning time-lapse videos of the sky in motion above landscapes using video editing software. *Star Trails* freeware gives you a quick preview result of videos, too, but the result is not made for professional use, and I recommend that you create them in

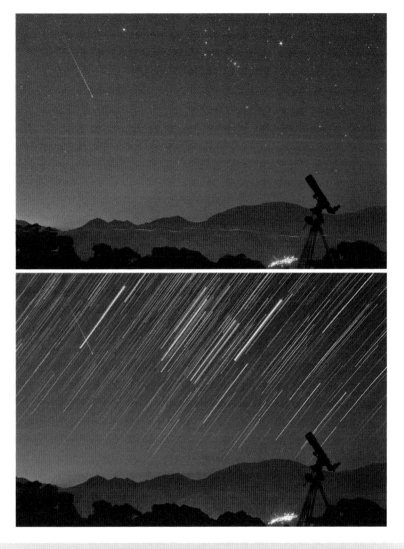

Fig. 13 A sequence of nightscape photos can be used in several ways: as a timelapse video, a star trail image, or selecting single shots of interest from the sequence like this meteor during the Perseid meteor shower in August

sophisticated software such as Adobe *Premiere* (or other applications in the same class) so you can fully control the editing and speed of your motion.

Although there were only few nightscape time-lapse photographers in the beginning of the DSLR age, this has become a passion to thousands of photographers worldwide, using just a camera or a tripod equipped with cinematographic rails, cranes, and motion control accessories (see a diverse collection of nightscape timelapse videos on twanight.org/motion).

Painting with Light

The Moon is your best friend. The most natural source of illumination for landscape astrophotos is the Moon. You will be amazed at how the quarter Moon can gently illuminate the landscape while the sky is still starry. To record fainter details in the sky the crescent Moon would be a good compromise solution. Using fast lenses and high ISO would still record considerable illumination and bring out some details in the foreground. While full Moon nights have its own value for nightscape photography, the sky is washed out with only few stars visible, and the light is too strong for landscape illumination and results in a daytime feel to the image (Fig. 14).

There are many other creative ways to illuminate the foreground. An experienced eye can find the best balance of starlight and foreground illumination. With too little light on foreground objects, stars float unanchored above a featureless silhouette. Too much light may cause the reflected glare of an ancient structure to wash out the faint glimmer of the stars above it. No two situations are alike, and even careful planning must be augmented by trial and error. Light may come from twilight, an artificial lighting of a nearby village or town, or you might "paint" the foreground with your flashlight! This is what I often do and enjoy it as a painting, a work of art, where light is your brush. I also have more control compared to manually flashing the foreground. Another good solution is the photographic LED lights with daylight Kelvin (about 5,600 K), which provide a delicate dimmable light in a very small package.

Fig. 14 The planet Venus sets over colorful salt domes in the Iran central desert, strongly illuminated by the rising full moon at the other horizon

Panoramas and Virtual Reality

Reaching higher resolution and wider fields of view are two of the main reasons for digitally stitched panorama and mosaics. But from a composition point of view panoramic format gives a unique framework for landscape astrophotography, from starlit sky above a range of mountains to the Milky Way over a strip of desert dunes.

Both fisheye and rectilinear lenses under 20 mm, that offer ultra wide angle views, are generally not available faster than f2.8. However wide-angle lenses in the range of 24–35 mm are manufactured in very fast nightscape-friendly optical designs as fast as f1.4. Although these are ideal lenses in landscape astrophotography their field of view is not favorable for very wide sceneries such as the arch of the Milky Way, zodiacal light, or the largest constellations. Panoramic imaging enables having both the light collection power of these lenses and ultra wide fields of view (Fig. 15).

Panoramic stitching also helps with flattening the curved horizon of a single fish-eye view. Continuing the panoramic images across the horizon you can also reach a 360° view of the sky around you. Using software such as *Pano2VR* this panorama can turn into an enchanting virtual reality (VR) flash or video animation that allows the visitor to look around the view, zoom in, and experience the moment and the location you have photographed.

Completing the 360° panorama in this way that covers the entire sky has benefits over a single exposure using a circular fisheye lens (8 mm for full frame and 4.5 mm for crop sensors) because it's the result of several photos and contains much higher resolution. For example using a 10 mm lens on a crop sensor camera you can create an ideal all-sky image with seven shots – six around you and one looking above.

Fig. 15 A panoramic view made of six vertical shots has captured a moonlit rock in the Atacama desert of Chile under southern skies from Andromeda at left to Carina and the large Magellanic cloud at right

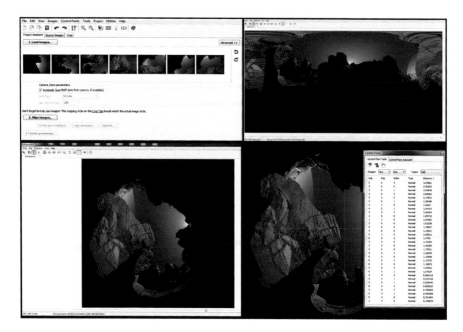

Fig. 16 A set of seven fisheye images, covering a 360° view, made by a 15 mm lens on a full frame camera (achievable with a 10 mm lens on crop sensor) is imported to PTGui panorama software. After auto-aligning, selecting circle panorama, manual control points are added and control points with large inaccuracies are deleted to reach an ideally precise all-sky view over a moonlit landscape

Overlapping of minimum 30 % (and ideally 50 %) is necessary between the frames in all nightscape panoramas; otherwise the lens aberrations and vignetting near the edge will cause problems in the final panorama (Fig. 16).

My preferred software in creating panoramas has been *PTGui* in the past years. Creating circular images and exporting VRs is also possible with this software. To avoid unnatural double stars and stitching artifacts using manual control points between the frames is necessary for night sky panoramas, as the software cannot automatically match the faint stars in the neighboring frames. Use fainter stars with smaller image discs as points for more accuracy. Before creating the panorama check the control point tables and delete any with inaccuracy above four pixels and then optimize the panorama again.

Process Me Softly!

Although in deep sky imaging, mixing various exposures and stacking are the basis of processing to achieve longer collected exposure and resolve faint details and to generate highest dynamic range, the rules in nightscape imaging follow nature and

landscape photography in general. In this medium such deep processing can be looked at as excessive photo manipulation. The future might change this classic view on nature photography, but it's still a widely agreed philosophy by major magazines, photography associations, and the leading photo contest in the field. Therefore astrophotographers avoid using many of their deep sky image-processing techniques when trying their hand at nightscape photography! In this style deeper is not necessarily better. Saturation and contrast manipulations should be gentle. Some of the most accomplished landscape astrophotos are "shallow" but elegant views of natural-looking sky made at the right time and framed in an intelligent way. Deep, high contrast and low noise images of the night sky will be less of a challenge for future generations of digital cameras. What makes a nightscape image an eternal piece of work that future generations can appreciate, too, will be strong composition, an image with a story or a message, and a timeless view that has captured a special moment.

That said, nightscape photographers do try new editing possibilities and techniques on their images. When clearly noted in the image caption that it is a result of a digital manipulation, applied for either educational or artistic purpose, it won't be regarded as fakery and will be considered in its own class of creative photography. Stacking a photo sequence to create star trails is widely accepted in nightscape imaging and considered a "soft" digital manipulation. Combining three or more bracketing exposures to reach a high dynamic range (HDR) image depends on personal taste, and fewer nightscape photographers use this method. Another popular method is stacking a few photos of the same exposure, not to make star trails but to reach a stronger signal/noise ratio that enables more aggressive processing. This is certainly not my personal taste, but If you are suffering from a noisy camera or if you wish to reach deeper structures in nightscape images this would be a solution.

It's All About RAW

My processing of nightscape photos begins with opening the RAW files in the Camera Raw (ACR) plug-in for Adobe software including *Photoshop*. I do most of the processing here directly on the raw file, and only slight edits are added later in *Photoshop*.

With the revolution of graphic design software creating a photomontage has become easier than ever. These days the originality of nature documentary digital photos is mostly based on the raw files. Latest DSLRs models even offer many of the RAW editing capabilities inside the camera; however, these are all available in the Adobe Camera Raw. ACR is a very powerful tool, and enhancing the photo causes minimum emergence of noise and artifacts. When you open the file ACR automatically removes the hot pixels at a glance, and you can further reduce the noise at the Detail tab. (Sharpening and noise reduction at ACR will be further explained under Fight the Noise section in this chapter) (Fig. 17).

Fig. 17 This 35 s exposure made at ISO 3200 and a fast 24 mm lens (tracked on a portable mount) is softly enhanced in the Adobe Camera Raw

First of all set your image size and color space on the bottom of the window. Set the image to maximum size available unless you desire to make it smaller for a purpose (for example when the image is not sharp enough or too noisy and down-sizing means a quality increase). You can also enlarge the image to increase the virtual camera pixel size, and this will result in less quality loss compared to *Photoshop* resizing, It should be noted that the size increase is limited here. Set the image depth to 16 bits. The other option is 8 bits, which is good if you export JPEGs and not TIFF, for example when exporting a photo sequence for a time-lapse video. Most DSLRs shoot in 12 and 14 bits, which are far from the data depth of astronomical CCD cameras at 16 bits. Upgrading to 16 bits in ACR does not increase the real color depth of the pixels, but it does create a stronger file for further editing inside *Photoshop* or other software. Along with the depth and size set the resolution to 300, and the color space (profile) to sRGB. This is standard for web images and a widely popular color space in the printing market, a standard space for photo finishers.

The second step is the camera profile (the camera icon tab). Better to set this before image enhancing, as it can dramatically change the view. Camera Landscape is a favorite profile for nature photographers with clear color contrast, but for nightscape this might cause some aggressive adjustments and stronger red/yellow sky glow. Therefore try a few other beneficial profiles on your image: Adobe Standard (mild and easy to process), Camera Portrait (a high contrast profile with less color saturation compared to the landscape profile), and Neutral (when the sky glow is

dominated by the light pollution or when the color contrast is naturally strong like an active aurora, or when high dynamic range of brightness is captured in the image).

It's also better to correct the lens problems earlier in the processing. On the "Lens Corrections" tab you have two options: manually correcting for distortion, chromatic aberrations, and lens vignetting, or do all these automatically by the ACR based on your lens profile available in all the newer editions of the plug-in. You will notice that the lens profile tries to remove all the vignetting of your image (reduction of an image's brightness towards the corners). But in nightscape photos where wide angle lenses are used vignetting is quite strong and corners are much darker than daytime images with very low signal/noise ratio. So the full vignetting recovery causes noise and some color or brightness gradient near the edges.

After applying the lens profile you can reduce the correction amounts to reach an ideal result. Another exciting feature here is distortion correction. For example if you have used a fish-eye lens and you are not happy with the fish-eye distortion you can reduce the effect. The lens correction application needs a lot of RAM memory and applying it in small portable computers might be difficult especially when exporting several raw photos together. Many lenses are listed here, and you can always download the latest ACR version for up-to-date lens profiles and new features. However if your lens is not listed you can introduce a profile to it once you reach a good manual correction.

Now continue with the first tab (Basic). You can correct the white balance if needed. Don't forget that shifting it too far to lower temperatures, in order to remove the red/yellow cast of light pollution from the sky background, will also change the natural colors of the stars, the Milky Way, and other celestial objects. The exposure increase here is a noise-generating task, so better to play with the brightness and contrast as well as the curve. But when you decrease the exposure you can see how colors of brighter stars become more evident, and some of the overexposed and washed out areas begin to show some details. Some of the data is preserved in those areas. The recovery tool in the ACR further assists you in this regard, but be aware of its bordering artifacts when applying it too strongly (Fig. 18).

To increase the color contrast of your image apply Vibrance instead of the saturation. It works gentler and causes fewer artifacts. Vibrance up to about +50 brings out star colors that otherwise looks pale white. Depending on your lens and f stop you will notice this also increases the color aberration around the corner stars. In the same tab Clarity is another interesting option. When necessary you can dramatically increase star contrast by applying it, but it flattens the stellar magnitude difference and affects the astronomical accuracy of your image by making fainter stars more evident. Applying it too strongly results in a sky full of similar stars. If the image becomes noisy, slightly reducing clarity will apply a softening effect to the sky that reduces the background noise.

Enhancing the photo further is still doable in Camera RAW using the Tone Curve tab. As with any other high-level processing platform "curves" is one of the most effective ways to enhance the image. ACR also provides manual micro control

Fig. 18 The color balance of this image is considerably different from the previous example as it was made using a modified camera. The photo was made using a 15 mm lens however the fisheye distortion was reduced in the lens correction tab

on the highlights and shadows, which is very helpful in nightscape photos where we generally need to darken the sky background while the lowlight landscape should be kept visible. Another great solution in this regard is the ACR Graduated filter (shortcut is G). This works similar to an actual graduated filter in front of the lens where one side is an ND filter. It gradually becomes transparent on the other end. This is a unique tool for images with excessively bright foregrounds, such as a village light or if you have illuminated the foreground too brightly. It works the other way as well – if one side of the image is too dark and you need to bring out details there, such a starlit landscape in a moonless night. When increasing the brightness of the dark low-signal area, reduce the contrast as well to retain the faint details. Then reduce saturation and sharpening so this part of the image does not become too noisy by the added brightness.

A good way to apply your successful nightscape editing to other images is to save the applied setting in the ACR and make it available for future projects in the Presets tab. Of course everything you applied will be saved on your RAW file and the accompanied xmp file as well, and it's visible whenever you open the RAW file again. Saving the setting lets you apply all these to one or many other future images with one click (Fig. 19).

Another major benefit of Camera Raw is that you can process a large collection of images together. For example if you have made a sequence of 300 photos for the purpose of creating a star trail or a time-lapse video, you can simply open all the

Fight the Noise

Fig. 19 A sequence of photos is opened in camera Raw. The edit of the first selected shot is applied to the entire set

RAW files in the ACR. It's very quick, and they all open together in a strip of thumbnails. Now you can edit one and while you are still on the edited image select all and press synchronize. Within a few moments (depending on your computer performance) the entire sequence will be edited in this way. Now you can just press save and have some coffee! It takes a few minutes until all the photos are saved to the configured format.

Fight the Noise

There's always a trade-off between ISO and image quality. It is still a major challenge of manufacturers to produce noise-less digital cameras. Most DSLRs offer "long exposure noise reduction." This option causes the camera to make an extra equal exposure after the main shoot but with the shutter off. The resulting "dark frame" allows the camera to recognize noise and subtract it from the main image. This is certainly worth the extra time. However if you plan for a sequence of images there is no time between frames for noise reduction. Some higher class DSLRs continue to shoot several images in a sequence and then apply one dark frame to all of them, but this doesn't work as well for longer sequences of dozens or hundreds

Fig. 20 The long exposure noise reduction option is usually in your camera's custom functions

of photos. Also be aware that noise reduction in some older Nikon DSLRs may remove some stars along with the noise! Similar to CCD astrophotographers you can reduce the dark frame manually. Make a dark frame (preferably during the imaging session at the location) with a closed lens cover and use it later on during image processing (Fig. 20).

Noise depends on ambient conditions in addition to sensor characteristics. You might be surprised to see how dramatically the sensor noise becomes less on cold winter nights when you can record quality images at highest ISO. Some astrophotographers cool down the camera sensor with an external fan to make it work similar to a cooled CCD camera. Cameras are now commercially available from a few companies that are both modified (IR-cut filter replaced) and equipped with a cooling system. Such a camera would be a major benefit in DSLR deep sky imaging, but these options are not vital to nightscape photographers.

The camera noise reduction doesn't remove all the noise. A majority of the background noise in these low-signal images will remain to be removed later in the processing workflow. As mentioned earlier shooting in RAW allows you to reduce the noise dramatically in the Adobe Camera RAW plug-in. If your image is still noisy go to the Details tab in ACR and reduce sharpness all the way to zero. You can return some of this using the Clarity option in the Basics tab.

Another general technique is applying a very gentle Gaussian Blur filter in *Photoshop,* with the radius between 0.2 and 0.5 pixels only. This removes a lot of background noise but also reduces sharpness. In a second step apply some Unsharp Mask filter. This should also be done gently. Use lower amounts (15–30 %) and Radius between 3 and 10 pixels. The threshold can be set around three levels. Some other general techniques of deep sky image processing, such as blending a Gaussian blurred mask on the image with selective processing, are often used by nightscape

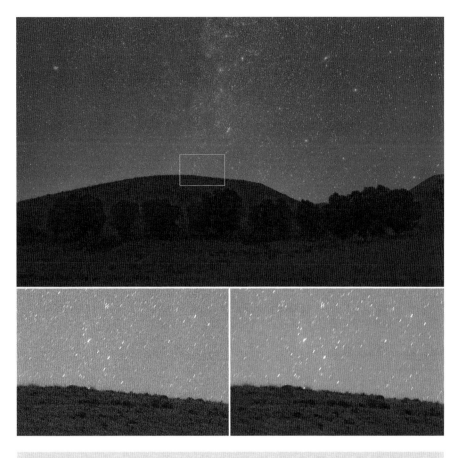

Fig. 21 On this 30 s exposure photo at ISO 3200, the background sky is noisy as shown in an enhanced 100 % crop of the center. Applying Dfine pluging has softly removed most of the noise

photographers, too, in order to remove contrast-driven noise. However I personally prefer simpler methods for the noise reduction that don't require retouching the image (Fig. 21).

There are also many noise reduction plug-ins for Adobe software. One of the earliest and most popular was Noise Ninja, which is now part of the *Photo Ninja* software, and a *Photoshop*/Lightroom plug-in called Dfine by Nik software. It is a simple and very powerful noise reduction application. Be aware that you will always need to manually reduce the automatic setting; otherwise you end up with a totally soft and blurred background like a painting where all the fine data in the sky has disappeared. Be aware that using a strong "color noise reduction" on these applications can wash away the star colors, too!

Natural Sky Colors

The natural color and look of the sky is an essential issue for nightscape photographers to consider. The annual international Earth & Sky photo contest we have organized in The World at Night program since 2008 proved to me that this issue is significant. At the contest we received images of the Milky Way in nearly all colors of spectrum; some processed it to romantic blue, some made it purple and red, or even green, and fewer images showed a natural-looking pale-yellow Milky Way. (See examples of natural-looking Milky Way colors in nightscape images on Twanight.org/color.)

In daytime nature photography altering the natural colors of any landscape will look unusual and obvious to viewers at a glance, like a green forest turned to blue or mountaintop snow in red. If you publish a photo of a blue sunset it's clear that either there is something badly wrong with your camera/processing or you were the first human on Mars to see this view! But most people are unfamiliar with the natural colors and the appearance of the night sky, especially as our eyes are not color-sensitive enough at low light to see the hues as they appear in our camera. Unfortunately the public, publishers, and media get easily excited with such exotic-looking images of the sky without asking if this is anywhere close to reality in term of photo originality. This fascination with exotic processing of sky images might further promote photographers to create unnatural images with shifted and highly saturated colors of night sky.

Setting the white balance close to the daylight setting doesn't always work because the sensitivity of different cameras to the spectrum varies and some correction for the sky glow is often needed. Below are a few of the parameters that may help you calibrate the sky color in nightscape images based on white balance and tint correction.

1. The high concentration of dust in the galactic plane can cause a general absorption and reddening of the light of billions of stars that form the Milky Way band. The central brighter part of the band in Scorpius and Sagittarius is more yellowish, with hints of red in the regions of bright emission nebulae. Away from the galactic bulge the band changes from pale yellow to colorless and shifts to very pale blue and red in some other regions.
2. Notable brighter stars should appear in the colors that match their temperature range (if they are not white saturated by the sensor). If you capture the red giant Antares in blue, or the white-blue Rigel in red, there is either a wrong calibration or something dramatic has happened to these stars!
3. The sky background color (natural sky glow) in an ideal dark site where light pollution or aurora activity is absent is not totally black but is actually has a very pale green-red cast depending on the airglow activity (more explanation follows). See this unique example of ideally dark sky where no major sky glow is affecting the site (twanight.org?ID=3002840).

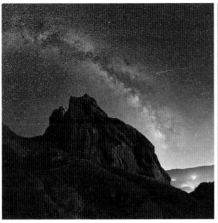

Fig. 22 The Milky Way is imaged above the ancient castle of Alamut in the Alborz mountains of Iran. The white balance setting of the modified cameras are trickier. The *red-purple* dominated view on the *right* might be more eye-catching to public but it shows a totally unnatural color compared to the correct setting at *left*

4. Blue background sky is caused by the moonlight or twilight. A blue night sky is a favorite color of many nightscape photographers, but this is often achieved artificially by shifting the camera's white balance.
5. The zodiacal light is not totally white but actually pale blue. This mystical light is caused by reflection of sunlight from dust particles in the Solar System plane. It is visible only on moonless nights from dark areas along the ecliptic in the sky, and it becomes brighter closer to the Sun. It is seen best as a large elongated cone-shaped light over the horizon right after dusk or before dawn (Fig. 22).

As mentioned earlier the color of the background night sky does change both by natural and artificial sources. Below is the list of all the usual sources of sky glow that we should take into account. Note that the more prominent sources cast an overall glow across the sky that sits as a layer against the Milky Way and can shift its color in the images.

1. Light Pollution: This manifests as a yellow-red glow to the background sky that many nightscape photographers try to remove by changing the photo's white balance, which also changes the colors of stars and the Milky Way. With the increasing number of LED lights in urban areas in the future, blue will also be a dominating color of light pollution sky glow: There is only a small portion of Earth's surface that remains today with a night sky unaffected by this artificial glow.
2. Twilight: This is an important factor especially in high latitudes where twilight influences the sky color for a much longer duration during the night, especially during spring and summer with its blue cast.

3. Moonlight: The amount of natural sky glow by the Moon not only depends on the Moon phase but also the sky transparency. At low altitudes dust or humidity in the sky with even a crescent Moon can cast a blue color to the sky while at high altitudes the sky on the opposite side of the Moon remains dark even during the quarter Moon. One of my experiences in this regard was imaging at 5,000 m high at the site of the ALMA radio telescopes under a stunningly transparent sky. A brightly shining Moon at over 50 % phase was in the sky, and there was no sign of blue sky glow in the images. The sky was amazingly dark only a few degrees away from the Moon.
4. Aurora: The green or red cast of an unseen aurora should be considered in images, especially when shooting from high latitudes or during solar peak of activity. The sky above polar latitudes, even at locations far from major cities, is often dominated by some aurora activity. Even if it's not visible to unaided eyes the green cast appears in the images. These areas offer breath-taking scenes to nightscape photographers, but they are not welcomed by deep sky imagers because of constant aurora sky glow!
5. Zodiacal Light: The sky glow effect of the zodiacal light is mainly colorless, but it may look pale blue within the light itself. Therefore it only adds to the sky brightness depending on the sky transparency and the brightness of the zodiacal light. The effect is stronger near the equator, where the ecliptic stands vertically above the horizon and causes the zodiacal light to appear higher and brighter in the sky. The light becomes weakest in the polar regions. In the mid-latitudes zodiacal light is best visible in the evening sky of March to April (near to the vernal equinox) and in the pre-dawn morning sky of September to October (close to the autumnal equinox).
6. Starlight: A weak but noticeable part of the natural sky glow comes from the Milky Way itself.
7. Airglow: Last but not least this component of natural glow of our atmosphere is one of the most interesting. Because of airglow the night sky is never completely dark. Even in the absence of light pollution or major natural sources of sky glow Earth's night sky always has this faint glow. Airglow becomes visible to the naked eye only under dark skies. The glow is mostly visible at 10–15° above the horizon, but when it's active it appears higher in the sky and even has stripes and faint bands that appear across the sky. Airglow is green and red in the images, but we can't visually see these colors. (See various examples at twanight.org/atmospheric.) The weaker red airglow usually appears near the twilight while the green dominates the sky the rest of the night. Unlike aurora light, which is powered by collisions with energetically charged particles and seen at high latitudes, airglow is due to the production of light in a chemical reaction and is found around the globe. The chemical energy is provided by the Sun's extreme ultraviolet radiation. Similar to an aurora, airglow is connected with solar activity. It changes in a pattern with the solar cycle. The green airglow originates at altitudes of about 100 km dominated by emission from excited oxygen atoms. In many of the images taken by astronauts from the ISS this green glow is clearly visible like a bubble around Earth, marking the edge of space.

Fig. 23 While adjusting the white balance is possible in the post processing (using RAW files) you can also precisely set this in the camera using the custom white balance function, similar to white balancing video cameras

Besides the ever-increasing capabilities of processing software and sophisticated efforts to remove the red cast of light pollution, there is yet another factor that causes a stream of unusual colors in landscape astrophotos. It is the modification of DSLR cameras. Replacing the standard IR-cut filter of DSLRs that sits in front of the sensor dramatically increases the astronomical capabilities of the camera but also changes the white balance of the system completely. The camera becomes much more red sensitive, and images without a compensatory custom white balance calibration seem to be dipped in red and purple.

When I modified a DSLR camera for the first time I quickly noticed magenta and red-dominated sky images. Later I learned how to compensate precise calibration either in the camera or in post-processing with white balance and color tint. I remember my first modified image that appeared as Astronomy Picture of the Day (APOD). It was the Milky Way, strangely colored in magenta, above the ancient castle of Alamut in Iran. The image became very popular on the Internet. I then heard from David Malin, the master of astrophotography, that the natural colors of the night sky were altered in this image. That was the moment I became ever more interested in this subject and the many factors that affect sky colors. A modified camera is still an essential component of my work, but I learned to bridle this strongly sensitive but rebellious device (Fig. 23)!

An easy and reliable way to calibrate a modified DSLR is by using a custom white balance. During the imaging session take an exposure of a white paper in front of the camera with a flash (with normal daylight Kelvin temperature). Try to reach a good exposure without saturating the paper. Now introduce this as the reference in the camera custom WB. A similar result can be achieved by imaging the paper under moonlight or starlight (in long exposure). By shooting in RAW you can always correct this in the RAW reader plug-in.

Final Words

Two of the most common image processing software packages in photography are *Photoshop* and *Lightroom,* both by Adobe. Many nature photographers prefer *Lightroom* for processing and preparing the image for the purpose of printing. *Lightroom* applies functions more gently and color contrast is stronger. Be aware however that *Lightroom* has a rather aggressive effect on nightscape photos regarding the natural colors, as explained earlier in this chapter. Processing with this software requires that you are familiar enough with the functions; otherwise it can result in overly saturated and altered sky colors. I do recommend *Photoshop* as a better software program for nightscape photographers.

Although the potential for creativity and extreme challenges exist in all fields of photography the main goal in landscape astrophotography is to capture what was experienced by the eyes of the photographer at the scene. The process might require as much time as deep sky imaging but not for the purpose of revealing faint details but rather to create a natural-looking view without major digital manipulations (Fig. 24).

Fig. 24 A bright colorful meteor is captured in this chance shot using a wide-angle lens. The single-exposure image also shows the rising colors of the morning twilight against the fading Milky Way, with Jupiter in the constellation Taurus (*left* of the meteor), the Pleiades star cluster and California nebula (the red patch at *top*), and Sirius and the constellation Orion at the lower *right*

Imaging and Processing Images of the Solar Corona

Fred Espenak

Of all astronomical phenomena visible to the naked eye, none is as spectacular, or as fleeting, as a total eclipse of the Sun. For a few brief minutes, the Moon blocks the Sun's blindingly bright photosphere to reveal the ethereal solar corona. This gossamer halo, forming the outer atmosphere of the Sun, can only be seen in the eerie twilight brought on by totality.

Although the corona looks tranquil and serene, it is actually a maelstrom of dynamic activity. The gas composing it is super heated to temperatures in excess of two million degrees. Under these conditions, normal gas is rendered into a plasma in which the electrons are torn from the outer shells of atoms. The remaining fragments are electrically charged and subject to the intense magnetic fields produced below the surface of the Sun. Following strong magnetic lines of force, the coronal plasma forms long, intricate streamers, helmet-shaped plumes, polar brushes and equatorial loops. This wealth of fine detail is dramatically different from day to day because of the Sun's constant activity. Indeed, no two total eclipses look the same since the typical interval between consecutive them is 1–2 years. Over such a long interval, the Sun makes dozens of rotations and many solar storms come and go.

In appearance, the corona is pure white in color, but it may take on the hue of the ambient sky conditions especially when the Sun nears the horizon. Its integrated brightness is comparable to the full Moon, but this is a million times fainter than the Sun's photosphere. In addition, the luminosity of the corona drops off rapidly with distance from the Sun's surface. For example, the corona's brightness typically decreases by a factor of 1,000 between a point near the limb of the Sun and a second point one solar radius higher in the corona (about 1/2° from the solar limb).

This radial dependence in coronal brightness presents special challenges to image capture and processing. Before delving into these topics, a quick review on eclipses is in order.

Solar Eclipse Basics

A solar eclipse can occur only when the Moon passes between the Sun and Earth during the new Moon phase. Since the Moon's orbit is inclined about 5.4° to Earth's orbit around the Sun, the Moon usually passes above or below the Sun-Earth orbital plane during the new Moon, so no eclipse takes place. But every 5 or 6 months the Moon passes through the orbital plane around the new Moon, resulting in an eclipse of the Sun. Most of the time, the alignment isn't perfect enough for the eclipse to be total. In these instances, only part of the Sun is eclipsed, thereby producing a partial solar eclipse.

Once every year or two, the new Moon occurs as the Moon passes directly between the Sun and Earth, producing a total eclipse. Unfortunately, the total phase can only be seen from within the Moon's small umbral shadow, which is typically about 100 miles in diameter. During an eclipse, the orbital motion of the Moon around Earth causes the Moon's umbral shadow to sweep across the surface of our planet. The resulting shadow track is called the path of totality, and the total phase of the eclipse and the solar corona are only visible within this zone. Outside the path is a much larger region covering up to half of the daylight side of Earth where a partial eclipse is seen.

The path of totality of each eclipse covers just a fraction of 1 % of Earth's surface, so would-be eclipse photographers must travel great distances, often to remote areas of the world for a few precious minutes of "dark time" in the Moon's shadow. Although the exact time and place of each total eclipse can be predicted many years in advance, all the planning, expense and effort can be ruined at the last minute by bad weather. Long-range climate statistics can help in choosing an eclipse site with a high probability of clear sky, but this is small comfort if the clouds roll in on eclipse day. Nevertheless, many have found that the experience of totality is worth the risk.

But how do you capture and process images that faithfully reproduce what you see? Although the solar corona is the ultimate imaging target of a total solar eclipse, this unique event offers a number of additional photo opportunities. They include wide-angle imaging of people and surroundings, especially if the sky with eclipsed Sun are included. Such images provide a powerful context to the eclipse, which is rarely possible in other facets of astrophotography. Video recordings capturing both sight and sound are especially effective in revealing human reactions and the rapid change in the local environment as the Moon's shadow sweeps across the landscape. Although compelling and worthy of their own chapters, these topics lie outside the scope of the current discussion. A useful reference on these topics as well as a complete guide to solar eclipses is *Totality: Eclipses of the Sun* (Mark Littmann and Fred Espenak, Oxford University Press, 2009).

Image Scale, Focal Lengths and Lenses

If the overall goal is to image each phase of the eclipse with a single camera and lens, then the imaging process can be divided into three distinct stages: (1) partial phases, (2) diamond ring, and (3) totality/corona. Each of these subjects has different imaging requirements, but they also share some things in common.

First and foremost is image scale. Both the Sun and Moon appear to subtend an angle of approximately 1/2° in the sky.[1] For any lens or telescope, the diameter of the Sun's image at perihelion is equal to the focal length divided by 105.7. For example, a 400 mm telephoto lens will produce an image of the Sun's disk 3.78 mm in diameter. This is rather small, but the format of your camera also plays a significant role.

Just a decade ago, the 35 mm film SLR (single lens reflex) was the most widely used camera for photographing eclipses. The SLR's original lens could be replaced with a long telephoto lens or even a telescope to achieve magnifications high enough to fill the field of view with the eclipsed Sun and corona. Today, the SLR has been replaced with the DSLR (digital single lens reflex). Film has been superseded by the digital sensor be it the CCD (charge-coupled device) or CMOS (complementary metal-oxide-semiconductor). The actual difference in these two technologies is of little concern to the eclipse photographer, but the chip size is critical.

DSLRs generally fall into two sensor-size categories: (1) the professional DSLR employs a full 35 mm film size sensor (approximately 24×36 mm), and (2) the consumer/prosumer DSLR employs a smaller (less expensive) sensor often referred to as APS-C after another common film size used in compact cameras 10 years ago. Nikon calls the full frame DSLR the FX format, while the smaller APS-C size is the DX format. Canon does not use these terms, and their APS-C format is slightly smaller than Nikon's. The Canon APS-C format measures 14.8×22.2 mm (= 329 mm^2), while the Nikon's is 15.7×23.6 mm (370 mm^2). Most of the other DSLR manufacturers (e.g., Pentax, Samsung, Sony, and Fujifilm) offer an APS-C format comparable to Nikon's DX.

Any discussion of DSLRs invariably turns to the subject "crop factor." The most common definition of crop factor is the ratio of a 35 mm frame's diagonal (43.3 mm) to the diagonal of a DSLRs image sensor. In the case of Canon APS-C, the crop factor is 1.6× while for Nikon it is 1.5×. Given the same 3:2 aspect ratio of both full frame and APS-C formats, the ratio of the sensor areas is equal to the square of the crop factor.

The crop factor is also referred to as the focal length multiplier. Multiplying a lens focal length by the crop factor of a DSLR gives the corresponding focal length required to produce the same field of view on a full frame DSLR. For example, if a 400 mm lens is used on a Nikon DSLR with an APS-C sized sensor (crop size=1.5×), you would need a 600 mm lens to achieve the same field of view on a full frame camera. The 400 mm lens produces exactly the same size image in

[1] Actually, the elliptical orbits of Earth and the Moon cause small variations in the angular diameters of the Sun (0.524°–0.542°) and the Moon (0.490°–0.559°).

Table 1 Eclipse photography with DSLRs

DSLR sensor class	Sensor size	Crop factor	Minimum focal length[a]	Nominal focal length[b]	Maximum focal length[c]
Full size (35 mm)	24×36 mm	1.0×	634 mm	846 mm	1,268 mm
Nikon APS-C	15.7×23.6 mm	1.5×	415 mm	553 mm	830 mm
Canon APS-C	14.8×22.2 mm	1.6×	391 mm	521 mm	782 mm

[a]Focal length producing a solar image 1/4 the size of sensor's narrow dimension
[b]Focal length producing a solar image 1/3 the size of sensor's narrow dimension
[c]Focal length producing a solar image 1/2 the size of sensor's narrow dimension

both APS-C and full size sensors, but the size of that image relative to the dimensions of the field of view is where the crop factor comes into play.

What this means to the eclipse photographer is that you need a longer focal length lens to cover the equivalent field of view when using a DSLR with a full-size sensor. This is a distinct advantage for DSLRs with the smaller APS-C sensor because it means you can use a smaller telescope or lens to image the eclipse. With airline baggage fees and the hassle of transporting equipment half way around the world for each eclipse, this is no small consideration.

On the other hand, a DSLR camera with a full size sensor is a professional machine with higher reliability, more features and faster continuous shooting speeds. The full frame sensor usually has lower noise and more pixels than an APS-C sensor.

Regardless of which DSLR sensor format is used, all are capable of producing top quality results for eclipse imaging. However, the sensor size will definitely drive the decision on the lens focal length. The minimum focal length to aim for is one producing a solar disk image one quarter the size of the sensor's narrow dimension. This offers reasonable scale and permits imaging long streamers in the outer corona. A nominal focal length at a higher magnification that captures more detail without cropping the outer corona is one in which the solar disk appears a third the size of the sensor's narrow dimension. Finally, the maximum focal length to consider is one producing a solar disk half the size of the narrow dimension. This still captures the inner and middle corona, but requires good centering of the Sun in the frame.

Table 1 shows the minimum, nominal and maximum focal lengths for the different DSLR sensor sizes. The minimum focal length for an APS-C sensor is around 400 mm, while a full frame sensor requires at least 600 mm. Some photographers may be tempted to increase the focal length of a lens using a 1.4× or 2× teleconverter (sometimes called tele extender). Although it might seem like a good idea, a teleconverter can introduce serious internal reflections. This is especially true when photographing the diamond ring stage or during long exposures for the middle and outer corona. Shooting +6 EV[2] to +10 EV exposures of the crescent Moon can test

[2]The exposure value, or EV, is used to indicate an interval on the photographic exposure scale. A step of 1 EV corresponds to an exposure difference of 2 (one full f-stop).

for the presence of internal reflections. By placing the Moon off-center, internal reflections will reveal themselves on the opposite side of the optical axis from the primary image. A teleconverter should only be considered after passing this test.

Even without a teleconverter, prime camera lenses should also be tested for internal reflections. With their many optical components, there are multiple lens-to-air surfaces where internal reflections can arise. Eclipse photography is not like conventional photography – you are shooting directly into the Sun while trying to capture features that exhibit exposure differences of 10 EV or more. Such conditions are ripe for producing internal reflections.

A better alternative is to consider a good apochromatic refractor telescope. There are many on the market with focal lengths in the range shown in Table 1. They typically have fixed focal ratios of f/6 to f/8, which is fine for eclipse photography.

Many refractors with apertures of 60–90 mm are relatively lightweight, which makes them great for international travel. They can be supported well with a solid, intermediate-size tripod. A good test for stability is to photograph the crescent Moon using a range of shutter speeds from 1/2 to 1/125. Sandbags or water jugs can be duct-taped to the legs or center column for added stability. Since these items can be procured after traveling to an eclipse destination, they need not count towards airline weight limits.

There is a limit to the longest useful shutter speed when using a simple tripod. Earth rotates 360° every 24 h, resulting in an apparent westward drift in the Sun's position of 15 arc-seconds per second. In other words, the Sun appears to move across the sky by its own diameter every 2 min. Most modern DSLRs have pixels around 5 mm in size. This corresponds to an image scale of approximately 2 arc-seconds per pixel for a 500 mm lens. Given the Sun's drift rate of 15 arc-seconds per second, the Sun's image drifts by 1 pixel in 2/15 s (shutter speed of ~1/8). In the real world, a value three times larger is an acceptable upper limit. Thus, a 500 mm lens using a DSLR with 5 mm pixels is limited to a maximum shutter speed of 6/15 or 2/5 s when using a fixed tripod. Table 2 gives the image scale and maximum shutter speeds for a range of focal lengths. For DSLRs with a pixel size other than 5 mm, the values in Table 2 should be scaled by the factor "(pixel size)/5".

Although heavier and more complicated to set up in the field, a small equatorial mount with a battery-operated drive is a great asset when shooting eclipses. A rough polar alignment is usually good enough to keep the telescope tracking on the Sun with only occasional adjustments in RA and Dec. This is especially helpful during totality because the camera tracks the Sun and is not subject to the shutter speed limits in Table 2. It is then possible to make exposures of several seconds, which are necessary to image the far outer corona. With a little planning, a refractor telescope and equatorial mount can be packed into a standard suitcase without exceeding the 50 lb (23 kg) weight restriction on many international flights.

Table 2 Drift time of sun (due to earth's rotation)

Focal length (mm)	Image scale[a] (arcsec/pixel)	Drift time for 1 pixel (s)	Drift time for 3 pixels (s)
200	5.16	0.344	1.031
300	3.44	0.229	0.688
400	2.58	0.172	0.516
500	2.06	0.138	0.413
600	1.72	0.115	0.344
700	1.47	0.098	0.295
800	1.29	0.086	0.258
900	1.15	0.076	0.229
1000	1.03	0.069	0.206

[a]Assuming a 5 mm pixel size

Partial Phases

Every total eclipse begins and ends with a partial eclipse. The eclipse starts with "1st contact" when the Moon's limb first touches the edge of the Sun. The partial phases then proceed at a leisurely pace. It typically takes an hour or more for the Moon to slowly crawl across the Sun's photosphere. During this period, the Moon's motion relative to the Sun can be seen most easily as it occults sunspots on the solar disk.

Photographing the partial phases is quite easy, but a solar filter is mandatory. Whether they are made of glass, polycarbonate or some other material, solar filters are typically designed to transmit 1 part in 100,000. This is equivalent to a 5.0 neutral density filter and is nearly 17 full f-stops in exposure difference. Never try to observe the partial phases of a solar eclipse without using a solar filter. Failure to do so can result in permanent eye damage. Even if 99 % of the Sun's disk is eclipsed, the remaining 1 % is still dangerously bright. The Sun can only be safely viewed without a solar filter during the total phase of the eclipse.

Solar filters are available from a number of companies and telescope dealers (Table 3). Some filters come in a threaded cell and screw onto the front of a camera lens. Others use a friction fit with felt – they just slide on and off the front of the lens or telescope. Whichever filter type is chosen, it should be secure enough to resist any wind gusts but should also be easy to remove for the diamond ring and totality.

Proper exposure for the partial phases can be determined using spot meter mode. Otherwise, use trial-and-error and the DSLR image histogram to evaluate and adjust the exposure. The Sun's surface brightness does not change during the eclipse, so no exposure adjustments are needed unless haze or low altitude becomes a factor. The DSLR should be used in manual exposure mode because auto exposure or program modes do not work properly when the partial phase shrinks to a thin crescent.

Table 3 Sources of solar filters

- Astronomics, 110 E. Main, Norman, OK, 73069
 Phone: 800-422-7876; web: www.astronomics.com
- Oceanside photo & telescope, 918 Mission Ave., Oceanside, CA 92054
 Phone: 800-483-6287; web: http://www.optcorp.com
- Orion telescopes, 89 Hangar Way, Watsonville, CA 95076
 Phone: 800-447-1001; web: www.telescope.com/
- Rainbow symphony, 6860 Canby Ave. Suite 120, Reseda, CA 91335
 Phone: 800-821-5122; web: www.rainbowsymphonystore.com
- Seymour solar filters
 web: stores.ebay.com/Seymour-Solar-Filters
- Thousand Oaks optical, P.O. Box 6354, Kingman, AZ 86402-6354
 Phone: 928-692-8903; web: www.thousandoaksoptical.com

Many Nikon DSLRs have a built-in intervalometer, which is very useful for shooting the partial phases at fixed time intervals. Otherwise there are some very inexpensive ($20–$30) third-party (e.g., Neewer, Shoot) remote shutter release cables with intervalometers or timers that do the same thing. They are available for most Canon and Nikon DSLRs, and they also work as simple remote shutter triggers to minimize camera vibration. Look for them on amazon.com or from major camera retailers (e.g., Adorama, B & H Photo, etc.).

When a DSLR is mounted on a tripod and pointed high in the sky, the viewfinder is in an awkward position. The use of a right-angle finder makes viewing much easier, and the 2× zoom feature available in most units is a great aid in obtaining critical focus. Autofocus is unreliable during the rapidly changing lighting conditions of a total eclipse. Keep the DSLR in manual focus mode and use a piece of masking tape to keep the focus ring from accidentally turning after good focus is achieved.

Shoot the entire eclipse using the camera's native RAW format. While JPEG is an 8-bit format (covering a brightness range of 0–255), the RAW format typically has 12 bits (a range of 0–4,096). The extra bit depth of RAW is especially useful given the huge dynamic brightness range of the solar corona. RAW files also offer greater ability to correct for underexposure or overexposure. Although JPEG files are smaller than RAW, the prices of CF and SDHC memory cards have dropped so low that there is no economic argument for shooting JPEG instead of RAW. Just be sure to have enough storage room for the entire eclipse.

Diamond Ring Stage

During the first half of the partial phases, it is difficult to notice anything without viewing the Sun through a solar filter. Then the landscape begins to change gradually as the Moon occults more of the Sun's disk. By the time 90 % of the Sun is covered,

the ambient light is rather odd looking. It resembles the appearance of an approaching storm, which is especially disconcerting if the sky is (hopefully) free from clouds. Still blindingly bright, the Sun gives little hint of the impending event. At 95 %, the air is cooling, and shadows have a most peculiar appearance. They are sharp in one direction but fuzzy at 90°, because the Sun is now a thin crescent rather than a disk.

During the last 2 min, shadow bands are sometimes seen rippling across the ground like patterns on the bottom of a swimming pool. It is thought that they are related to the same atmospheric phenomenon that causes stars to twinkle.

In the final 60 s, events occur at an accelerating pace. Daylight visibly fades as the sky grows darker, especially in the direction of the approaching lunar shadow, which is traveling at more than 1,000 miles per hour. With 10 s remaining, the solar crescent can now be glimpsed ever so briefly (and carefully) without a solar filter as the solar corona begins to appear. The horns of the crescent quickly merge together to form a dazzling jewel along one edge of the Moon's black disk as the rest of the lunar orb is encircled and silhouetted by the corona. This splendid event is known as the diamond ring effect and lasts only a few seconds. As the diamond shrinks, it breaks up into a string of sparkling pinpoints of light. These are Baily's beads, formed by the last remaining rays of photospheric sunlight shining through deep valleys along the edge of the Moon. Totality officially begins with second contact when the last Baily's bead vanishes.

It is difficult to remain calm during the events described in the previous paragraph. Nevertheless, the eclipse photographer must execute his or her photo sequences with the precision of a military operation, because there are no do-overs. Although imaging the diamond ring effect is not difficult, the timing is critical. Both exposure and focus must be set to manual because auto modes are not reliable under these conditions.

One minute before totality begins, the Sun should be recentered in the camera. The tricky thing here is to place the invisible point corresponding to the middle of the Sun's hidden disk at the center of the field and not on the crescent itself. In the final 20 s, the solar filter must be gently removed from the telescope or telephoto lens. Great care is needed to prevent jarring the camera or tripod, which could jeopardize the careful alignment on the Sun. Once the filter is removed, it is dangerous to look through the camera again until totality begins. Fortunately, the diamond ring can be shot without using the viewfinder, and there are two primary strategies for doing so.

In the first case, the DSLR can be set up to shoot sets of bracketed exposures. For example, set the camera to bracket three shots at −1.5 EV, 0 EV and +1.5 EV, where the 0 EV exposure is manually set using the eclipse exposure guide in Table 4. The recommended exposures in this table are for ISO 200, which works well for telephoto lenses and telescopes in the f/5.6 to f/11 range. Use ISO 100 for faster optics and ISO 400 for slower f-ratios. Of course, the exposures recommended in Table 4 must then be changed accordingly. Bracketing exposures during the diamond ring produces images with varying amounts of coronal ring and brilliant diamond, both of which are changing rapidly just before totality begins.

In the second case, a fixed exposure from Table 4 is chosen for the diamond ring, Baily's beads, or an intermediate value between the two. This single exposure should

Diamond Ring Stage

Table 4 Eclipse exposure guide

Eclipse feature	Suggested exposures at ISO 200					
	f/4	f/5.6	f/8	f/11	f/16	f/22
Partial phases[a]	1/4,000	1/2,000	1/1,000	1/500	1/250	1/125
Diamond ring	1/1,000	1/500	1/250	1/125	1/60	1/30
Baily's beads	1/4,000	1/2,000	1/1,000	1/500	1/250	1/125
Prominences	1/2,000	1/1,000	1/500	1/250	1/125	1/60
Inner corona	1/500	1/250	1/125	1/60	1/30	1/15
Middle corona	1/60	1/30	1/15	1/8	1/4	1/2
Outer corona	1/8	1/4	1/2	1 s	2 s	4 s
Far outer corona	1 s	2 s	4 s	8 s	15 s	30 s

[a]Exposure using ND 5.0 solar filter (must be removed for other eclipse stages)

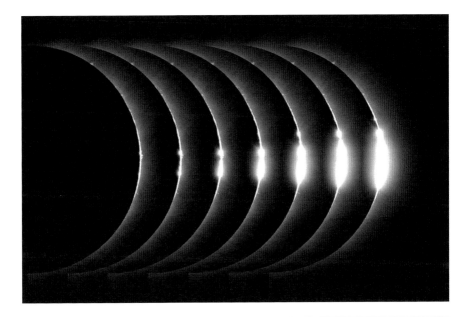

Fig. 1 Image sequence of Baily's beads at third contact was captured with a Nikon D200 and 90 mm Vixen fluorite refractor (f.l. = 820 mm, f/9) during the total solar eclipse March 29, 2006. The seven exposures were all shot at 1/1,000, ISO 200 with the camera drive set on continuous at 1 frame per second

be used throughout the brief period preceding totality. The resulting image sequence can reveal details in the formation and evolution of Baily's beads (Fig. 1).

In both imaging strategies, the DSLR drive is set to continuous mode and the remote cable trigger button is held down during the 10-s window before second contact. The motor drive can be set to 1 or more frames per second, but care must

be taken not to overflow the camera's memory buffer during the 10-s burst. This should be determined beforehand by running tests at different frame rates. A faster memory card may also be needed to handle high burst rates. Finally, make sure that tripod vibrations do not become a factor when operating the DSLR in continuous shutter mode. Once again, this can be tested shooting the crescent Moon.

Totality and the Solar Corona

As totality begins, the landscape is enveloped in an eerie twilight. Although not as dark as night, the rapid drop in illumination is quite startling. The sky brightness resembles normal twilight about half an hour after sunset. Planets and brighter stars can be seen, and the entire horizon is often ringed with the colors of sunrise/sunset.

The solar corona is now visible in all its glory as it surrounds the inky black disk of the Moon. During the first few seconds of totality, a bright red arc of light is usually seen along the lunar limb where second contact has just occurred. This is the Sun's chromosphere, a 1,000-mile thick layer of hot hydrogen gas just above the photosphere. Solar prominences may appear as bright red flames at various points surrounding the Moon's disk. These are relatively cool plasma clouds that extend up into the corona.

During the brief minutes of totality, the corona appears static. It does not flicker or change. However, it contains a wealth of detail that is challenging to capture. The biggest problem concerns the corona's immense intensity gradient as it extends out from the Sun. Any single exposure is only capable of recording a narrow range of coronal brightness. For this reason, the eclipse photographer must shoot a bracketed series of images covering an exposure range of 9 or more f-stops (Fig. 2). This can be accomplished in a number of ways.

The most straightforward method involves manually adjusting the camera to shoot each individual image in the series. Using Table 4 as a guide, the sequence should cover all exposures from "Prominences" to "Outer Corona." If the camera is tracking the Sun using a motorized equatorial mount, then the sequence can be extended to include exposures for the "Far Outer Corona." For an f/8 lens at ISO 200, the bracketed sequence consists of 13 separate exposures at: 1/1,000, 1/500, 1/250, 1/125, 1/60, 1/30, 1/15, 1/8, 1/4, 1/2, 1, 2, and 4 s. A 1-stop step size is used for good exposure overlap, but a step size of 1 1/3 or 1 1/2 stops would also work. Using a 1 1/2 stop step size, the sequence would consist of nine exposures at 1/1,000, 1/350, 1/125, 1/45, 1/15, 1/6, 1/2, 1.5, and 4 s.

Even though totality is short, allow time to center the eclipsed Sun in the viewfinder before beginning a bracketed sequence. If time permits take several bracketed sequences – they can be averaged together to improve the quality of the processed image. Care should also be taken to minimize vibrations as each sequence is shot. Once again, it is difficult to remain calm during the excitement of totality. The best advice is to rehearse all camera operations before the eclipse so that they can be executed reliably without thinking or looking at the camera.

Totality and the Solar Corona

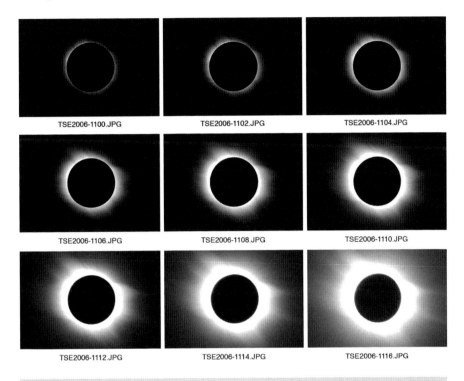

Fig. 2 A bracketed image sequence was captured with a Nikon D200 and 90 mm Vixen fluorite refractor (f.l. = 810 mm, f/9) during the total solar eclipse March 29, 2006. The nine exposures at ISO 200 were shot with the following shutter speeds: 1/500, 1/250, 1/125, 1/60, 1/30, 1/15, 1/8, 1/4, and 1/2 s

A useful feature found on Nikon's higher end DSLRs (including the D300, D700, D800, D3 and D4) is the ability to shoot bracketed series of up to nine images. During totality, the camera can then be switched into bracket mode. The photographer holds down the button on the remote shutter cable and all nine bracketed shots are made without touching the camera. Canon does not offer this feature on any of its cameras, even though it would be enormously useful for anyone shooting bracketed exposures for HDR (high dynamic range) imaging.

Another option for exposure bracketing is to control the camera with a laptop computer running special software. Fred Bruenjes of Moonglow Technologies (www.moonglowtech.com) has developed a program called *Eclipse Orchestrator* that runs on the Windows PC platform. The user selects the eclipse date and enters the geographic coordinates of the observing site. The software then calculates all the contact times and generates a simple script to photograph each stage of the eclipse including bracketed exposures during totality. The script is a simple ASCII text file that can be modified and optimized using easily learned syntax rules. *Eclipse Orchestrator* works with most recent Nikon and Canon DSLRs.

Camera communication is achieved via a USB cable, and the program can be run in simulation mode to develop and test an eclipse script. The author used this program during the 2009 total eclipse in China and it worked flawlessly.

Xavier Jubier developed a similar program for the Macintosh platform called *Solar Eclipse Maestro* (xjubier.free.fr/en/index_en.html). It has comparable features to *Eclipse Orchestrator,* including an editable script and simulation mode for testing.

The biggest down side of using either of these programs is that they involve setting up additional equipment in the field. More equipment means more things that can go wrong. At the very least, an eclipse script should be fully tested at home under simulated conditions to reveal any problems. It is important to verify that the laptop has enough power to run on battery alone for the duration of the eclipse.

On the plus side, these programs free you to watch and enjoy totality rather than slaving over a camera. And a well-tested script will not make any mistakes under stress. Whether you choose to run your camera from a laptop or not, these programs are excellent planning tools that can simulate the eclipse circumstances from any location on Earth.

After Totality

All too quickly totality ends with third contact shortly after the reappearance of the red chromosphere along the Moon's opposite limb. This is a second opportunity to photograph the diamond ring and Baily's beads. Remember to center the eclipsed Sun in the viewfinder before totality ends. After shooting the diamond ring sequence, replace the solar filter on the telephoto lens or telescope. The final partial phases can now be shot, but they are quite anticlimactic after totality.

Once the eclipse is over, all memory cards should be backed up to a laptop PC or an external drive. Remove the memory cards from the camera and store them in a safe place. Don't be tempted to shoot additional vacation or travel pictures on the same cards and don't erase them until additional copies have been made after returning home.

Coronal Image Processing

Viewing unprocessed images of the corona is always disappointing. While the mind's eye recalls the full dynamic range and fine details visible in the corona, the camera captures only a narrow slice in each exposure. In order to produce an image that resembles the visual appearance of the solar corona during totality, the bracketed exposures must be combined and enhanced.

Adobe *Photoshop* is one of the most widely used programs for processing digital images, and the techniques discussed here will rely heavily on it. When issuing *Photoshop* commands, a simple shorthand will be used. For example, the statement "select Radial_Blur… via Filter>Blur>Radial_Blur…" is shorthand for "go to the

Filter menu, and when it drops down you select the Blur option, which produces a sub-menu from which you select the Radial_Blur... option." *Photoshop* has shortcuts and buttons for executing many commands, but the explicit menus and submenus will be used here.

It is frequently necessary to save images from intermediate steps in creating the final composite. These intermediate images should always be saved in a non-lossy format to retain all digital information. Always use either *Photoshop* or TIFF format (not JPEG) to save these images.

To illustrate the following techniques, a set of eight bracketed images from the March 29, 2006, total solar eclipse will be used. The images were shot with a Nikon D200 DSLR (10.2 MP, APS-C format) and a Vixen 90 mm f/9 fluorite refractor (fl = 810 mm). The exposures in the series were shot at ISO 200 and covered shutter speeds from 1/250 to 1/2 s.

Radial Blur Technique

Crop Image

One method of producing a coronal composite with *Photoshop* was first described by Gerald Pellett (*Sky & Telescope,* Jan. 1998, pp. 117–120). It takes advantage of the corona's radial brightness distribution through the use of *Photoshop*'s radial blur filter as an unsharp mask. In order for the technique to work correctly, the Sun's (or Moon's) disk must be perfectly centered in each digital image. This can be accomplished by trimming the edges off two sides of each image in such a way that the Moon's disk is then located in the center of the frame.

The first step is to determine the current pixel coordinates of the center of the Moon. A simple way is to measure the left, right, top and bottom edges of the Moon's image. Enlarge the image to 200 % and open the Information Window via the Window>Info menus. Next, use the rectangular Marquee selection tool from the toolbar to draw a box with one edge tangent to one side of the Moon (either left, right, top or bottom). The pixel coordinates of the selection box are displayed in the Information Window. Write down the coordinate corresponding to the edge of the Moon's limb. Repeat the process until the pixel coordinates of all four sides of the Moon have been measured. The x coordinate for the center of the Moon's image is the average of the left and right positions. Similarly, the y coordinate is the average of the top and bottom positions.

Now it is time to crop off the edges of the image so that the Moon's disk will be perfectly centered. Change the Marquee tool to the Cropping tool. Next, position the cursor in the image at the x and y coordinates of the Moon's center as displayed in the Information Window. It is best to use a magnification of 100 % for accurate cursor placement. Now hold down the Alt key (Option key for Mac users) and drag the mouse diagonally in any direction while holding down the mouse button.

Continue dragging diagonally until the maximum limit is reached (i.e., when numbers in the Information Window stop changing). Release the mouse and keyboard

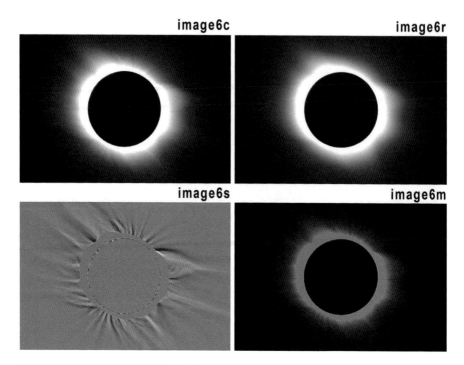

Fig. 3 The four steps of the "Radial Blur Procedure" are illustrated for a single image. The steps consist of "Center and Crop," "Radial Blur," "Subtraction," and "Multiplication"

buttons. Hit the Enter key (Return for Macs) to crop the selection. The Moon's disk is now perfectly centered in the cropped image. This should be verified using the steps in the previous paragraph before the cropped image is saved. Choose File>Save_As… and add a suffix to the file name to identify it as the cropped version of the image. For example, if the original image is called image6, then the cropped image would be image6c where the suffix "c" is for "centered and cropped" (Fig. 3).

This process is now repeated on all images to be used in the composite. While performing these actions, use the Information Window to note the final dimensions (pixels) of each "c" image file. Besides centering the Moon in each frame, another compositing prerequisite is that each digital image must have the same physical dimensions (in pixels). After centering the Moon in all files, make note of the physical dimensions of the smallest file. These will be used as the common or standard dimensions of all the image files. Open each file and crop it to the standard size using the Canvas_Size… dialog box (via Image>Canvas_Size…). If necessary, use the pop-up menus in the Canvas_Size dialog box to change the New Size units to pixels. Enter the common or standard width and height (in pixels) and hit the OK button. Save the file and repeat until all the files have the same physical dimensions.

All images now have the same dimensions and the Moon's disk is centered in each. They are ready to be processed with the Radial Blur filter in spin mode. This tool blurs an image by rotating it about its central axis through a user-selected

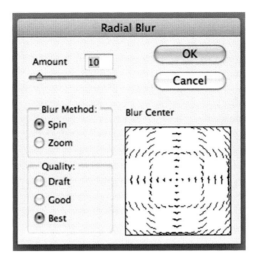

Fig. 4 The settings in *Photoshop's* "Radial Blur" filter are shown

angle. In the process, the brightness values of every pixel at a given radial distance from the central axis is averaged with all other pixels at the same radius and over the user-selected rotation angle. This arc can have any integer value from 1 to 100°. An angle of 5–10° works well for this application. Larger angles result in the loss of small details in the corona.

The Radial Blur filter should be performed on a copy of the "c" image so as not to destroy the original, especially since it will be needed later. To make a copy of an image within *Photoshop,* click on the image to select it and then choose Image>Duplicate. When the dialog box appears, modify the copy file's name by appending an "r" to it (e.g., image6r where "r" is for "Radial Blur"). Click the OK button to finish the duplication.

With the new "r" image selected, choose Filter>Blur>Radial_Blur. In the Radial_Blur dialog box, set the amount to 10° (Fig. 4). Choose the Spin and Best option buttons and then click the OK button. Depending on the speed of the CPU and the size of the image file, the radial blur filter may take several minutes to run. A dialog box displays the relative progress of the filter. Save this image when the radial blur is complete.

It is interesting to compare the new "r" image with the original "c" image (Fig. 3). Although the "r" image preserves the brightness distribution and overall shape of the corona, it is completely devoid of any fine details.

Subtraction Image

If the devil is in the details, then the next step is a perfect example. By subtracting the "r" image from the "c" image, the resulting subtraction or "s" image contains

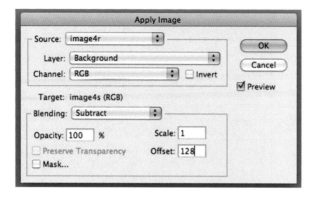

Fig. 5 The settings in *Photoshop*'s "Apply_Image..." filter are shown for the "Subtraction" step

all the fine details in the corona without the underlying brightness distribution. In a sense, it is the complement of the "r" image. In fact, if "r" and "s" are added together, the result resembles the original "c" image.

Photoshop makes it easy to add images together, provided that they have exactly the same physical dimensions. This is why all the images were cropped earlier. To preserve the original "c" image, click on it and make a copy by selecting Image>Duplicate. Append an "s" (for "subtraction") to the name of the new copy (e.g., image6s). Next, choose the Image>Apply_Image... menu. When the Apply_Image... dialog box appears (Fig. 5), use the Source pop-up menu to select the "r" image (e.g., image6r). The target image is the "s" image because it was the last image clicked on. Next, use the Blending pop-up menu to select the Subtract mode. When this is done, two new input fields appear: Scale and Offset. These are used to determine how the two images will be blended together. In this case, Scale should be set to 1 and Offset to 128. All other controls should be set as shown in Fig. 5.

The Offset value deserves a short explanation. Each image is composed of red, green and blue channels containing pixels with values from 0 to 255. The subtle structure in the corona is typically just a few brightness values higher or lower than the underlying background. For example, imagine a pixel in some fine detail in "c" which has a value of 100, and an underlying corona in "r" with a value of 97. When image "r" is subtracted from "s" ("s" is actually a copy of "c"), the resulting pixel will have a value of 3 ($=100-97$). Now consider the opposite case where the pixel in "c" is 97 and the background pixel in "r" is 100. The new value after subtraction will be -3 ($=97-100$). Since *Photoshop* cannot display negative brightness values, the new pixel brightness will default to 0.

The net result of this thought experiment is that information will be lost whenever a pixel in "c" is darker than the corresponding pixel in "r." The solution is to add a scalar to all pixels when the subtraction is performed. The scalar value 128 is chosen as this offset because it is midway between 0 and 255. A value of 128 appears as a medium gray shade when displayed in black and white.

Radial Blur Technique 309

Fig. 6 The settings in *Photoshop*'s "Apply_Image..." filter are shown for the "Multiplication" step

This explanation applies to both 8-bit and 16-bit images. For the purposes of the Apply_Image... dialog box, *Photoshop* scales the numbers displayed for 16-bit images to the range of 0–255. This is a relative scale (darkest to lightest). The actual data in a 16-bit image is not is lost or clipped.

The Apply_Image... dialog box also has a Preview check box. Selecting it shows what the blended image will look like before the operation is performed. Once all parameters have been set correctly, click on OK. Save this image immediately. The new "s" image will appear gray and nearly featureless, but closer inspection will reveal subtle coronal details. The contrast in Fig. 3 (image6s) has been exaggerated to show this detail more clearly.

Multiplication Image

Now that an image has been produced containing the corona's fine detail (image6s), it can be used to enhance the original image (image6c) by multiplying the images together. Once again the "c" image must be selected and duplicated via the Image>Duplicate menu. Append an "m" (for "multiplication") to the name of the new image. Choose the Image>Apply_Image... menu to activate the Apply_Image... dialog box (Fig. 6). Use the Source pop-up menu to select the "s" image (e.g., 'image6s'). The target image is the "m" image, which is currently a copy of "c." This time the Blending pop-up menu must be set to Multiply mode. All other controls should be set as shown in Fig. 6. Click OK and save the result. The "m" image appears like a darker version of "c," but with enhanced coronal detail (Fig. 3).

Of course, fine structure in the corona is revealed only in those portions of the "c" image that were properly exposed. Upon examining the panels in Fig. 3, it is readily apparent that the inner corona has no detail because it was grossly overexposed. On the other hand, the middle to outer corona shows a lot of structure

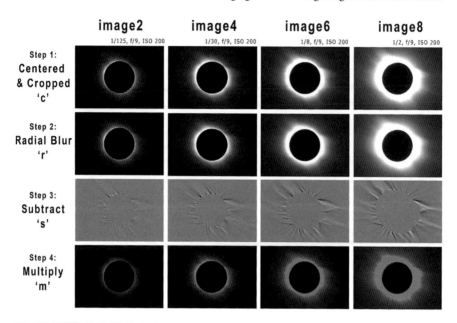

Fig. 7 The four steps of the "Radial Blur Procedure" are illustrated for a four eclipse images (shutter speeds of 1/125, 1/30, 1/8, and 1/2 s). The steps consist of "Center and Crop," "Radial Blur," "Subtraction," and "Multiplication"

since it received a good exposure for that region. Using a series of images shot at different exposures, a detailed image of the corona can be constructed over a much broader dynamic range than is possible with conventional photographic techniques. The radial blur, subtraction and multiplication operations must now be performed on each of the remaining "c" images.

Assembling the Composite

Figure 7 illustrates all the steps needed to process 4 of the 2006 eclipse images. They were shot at shutter speeds of 1/125, 1/30, 1/8, and 1/2 s at f/9 and ISO 200. The top row shows the centered and cropped "c" images. The second row contains the radial blur "r" images. The third row shows each of the subtraction "s" images (with the contrast increased for clarity). Finally, the bottom row shows the final multiplication "m" images.

At this point, a composite image can be assembled by adding together all "m" images. First make a copy of the "m" image with the shortest exposure (i.e., image1m) via Image/Duplicate and call it comp1. This will form the foundation of the composite. Now select Image>Apply_Image... to bring up the Apply_Image... dialog box. Change the Source pop-up menu to image2m and the Blending pop-up

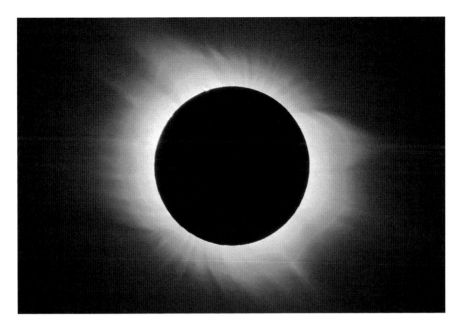

Fig. 8 The "Radial Blur Procedure" was used to combine nine bracketed images of the solar corona into a single composite that shows fine details in the inner, middle and outer corona. This version approximates the visual appearance of the corona

menu to Add mode. Set Scale to 1.4 and Offset to 0. Click OK to add the images. With comp1 still selected, repeat the Apply_Image… operation until all of the "m" images have been added to the comp1 composite image.

The final result is shown in Fig. 8. The composite has enhanced structure in the corona and shows details in the inner, middle and outer corona. Compare it to the initial images in Figs. 3 and 7.

Much experimenting can be done to fine tune the appearance of the composite image. For instance, a different value for Scale can be used in the Apply_Image… dialog. This will control the contrast and dynamic range of the final composite. If additional "c" images are available, they can be included in the overall processing to increase the brightness range and resolution of the composite. Averaging composites produced from separate image sequences will reduce image noise that appears as grain.

Variation on a Theme

In order to exaggerate the coronal detail even more, a small variation in the above procedure works well. It involves modifying the "s" image corresponding to the longest exposure "c" image by adding all other "s" images to it before assembling the final composite.

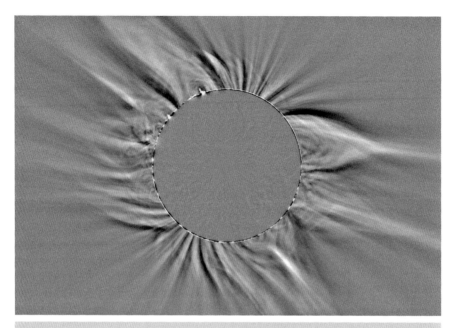

Fig. 9 Using *Photoshop*'s "Apply_Image..." filter, the "Subtraction" steps from all images can be added together to isolate and enhance structure throughout the corona. The contrast of this image was also increased for clarity

Begin by duplicating the "s" image from the shot with the longest exposure in the series. In this case, it corresponds to image8s (1/2 s exposure). Rename the duplicate "s" image by appending an "x" to it (i.e., image8sx). Add all the other "s" images to it (one at a time) using the Apply_Image... function (with Scale=1, Offset=−128). This produces an "s" image containing the structure information present in all eight "c" photographs (Fig. 9). Duplicate the longest exposure "c" image (i.e. – image8c) and name it image8mx.

Use the Apply_Image... function to multiply image8mx by image8sx. Duplicate the shortest exposure "m" image (i.e., image1m) and call it comp2. Use the Apply_Image... function (Scale=1.4, Offset=0) to add image2m through image7m plus image8mx (not image8m) to comp2 (Fig. 10). The difference between this composite and the first one (i.e., comp1) is that it uses image8mx instead of image8m.

The resulting composite (Fig. 10) reveals far more structure in the corona than the previous version (Fig. 8), which more faithfully reproduced the visual appearance of the corona. Of course, these two images can be blended together by making them separate layers in a single *Photoshop* file. The transparency of the top layer (found in the Layers window or panel) can be adjusted to blend the two images as desired.

Another way of achieving a result similar to comp2 (Fig. 10) is to take comp1 (Fig. 8) and add a layer to it consisting of the combined subtraction file image8sx (Fig. 9). If the Blending mode (in the Layers window or panel) of this second layer is changed from Normal to Overlay, then all the coronal structure visible in

High Dynamic Range Imaging

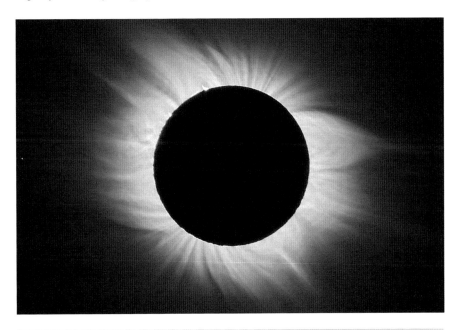

Fig. 10 Using the "Radial Blur Procedure" and the grand "Subtraction" image in Fig. 9, the resulting composite image shows exaggerated structure in the corona in order to reveal subtle details

image8sx will appear superimposed on the underlying layer containing comp1. Again, the transparency of the image8sx layer can be adjusted to vary the effect.

Much of the color lost in the compositing process can be recovered in several steps. The dark gray background of the sky can be adjusted with a Curves layer to add some blue color to it. Using a mask on one of the short exposure bracketed images can isolate the bright red prominences, which can then be added as a separate layer in the composite. It may be aesthetically pleasing to maintain the Moon's image as a black disk. This can be accomplished by using any combination of *Photoshop*'s many selection tools to copy the Moon's disk from one of the short exposure images. It is then pasted into a separate layer above the composite and Curves layers.

Figure 11 is the final result using two bracketed sequences (1/500–2 s) and many of the adjustments described above.

High Dynamic Range Imaging

When *Photoshop CS* was released in 2003 it marked a major change in digital photography with the ability to handle 16-bit images. As the 12-bit (and 14-bit) RAW format made its way into more DSLRs, the ability to combine multiple images shot with different exposures gained momentum. The power of HDR

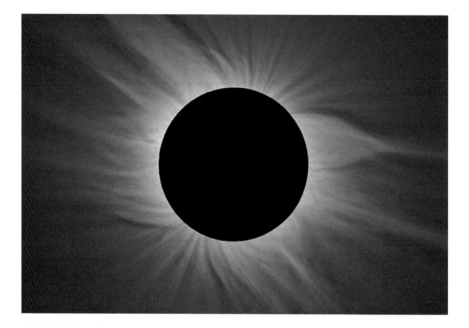

Fig. 11 The final composite image using the "Radial Blur Procedure" is composed of two sets of bracketed exposures (1/500–2 s). The color of the background sky has been adjusted with a *Photoshop* Curves layer to give it a more natural *blue* hue. The Moon's disk has also been placed in a separate layer to maintain its *black* appearance

(high dynamic range) imaging is that it can capture a much greater variation in intensities from the darkest to the lightest areas of an image than is possible with conventional 8-bit (or even 12-bit) digital photography. This expanded capability allows HDR to more accurately reproduce the range of illumination levels found in the real world – from faint starlight to brilliant sunshine.

The initial step in creating an HDR image is to capture a series of images of a static subject using different exposures. The process is particularly popular among landscape and nature photographers, but it is also ideal for capturing images of the solar corona.

Although the newest versions of *Photoshop* can combine multiple exposures into an HDR image, another program called *Photomatix Pro (PP)* (www.hdrsoft.com/) allows far more control of the process. It is reasonably priced (US $99), is available on both Windows and Macintosh platforms, and has a free trial version for evaluation.

HDR processing has two primary steps. The first is to superimpose and combine two or more digital images of different exposures into a single 16-bit HDR image containing all the intensity information of the separate images.

Because of the enormous range of intensities contained in an HDR image, it usually looks terrible when viewed on a computer monitor. Therefore, the second step in HDR processing is to compress the large dynamic range of the HDR image into a new range appropriate for computer monitors or output for printing. This is referred to as tone mapping, and its goal is to reduce the enormous contrast in an

Future Work 315

HDR image to a displayable range while preserving details in the original image. *Photomatix Pro* excels at tone mapping by providing a number of controls as well as a series of presets for experimenting.

Coronal Processing in HDR

The workflow in *PP* begins by opening the coronal image sequence within *PP*'s browser. If the images contain exposure information via their EXIF records, then *PP* will be able to identify the relative EV of each image in the sequence. Otherwise, this information must be entered manually through a dialog box. *PP* offers three options for aligning the images: (1) no alignment, (2) alignment through horizontal and vertical shifts, or (3) alignment by matching features.

The *PP* alignment process works best if the images were captured in rapid succession with little or no drift between exposures. After hitting the Preprocess button, *PP* generates an HDR preview image that is displayed along with a tone mapping control panel. Entire books and online tutorials have been written about the settings in this panel. Fortunately there is another window containing thumbnail previews of the HDR image as processed with over 30 different presets. Choose a preset and the larger HDR preview will be processed with that preset. The tone mapping panel shows all the settings for each selected preset so the user can experiment to see what effect each control has. All settings in the tone mapping panel can be saved as a new preset.

Figure 12 shows an example of the 2006 coronal image sequence processed as an HDR and tone mapped using Photomatix Pro Using the "Natural" preset. After processing in PP, the image was opened in Photoshop where additional processing took place. This included running a High Pass filter (Filter>Other>High_Pass…) on a separate layer set to Overlay mode, as well as using Curves to restore a blue colored sky. Prominences from one of the shorter bracketed exposures were copied into another layer and a separate layer was created for the Moon's disk to preserve its black appearance.

Future Work

The techniques presented here are only starting points for processing images to capture the full range of brightness and details present in the solar corona. *Photoshop* and *Photomatix Pro* both offer endless opportunities to experiment and develop new techniques as one learns more about these powerful programs.

The only thing left is to plan a trip to a future total solar eclipse so that a good set of bracketed exposures of the corona can be acquired. Fortunately, two total solar eclipses will pass directly across the United States on August 21, 2017, and April 8, 2024 (Fig. 13). Table 5 gives a brief summary of all total eclipses from 2013 through 2030. More information and maps for upcoming eclipses can be found at the NASA Eclipse website:

eclipse.gsfc.nasa.gov/eclipse.html

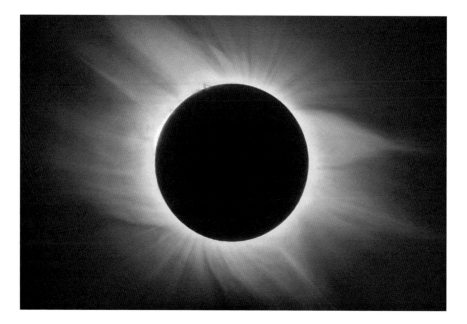

Fig. 12 *Photomatix Pro* can be used to create an HDR image of the corona using a series of bracketed exposures. The *blue* color of the sky was in a separate Curves layer in *Photoshop*

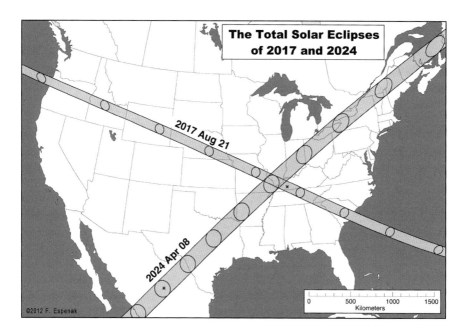

Fig. 13 The paths of two upcoming total solar eclipses cross the United States. The dates of the total eclipses are August 21, 2017, and April 8, 2024

Table 5 Summary of total solar eclipses from 2013 through 2030

Date	Maximum duration[a]	Geographic region of visibility
2013 Nov 03	1min40s	Atlantic Ocean, Gabon, Congo, Democratic Republic of the Congo, Uganda, Kenya, Ethiopia (annular at beginning of path)
2015 Mar 20	2min47s	North Atlantic Ocean, Faroe Islands (Denmark), Arctic Ocean, Svalbard (Norway)
2016 Mar 09	4min09s	Indonesia (Sumatra, Borneo, Sulawesi, Halmahera), Pacific Ocean
2017 Aug 21	2min40s	Pacific Ocean, USA (Oregon, Idaho, Wyoming, Nebraska, Missouri, Illinois, Kentucky, Tennessee, North Carolina, Georgia, South Carolina), Atlantic Ocean
2019 Jul 02	4min33s	South Pacific Ocean, Chile, Argentina
2020 Dec 14	2min10s	Pacific Ocean, Chile, Argentina, south Atlantic Ocean
2021 Dec 04	1min54s	Antarctica
2023 Apr 20	1min16s	South Indian Ocean, western Australia, Indonesia, Pacific Ocean (total except at beginning and end of path)
2024 Apr 08	4min28s	Pacific Ocean, Mexico, USA (Texas, Oklahoma, Arkansas, Missouri, Kentucky, Illinois, Indiana, Ohio, Pennsylvania, New York, Vermont, New Hampshire, Maine), southeastern Canada, Atlantic Ocean
2026 Aug 12	2min18s	Greenland, Iceland, Spain
2027 Aug 02	6min23s	Atlantic Ocean, Morocco, Spain, Algeria, Libya, Egypt, Saudi Arabia, Yemen, Somalia
2028 Jul 22	5min10s	South Indian Ocean, Australia, New Zealand
2030 Nov 25	3min44s	South West Africa, Botswana, South Africa, south Indian Ocean, southeastern Australia

[a]Maximum duration of totality as seen from the central line in minutes and seconds

Catching Sunlight

Alan Friedman

Why the Sun?

Everyone knows that astronomy is done in the dark. Astronomers are creatures of the night, like vampires, sleeping during the day and working all night long to catch the faint light of their elusive prey.

Enter the Sun. Our neighborhood star offers unique challenges and opportunities for the astrophotographer. From most latitudes, the Sun is a target any day the clouds don't get in the way. Imaging the Sun might make you late for work on occasion, but unlike nighttime adventures, it won't leave you a bleary-eyed, sleep-deprived zombie. The Sun is dynamic. It shows a different face every day with a wealth of ever-changing features to keep you engaged and challenged. At risk of stating the obvious, the Sun is big and bright, which means that it can be imaged successfully through many types of filters and with instruments of all sizes.

Creating compelling images of the Sun is astro photojournalism. The features on the Sun offer a different story each day, and that story can be retold in many variations depending on your equipment and the magnification of your telescope. The full solar disk against the darkened sky background through a small telescope is quite a different perspective from a close-up view of an active region in high resolution. The filter choice influences the story, too. The solar face changes dramatically across the electromagnetic spectrum, even through the visible wavelengths that are typically in range of amateur imagers. The Sun is dynamic. Its features transform over hours and sometimes over minutes. Tomorrow the Sun will be different than today, and yesterday's image, however beautiful, will be old news. To catch this

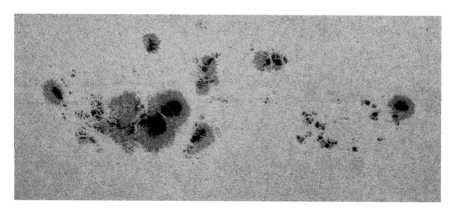

Fig. 1 The sprawling archipelago of active region 1520. Captured July 11, 2012, this panorama spans more than 200,000 miles on the surface of the Sun

ever-changing spectacle takes both spontaneity and planning. What story will you tell? What tools will you use to tell it? How and where will you share your images when you complete them?

As I write this, the Sun is putting on a good show. An archipelago of large sunspots (Fig. 1) is stretched across the disk spanning an impressive 200,000 miles of photosphere. With the parade of beautiful large active regions this year one might forget that for much 2008 and 2009 the Sun was completely spotless. Sunspots are an ideal place to begin an exploration of solar imaging – not because they are easy, but because the cost of entry is affordable. With the introduction of AstroSolar film from Baader Planetarium, a white light filter of high optical quality is within the reach of almost any telescope design, aperture or budget. The visual image is neutral white, and the resolution is very good. A Herschel wedge is another excellent though more expensive choice for viewing the Sun in white light with a refractor.

An image of the full solar photosphere with blemishes is a dramatic subject – especially so after the long drought of our last solar minimum. Larger more complex active regions warrant a closer inspection with a longer focal length and bigger aperture (Fig. 2).

Despite the advantages and accessibility of white light solar astronomy, the excitement today is centered on the spectral line at 656.28 nm, the hydrogen alpha wavelength. On a day when the Sun is a peaceful spotless disk in white light, it is a boiling spectacle in Hα, showing prominences, filaments and chromospheric structures that change rapidly. Once limited only to professional observatories, hydrogen alpha filters are now available to amateurs from several manufacturers in a range of sizes and prices to fit almost any budget. One look at the Sun in Hα and you are hooked. The image-processing workflow that I've selected for this chapter will focus on the preparation of a hydrogen alpha portrait of the Sun (Fig. 3).

Fig. 2 A high resolution close-up of AR 1520 captured with a 10-in. telescope and white light filter

Fig. 3 Two layers of the sun are imaged most frequently by amateur astronomers. The surface or photosphere can be photographed in the full spectrum of white light using a safe filter on the front of the telescope. Sunspots will be visible, along with bright plage areas at the limb and when the seeing is good, solar granulation is seen. A narrow band filter isolating the hydrogen alpha wavelength (656.3 nm in the deep red) shows edge prominences, arching filaments, active regions and the beautiful convolutions of the chromosphere, or solar atmosphere

While we call imaging of the solar photosphere and sunspots "white light" photography, the term is a bit of a misnomer. Rarely is there an advantage to using the full spectrum of visible light for a solar image. Narrowing the bandpass with color filters will help to tame the air turbulence – by far the biggest obstacle to taking sharp pictures of the Sun. Filters also assist by increasing the contrast of subtle structures. The small decrease in light throughput is more than offset by the gain in image quality. The quality of air stability, *seeing,* increases with the wavelength of the filter. A green filter (such as the popular Baader Planetarium Continuum centered at 540 nm) is excellent for visual observation because the eye has peak sensitivity here. For imaging, I prefer a red filter. My typical set-up for sunspots uses a 7 nm wide hydrogen alpha filter. Designed for deep sky photography this filter works very well for imaging. My camera has excellent sensitivity at these wavelengths. The seeing is more stable and the contrast of solar granulation and faculae are improved as well. Filters in the near UV wavelengths are another option. The 8 nm bandpass Baader K-line filter can record the structures visible at the CaK wavelength of 395 nm, though air turbulence at this end of the spectrum can make imaging at longer focal lengths challenging.

The difference in cost for outfitting a modest aperture versus a large aperture instrument for white light imaging is minimal. If you have a small refractor and a larger reflector, it might be very possible to have both available as an imaging platform in white light. The choice of which to use on a given day will come down to the level of solar activity and the seeing. With hydrogen alpha, the costs of a large imaging platform can become astronomical. Experience will guide you towards the optimum imaging focal length of your instrument and help you find a workflow that best uses the capabilities of that aperture.

Although many cameras can be used to take photos of the Sun, the streaming camera is the most versatile. With individual frames that rival still camera quality, today's industrial webcams have very fast capture rates, capable of gathering lots of data in the micro moments of steady seeing. Some models have large sensors that can capture a full disk, eliminating the need to combine multiple images into mosaics. New sensors and connection protocols are being released constantly. The online imaging forums will keep you abreast of the changes and help you make the best purchase for your set-up.

On Seeing

As with other types of astronomical photography, seeing is the ruling force in solar imaging. When the air is steady and the detail at the eyepiece rendered like a fine engraving, imaging is a dream where everything turns out well. The other 364 days of the year we have to improvise.

Air turbulence in the daytime is a somewhat different animal than the conditions we contend with in nighttime imaging. Although the position of the upper atmosphere is still a concern, the radiant energy of the Sun can create its own "jet stream" just above your telescope. It is very difficult to achieve the resolution

potential of any instrument during the daytime. For this reason, many imagers prefer to capture their solar data early in the day or late in the afternoon, when the Sun is low in the sky. By 10:00 a.m. local time, the Sun has had a chance to heat roadways and rooftops, which then radiate solar energy back into the field of view, turning the image into a boiling, gurgling mess.

My urban backyard is hardly a solar imager's dream location. I am surrounded by houses topped with asphalt, snaking telephone lines, electric transformers and blacktop driveways. My pre-10:00 a.m. window of opportunity is limited to a month or so on either side of the summer solstice. But there is a big advantage to this location. My solar set-up is 15 feet from my back door, and all my equipment is at hand at a moment's notice. So I've adapted to the reality that most of my work will be done under less than ideal conditions.

Through necessity, I've discovered that daytime turbulence can change dramatically and rapidly throughout the day. A glance in the eyepiece that shows a hopelessly turbulent view can improve in minutes and eventually yield frames sharp enough to collect for imaging. Sometimes a handful of frames is all that's needed. The Sun is the brightest of imaging targets (we have to discard most of the light to image it at all). We can set the camera at the fastest shutter speeds with little or no need for brightness amplification (gain). The individual frames in our captures generally have very good signal/noise ratio. A small number of good frames can make an excellent image.

Selecting your target for solar imaging involves weighing several factors. What is the story or stories of the day? Nice large sunspots call out for white light. If the seeing is good, a larger aperture refractor with Herschel wedge or reflector with front filter can be used. Experience and a few moments at the eyepiece will help determine the usable focal length for the seeing conditions.

Capture Considerations

It is important at this point to include a safety caution. *Solar imaging can be dangerous*. Even a brief glimpse of the sun through a telescope that is not safely filtered can cause *immediate and permanent blindness*. Be sure that your solar filtering equipment meets accepted standards for safety and is securely attached to your telescope!

Although Sun images can be created from almost any type of camera behind a safely filtered optic, my work and most contemporary solar images today are created using some form of streaming digital camera that captures movies. Combating the turbulence of our atmosphere during the daytime requires speed, and video offers unique and powerful tools to make sharp images possible.

The hardest part of capturing images of the Sun might be deciding on a camera. There are hundreds to choose from, and new cameras are being released daily. Many of the cameras use the same sensors, so the choice becomes a decision based on a few factors:

Fig. 4 The author's main solar telescope for imaging at the hydrogen alpha wavelength – a 92 mm f4.8 Astro-Physics refractor with a 90 mm .7 Å Coronado Ha filter. A Barlow and a streaming camera from Point Grey Research are attached at the focuser end

- Capture software/computing platform
- Sensor specifications
- Connection method
- Budget

Whichever computing platform you use, there are good choices for capture software. Many are freeware, and some may be included with the camera you purchase. I've used a Macintosh platform for decades and use Mac-based programs for my imaging. I've used a dozen streaming cameras – from the venerable Phillips ToUcam to my latest Grasshopper Express, a tiny marvel from Point Grey Research with a behemoth 6 megapixel chip. If you've ever scratched your head at the complexity of a deep sky imager's set-up with its ganglion of cables and power supplies, solar imaging might make you smile. My main telescope is tiny (Fig. 4), resting on a small equatorial mount somewhat polar aligned. A camera the size of an ice cube sits in the eyepiece holder with single cable tethering it to my laptop. The single cable carries power to the camera and streaming data from the camera to computer. All settings for the camera are controlled from the computer. It's deliciously simple and can be set up in minutes. A large solar observing cloth, black on the inside, silver lame outside, allows me to work comfortably under a hot Sun.

Speed or size? Choosing a streaming camera involves trade offs between the two. If your budget allows more than one camera you can have the best of both worlds. There is a decided advantage to a small sensor that can record data at 120 frames per second or faster. The good seeing comes in micro moments, and a fast capture rate will yield many good frames in the brief window.

Big pictures are more versatile. You can make them smaller, but it is hard to make a little picture big. Mosaics are possible, but time consuming and challenging to get right. The price you pay with a large sensor is slower frame rate and higher cost. Certain cameras will permit the software to select a smaller region of interest (ROI) from a large sensor when the full field of pixels is not needed. This will achieve faster download speeds than using the full chip but will not be as fast as a dedicated sensor of the same size. Currently, The Imaging Source and Point Grey Research offer a wide range of excellent cameras and are well versed in the application of their equipment for astrophotography. I would recommend limiting the selection to monochrome cameras for imaging the Sun.

The method for capturing data is intuitive. Focusing the telescope with real time live view through the imaging chip is simple and fast. It will take some experimentation with gamma (contrast) and shutter speed settings to arrive at the best choices for your intentions. The main ingredient is patience. Be prepared to wait for the best moment and then wait a little longer. When the seeing starts to settle, pounce!

Processing Your Images

As simple as image capture is, processing solar images is a journey and will be the focus for this discussion. We will assume that the data has been collected as a stream of movie frames. Although there are many places where the paths diverge, a solar workflow is likely to follow these steps:

1. Create a back-up copy of the day's imaging session on an external hard disk.
2. Review the individual movies for subject and quality.
3. Highlight the best movies for further work. Rank them for quality and the order in which you will work on them.
4. Open the selected files in an image-stacking program.
5. Use the software to evaluate, select, align and stack the frames for each movie file.
6. Use the software to perform a mild processing routine on the frame stacks.
7. Open the frame stack(s) in Adobe *Photoshop* for additional image processing.
8. Upload and share the finished images.

Now, here's a bit more detail.

Create a Back-UP Copy of the Day's Imaging Session on an External Hard Disk

With today's streaming cameras, raw files from an imaging session can get tremendously large very fast. My newest camera has a 6 megapixel sensor capable of recording data in 16 bit mode (65,000 Gy levels). A typical video comprised of 1,000 frames at this setting will take up more than 10 gigabytes of storage space. It is not uncommon for an hour-long imaging session to fill up 200 gigabytes of storage space. Much of the recorded data will be unusable. I've watched the films anxiously during recording, so I can make some decisions on the fly about movie quality and color code the file icons based on my assessment of their potential for good images. After the session, I make a back up of the data and free up space from my internal hard drive so that the image processing software has room to work. Small portable hard drives are inexpensive and reliable and great for archiving your work.

Review the Individual Movies for Subject and Quality

Image processing takes time. Previewing your captured data and making decisions about which files are worth spending more time on is an important step. On some days, the Sun is rich with activity, and I might have moved my telescope to record a dozen intriguing regions in high resolution. Other days, the only feature selected was an interesting prominence. I might have camped out under my blanket and watched that prominence for an hour, hunting a steady moment, hitting the record button 40 times during the wait. I don't want to spend the time processing all of these, so some housekeeping is important. After looking for an hour, a few moments of clarity are exciting enough to get your pulse racing. I make a point to indicate these good moments by marking the file icon as soon as the capture is ended. When I begin to process, I have a number of file icons colored to indicate they warrant a second look, with the red marking the best of the lot. A short time spent in better lighting with a movie viewer helps me narrow down the selection further to the files with the largest number of quality frames.

A few additional thoughts on seeing are needed here. In a recorded video of the Sun captured with a very fast shutter and rapid frame rate, astronomical seeing takes on a more complex identity than that covered by the traditional scales of Pickering and Antoniadi. Excellent seeing is the easiest to classify and remains the holy grail. When the air is almost motionless and many movie frames show breathtaking detail, everything else becomes an almost effortless exercise. This occurs in my location very rarely, if ever. It's in the middle ranges – mediocre to good seeing – where things get complex. Certain types of average seeing hold the promise of a good image. Jittery, jumpy seeing tends to have consistency in the good frames. Once the poor data is weeded out, these files can be stacked and processed to show surprisingly sharp detail.

Other times, when the turbulence is more uniform, a frame by frame review shows considerable bloat and morphing of fine detail. In this type of seeing, the movie can appear sharp when played (our brains are very good at accommodating this type of turbulence). However, trying to align and stack features that vary in shape will yield a softened result that defies sharpening. Sometimes the only way to work with this data is to hand select a very small number of frames. Fortunately, if you've recorded with minimal gain, this might be a possible solution.

Once I've identified the movie files to work with, I am ready to open my stacking software and begin work.

Open the Selected Files in an Image-Stacking Program

Inspecting and selecting individual frames from a movie is time consuming work. There are many programs available that will do this work accurately and with automation. I do this processing on a Macintosh platform in Astro IIDC. Your choice of software and operating system might be different. Rather than focus on the settings exclusive to a particular program, I will speak about the techniques you will use to ensure quality results from whatever stacking software you choose.

Once a movie is selected, stacking software will select a good reference frame, then compare quality and rank all remaining frames to this. After this evaluation, I am presented with a histogram (Fig. 5) graphically portraying the movie frames in terms of their contrast and sharpness. Using the histogram, I select a range of frames for further processing, starting with the sharpest and increasing the selection to include a percentage of the movie. How many to choose? This will vary – as many as 25 % and as few as 15 % – depending on the seeing conditions from that day's session. The greater the number of frames selected, the better the signal/noise ratio of the resulting stack and the more processing the image can accept before noise becomes objectionable. But the deeper one delves into the poorer quality frames, the more the stacked image is softened and requires sharpening to reveal details.

Astro IIDC provides additional tools to help me discern the best frames. I can choose whether to analyze the entire image or focus on a particular area for sharpness evaluation. I can change the spacing of detail for the software to expect when it looks to the sample for sharpness. This can be quite different at different focal lengths. A wide field full disk image might have very fine detail across the image, while a high magnification look into the solar chromosphere will display the same structures spread across many pixels. Adjusting the spatial settings helps the software to make better frame selections over a wider type of captured data.

A region of a specific dimension in pixels is set at this point for use in comparison and later for alignment of the frames. It is important to set this area large enough to contain meaningful differences in image contrast. A smaller box will save time in processing, but a larger box is needed for area of low contrast, such as the disk of the Sun at high magnification.

Fig. 5 Software analyzes the frames of the captured video for sharpness and presents this information as a histogram. The red section indicates the frames that have been selected for stacking

The software is not infallible. Certain conditions will confuse the evaluation process. Digital noise is particularly troublesome. If the frames were captured with a high gain setting, sensor noise can masquerade as sharpness and cause the software to make poor choices. Changes in image brightness during the movie (as from passing thin clouds) and movement of features due to drift from poor equatorial alignment can also affect the selection of frames. Fortunately, solar movies can usually be captured with very low gain settings, so noise is generally low. If this is not the case, I can set my software to apply a small Gaussian blur just for sharpness estimation. This can help to remove the distraction of digital noise and result in a better set of selected frames. I can also set the software to apply an unsharp mask to the frames to assist with accurate alignment in stacking. Helpful when the detail is of low contrast, the mask is only used for alignment and is not applied to the final image.

Automation is grand, but I am a skeptic and always set my software to allow visual inspection of the selected frames, just in case. I set the selection slider to accept a slightly higher percentage of frames than I expect to use. The result is an ordered list of frames, from the best downward (Fig. 6). Using the cursor keys, I can scan down the list, focusing on particular features that are of paramount importance to me, omitting frames that are less detailed in these areas from further processing. I also look carefully at the lead frame. This will be used as the standard

Fig. 6 The frames can also be reviewed visually to refine the selection before further processing

when the frames are aligned and stacked. If I see a better choice among the top quality frames, I can make a change at this time. Although the software is remarkably capable and saves hours of work inspecting each frame by eye, sometimes it is led astray. A visual examination will sometimes cause me to go back and tweak the preliminary settings to better suit the file and rerun the selection process. In the end, I feel a better image results from hands on work with the data.

Once I've finalized the frames for my image, the next step is to select the alignment points that will be used in stacking the selected frames. In a perfect world, seeing would be extraordinary, each frame of the movie would be identical and selecting a single area in the center of the image would cause all frames to align perfectly. The image would be sharp across the entire field. Unfortunately, my backyard does not provide this type of perfection. Aligning the frames on one location of interest – say the umbral region of a small sunspot – will yield a nice sharp result at this location, with increasing softness as you move away from it.

For most of us, on most days, multiple alignment points (MAP) provide a better result. A box is drawn around many regions in the image, and the software automatically aligns and stacks the frames at each of these points. A merged image is created combining the chosen regions of many stacks into one optimized image that

Fig. 7 The red boxes correspond to the regions in the image that will be used for alignment. These small areas will be processed separately and added to the final result to maximize the sharpness and reduce the blurring from atmospheric turbulence

is sharp across the entire field. In my software, I can select as many regions as I like, but there are conditions. The regions must display adequate contrast for alignment to work. I can see this contrast as I select my regions. It is expressed on screen as pixel variance value – the spread between the lightest and darkest pixels in the selection area. Below a certain threshold, the alignment will fail and ghost images will result as the software unsuccessfully struggles to line up the frames. Successful MAP processing techniques require practice and trial and error. How large should the sampling box be? How many regions should one choose? The answers are different for different subjects. For large complex solar prominences seen against a black sky background, a set of small sampling boxes work very well (Fig. 7). For the solar chromosphere on a day of poor seeing, it can be more difficult to find suitable areas to select. In this case, increasing the contrast settings (gamma) during recording can help deliver a file that will yield good sampling regions and process successfully.

Creating a stacked image composite of many alignment points is the first step in preparing a solar image. The stacked image will have lost some sharpness compared to the best individual frames – a blur inevitable from shifting of detail in our

Fig. 8 Mach bands illustrate our appetite for visual sharpness. Though the grays are solid, our eyes perceive a gradient as our mind looks for increased contrast at the borders of each tonal gradation

moving atmosphere. But in stacking, we have eliminated the random digital noise in each frame, allowing headroom for the features to be drawn out in even greater detail through image processing.

Use the Stacking Software to Perform a Mild Sharpening on the Stacked Image

To see the potential from my stacked file, I always perform a first sharpening run in *Astro IIDC*. This allows me to inspect the relative sharpness across the field and to determine if my MAP selections were well chosen and combined successfully. The sharpening tool in my software and most other astronomical image processing programs is global. It is applied to the entire image and affects all regions of the image equally. With too heavy a hand, areas of high contrast in the image will find their highlights blown. It is important at this stage to sharpen no more than the most sensitive areas of the image can handle.

Everyone has their own threshold for image sharpness. I prefer restraint. Much in the way that our bodies love salt, sugar and fat, our brains are programmed to love sharpness in visual perception. Looking at Mach bands (Fig. 8), you can

Fig. 9 A large pixel radius unsharp mask can result in exaggerated levels of contrast. Left, a 1-pixel radius mask, middle, a 3-pixel radius mask. The image to the right has no mask applied

appreciate how our perception heightens the difference between two areas of even tonality, encouraging us to see additional contrast that is not there.

Sharpening routines are at the foundation of astronomical image processing. Along with the potential for magically revealing detail come side effects. Edges can be created or accentuated where they are not present. Residual noise or artifact hidden in the image is enhanced and made more visible along with real detail. Although heavy sharpening can be valuable for specific research goals, our purposes here will be to achieve a natural balance and faithful interpretation of our subject. Different sharpening settings applied to the same image will produce different qualities (Fig. 9). Experiment and proceed thoughtfully.

A pyramidal sharpening tool (wavelets) is a sharpening routine included in most astro imaging programs. With one action, it applies several unsharp masks at a range of pixel radii and intensities to the same image simultaneously. The best setting will vary, but in general, large structures are sharpened most effectively with a larger pixel radius. Small structures will be revealed most accurately using the small pixel radius slider. Because this pyramid is applied to the entire image, you will not be able to serve all areas of the image fully without over processing another. Once an area is over sharpened, it cannot be brought back through further processing. Sharpen only as much as the most sensitive area can handle. Additional processing can be applied selectively later on in *Photoshop*. While *Astro IIDC* can apply levels, curves and noise reduction at this point, I prefer to apply these adjustments in later stages of the processing.

My work is always saved as a 16-bit TIFF file, regardless of whether the capture was recorded in 8- or 16-bit mode. Once I am happy with my preliminary work, I'm ready to save and bring the file into Adobe Photoshop for final processing.

Open the Frame Stack(s) in Adobe Photoshop

Photoshop is the gold standard of photo processing programs. It is expensive but, to my mind, indispensible. Although astronomy imaging programs can perform many of the basic functions of *Photoshop,* they are limited to applying their tools to all parts of the image. In *Photoshop,* we can use layers and masks to apply sharpening and noise reduction only to the areas that require them. We can apply color, adjust the tonal levels up or down – even invert them to create a negative of all or parts of the image.

The power of *Photoshop* brings with it a responsibility to consider the intentions of our image making. My goal is to tell a story, showing the Sun in a way that is compelling aesthetically, but also respectful of accuracy. It is a blend of science, journalism and art. I use *Photoshop* to help tell a provocative story that remains faithful to the information captured by my camera.

Image processing in *Photoshop* can take some different turns depending on the type of solar image being constructed. The example I've chosen uses a data capture from the spring of 2012 featuring a large dramatic prominence on the solar limb. It was recorded with my 92 mm apochromatic refractor fitted with a 90 mm hydrogen alpha filter. The effective focal length was approximately 1.7 m. Seeing that day ranged from fair to good – a pretty average day in my Buffalo backyard.

With a camera that captures in 16-bit depth, it is possible to record the prominence and disk detail in the same video recording. The 16-bit mode works with larger files and requires a slower download speed. Unless there is a feature of tremendous dynamic range – such as flare activity – I usually prefer to record in 8 bit and use two separate exposures combined in *Photoshop* to show the Sun disk and prominences. Using low contrast and an exposure four times that for the bright solar disk, I can record the fainter tendrils of the prominence better than with a compromised setting.

The preliminary work on the separate images was accomplished in *Astro IIDC* using MAP processing. The prominence was dramatic and worthy of its own showcase. I decided to prepare a version designed to show the beautiful structure of this feature in monochrome without disk detail. You can do this relatively fast, and the work can be used for a composite image later on. Prominences come in all shapes and sizes, and I have kept a running catalog of these images dating back 10 years (Fig. 10). They are quick to prepare and can be shared with news sites while the story is still hot.

I open the image in *Photoshop* (Fig. 11), immediately changing the name of the background layer to "original" and saving the file in native *Photoshop* format (.psd). This format supports multiple layers, and I will be adding many – a new

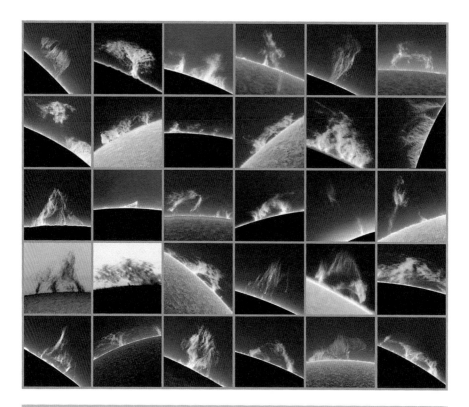

Fig. 10 Prominences provide a never ending and constantly changing subject for the solar astronomer

Fig. 11 The working desktop for a monochrome prominence image in Adobe *Photoshop*

layer for each change. Layers are a wonderful way to make adjustments to an image. They allow you to retain the previous version and click quickly between the two for comparison. Sometimes the changes are helpful, sometimes not. By clicking the visibility "eye" icon I can toggle between before and after to decide whether the modification has improved the image.

A first adjustment would be to apply a mild unsharp mask to see if the image can support additional contrast without introduction of artifact. The finest sharpening level in some astronomy programs will be a 1 pixel radius. I find this too coarse for the finest filamentary structures in some prominences. I prefer to sharpen these with a pixel radius smaller than 1 pixel – between .5 and .8 typically. Working from two identical layers, I make the top layer invisible, click in the layer underneath to make it active and proceed to sharpen. The sky background will not benefit at all from additional sharpening, and there will likely be high contrast areas of the prominence that will not be able to take much more sharpness than the original layer. In *Photoshop* I can focus on a particular area of the image and not worry if another area is oversharpened. I will only be using the areas where sharpening was beneficial.

The top layer remains a duplicate of the original layer. Click on the icon to make it visible again and click in it to make it the active layer. Using the eraser tool, I can carefully remove areas of the original to allow the sharpened layer below to show through. Setting the values for the eraser diameter and hardness allows you to tune the visibility of the changes from the bottom layer. Setting the opacity of the eraser tool gives you additional power to reveal the sharpness of the underneath layer selectively and only to the degree that each area needs it. I try to avoid the temptation to over sharpen the prominences, preferring to leave a certain amount of soft cloudlike quality. Others prefer a crispier result. Experiment with the radius, level and threshold settings in the unsharp mask filter to determine which quality you prefer. Once you are happy with the changes made, merge the two layers as one.

Even mild sharpening will often leave some remnant in the image that is undesirable. Zooming in will help to show the speckles and noise that might have become visible. *Photoshop* has many tools to deal with these artifacts. Make a duplicate of your latest working layer and click the visibility of the upper copy to hide it from view. Working on the lower layer, experiment with noise reduction tools in the filters menu. Gaussian Blur, Median and Despeckle offer different algorithms for the same purpose – to smooth noise in the image. These are powerful filters. A small amount will have a large effect, so use sparingly. They also leave a permanent signature in the image, which will re-emerge as artifact if additional sharpening is done afterwards. I use noise reduction gently and only after all sharpening enhancement is completed. Once you are happy with the smoothness, make the upper layer visible again and click in it so that it becomes the active layer. Using the eraser tool, allow the under layer to show through, reducing the visibility of artifact where needed.

Layers can, of course, be used without the eraser tool to apply a change across the entire image. By setting the layer transparency, increased sharpness or noise reduction can be applied globally at any intensity you choose. You can also fade any filter or adjustment right after it is performed.

Levels and Curves commands under >Image>Adjustments can be used to brighten or darken the prominence component of the image. Care should be taken not to clip off information in the highlights or shadows or to create banding in the subtle gradations in the background sky. Although the effect is almost always too severe, I will often apply an auto levels adjustment just to see the effect. Looking at an image for a long time, our eyes can get used to a low level of contrast. Auto levels will stretch the histogram unmercifully, but it will also show contrast inherent in the data that we might have ignored. If you find that you like the contrast enhancement of auto levels, applying it with less force; using layer transparency might be a way to make the adjustment.

Once these adjustments have been applied, the prominence should be sharp and contrasty with the faintest regions serving to trace the magnetic reaches of this massive arc of hydrogen plasma. Does its shape remind you of anything? You might be thinking of a name for your picture at this point.

Just as the bright security light in a neighbor's yard hurts your ability to enjoy the night sky, a bright, overexposed limb of the Sun hinders your ability to see the faintest extensions of a solar prominence. A simple method to address this involves making a dark occulting disk to cover the white solar disk. It is very easy to use the magic wand tool to select the white disk of the Sun. But this method will also include the subtle peaks and valleys at the edge of the solar chromosphere, giving your selection a strange edge that is an echo of the spicules at the solar limb.

I prefer to set a true circle. This is easily done with the oval marquis tool. Create a new empty top layer for this action. Holding down the option and shift keys, drag a circular marquis from the center of the Sun. It will likely take some tweaks and adjustment with the transform selection setting in the select menu, but with a little work, you will have a circular selection just the right size. Move the circle with your cursor keys to center the selection just inside the ring of spicules. Make a note of the size in pixels of the circle you've created (you might need to enlarge your image canvas size to see this under >info). We will use this later. Under the edit menu, select fill to paint your selection in black. The occulting disk will have been created as the top layer of your working image. Deselect the marquis, and apply a very subtle Gaussian blur to this layer to soften the edge a little. Don't forget to save your work as you go.

Your image is almost complete at this point. I often choose to add a subtle tone of color to the prominence. It will add interest to the image and, depending on the tonality you choose, might increase visibility of the faintest structures as well. It is also a good way to practice with the colorization tools available to you in *Photoshop*. The simplest way to add color is with Hue/Saturation. Check to see that the image mode is set to RGB color. If not, change it. Duplicate your latest prominence image layer. Click on the new copy to make it the active layer. Choose the command Hue/Saturation from the Image>Adjustments menu. Click the colorize box to impart a tone to this layer and use the Hue and Saturation sliders to adjust the tone to your liking. Further tweaks can be made using the Color Balance adjustment found directly below Hue/Saturation. In the layers palette, set the blending mode for your color layer from normal to color. This will

impart only the color and retain the tonal values you've worked hard to create in your prominence image. Using the opacity slider for the layer, you can adjust the color effect from vibrant to a very subtle tint.

Another method, and the one I used in preparing this image, is to create a new blank layer over your monochrome prominence image and fill it with color. Changing the layer blending mode from normal will allow the luminosity of the prominence to show through. Experiment with the various layer blending modes and layer transparency to add color to the image in different ways. I selected "screen" to impart just a hint of purple tone to the prominence and sky background.

At this point I would suggest saving the image as a working file, complete with all modification layers. I save three versions of these as I work, with the words Working, Latest and Final in the file names to identify the history. It can be very helpful to have a path to return to down the road. If you noted the size of the solar disk in pixels when making the occulting disk, you can use a bit of math to create a scale for the size of the features in your image. Dividing the Sun's disk by 109 will give you the size of Earth to scale in your image. You can add a new layer and set a marquis circle this size in the sky background, or size an Apollo image of Earth and include it here. Earth size reference makes a great expression of the massive size of solar features in your image.

Use the rectangular marquis and crop tool to tweak the final presentation of the picture. Sometimes the capture focal length will have been too long for the seeing conditions and a resize is applied to achieve a more compelling image. Once these final adjustments have been made, flatten the image and save. You will want JPEG versions appropriately sized for screen viewing and sharing electronically, but don't forget to save a copy in uncompressed format for printing.

During most imaging sessions, I capture numerous video streams at different camera settings in an attempt to optimize visibility of the huge dynamic range of the Sun. If the seeing was good enough to show detail in the chromosphere, I will often take the extra time to process additional exposures separately and incorporate these into the picture. The processing steps for disk detail are much the same as for the prominences – only more challenging. The disk detail in my 'scope is usually softer and lower in contrast than the stark black and white of prominences against a darkened sky background. A narrower bandwidth or double-stacked filter might be better, so your mileage may vary.

Multiple alignment areas are used for stacking, just as with the prominence, but pay attention to select regions of good contrast so the software can align the frames successfully. If automated processing is not possible, I go through the video frame by frame and select a handful of the best frames to import directly into *Photoshop*. Even though the frames were captured with very low gain assist, they will be noisier than a stack and must be treated carefully to reduce speckles.

Whether you have aligned and stacked your chromosphere movie, or selected an individual frame to work with, the next step is to open the file as a *Photoshop* document for addition to the prominence image just completed. Select all of the surface image, and then copy and paste it into the previous document. It will be added as new layer on top of the original image (Fig. 12).

Fig. 12 Adding color and chromospheric detail to the monochrome image using layers in Adobe *Photoshop*

To reveal the background sky and prominence detail we must remove the sky portion of the disk image. Since the sky in the disk image is a uniform tone, this is easily accomplished with the magic wand selection tool. Click with the magic wand in the black sky of the disk image and look at your selection results. If the selection is not perfect, you can tweak it by entering a different number in the tolerance box above the picture – a larger value selects more, smaller, less. Once you are happy with the selection, choose cut from the edit menu to remove it. The prominence will now show through and you can use the move tool to position the disk detail in just the right location. If you shot all your data without moving the telescope, it should be a simple matter of aligning the curves. Remember to account for the spicule layer at the edge of the Sun's disk. This detail was rendered in the prominence capture. The surface image should come close to this edge, but a thin bright ring of spicules should stand proud of the disk.

Once the two sections of the image are properly aligned, we have some aesthetic decisions to make. At the eyepiece, the disk of the Sun transitions smoothly to a ring of faint prominences at the limb. In my prominence image I have increased the brightness and contrast so that the faintest reaches of its structure can be seen. The darkened edge of the solar limb now makes a strong transition where it meets the prominence and the sky beyond.

One technique that I have used extensively to bring the dynamic range back into balance is to invert the tonality of the disk of the Sun (Fig. 13). This command

Processing Your Images

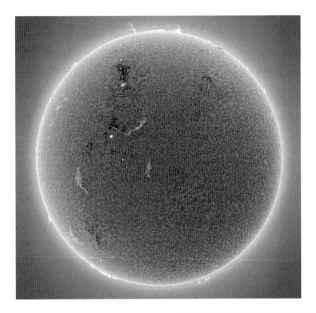

Fig. 13 Full disk portrait of the sun – surface detail is inverted

(Image>adjustments>invert) renders the disk as a negative, which accomplishes a few things. It makes the structures of the chromosphere easier to see. It also reverses the limb darkening to limb "brightening," creating a smoother transition to the prominence and sky background. For this image, I have processed the disk in both positive and negative variations on separate layers, deciding in the end to use the negative (inverted) version for the qualities that it brings to the image.

A few subtle tweaks can be tested and if deemed necessary improvements can be applied to the disk detail at this point. Some additional sharpening is added with unsharp mask. I selected a larger pixel diameter than for the prominences due to the wider spacing of detail in this part of the image. I used the curves adjustment to increase the contrast and brighten the details near the edge of the Sun. The outer edge of the disk image had a sharp cut line where the background sky was removed. To smooth this, I made a selection with the magic wand tool, clicking in the now empty sky region. Since this area is toneless, the entire sky region is selected. The selected area is enlarged using select>modify>expand to take in the first 6 pixels of the disk. Once the selection is feathered, a mild Gaussian blur softens the edge and makes a smoother transition to the spicule region in the prominence image.

The final step is to colorize the image, adding color to the disk and modifying the color in the sky background to fit the new composite image (Figs. 14 and 15). A new layer is made from the final version of the disk image, and the layer blending mode is changed from normal to color. Colorization is clicked in the hue/saturation

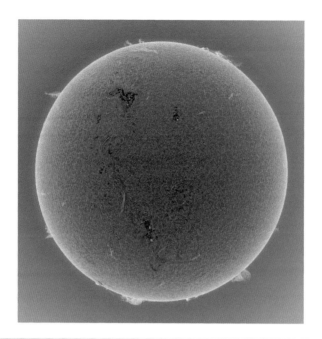

Fig. 14 Colorized full disk portrait of the sun – surface detail is inverted

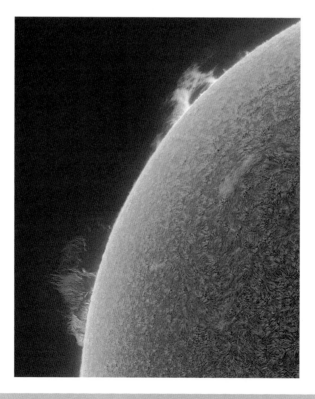

Fig. 15 A contrast in prominences at the solar limb

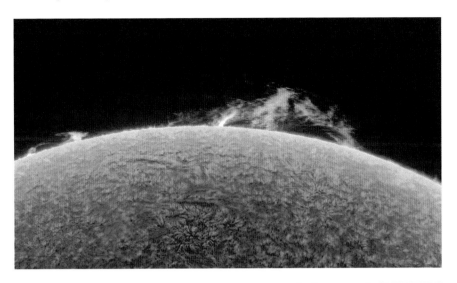

Fig. 16 A massive prominence observed on March 16, 2010

window to add a warm yellow orange tone, followed by the color balance adjustment to tweak the tones in the highlights, shadows and mid-tones of the color layer. Using Color balance will also increase saturation of the tone. This color adjustment layer can be set at 100 % opacity, or any transparency you choose to create the desired effect. In this image (Fig. 16), the color saturation in the prominence and sky background has been reduced substantially while the disk is quite saturated. Save the working file, merge layers and save again as a final version and the project is complete.

I hope these examples will guide you in your own solar journey. Our neighborhood star offers a constantly changing story for the astrophotographer to document, and you don't have to stay up all night or hunt through the sky to find it.

Wishing you an exciting Sun-day, every day of the week!

Aesthetics and Composition in Deep Sky Imaging

Robert Gendler

It's safe to say that many of us began astrophotography feeling overwhelmed by the unnerving task of creating even the simplest astro image. Typically those first successful images were met with a healthy dose of humility as we began to understand the reality of assembling an aesthetically pleasing astronomical image. As we acquired more experience and gradually mastered the fundamentals of image processing our goals and objectives likely evolved and matured.

Many advanced imagers today wish to take their images to an even higher level; that of photographic art. There is often a pivotal point when an imager decides that simply recording a cosmic scene is not enough and they wish to express their own personal vision and imagination through their images. In order to push our images to that higher level it's important to ask ourselves some fundamental questions. What is it that we want to communicate to the viewer? What do we want the viewer to see and more importantly to "feel"? The answer may be difficult to put into words, but in a visceral sense we all seem to know a powerful image when we see one.

The viewing experience is a deeply subjective and personal one; however there are important principles used for years by experienced photographers that effectively make use of visual resources, cues, and compositional strategies to provide the most meaningful and powerful viewing experience. Many of these principles are equally applicable to astrophotography. So how do we effectively communicate our own inner vision and creative experience with the viewer?

This is no easy task. First we need to explore and understand what we "feel" when we find ourselves truly inspired by a particular astronomical scene. Then we must ask ourselves what particular elements of that scene make us feel the way we do. The process demands that we know ourselves and understand what inspires us

before we can inspire others in a similar way. This can only occur through the arduous process of viewing and experiencing numerous astronomical images and emulating those that possess the special qualities we admire. This is an ongoing process that never ends and always can teach us something new regardless of our level of experience. Unfortunately there is no alternative way to develop and mature one's own personal artistic vision and style. Following are some concepts and strategies that can help the imager progress to that next level of "expressive astrophotography."

Focal Point and the Natural Visual Response

Whether they consciously realize it or not each viewer conducts a visual and psychological search for a focal point in an image. The focal point is that part of an image that draws the eye and commands the greatest attention.

I like to mentally divide an astronomical image into three components; the main focal point, the supportive structures, and the background. In an astronomical image the focal point is a commanding structure that dominates the image because of one or more naturally intrinsic elements. Those special elements may include greater brightness or contrast, more highly defined structures, or greater color emphasis. Other more subtle structures in the image have great importance, too, but they play a more supportive role in directing the eye's journey to the natural focal point by way of visual and directional cues. By doing so the viewing experience becomes an orderly passage in which the structures of an image function like a GPS, unconsciously guiding the eye and brain in a logical and psychologically satisfying journey through the image. As the eye grasps the focal point the viewer will typically pause, and the viewing experience reaches a visual climax or point of maximal interest. The importance of the focal point should not be underestimated. It is the leading structure in an image, and the quality of the viewing experience critically depends on it. All viewers will invariably search for it.

There is a physiological explanation behind the positive viewing experience. The physiological response of the human senses (including vision) evolved to react maximally to stimuli that are perceived as having greater intensity relative to the background. The senses are constantly bombarded with background stimuli from our environment, and hence they adapt to this undercurrent by suppressing repetitious or uninteresting stimuli. However, the sensory organs will respond maximally when a stimulus rises above the background. This process of reaction and blunting applies to the viewing experience as well. If there is not an orderly progression of visual cues, increasing in intensity, and leading to a dominant focal point, then the mind's eye becomes distracted and frustrated and the viewing experience becomes increasingly dull and uninteresting. As a result the viewer quickly loses interest and motivation to explore the entire image. In actual images this deleterious effect can occur because of a variety of negative factors such as rendering all the structures of a scene with equal brightness (excessive shadow/highlights in PS), rendering stars (great supporting structures) too bright and distracting, or rendering the focal point too dark or without sufficient detail or color emphasis.

Fig. 1 Antares Nebula. The brilliant supergiant Antares serves as a natural focal point. The luminosity gradient of the glowing nebulosity in addition to the nearby dust clouds serve as supporting structures which draw the eye to the focal point (Copyright © 1993 David Malin)

In reality many astronomical objects have natural focal points. Examples include the bright cores of galaxies, the illuminating sources of bright nebulae such as the core of the Orion Nebula, the concentrated centers of globular and open star clusters. On the other hand there are interesting objects and fields that lack a natural focal point. In these situations it becomes the task of the imager to create one. One may ask how to create a focal point when a particular field lacks one. Clever framing of a scene using existing supporting structures can create the illusion of a natural focal point (Figs. 1, 2, and 3).

To Center or Not to Center?

The focal point need not occupy the geometric center of an image. There are many fine examples of asymmetric focal points in highly regarded astronomical images. In fact off-center focal points if composed skillfully can help craft a more captivating image with a highly engaging visual flow. A caveat is if the focal point is off center

Fig. 2 Trapezium, one of the most natural focal points in any astronomical scene. The original composition was rotated so that the *blue giant stars* along the left side form a pleasing directional cue, creating a visual "flow" that leads to the bright and detailed central focal point (Copyright © 2011 Robert Gendler, Hubble Legacy Archive)

then an interesting supporting structure needs to occupy the "empty area" opposite the focal point. With the appropriate supporting structures helping to fill the void an off center focal point can make for a very pleasing composition. Asymmetric focal points tend to work best in a landscape presentation (Figs. 4 and 5).

Visual Flow of an Astronomical Image

The human eye viewing an image for the first time needs to be led by visual, emotional, and cognitive cues. A visually compelling image tells a story. Visual elements that traditional photographers use in a composition include lines, forms,

Fig. 3 Vela supernova remnant. The structures in the image lack a true focal point, but the framing provided by the three bright peripheral stars creates the feeling of a center (Copyright © 2008 Robert Gendler)

textures, balance, symmetry (or lack of), depth, color, perspective, scale, lighting, and mood. Some of these features do not have clear counterparts in astrophotography, but many do. Several variables such as light, color, scale, depth, balance, and symmetry are variables that often are within control of the imager. "Flow" is the photographic term that describes how a viewer's eye is directed unconsciously through an image.

In Western cultures language progresses from left to right, and we are trained from an early age to look at a printed page from left to right. Even children who cannot read will follow words in this direction with their fingers. As adults we adopt this unconscious process when viewing a photographic image. We come to associate a visual direction of left to right as telling a story. Experiments have shown that humans viewing an image for the first time will enter from left (usually lower left) and will then scan the image searching for the focal point (usually the brightest or highest contrast part of the image). For an image to succeed elements that block this natural flow need to be eliminated or modified.

As astrophotographers we work with static subjects and cannot change our perspective to those subjects. Visual flow in astrophotography is therefore somewhat challenging to accomplish. We must use the existing elements of our scene and

Fig. 4 IC 1805. This image demonstrates the effective use of an off-center focal point. Fortuitously the *arrow-shaped* dust clouds on the left serve as perfect directional cues leading the viewer to the main focal point on the right side of the image (Melotte-15) (Copyright © 2012 Jan Rek)

Fig. 5 NGC 7023. The positioning of the illuminating star and its surrounding nebula slightly off the geometric center of the frame succeeds in creating a sense of spontaneity and curiosity in this intriguing composition (Copyright © 2009 Jay GaBany)

Fig. 6 Clockwise from *top left* figures (**a, b, c**, and **d**): M31, Dark Tower, NGC 6334, Pismis 24. All images follow traditional lower left to upper right directional "flow," which viewers tend to find the most pleasing. The eye begins scanning from lower left, encounters the focal point, then proceeds to explore the remainder of the image (All images copyright © 2013 Robert Gendler)

work with the factors we have control over, which include light, color, and framing. Often astronomical scenes have supporting structures such as dust clouds, stars, background galaxies, etc., which can be intentionally framed and worked into a composition to create a sense of flow in an otherwise static image (Figs. 6 and 7).

Balance in Astronomical Images

The concept of proper balance is one of the most crucial compositional features of a successful image. As a rule pleasing balance results from appropriate contrast between the focal point, the supporting structures, and the background. The background of astronomical images is often dominated by stars. How those stars are

Fig. 7 In this image of NGC 3521 the long axis of the galaxy extends from upper left to lower right, which defies the standard "lower left to upper right" direction of flow. The reason this orientation works for this image is that the short axis of the galaxy, with its bright and highly detailed core, "steals the show" and dominates the image. The short axis runs in the standard direction from lower left, to center, to upper right, obeying the traditional direction of visual flow. The image succeeds in this orientation because the short axis of the galaxy is more interesting and visually powerful, engages the viewer's eye, and makes the image "work" in this composition (Copyright © 2012 Subaru, HLA, Robert Gendler)

presented can literally determine the success or failure of an astronomical portrait. Colorful star fields can be striking, but if stellar intensities are too great they may detract from the focal point and other supporting structures of an image. On the other hand a compact cluster or series of bright colorful stars can be framed effectively to compose an interesting and engaging image. As mentioned in the section on "Visual Flow" a series of bright stars framed along the left side of an image can serve as an important directional cue, leading the eye to the focal point and helping to make for a more dramatic cosmic scene.

There are several tools for suppressing stellar intensities or shrinking stars. These techniques are well known to advanced imagers and include the "minimum filter," the "spherize tool," "Gaussian or radial blur," and a variety of noise reduction programs that also suppress star intensity. In most cases these tools are best

Fig. 8 M20. Proper balance was carefully planned and achieved in this image using gentle suppression of the dense Milky Way star field by use of a selective application of the minimum filter. The brighter blue foreground stars help to frame the nebula complex and encourage the viewer to engage the focal point at the center of the trifid. The subtle suppression of the concentrated star field directs attention to the nebula and makes it "pop" from the background, creating the desired contrast and balance (Copyright © 2009 Robert Gendler)

applied selectively to the stars, sparing the background and other structures. In particular the "minimum filter" can have a deleterious effect (curdling) on low S/N structures so knowing how far to go is probably as critical as understanding how to use the technique itself. The stopping point should be based on enough suppression of the stars so the focal point and supporting structures "stand out" from the background and the stars are pleasing but do not distract attention from the composition (Fig. 8).

Symmetry

Natural symmetry in an astronomical image can make for a striking and graceful balance in an astronomical vista. In reality it may only exist in specific cosmic scenes, such as colliding galaxies or symmetric clouds or star clusters. Symmetry can be created however by the careful framing of neighboring objects or complexes (Fig. 9).

Depth of Field

One of the greatest challenges in astronomical image processing is successfully creating the perception of three dimensions in a two dimensional image. Likewise the greatest praise received from a viewer is that the image has "depth" or appears "three dimensional". It should be noted that "depth" can have different meanings in

Fig. 9 NGC. The positioning of the reflection cloud NGC 1999 and the bow-shock, HH-222 (Waterfall Nebula), on opposite sides of the frame, equidistant from the center, succeeds in creating a pleasing symmetry and balance in this composition (Copyright © 2007 Robert Gendler)

Depth of Field

Fig. 10 M8. This image conveys a strong sense of depth as a result of the careful sculpting and accentuation of detail in the luminous core of the nebula complex (Copyright © 2008 Robert Gendler)

astrophotography. "Great depth" can infer that an image is "deep" in the sense of recording faint structures. Here we are talking about "depth" in the sense of creating a three-dimensional appearance from a two-dimensional image.

There are methods that can help achieve a sense of "depth." If the focal point of an image has greater detail, color intensity, or contrast compared with the supporting structures then a perception of "depth" can often be created (Fig. 10). Conversely, if all the components of an image are rendered the same brightness, then the degree of "depth" suffers, and the image takes on a "flat" appearance. I've seen this negative effect more recently with over judicious use of the shadow/highlight tool in *Photoshop*.

Complementary Colors

True color astronomical images have a limited number of colors. The colors of astronomical objects tend to include blue, teal, red, magenta, brown, yellow, black, and white. Visually speaking certain colors have greater appeal when they appear opposite other colors. These color pairs generate the perception of more pleasing color contrast. I am not advocating changing the natural colors of an astronomical scene, but knowing the hues of objects in advance can sometimes help create striking color contrast in compositions.

This concept is more applicable to narrowband mapped color imaging where the palette used is at the discretion of the imager. Looking at the complementary color wheel we notice that certain colors juxtaposed to each other can produce either a pleasant or an unpleasant reaction (Fig. 11).

Less Can Be More

Large format CCD chips coupled with well-corrected optical systems have dramatically increased the field of view of CCD imaging systems over the last few years. The increased coverage can be a real positive if the target is large as well. On the

Fig. 11 In the complementary color wheel (left) hues opposite each other form the most pleasing complementary color pairs. The Tulip Nebula (Copyright © 2012 Robert Gendler, BYU) rendered in Hubble Palette juxtaposes complementary colors that result in a pleasing combinations of hues in this false-colored image

Fig. 12 NGC 6188. The original landscape framing (left) of this star-forming region in Ara was lacking in drama. Rotating 90° with appropriate cropping succeeded in creating a much more appealing scene with a storyline and clear focal point. In addition the square framing seems to support the natural axis of the structures in the image (Copyright © 2008 Robert Gendler)

other hand a huge field of view for a small NGC galaxy leaves much wasted space that prevents the image from reaching its full potential. Even if the target is large, cropping out non-significant aspects of an image can sometimes be the aesthetically correct decision. Areas of an image busy with non-significant structure can grab attention from the focal point and detract from the visual flow of an image. In simpler terms, sometimes "less is more." Once I complete an image I often experiment liberally with different degrees of cropping as well as rotating the image to find the most appealing presentation. In astronomical imaging one cannot change his or her viewpoint to the object, so managing the scene by way of framing, cropping, and rotating becomes extremely important and can produce some spectacular results (Figs. 12 and 13).

Landscape Versus Portrait Versus Square Presentation

One of the simplest but most important processing decisions is how to manage the aspect ratio. In general photographic terms the decision is whether to present the image in landscape or portrait mode. This can have profound effects on the overall visual impact and presentation of an image. With the advent of large

Fig. 13 NGC 5033. The landscape framing (left) does nothing for the impact of this image and opposes the natural axis of the galaxy. Cropping and rotating it 45° greatly improves the overall presentation and flow of the image. Also the orientation of the short axis of the galaxy from lower left to upper right brings attention to the central core structures that have the greatest detail and contrast. It is also worth noting that diagonally oriented objects do well in a *square* format (Copyright © 2005 Robert Gendler)

format square detectors the additional option of a full uncropped square frame is available to the imager.

In reality there are infinite aspect ratios available to the imager, and the task is to find the one that best compliments the flow of the image and the specific properties of the object. One important feature to consider when making this decision is the dominant "axis" of the structures in the image.

As a general rule it is best to go along with the axis of the dominant structures in an image when deciding on the mode of presentation. For instance if structures in an image tend to run along the horizontal axis then landscape mode will likely be in harmony with those structures and offer a more pleasing viewing experience. Along the same lines a composition with mostly vertical structures will in all likelihood benefit most from a portrait composition. Objects or fields in which the long axis runs diagonally or an object with a well-centered, round focal point will likely present best in either square or almost square presentation.

Here's a general rule: *When composing the frame don't fight the natural dominant axis of the object* (Fig. 14).

Rules, Rules, Rules

In traditional photography the well-known "rule of thirds" and its variations and origins (Golden Ratio, Golden Mean, Golden Triangle, Fibonacci Spiral) are helpful guidelines for composing visual images (Fig. 17). The popular rule of thirds

Fig. 14 Clockwise from upper left: Orion Sword (Copyright © 2007 Gendler), IC1396 (Copyright © 2012 Joahannes Schedler), Eta Carinae Nebula (Copyright © 2011 Gendler), NGC 2403 (Copyright © Gendler, Subaru, HST). These objects were framed to best fit their natural geometric axis. NGC 2403 runs diagonally and is best framed in a *square* format

Fig. 15 Tulip Nebula. This object was generally composed so interesting structures fell on or near the intersecting lines created by the rule of thirds. The result is an interesting off-center focal point and a coherent direction and flow of the structures within the nebula (Copyright © 2012 Robert Gendler, BYU)

suggests that when planning a composition, an image can be divided into nine equal parts by two equally spaced horizontal and vertical lines, and that important compositional elements be positioned roughly at the four points of intersection of those lines.

This compositional strategy works extremely well in certain compositions by creating a feeling of a story line with energy, direction, and flow accentuated by a more intriguing off-centered focal point. The important structures do not necessarily have to fall exactly on the point of intersection to take advantage of the rule of thirds, but close is often good enough. Astronomical objects that benefit most from the rule of thirds are "C" or "U" shaped nebulae, complex star-forming regions with juxtaposed stars clusters and nebulae, and galaxy clusters (Figs. 15 and 16).

Fig. 16 Tarantula Nebula. This 17-panel mosaic was composed so that the Tarantula Nebula, being the main focal point, was positioned on the intersecting lines of the upper left. Other cloud complexes serving as critical supporting structures were also positioned on or near intersecting lines. This is another example of the utility of the rule of thirds and intersecting lines in composing astronomical scenes (Copyright © 2010 Robert Gendler)

Panoramas

Producing wide field panoramas can be one of the most daunting tasks in astrophotography. By their nature they are exclusively mosaics, so there are greater opportunities to plan the composition and to position the important objects and focal points in advance. Because of the extreme aspect ratio of panoramas they may require some deviation from the standard compositional rules. Also panoramas typically contain more than one focal point. Standard rules, such as the rule of thirds, do not always work with positioning important objects and structures within an astronomical panorama. An alternative strategy that seems to work well is known as "center dominance." The important objects or main focal points of the panoramic vista are framed so they are positioned within the center third of the image. Supporting structures and background elements fill the outer thirds.

Fig. 17 Golden rules of composition. (**a**) *Rule of thirds*: Two *horizontal* and *vertical lines* equally spaced. Important structures fall on or near the four intersecting lines. (**b**) *Golden Sector Lines*: Similar to rule of thirds but spaced according to the ratio of Phi (1.618:1). (**c**) *Golden Spiral Lines*: Also based on ratio of Phi (1.618:1). *Structures, lines* or *curves* in an image can be placed according to the *lines* or *spiral curve*. (**d**) *Golden Triangle*: Helpful with fields containing diagonal structures. *Note: Obviously many astronomical fields do not conform to these rules, but some do and many can be framed with at least some guidance from the Golden rules*

This compositional strategy tends to make for a unified coherent image and a visual flow that brings the eye towards the main focal points without creating confusion or distracting the viewer. Another alternative strategy is to fill one of the outer thirds with bland structure having no significant visual elements. This configuration will force the eye to regard the other two contiguous thirds as the main composition. Composition is a major challenge with panoramas because of the increased number of elements in the scene. Planning the right compositional strategy can be the difference between a very "busy" image and a lasting masterpiece (Fig. 18).

In conclusion, composing astronomical scenes can be extremely challenging because of the limitations of photographing astronomical objects from a fixed viewpoint. Taking the time to plan the composition properly can make the difference between a good image and a timeless masterpiece.

Fig. 18 In this Perseus panorama by Rogelio Bernal Andreo (Copyright © 2010 Rogelio Bernal Andreo), the main focal points are the California Nebula (left of center) and the "Flying Ghost Nebula" (right of center). The composition is "busy" with myriad objects and clusters, but a pleasing and coherent composition was created by having the two main focal points "straddle" the center. This image illustrates the concept of the "center dominance" strategy for composing panoramas

Hybrid Images: A Strategy for Optimizing Impact in Astronomical Images

Robert Gendler

This chapter is less about specific techniques and methods and more about a paradigm shift in astronomical imaging. Since my early days in astronomical imaging my goal has been to create high resolution celestial portraits with generous field size and maximal visual impact. The hard reality is that those qualities are often mutually exclusive because of inherent limitations of imaging systems and locations. Any single imaging system, regardless of quality, is locked into certain specific constraints such as focal length, f-ratio, filter systems, and local sky conditions.

In order to assemble the kinds of images I dreamed of making would require new and creative ways of putting images together that transcended the methods of traditional tricolor astronomical imaging. Within the framework of this new paradigm, "image taking" evolved into "imaging projects" and in turn required more meticulous planning, and by necessity liberal experimentation. I found myself investing increasingly more time developing a single image. A pivotal point came when I realized that combining data from a variety of sources could maximize the aesthetic and informational content of an image. More recently I've expanded this paradigm to include the assembly of unique images made by combining professional and amateur data.

Webster defines the term "hybrid" as "something of mixed origin or composition." A hybrid image is therefore defined as an image assembled from disparate data components recorded by different imaging systems. The disparate data may be recorded by different telescopes, the same telescope used at different focal lengths or f-ratios, different cameras, or different filters. In essence the individual components of a hybrid image may differ in their spectral properties, resolution, and image scale. Yet when the different data is brought together in a logical and

coherent way the final integrated image is synergistically enhanced beyond what can be accomplished with traditional methods and a single imaging system.

Hybrid images can be assembled using data from:

1. Instruments having different focal lengths or f-ratios
2. Different detectors or even different media
3. Spectrally disparate filter systems (i.e., conventional RGB and narrowband data)

The reasons to move in this direction are clear. In a given image small-scale structure can always benefit by higher resolution data. The higher resolution data can come from the same imaging system used at longer focal length or under better sky conditions, or may be available only by way of another larger and better imaging system. Conversely areas of large-scale faint structure might be better imaged using a faster f-ratio, shorter focal length imaging system. Areas of faint emission nebulosity or HII clouds in galaxies will almost always benefit from appropriate narrowband data that can potentially render those specific structures with greater S/N and in greater detail.

The guiding spirit of the hybrid image philosophy is that there is tremendous freedom and few rules. The only rule is that we acquire the data from the sky. We are then free to assemble the various data in a manner that optimizes the overall aesthetic and informational impact of the final image. The benefits apply not only to the image but also to the "imager" who gets to enjoy this dynamic process that adds elements of originality, innovation, resourcefulness, and most of all fun to the traditional workflow.

Successful Blending of Hybrid Data

The ultimate outcome of a hybrid image depends on the successful blending of data from disparate sources. The ability to do this became possible with the advent of appropriate software. In 2000 Auriga Imaging came out with *RegiStar* (current version 1.0.7 as of this writing). *RegiStar* essentially revolutionized amateur astronomical imaging by providing the means of "registering" two images with disparate image scales so they can be used as components of the same image. It therefore laid the groundwork for amateurs to go forward with more creative and complex imaging projects.

The following description of *RegiStar* is taken from the product's web page (Auriga Imaging):

> *RegiStar* is an image alignment, or registration, program that was designed to work specifically with astronomical images. *RegiStar* finds the stars in an image, and uses their positions to align this image to another image or group of images. *RegiStar* uses a sophisticated matching algorithm that allows images at different scales and orientations to be registered. *RegiStar* automatically corrects for geometric distortions, so it works on images taken with different optical systems. Also, it works on image pairs that have only a small

overlap. *RegiStar* registers most images that have at least a 1 % overlap and at least 10 stars in common.

Some personal caveats about using *RegiStar*:

1. I have found that 1 % overlap is usually not enough for use with mosaics. I prefer at least 10–20 % overlap. Minimal overlap will often result in a very distorted and unusable registered image.
2. Markedly disparate star sizes can make it impossible for *RegiStar* to match image frames. When attempting to register images of very different inherent resolution star sizes can be markedly disparate (i.e., registering Hubble data to ground-based data or narrowband data to wideband data). I've found it helpful or even necessary to prepare the higher resolution image or narrowband image by enlarging the stars using the maximum filter in *Photoshop*. Of course the purpose of this manipulated image is only for registering the lower resolution image and the original image is used for making the composite.
3. After completing the registration of two images a useful workflow sequence is "operations," then "Crop/Pad control," and then under "Target dimensions" choose "match." This produces a registered image with the same dimensions as the primary image and makes for an easy "cut and paste" without the need for alignment in *Photoshop*.

Here are some useful combination strategies for constructing hybrid images:
- Higher resolution data can be layered onto a lower resolution field or object to enhance small-scale structural detail.
- Combine narrowband data with traditional tricolor wideband data (i.e., incorporating h-alpha NB data to enhance HII regions in a tricolor galaxy image, or to enhance faint emission nebulosity in emission clouds or halo structure in planetary nebulae).
- Add hybrid data to an existing field to expand field size or improve composition.
- Use hybrid color data to colorize a monochrome image or to improve the color depth or range of a weaker tricolor image.

M83 Hubble Core-Subaru Composite

Presently for me the most common use of hybrid data involves the layering of higher resolution data to enhance small-scale structure in a lower resolution image. In the example of M83 (Fig. 1) I layered HST data of the core of M83 (retrieved and processed from the Hubble Legacy Archive) onto a complete tricolor image of the galaxy made from lower resolution ground-based data (ESO and Subaru Telescope data). The core region of most galaxies contains small-scale structure that can benefit greatly from higher resolution data. Specifically the core of M83

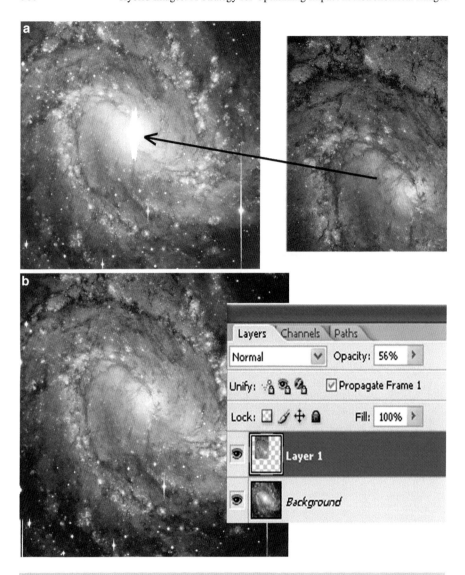

Fig. 1 M83-Subaru composite image with central Hubble detail. (**a**) Hubble composite (*right*) (from Fig. 4) will be layered over cropped background image on *left* (LRGB made with Subaru, ESO and amateur ground-based data). (**b**) Higher resolution Hubble data is layered over the background image in normal mode in multiple iterations of partial opacity layering. (**c**) Final image accomplished by blending a second layer of the central core to maximize detail

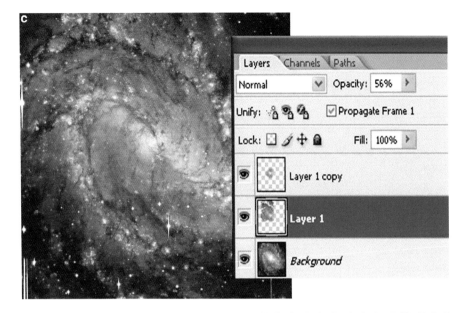

Fig. 1 (continued)

has an amazingly intricate network of HII clouds, starburst regions, and complex dust lanes that collectively form a dramatic focal point in this iconic grand design southern spiral.

The art of layering higher resolution data onto a lower resolution background is not a single step technique but an iterative process that requires a measure of processing patience in addition to specific technical skills. Once the first step of registration to the background image is complete the two images are opened in *Photoshop*. Most often the data is layered in normal mode but there are times when alternative blending methods such as lighten mode, darken mode, or luminosity mode are useful or even preferred. Most importantly the success of the process depends on multiple iterations of partial opacity layering.

When one examines Hubble data, structures and stars are much more highly resolved than data from even the largest ground-based telescopes such as the 8.2 m Subaru telescope (NAOJ). The superior resolution of HST data requires that it be used at partial opacity during each iteration to improve the chances of achieving a unified, well integrated, and coherent image that gives the visual appearance of coming from a single data source.

Along with multiple iterations of partial opacity layering one will need to match the color, contrast and brightness of the layered data with the background image. This may require combinations of levels, curves, color balance, saturation, shadow/highlight, and opacity adjustment in *Photoshop* or equivalent maneuvers in the graphics program of choice. There is no set formula or sequence that works uniformly, but rather the tools are used in the spirit of trial and error to ultimately match the two data sets. This process often takes considerable time, patience, and liberal experimentation.

During the initial layering the sharp edges of the layered HST data were removed with the eraser tool. Then the outer portion of the layered data was selectively adjusted using curves and levels to create an imperceptible seam with the background Subaru image. In actuality this step was repeated several times and required different blending modes. Selective processing at the seam-background junction was needed to achieve the desired blending. Next (Fig. 1c) a second round of layering and blending was performed using a smaller section of the central core of the galaxy. This was also blended using multiple iterations with the same techniques discussed above until a unified and integrated appearance was achieved in terms of color, contrast, brightness and satisfactory blending of small scale detail.

NGC 2403 Hubble-Subaru Composite

For this project I began by assembling a monochrome mosaic of the core and central arms of NGC 2403 using wideband monochrome (606 nm) and narrowband h-alpha (656 nm), which I found in the Hubble Legacy Archive (HLA). The 656 nm data was especially important to feature the giant HII clouds that populate this galaxy's spiral arms.

There was insufficient data to make a tricolor image so I combined the different filtered data into a single monochrome mosaic image with a plan to find a separate color source at a later time to complete the LRGB tricolor image. Because of the abundance of small-scale detail the color data would need to come from a high resolution source.

Several months later I did come across a high quality wideband color image of the galaxy acquired by the 8.2-m Subaru telescope (NAOJ). After appropriate registration in *RegiStar* I brought the two data sources together to form a standard LRGB composite in *Photoshop CS2* using the Hubble data as luminance and the Subaru data as color. The resulting LRGB composition was incomplete due to areas of missing data along the edges of the luminance. In order to complete the composition I filled in the edge defects with data from the original Subaru image. After considerable work the final hybrid color composite looked like an image from a single data source featuring the enormous Hubble detail in the HII regions, galactic core and inner arms, and in natural RGB color provided by the Subaru image.

One caveat about this image is that the color and luminance detail needed to be reasonably close in their resolution of small-scale structure. The 8.2-m Subaru telescope data matched reasonably well with the higher resolution Hubble data. In general large scale structures such as large dust clouds, unresolved star clusters, HII clouds with minimal small scale structure can be matched more liberally with color data considerably lower in resolution. On the other hand small-scale structures such as well resolved star clusters, highly detailed HII clouds, and complex nebulae need a much closer match in resolution to achieve a coherent, unified, and well integrated final composite (Fig. 2).

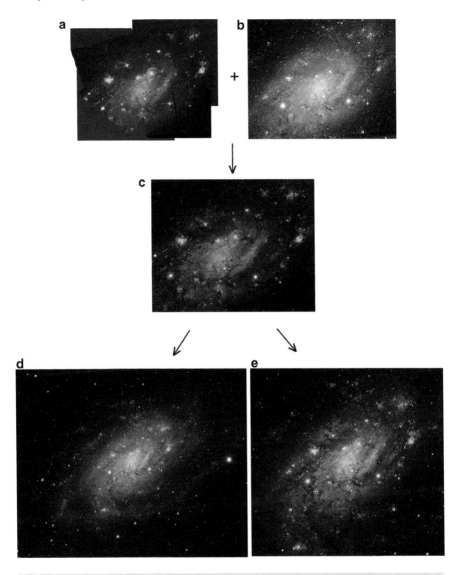

Fig. 2 NGC 2403 Hubble-Subaru composite. (**a**) Luminance mosaic assembled from Hubble Space Telescope data. (**b**) Color data from Subaru telescope image. (**c**) Final LRGB composite made from the two data sources. Edge defects were filled in using the original Subaru color image. (**d**) Image C layered onto a wide field image created from additional Subaru and ground-based color data. (**e**) Detailed high contrast crop of image D

M8 Hybrid Image

In this example a low resolution hydrogen alpha color composite was made using a 6″ refractor at a focal length of about 1,000 mm.

The image data was recorded under a fairly light-polluted 4.5 magnitude sky. The outer nebula complex is comprised of mostly large-scale structure with extended bland emission clouds. However the inner nebula (with its several detail-rich areas famously known as the "hour glass" and "the lagoon") has substantial small-scale structure with complex hues, intricate dust lanes, young hot stars, and glowing reflection and emission clouds. The entire complex emits a myriad of complex hues representative of the dynamic energy emission from this stellar nursery. Consequently although shorter focal length data is adequate to record the outer large-scale bland structure, the inner nebula with all its complexity and dynamic structure requires data with greater resolution and superior color quality. For the inner nebula the data was acquired using a longer focal length instrument (20″ Ritchey Cretiene Cassegrain) under darker skies (New Mexico).

The initial hydrogen alpha color composite that will later serve as the lower resolution background image was created first. This image was assembled by incorporating the stretched hydrogen alpha data set into the traditional wideband RGB color composite. This is achieved by first creating a standard RGB composite. Since the narrowband h-alpha emission is in the red part of the visual spectrum a new red channel was created that made visible all the faint extended emission nebulosity captured in the hydrogen alpha set. The new red channel was made in the following way. After opening the traditional RGB in *Photoshop* the red channel is extracted by highlighting "red" under channels and then converting to gray scale. Next the stretched hydrogen alpha data set is layered onto the red channel of the RGB composite using lighten mode.

Alternatively, the opposite layering configuration of extracted red channel layered over h-alpha in lighten mode sometimes works better, depending on the data sets. It is worth experimenting with both layering configurations as well as varying opacity. Lighten mode layering of the h-alpha signal preserves the star size and intensity and subsequently will later preserve the RGB star color balance when the new composite is made. The subsequent new red channel is then used to create a new (Ha+R) GB composite. I make this new color composite in *Maxim DL*.

A caveat about successful blending of h-alpha into RGB data is to avoid using the h-alpha as luminance or to use it with a low opacity. Overuse of h-alpha as luminance (high opacity) will tend to overwhelm the RGB colors, resulting in nebulosity having an unnatural salmon-pink hue. Also as a final step some of the natural nebula and star colors can be restored by selective layering of the RGB over the h-alpha color composite in color mode. "Color range" selection can then be used to restore the RGB hues to selected areas.

A critical point which I learned from experience is that narrowband h-alpha signal is most effective for bringing out the low S/N (signal/noise) nebulosity. If used in areas of high S/N (bright) it can be detrimental to the presentation of those areas by washing out the natural hues of those regions.

Once the h-alpha color composite is complete this image serves as the background for the layering of higher resolution tricolor data. The higher resolution image in this example was created using a 20″ Ritchey Cretiene Cassegrain (focal length 3,200 mm) under dark skies in New Mexico. This data possessed superior

resolution, and S/N and the color data was stronger by virtue of the larger aperture, longer focal length and dark skies. A traditional LRGB composite was assembled from this data and then layered onto the background image in normal mode. Similar to the other examples successful blending is accomplished by using multiple iterations of partial opacity layering and varying degrees of opacity along with appropriate global and selective processing (curves, levels, color balance, shadow highlights) as needed (Fig. 3).

Hubble Composite of M83

This composite image of M83, made with Hubble data, was constructed using two complete WFC-3 (Widefield Camera-3) data sets. These were stitched together in a two panel mosaic. However the adjoining edges were staggered, making for an awkward composition. Additional data would be needed to complete the composition. Searching further within the HLA I found several monochrome ACS (Advanced Camera for Surveys) frames that would need colorizing to complete the image and achieve a pleasing landscape composition. The color for the fill-in frames would need to come from another source, such as an existing amateur or professional tricolor image. I had imaged M83 several times from southern skies and had several good RGB data sets, which I used to colorize the monochrome HST fill-in data.

First step was to register the various components of the fill in data to the original mosaic using *RegiStar*. I then proceeded to make LRGB composites using the HST monochrome data as luminance and my own data as RGB color. This required multiple iterations of luminance layering to arrive at a natural-appearing result, which was subsequently stitched to the original mosaic.

Because of the disparate resolution of the luminance and RGB data sets considerable blemish repair was required. The repair was mostly in the form of using the clone tool to eliminate "spillover" of disparate RGB data onto smaller scale structures. It can be highly problematic to use lower resolution RGB data to colorize a higher resolution luminance because of contamination of adjacent small-scale structures by "spillover" of inappropriate color data.

Once the fill-in composites were ready, then assembly of the new mosaic proceeded in fairly straightforward manner by matching each frame to the original image using adjustments in levels, curves, color balance, etc. (Fig. 4).

NGC 891-HST-Subaru-BYU Composite

In this example I attempted to combine three separate data sets into a single image. I used a previous LRGB image made with a moderate-size imaging system (0.9 m telescope, Brigham Young Observatory) as the RGB color component. I then used very high resolution data from the Subaru telescope archives as luminance data for

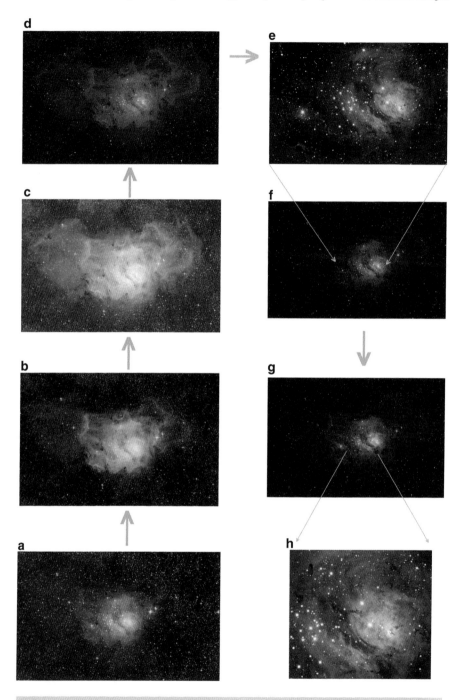

Fig. 3 M8 Hybrid Image. (**a**) A traditional RGB composite is created. (**b**) The red channel is extracted (**c**) The stretched hydrogen alpha image is layered over the red channel in "lighten mode" and opacity is adjusted to produce an appropriate balance of nebulosity and star density.

most of the image. Finally I layered in data from the Hubble Space Telescope in selected areas of small-scale structure to provide the highest degree of resolution possible for the complex and unique network of dust lanes that populate this galaxy's equatorial disk and adjacent halo (Fig. 5).

NGC 6946 Subaru-Amateur RGB Composite

In this example the luminance for NGC 6946 came from the 8.2 m Subaru telescope (NAOJ) and the color came from an LRGB image I made using my 14.5″ Ritchey Cretiene Cassegrain (FL=3,200 mm). The original tricolor Subaru image, despite having impressive resolution, suffered from poor color quality.

The challenge of this strategy is the successful blending of lower resolution color data to higher resolution luminance. This type of composite is typically easier and more successful for data with similar sampling than it is for data with markedly disparate resolution. With markedly disparate resolution, a successful blend of data sets can still be achieved but requires considerable additional work. In general blending disparate RGB and luminance is fairly straightforward for larger scale structures such as featureless emission clouds or large-scale galactic structure, but blending in areas of small scale structure can be problematic. Smaller scale structure often gets contaminated with what I call "color spillover" from adjacent larger scale structures in these situations. Repair or adjustment of these areas is often possible but somewhat tedious using the clone tool in color mode to remove or repair "color bleed."

In this example (Fig. 6) I converted the original Subaru image to gray scale to be used as luminance. The luminance was aggressively stretched. I then registered my color image to the luminance in *RegiStar*. I then proceeded to assemble a traditional LRGB. I have found that assembling these types of non-traditional LRGB composites can produce different results with different programs. For reasons I cannot explain I have found that with some composites the results are better with *Photoshop*, while with others the results are better with *Maxim DL* or *Registar*. Therefore some experimentation may be helpful in this regard. After some blemish repair the final tricolor LRGB composite was far superior to the original image in terms of color and overall impact.

Fig. 3 (continued) This image is then designated as the "new" red channel, (**d**) The new red channel is then composited with the original green and blue channels to make a new (Ha-R)GB composite that will become the background image. (**e–f**) The higher quality, longer focal length image of the center of M8 is layered onto the background image in "normal mode" using multiple iterations of partial opacity layering. (**g–h**) The final composite now has the extended faint nebulosity of the background image and the higher quality color and more highly resolved small-scale structure of the layered image in the final integrated composite image

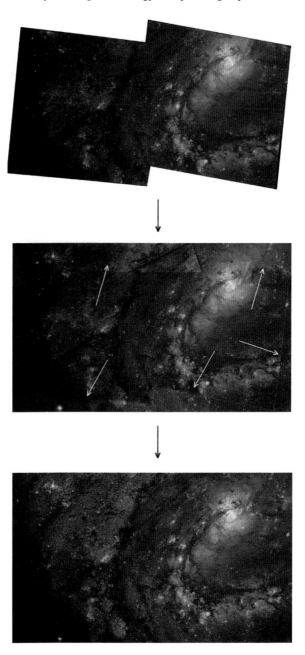

Fig. 4 Hubble composite of M83. Staggered edges create an awkward composition. This was corrected by filling in staggered areas with hybrid image data made with monochrome Hubble data as luminance and ground-based amateur data as color

Fig. 5 NGC 891-HST-Subaru-BYU Composite. (**a**) The color data is from an LRGB image acquired with the 0.9 m Brigham Young University Telescope. (**b**) Luminance made from 8.2 m Subaru Telescope data (NAOJ). (**c**) Available Hubble data layered onto luminance (**b**) for detail in dust plane of galaxy. (**d**) Final LRGB color composite

Fig. 6 NGC 6946 Subaru-Amateur RGB composite. (**a**) Original tricolor Subaru image. (**b**) Original Subaru image converted to gray scale and aggressively stretched to create new luminance for later LRGB composite. (**c**) Ground-based amateur image used for RGB component. (**d**) Final LRGB composite

Final Images

Completed Images for the above example can be found on my web site at the following URLs.

 http://www.robgendlerastropics.com/M83-Subaru-HST-ESO.html
 http://www.robgendlerastropics.com/M83-HST-Gendler.html
 http://www.robgendlerastropics.com/NGC2403-Subaru-HST.html
 http://www.robgendlerastropics.com/NGC2403-HST-Subaru-Detail.html
 http://www.robgendlerastropics.com/NGC2403-Subaru-HST-Full.html
 http://www.robgendlerastropics.com/NGC891-Subaru-HST.html
 http://www.robgendlerastropics.com/M8AUComposite.html
 http://www.robgendlerastropics.com/NGC6946-Subaru-Gendler.html

Author Biographies

Rogelio Bernal Andreo is a Spanish-American astrophotographer. In 2008, Rogelio started exploring astrophotography as a hobby and developed a personal style defined by deep wide field images that has led to international recognition and a meaningful influence on the discipline. His work has included using post-processing techniques not very common at the time of their introduction. Rogelio's photography has been published in international magazines and periodicals and it has been recognized by NASA as their Picture of the Day multiple times. His work has also appeared in motion pictures and in a variety of programs in television networks. Rogelio has received numerous awards for his work.

www.deepskycolors.com/

Adam Block graduated from University of Arizona with a B.S. in Astronomy and Physics in 1996. He spent the next 9 years developing and administering public outreach programs at the National Observatory at Kitt Peak. Since 2007 his dream to create foremost public outreach experiences in astronomy is being realized with a return to the University under Steward Observatory and the College of Science at the Mount Lemmon Sky Center. Adam is most well-known for his abilities to speak and communicate difficult concepts in astronomy in simple and creative ways. Adam is also recognized around the world as a leading astrophotographer. The images he produces as part of public outreach programs are published in magazines, books, posters, and widely on the internet. His images have graced NASA's "Astronomy Picture of the Day" website more than 60 times and have been used as reference images by amateur and professional astronomers alike. In 2012 he was the recipient of the "Hubble Award" from the Advanced Imaging Conference – one of the highest awards for work in astrophotography that is recognized around the world.

http://skycenter.arizona.edu/about/people/ablock

Stephen A. Cannistra has been performing deep sky imaging from a rural suburb in Rhode Island for over a decade. A native of Massachusetts where he currently lives, he travels over 50 miles to an imaging site that is reasonably dark, although still plagued with light pollution from nearby Providence, RI. A physician and cancer researcher by day, at night he enjoys tinkering with optics, computers, and setting up his portable imaging system for each session. He has concentrated his efforts on equipment and post-processing techniques that lend themselves to widefield and moderate focal length targets. He has published widely in the medical literature but is quick to admit that some of his proudest publications also include those involving his amateur astrophotography work. He has several APODs, has developed novel techniques such as the bicolor method using data from Ha and OIII filters, and has published several technical analyses relevant to CCD camera characteristics. More details may be found on his website at www.starrywonders.com.

Ken Crawford has been pointing telescopes toward the night sky since the eighth grade. He built his Rancho Del Sol Observatory in 2002 and started taking images of the deep sky. In 2004 Ken was one of the principle founders of The Advanced Imaging Conference, Inc held every year in the Bay area and has served as President since 2007. In 2008, Ken was invited to sit on the NASA "Astronomy Picture of the Day" advisory committee to participate in the future planning and funding efforts of this amazing website. Ken was also the Chief Docent for the Cameron Park Rotary Community Observatory in Placerville, CA. and is also a coordinator of the local observing club called the Sierra Star Gazers that hold a monthly star party. In 2008, Ken joined a professional, international research team headed by Dr. David Martinez-Delgado of the Max-Planck Institute, searching for galactic tidal streams which are the remnants of galaxy mergers. Ken's images and contributions to this research resulted in being a coauthor on several Astronomical Journal publications. This Galactic Archaeology shows that real science can be done by amateurs with modest equipment, clear, dark skies and dedication. Ken Crawford's images have been featured in numerous magazines, books, websites, movies, and public displays. To date, his images have been featured 29 times as the NASA "Astronomy Picture of the Day".

http://www.imagingdeepsky.com/

Fred Espenak is a scientist emeritus at Goddard Space Flight Center and is NASA's expert on eclipses. He maintains NASA's official eclipse web site (eclipse.gsfc.nasa.gov) as well as his personal web site on eclipse photography (www.mreclipse.com). Fred has published numerous books and articles of eclipse predictions and he is the co-author of the popular book "Totality – Eclipses of the Sun". His magnum opus, the "Five Millennium Canon of Solar Eclipses", includes a map of every solar eclipse occurring between 2000 BC and AD 3000. His interest in eclipses was first sparked after witnessing a total solar eclipse in 1970. Since then, he has participated in 34 eclipse expeditions around the world including Antarctica. Fred's eclipse photographs have appeared in both national and international publications, and he has lectured extensively on the Sun, eclipses and photography. In 2003, the International

Astronomical Union honored him by naming an asteroid "Espenak". Now retired and living in rural Arizona, Fred spends most clear nights losing sleep and photographing the stars (www.astropixels.com).

Alan Friedman is an artist, greeting card publisher and president of Great Arrow Graphics. By night he is an avid astrophotographer, recording the solar system from his backyard in Buffalo, NY. His images of the sun, moon and planets are featured frequently on popular websites, the Astronomy Picture of the Day and in exhibitions including Starstruck at Bates College Museum and the International touring exhibition, From the Earth to the Universe. Fine art prints of his work are represented by Photo-Eye Gallery in Santa Fe. His imaging techniques have been the subject of lectures, articles, a TEDx talk and interviews on MSNBC's TODAY show. Alan is a past president of the Buffalo Astronomical Association and holds the title of Research Associate in Astronomy at the Buffalo Museum of Science. He is also an avid collector of vintage hats. To find out more visit his website, avertedimagination.com.

http://www.avertedimagination.com/main1.htm

R. Jay GaBany is an American amateur astronomer and astrophotographer who is also known for his collaboration with an international team of astrophysicists led by Dr. David Martínez-Delgado (Max Planck Institute for Astronomy). GaBany helped pioneer the use of modest size telescopes and off the shelf CCD-cameras to produce long exposure images that revealed ancient galactic merger remnants in the form of star streams surrounding nearby galaxies that were previously undetected or suspected. Jay has spoken to audiences across the US, in Europe and Australia; authored over 50 articles for the Universe Today, Sky & Telescope and the UK's AstronomyNow and has been featured by popular magazines such as Wired and Discover. His images have graced the covers of books and appeared in the journal Science, the journal Nature, on the cover of the journal Astronomy & Astrophysics and in other leading astronomy magazines around the world. GaBany was awarded the Chambliss Amateur Achievement Award for 2010 by the American Astronomical Society (AAS). In September of 2011, his image of NGC 3521, the Bubble galaxy, was selected by NASA to serve as the uncredited back drop for the International Space Station Expedition 30 official crew portrait – a non-professional astrophotograph has been used for this purpose only once before. In 2012, Jay was selected as one of the 25 most influential people in space and astronomy by the Editors of TIME magazine.

http://www.cosmotography.com/

Robert Gendler is an American amateur astronomer and astrophotographer who specializes in images of deep sky objects. His photographs are regularly published in astronomy magazines, including Sky & Telescope and on the Astronomy Picture of the Day website. Two of his images have been featured in National Postal Stamp issues including IC 405, the Flaming Star Nebula, which was featured as one of six Royal Mail commemorative stamps in 2007, commemorating the 50th anniversary

of The Sky at Night and In 2011 his image of the Pleiades appeared in a German Postal series "For the Youth". In 2007 he was awarded the "Hubble Prize" at the annual Advanced Imaging Conference in San Jose California. Also in 2007 he was featured in Timothy Ferris's PBS documentary "Seeing in the Dark". He is the author of A Year in the Life of the Universe: A Seasonal Guide to Viewing the Cosmos (Voyageur Press 2006), Capturing the Stars: Astrophotography by the Masters (Voyageur Press 2009), and "Treasures of the Southern Sky" (Springer 2011). In February 2013 he collaborated on an image of M106 for the Hubble Heritage Team. He is a physician and lives in Connecticut with his wife and two children.

http://www.robgendlerastropics.com/

Don S. Goldman is the founder and President of Astrodon Imaging, providing filters for astrophotography and photometric research. He is an avid astrophotographer, who is now imaging remotely from Siding Springs in Australia. He is a popular lecturer at astronomy conferences, has many images published astronomy magazines, and has been selected many times for NASA's Astronomy Picture of the Day (APOD). He was a co-founder of the prestigious Advanced Imaging Conference. He is interested the evolution of planetary nebula and images faint halos around these objects with narrowband filters.

http://www.astrodonimaging.com/

Tony Hallas's astrophotographic career can be summarized as a series of firsts. For example, starting out over 25 years ago, he was one of the first to produce film-emulsion images using an autoguider. Tony was also one of the first to champion the use of stacked astronomical images as a method that improved the final picture's signal to noise.

Particularly during the early years of digital astrophotography, Tony's pictures were the reference to which digital imagers compared their images. Finally, to many in the community, Tony's images remain the first among equals in their aesthetic quality, composition and color! Tony's pictures have been published in countless magazines, television productions and books. He is a highly regarded speaker and the recipient of numerous, prestigious awards including the 2009 AIC Hubble Trophy.

http://www.astrophoto.com/

Steven Mazlin's images have appeared in multiple magazines, including Sky & Telescope, Sky Watch, Beautiful Universe, GEO International, as well as on-line on NASA's Astronomy Picture of the Day website. His images have won several awards, but he is most proud that the "Witch Head Nebula" was chosen by UNESCO for its World Science Day poster in 2009. In 2006, Dr. Mazlin, along with fellow amateurs Jim Misti and Bob Benamati, hosted the East Coast Conference on Astronomical Imaging (ECCAI) in Philadelphia. He has lectured at multiple venues, including local astronomy clubs, the Franklin Institute, the 2009 Northeast Astroimaging Conference, and most recently (March 2010) was invited to Bates College in Lewiston, Maine to give a lecture on astrophotography, in preparation for the exhibition planned there in 2011. In advance of this event, the

"Lewiston Sun Journal" featured Dr. Mazlin in its February 28th, 2010 edition. Dr. Mazlin is a visiting scholar in the department of physics at UNC Chapel Hill.

http://fourthdimensionastroimaging.com/

Stan Moore is a lifelong amateur astronomer, and was an early adopter of CCD imaging. He is currently pioneering high resolution deep space imaging using intensified digital video cameras. His education and background in math and physics has informed his investigations into the basis of astronomical imaging. He created and continues to support and develop CCDStack, software dedicated to the construction of deep space astronomical images. He also consults as a programmer/analyst for statistical analysis of large data bases.

http://www.stanmooreastro.com/

Damian Peach's interest in Astronomy took flight at a young age while at primary school. It was soon after that he got his first instrument – a pair of 8 × 30 binoculars with which he learned his way around the sky. It wasn't until 1992 that his attention really turned toward the Planets (especially Jupiter.) In about 1992 Damian joined the Boston Astronomical Society of Lincolnshire headed by well known UK amateur astronomer, Paul Money. Damian spent many nights during his early teens observing the Planets, with a special fascination for Jupiter.

Later in the mid-1990s he acquired a 6″ F/6 Newtonian, and 90 mm F/11 refractor. The refractor gave wonderful views he recalled of Comets Hyakutake and Hale Bopp. During 1997 he acquired a Meade 20 cm SCT, and had relocated to the town of Kings Lynn, on the Norfolk coast. During that year Damian also became captivated by images by Florida Planetary guru Don Parker showing amazingly detailed images of Jupiter. Damian began to seriously consider buying a CCD camera and trying to take images of his own. It was during this period he upgraded his equipment and finally bought a CCD camera. He then began capturing high resolution images of the planets. From then on, his results rapidly improved and he is now well known as one of the best amateur planetary imagers in the world.

http://www.damianpeach.com/

Johannes Schedler's astronomical life started in 1997 with a simple Tasco reflector, a gift for his second son. Unfortunately, his son lost interest in the scope after a while but, fortunately, Johannes tried it out and began to explore the Moon and the Planets. In 1998 he joined a local astronomy club and acquired more sophisticated equipment and in 1999 he successfully introduced a webcam for planetary imaging and began his passion for astrophotography. Johannes has had articles and images published in Astronomie heute, Interstellarum, Sky & Telescope, Practical Astronomer, and Ciel & Espace magazines. He authored the Chapter: Deep Sky Imaging with a Digital SLR, in the book, Digital Astrophotography (Ratledge David Ed.). His images have been selected for NASA's Astrophoto of the Day (APOD) many times. Johannes currently observes from his home observatory at Wildon, Austria.

http://panther-observatory.com/

Babak A. Tafreshi is a freelance photographer, science journalist, and astronomy communicator, the creator and director of The World at Night (TWAN) program, a board member of Astronomers Without Borders, contributing photographer of Sky&Telescope magazine and the European Southern Observatory. He received the 2009 the Lennart Nilsson Award, a prestigious award for scientific photography, for his global contribution to night sky photography.

btafreshi@twanight.org

Index

A

Adjust display parameters, 31
Adobe camera raw, 281, 282, 286
ADU. *See* Analog to digital units (ADU)
Airglow, 211, 288, 290
Alpha channel, 39, 41, 79–82, 87, 91
Analog to digital units (ADU), 11–12, 15, 16, 19, 20, 23, 24, 211
Apochromat, 234, 270, 297, 333
Aspect ratio, 218, 219, 295, 356, 359
Astro IIDC, 327, 331–333
Astronomical seeing, 240–242, 244, 248, 326
Aurora, 263, 264, 268, 275, 283, 288, 290
Autostakkert 2, 239, 240, 253, 254
Averaging, 2, 16, 19, 21, 23, 53, 153, 161–164, 195, 197–199, 207, 208, 218, 220, 255, 257, 266, 275, 302, 305, 307, 311, 326, 333

B

Baader K-line filter, 322
BackgroundModelization, 100
Background noise, 14, 15, 200, 212, 283, 286
Balance, 59, 64, 66, 85, 141, 170, 185, 199, 202, 204, 205, 213, 214, 217, 223, 248, 257, 268, 273, 275, 278, 283, 284, 288, 289, 291, 332, 336, 338, 341, 347, 349–352, 369, 372–374
Bandpass, 322

Batch image defect removal, 196–197
Bicubic B-spline, 169, 198
Bicubic method, 170
Black point, 105, 179, 188, 190, 199, 200, 205, 213, 220, 221, 225, 226
Blur(ring), 6, 16, 24–26, 54–56, 58, 60, 61, 70–71, 73, 74, 86, 88, 93, 110, 133, 152, 164, 185, 205, 210, 219, 222, 224, 233, 254, 256, 259, 275, 286, 287, 304–311, 313, 314, 328, 330, 335, 336, 339, 350
Blurred saturation layering, 54–56, 71
Bracketed sequence, 302, 313

C

Calibration, 13, 16–22, 73, 98, 112, 118, 134, 160–162, 164, 169, 193–199, 204, 205, 207, 215, 219, 225, 268, 288, 291
Camera raw, 149–153, 281–286
Canon 5D, 268
CCDStack, 27, 31, 74, 78, 122, 133–135, 159, 160, 162–164, 166, 167, 172, 173, 194–198, 201, 208, 209, 383
CCDWare, 63, 122, 160, 194
Center dominance, 359, 361
CFHT Palette, 117
Channels, 36, 53, 76, 121, 132, 169, 199, 221, 250, 268, 308, 372
Channels palette, 121

Chromosphere, 302, 304, 321, 327, 330, 336, 337, 339
Clipping, 26, 32, 42, 43, 78, 105, 119–121, 124, 142, 143, 145, 161, 162, 188, 199, 200, 205, 220
Clone stamp, 68, 224
Cokin P830 diffuser, 271
Collimat, 234, 235, 237
Color burn layering, 58–59
Color management, 205, 214–215
Color noise, 54–57, 62, 69–71, 150, 205, 222, 287
Color profiling, 214, 215
Color range, 39, 68, 79, 126, 153, 154, 185, 202, 205, 209, 224, 374
Color ratio, 160
Color saturation, 53–54, 56, 59, 62, 63, 68, 159, 179, 181, 200, 205, 212, 229, 282, 341
Complementary colors, 354
Composite, 22, 44, 83, 85, 134, 135, 138, 140, 141, 223, 229, 256, 305, 306, 310–314, 330, 333, 339, 367–378
Coronal image processing, 304–305
Curves, 6, 7, 32–37, 42–44, 61, 66, 94, 97, 100, 106, 111, 112, 120–122, 139–143, 145, 154, 178, 179, 185–187, 201, 213, 220, 221, 226, 227, 279, 283, 313–316, 332, 336, 338, 339, 360, 367, 368, 371

D

Dark subtraction, 13, 15–19, 195, 219, 220
DDP. *See* Digital Development Process (DDP)
Deconvolution, 8, 24–27, 74, 87, 93, 94, 97, 122, 133, 171–173, 176, 195, 208, 209, 221, 226
Deep sky, 29, 30, 33, 88, 97, 159–215, 217–232, 238, 258, 264–266, 268, 270, 273, 280, 281, 286, 290, 292, 322, 324, 343–361, 380, 381, 383
Depth of field, 352–353
Diamond ring stage, 296, 299–302
Digital development process (DDP), 24, 26, 30–32, 78, 97, 100, 106, 134, 139, 140, 170, 174, 175, 199, 201
Digital single-lens reflex camera (DSLR), 264, 266–269, 273, 275, 277, 281, 282, 285, 286, 291, 295–303, 305, 313
DynamicBackgroundExtraction, 100
Dynamiccrop, 98

E

Edge glow box, 33

F

Flat fielding, 18–20, 22, 73, 161, 162, 170, 194, 196, 214, 219, 220, 238
Focal point, 39, 344–351, 353, 355, 356, 358–361, 369
F-ratio myth, 4, 9–10
Full width at half max (FWHM), 5–8, 25, 27, 172, 199, 208, 209, 218, 219

G

Gaussian blur, 24, 25, 55, 58, 60, 61, 70, 71, 185, 205, 210, 222, 256, 286, 328, 335, 336, 339
Golden rule, 360
Gradient removal, 98, 100, 104, 201–204
Gradients, 98, 100, 102–106, 108, 112, 132–137, 146, 154, 170, 173, 178, 200–202, 204, 219, 221, 222, 224, 283, 302, 331, 345
GradientXTerminator, 135–137, 146, 201, 202
G2V, 125, 134, 160, 170, 220, 221

H

H-beta, 140, 208, 212
HDR. *See* High dynamic range (HDR)
HDR Toning, 33–38, 86, 87, 94
HDRWaveletTransform, 30, 32
Healing Brush, 68
Herschel wedge, 320, 323
High dynamic range (HDR), 29–38, 281, 303, 313–316
High dynamic range processing, 29–50, 86
High ISO photography, 276
High Pass filter, 87, 89–94, 127–129, 181–183, 190, 208, 209, 213, 227, 315
Histogram, 31, 32, 34, 36, 61, 63–66, 78, 97, 100, 105, 106, 110–112, 143, 200, 202, 205, 213, 220, 221, 225, 257, 298, 327, 328, 336
HistogramTransformation module, 105
History tool, 71
Hubble Palette, 354
Hybrid image, 25, 27, 197, 365–367, 371–375
Hydrogen alpha, 138, 320–322, 324, 333, 371–373

I

Image scale, 4, 8, 10, 131–133, 244, 256, 295–298, 365, 366
Imaging Source DMK21AU618, 239
Iterative deconvolution, 25–27

J

JPEG, 129, 150, 151, 273, 282, 299, 305, 337
Jupiter, 8, 247, 249–251, 254, 257, 258, 292, 383

L

Lab color mode, 61–62
LAB color space, 61, 185–188
Lasso, 67, 79, 126, 135, 137, 201, 202, 221, 222, 224
Layer mask, 39–42, 46, 48, 68, 69, 79–81, 85, 87, 89–92, 121, 124, 128, 129, 157, 175, 176, 188, 189, 201–203, 222
LED flashlight, 273
Levels, 2, 7, 9, 12, 18, 19, 32, 33, 55, 58, 60, 61, 64, 76, 100, 129, 144, 152, 160, 162, 164, 166, 167, 173, 176, 178, 181, 188–190, 193, 200–203, 205, 210, 212, 213, 220, 225, 226, 234, 235, 242, 250, 256, 257, 259, 268, 271, 286, 314, 322, 326, 332, 333, 335, 336, 343, 344, 369, 370, 374
Light pollution, 4, 117, 132–138, 141, 144, 146, 147, 217, 219, 221, 265, 267, 275, 276, 283, 289–291, 380
Liquify, 129
LRGB, 16, 112, 130, 150, 159, 176, 180, 181, 190, 194, 201, 204, 208, 213–215, 218–220, 222–223, 256–257, 368, 370, 371, 374, 376–378
LumeneraSKYnyx 2.0M/C, 238, 239
Luminance, 33, 52, 74, 97, 122–123, 132, 150, 163, 195, 218, 248, 370
Luminance layering, 53, 54, 122–123, 138, 140, 145, 177, 178, 181, 184, 207, 218, 222, 223, 229, 257, 374
Lunar, 233–259, 269, 275, 300, 302

M

Magic wand, 67, 136, 338, 339
Magic wand tool, 67, 136, 137, 336, 339
Manfrotto tripod, 271
MAP. *See* Multi point alignment (MAP)
Marque, 68, 224, 305
Mars, 241, 242, 247–249, 254, 258, 259, 288

MaskGeneration, 106
Masks, 25, 30, 68, 73, 106, 120, 142, 152, 172, 202, 219, 286, 299, 330
Master flat, 18, 19, 195
Master production, 219–220
Match color tool, 59–60, 222
MaximDL, 122, 133–135
Merge color, 121
Midtone, 33, 36, 56, 105, 106, 143, 223
Minimum filter, 129, 185, 350, 351
MorphologicalTransformation tool, 107
Multiple alignment points, 329
Multiple exposures, 21, 33, 314
Multi point alignment (MAP), 254, 329–331
MultiscaleMedianTransform tool (MMT), 109

N

Narrowband filter, 16, 115–118, 124, 125, 130, 132, 138, 141, 199, 250, 382
Newtonian reflectors, 235
Nightscape, 261–269, 271, 273–275, 277–281, 283, 284, 286, 288–290, 292
Nikon D3, 268
Noise Ninja, 129, 145, 149, 152–153, 188, 287
Noise reduction, 112, 122, 129, 145–158, 175, 188–190, 205, 206, 222, 230, 256, 281, 285–287, 332, 335, 350
Nyquist sampling theorem, 6–8

O

OIII, 115, 117, 118, 120, 121, 124, 125, 141–147, 223, 226–229, 380
Opacity, 37, 48, 55, 59, 62, 68, 69, 79, 86, 87, 123, 126–129, 138, 140–142, 145, 146, 152, 176, 202, 205, 206, 209, 212, 213, 223, 229, 257, 335, 337, 341, 368, 369, 372–374
Overlay, 7, 9, 12, 89, 90, 127, 182, 222, 312, 315

P

Paint brush, 69, 76, 77, 81, 91, 92, 128, 144–146, 157, 176
Painting, 68, 69, 76, 77, 81, 82, 91, 92, 128, 144–146, 152, 157, 176, 177, 183, 205, 278, 287, 336
Palette, 117–121, 126–128, 153, 157, 160, 175, 221, 336, 354
Panoramas, 279–280, 359–361
Phillips ToUcam, 239, 324
Phillips ToUcam Pro/SPC900, 238

Photoshop, 29, 54–56, 76, 118, 131, 149, 159, 193, 218, 253, 281, 304, 325, 353, 367
Photoshop CS5, 29, 33, 37, 86, 160, 200, 201, 214
Photosphere, 293, 298, 302, 320–322
Pixel, 4, 32, 52, 77, 105, 126, 131, 150, 159, 194, 220, 244, 268, 296, 326
PixelMath dialog, 110
Pixel noise, 9, 20
PixInsight, 29, 32, 93, 98, 100, 106, 108, 109, 135, 159, 160, 170, 171, 220–222, 226
Plasma, 293, 302, 398
Point spread function (PSF), 5–8, 24–28, 221
Poisson noise, 1, 2, 4, 12, 13, 17
PSF. See Point spread function (PSF)

Q

Quantum efficiency (QE), 11–13, 17, 220, 267, 268

R

Radial blur technique, 224, 305–311
Raw files, 193–195, 197, 267, 281, 284, 285, 291, 299, 326
Raw format, 299, 313
Registar, 151, 197, 220, 366, 367, 370, 374, 377
Registax 6, 239, 240, 253–255
Register images, 163, 367
Registration, 8, 21, 22, 118, 169, 195, 197–199, 207, 366, 367, 369, 370
Resampling, 8, 22, 25, 133, 134, 164, 165, 169, 170, 213, 224
RGB combining, 199–200
Rule of intersecting lines, 359
Rule of thirds, 356, 358–360

S

Sampling, 6–15, 24–27, 39, 152, 244, 330, 377
Saturn, 243, 247, 251, 252, 254, 257, 258
Scaling, 24–26, 31, 33, 164, 166, 196, 199, 205, 206
Schmidt Cassegrains, 235–237, 245, 247, 248, 250, 252, 253, 255, 258, 383
Seeing, 6, 8, 9, 26, 42, 52, 85, 91, 105, 112, 126, 129, 131–133, 164, 199, 207, 217, 218, 234, 240–244, 246, 248, 249, 253–256, 265, 321–323, 325–327, 329, 330, 333, 337, 382

Shadow, 33, 34, 36, 37, 39, 56–60, 68, 88, 89, 106, 121, 143–145, 147, 152, 156, 157, 178–181, 190, 194, 200, 201, 223, 249, 251, 284, 294, 300, 336, 341, 344, 353, 369, 374
Shadow/Highlight Tool, 178, 353
Sharpen, 16, 25, 26, 32, 33, 36, 37, 39, 74–79, 81–83, 85–89, 92–94, 97, 109, 112, 127–129, 134, 149, 171, 172, 175–177, 190, 222, 240, 253, 255–256, 281, 284, 327, 331–333, 335, 339
Signal to noise Ratio, 1, 3, 132, 138, 146, 207, 255
SII, 117–121, 125
Skyglow, 4–6, 9, 13, 20, 145, 170, 211, 282, 288–290
Sky limited exposures, 13–16
Smart radius, 44, 83
Smart sharpen, 87, 88
Soft light layering, 57–58
Solar corona, 293–317
Spherize tool, 350
sRGB color space, 129
Stack data rejection, 23
Stacking, 8, 14, 16, 20–23, 166, 196, 199, 254–256, 276, 280, 281, 325, 327–329, 331–333, 337
Star mask, 39–50, 94, 106–108, 112, 221, 226
Starscape, 262, 266, 274
Stretching, 24, 30–32, 37, 39, 57, 74, 78, 97, 98, 100, 105, 106, 108, 110, 125, 129, 134, 139–143, 145, 156, 170, 173, 175, 177, 179, 194, 196, 205, 210, 212, 219–221, 223, 225–227, 320, 336, 372, 373, 377, 378
Sunspot, 298, 320–323, 329
Symmetry, 186, 347, 352
Synthetic luminance, 207–208, 213

T

TGPG. See Tony's Green Pixel Gun (TGPG)
Theoretical airy disk, 234
The World at Night (TWAN), 261–263, 266, 288, 384
Tif, 195, 201, 214
Timelapse, 277
Tony's Green Pixel Gun (TGPG), 153, 154
Totality, 293–295, 297, 298, 300–304, 317, 380
TWAN. See The World at Night (TWAN)

U

Umbral, 294, 329
Unsharp mask, 25–26, 152, 182, 201, 209, 213, 214, 222, 286, 305, 328, 332, 335, 339

V

Venus, 245–247, 275, 278
Vibrance, 33, 37, 48, 60, 61, 283
Vibrance tool, 60–61, 71
Vignetting, 17–19, 100, 238, 280, 283
Virtual image, 2–5, 7–9, 11, 12, 22, 24, 26
Visual flow, 345–350, 355, 360
Visual response, 344–345

W

Wavelet filtering, 210–211
White point, 33, 125, 178, 179, 181, 199, 205, 220, 221
WINJUPOS image de-rotation, 257–258

Z

Zodiacal light, 275, 279, 289, 290